KT-467-860

Richard J. Powell

BLACK ART
A CULTURAL HISTORY

Revised and expanded edition

192 illustrations, 39 in colour, 181 biographical notes

 Thames & Hudson world of art

For C. T. Woods-Powell

Acknowledgments

In addition to the institutional support and the many people who
helped me realize the original 1997 edition of this book, I thank
Duke University's John Hope Franklin Center for International
and Interdisciplinary Studies. This revised edition has benefited
greatly from the intellectual exchange that was generated among
my colleagues in the seminars on 'Historicizing Identities: Race,
Gender & Sexuality', held at Duke's Franklin Center during the
academic year of 2001–2002. For the sabbatical leave and research
assistance to study and revise, I am eternally grateful.

Designed by Liz Rudderham

Any copy of this book issued by the publisher as a paperback
is sold subject to the condition that it shall not by way of trade or
otherwise be lent, resold, hired out or otherwise circulated without
the publisher's prior consent in any form of binding or cover other
than that in which it is published and without a similar condition
including these words being imposed on a subsequent purchaser.

First published in the United Kingdom, under the title
Black Art and Culture in the 20th Century, in 1997 by
Thames & Hudson Ltd,
181A High Holborn, London WC1V 7QX

www.thamesandhudson.com

© 1997 and 2002 Thames & Hudson Ltd, London
Revised and expanded edition 2002

All Rights Reserved. No part of this publication may be
reproduced or transmitted in any form or by any means,
electronic or mechanical, including photocopy, recording
or any other information storage and retrieval system,
without prior permission in writing from the publisher.

British Library Cataloguing-in-Publication Data
A catalogue record for this book is available from the British Library

ISBN 0-500-20362-8

Printed and bound in Singapore by C. S. Graphics

	CORK CITY LIBRARY	
	06425663	✓
HJ	27/03/2008	
	£8.95	

Cork City Library
WITHDRAWN
FROM STOCK

Richard J. Powell
is john Spencer Bassett Professor of Art and Art History
at Duke University, Durham, North Carolina where he has
taught since 1989. He studied at Morehouse College and
Howard University, before gaining his doctorate in African
American art history at Yale University. In addition to
teaching courses in American art, the arts of the African
Diaspora, and contemporary visual studies, he has written
on topics ranging from primitivism to postmodernism, and
has helped organize several exhibitions, including
"Rhapsodies in Black: Art of the Harlem Renaissance" for
London's Hayward Gallery in 1997, and "To Conserve a
Legacy: American Art from Historically Black Colleges and
Universities" for the Studio Museum in Harlem and the
Addison Gallery of American Art in 1999. His publications
include: *The Blues Aesthetic: Black Culture and Modernism*;
Homecoming: The Art and Life of William H. Johnson;
and *Jacob Lawrence*.

Thames & Hudson world of art

This famous series
provides the widest available
range of illustrated books on art in all its aspects.
If you would like to receive a complete list
of titles in print please write to
THAMES & HUDSON
181A High Holborn, London WC1V 7QX
In the United States please write to:
THAMES & HUDSON INC.
500 Fifth Avenue, New York, New York 10110

Printed in Singapore

Contents

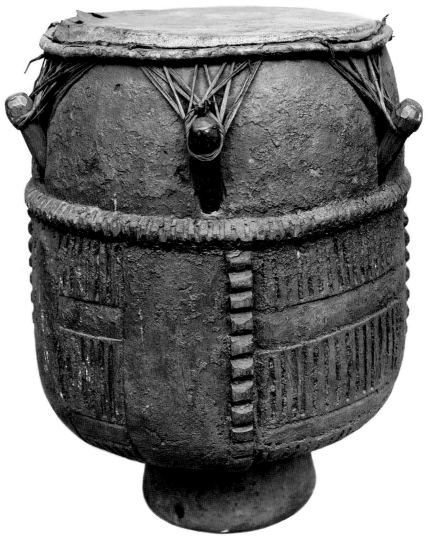

1 Slave drum, late seventeenth century

The Dark Center

THE ALCHEMY OF BLACK

In 1952, the Martiniquan psychiatrist and cultural theorist Frantz Fanon wrote *Peau noire, masques blancs (Black Skin, White Masks)*: a provocative book that in its analysis of the damaging psychological effects that racism had on peoples of African descent, shattered the more conciliatory views of race relations which were proffered by many social and political apologists during this period. In the section of the book that challenged French philosopher Jean-Paul Sartre's proposal that the black artist's declaration of cultural difference be eventually subsumed by a "future universalism" and "existential attitude," whose dominion meant cultural assimilation, Fanon responded with the following autobiographical disclaimer and "riddle":

> The dialectic that brings necessity into the foundation of my freedom drives me out of myself. It shatters my unreflected position. Still in terms of consciousness, black consciousness is immanent in its own eyes. I am not the potentiality of something, I am wholly what I am. I do not have to look for the universal. No probability has any place inside me. My Negro consciousness does not hold itself out as a lack. It *is*. It is its own follower.

Similarly, the late seventeenth-century "slave drum," acquired in colonial Virginia by the physician and naturalist Sir Hans Sloane, raises a racial conundrum for late twentieth-century students of black diasporal arts and cultural studies. With its stretched and pegged membrane, indented base, and rotund wooden body covered with decorative blocks and striations, this drum looks very much like percussive instruments found among Akan- and Fon-speaking peoples in West Africa. But even with this resemblance, and the likelihood that the people who made it retained Akan or Fon design sensibilities, its New World materials, its new context and possibly new use in colonial Virginia, removed it from its Old World frame of reference.

Sloane acquired the drum in the early eighteenth century, at the height of Virginia's involvement in the mass importation of enslaved

1

7

Africans; his collection ultimately formed the nucleus of the British Museum where the drum is still housed. The drum's specific Akan or Fon ritual identity has therefore been replaced with an identity that is African in kind, American in provenance, interpreted as an artifact through the lens of the Enlightenment, and founded on the social, political, and cultural austerities of slavery. What students have had to struggle with is the fact that the American-in-origin, African-in-design, and transatlantic-in-praxis lineages of this drum are perhaps more easily understood in the context of an African diasporal experience which, in practical terms, can be summed up by the all-encompassing, historical designation "black."

The intensity, irreducibility, and emphatic nature of the word "black" obviously contradict this drum's complex history and hybrid nature. Yet, following the irreversible impact of the transatlantic slave trade, the English *Black*, the French *Noir*, and the Spanish, Portuguese, and eventually Anglo-American *Negro* became terms that differentiated a largely New World phenomenon of African diasporal cultures and peoples from their ethnic-specific ancestors and relatives. Of course, the Europeans who were engaged in the slave trade had long referred to Africans as "blacks" (in addition to other, frequently disparaging designations), but over time and with a more entrenched colonial foothold in the Americas, ethnic terminologies like "Angolan," "Calabar," "Nago," and "Koromanti" (used for the first and second generations of African-born slaves) were superseded by the short and stinging "black": a term that, in its brusque utterance, contained a white supremacist sense of racial difference, personal contempt, and, oddly enough, complexity that came to define these new African peoples.

Conventional wisdom during and after slavery would have separated the perceived singularity of being black from the inherent multiplicity of being racially mixed, yet these polarities collapsed under their own short-sighted logic and inflexible nomenclature. Given the range of complexions and body types among African peoples, "black" (in spite of its stark, verbal fixity) has always signified more—visually and conceptually—than it has been allowed to represent officially. Sloane and other thinkers of the Enlightenment were often surprised by the variety of physical characteristics that they observed among New World "Negroes." They were certainly aware that this variation from partially African in appearance to almost entirely Caucasian-looking was due to the rape and concubinage of female slaves by white masters and male overseers, but they deluded themselves in classifying these mixed and enslaved entities as "black."

8

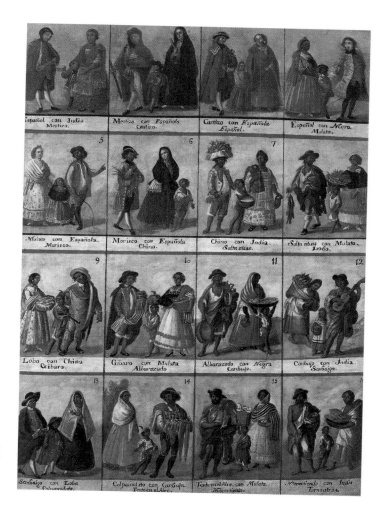

2 ANONYMOUS
Las Castas
late eighteenth
century

During the colonial period there were other more specific terms for perceived racial and/or cultural mixtures. Apart from the commonly and often loosely used *Creole, Mulatto, Quadroon,* and *Octoroon,* the Spanish-speaking élite of colonial Mexico invented at least fifty-three different names for various racial intermixtures. In an anonymous Mexican painting of "the castes" from the last quarter of the eighteenth century, sixteen of these race/class categories are illustrated with, surprisingly, those of a perceived African ancestry not always confined to the lowest social rungs. What this caste fluidity suggested was that, rather

2

than one's pigmentation or phenotype, proximity to the ruling majority's cultural norms in dress, occupation, and wealth was more important in determining status and class. Among the sixteen categories in this painting, an identifiable, New World Africanity—a result of the transatlantic slave trade, colonialism, and miscegenation—vaunted its hybridity and cultural defiance in a litany of imaginative, Spanish-derived labels, such as *Cambujo* (a male with a reddish-black complexion, similar to a horse's coloring), *No te entiendo* (which translated as "I don't get you," meaning someone whose ancestry was indeterminant), and *Salta-atrás* (which translated as "jump back" or, rather, someone whose African ancestry had unexpectedly reemerged). Although *Negra* in this context meant a female of Sub-Saharan African ancestry with tightly curled hair and a very dark complexion, Mexican social conventions concluded that all these categories (with the exception of *Español*) were culturally black or, rather, non-white, genealogically heathen and thus subject to the special laws and social boundaries of the Spanish crown and its colonial administration.

The political and economic realities that surrounded the African's encounters with the European (beginning in earnest during the fifteenth century) gave their perceived racial difference a social and cultural dimension: an aspect that, while life-altering for peoples of African descent, was obscured by the fact that blackness was a state of being that was rooted in perception. Notwithstanding the spurious biological basis of the definition of race, "black" has almost always initially meant racial identity, and only thereafter a social and/or political condition: an ingrained way of thinking that has been difficult to overcome. Yet for many people—particularly in England and France, and in response to Europe's colonization of Africa, Asia, and other parts of the non-Caucasian world—blackness is less a color than a metaphor for a political circumstance prescribed by struggles against economic exploitation and cultural domination: a state of consciousness that peoples of various pigmentations have experienced, empathized with, and responded to.

3 Arthur Drummond's *The Empress* (1901), while painted as a tribute to Great Britain's reign over much of the world's population, essentially recognized colonialism's power to render any subject black, as shown in Drummond's dream-like vision of three Africans, two Indians, one Pacific Islander, and three Caucasian females, all kneeling before a heavenly enthroned Queen Victoria. Of course, *The Empress* also communicated the politicizing and genderizing of whiteness, as seen in the painting's focal relationship between Lord Salisbury, King Edward VII, and the seven-year-old future King Edward VIII.

10

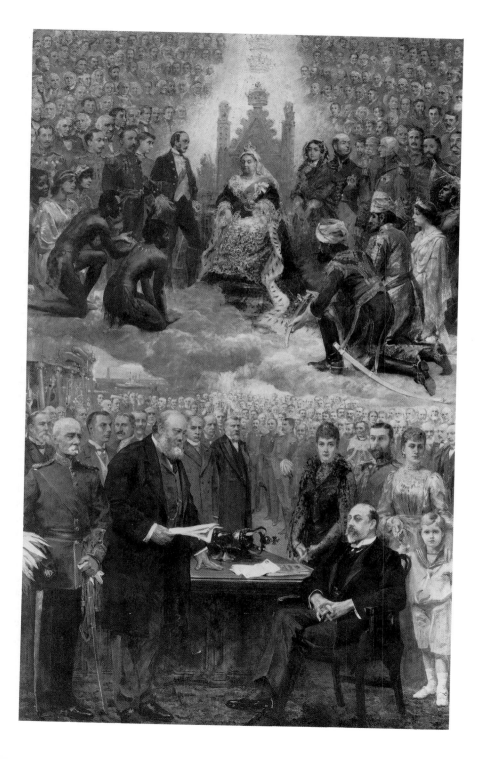

Despite these deep, unstable, and often contradictory meanings for black, one could argue that, by the twentieth century, it had become the most fitting name for a dispersed African peoples, whose common predicament of coming to terms with mass subjugation by Europe (and, later, Euro-America) raised the notion of a Pan-African solidarity that extended from London to Cape Town, as well as across the Atlantic. Even taking into account the more specific and nationalistic vogue—past, present and, no doubt, future—for hyphenated terminologies such as "Afro-American," "African-American," "Afro-Caribbean," "Afro-Brazilian," etc, "black" embraces a range of African diasporal experiences across national and linguistic borders. All the same—with its past, pejorative connotation, fluctuation between conciseness and ambiguity, and overtures to visual perception—"black" has not been fully appreciated as a way of describing cultural distinctions and peculiarities within the microcosms of African diasporal communities. However, it is with this understanding and acceptance of the problematic nature of blackness—both as a protean identity and as a proactive social presence—that one acknowledges Fanon and others' uses of it in defining, anchoring, and assessing cultural production in a similarly problematic modern and post-modern world.

FROM CREATION TO "MAKING DO"

Sociologist Stuart Hall, in his essay "What is this 'Black' in Black Popular Culture?" (1992), proffered a series of answers and additional questions to his rhetorical query on the occasion of the Black Popular Culture Conference, held at New York's Dia Center for the Arts and the Studio Museum in Harlem in 1991. Although wary of the often insular black nationalist positions espoused by activists and intellectuals, Hall offered the following definition of black popular culture that, while conscious of the ideological pitfalls of categorical absolutes and generalizations, acknowledged the reality, veracity, and even strategic necessity of such a concept:

> It is this mark of difference *inside* forms of popular culture—which are by definition contradictory and which therefore appear as impure, threatened by incorporation or exclusion—that is carried by the signifier "black" in the term "black popular culture." It has come to signify the black community, where these traditions were kept, and whose struggles survive the persistence of the black experience (the historical experience of black people in the diaspora), of the black

aesthetic (the distinctive cultural repertoires out of which popular representations were made), and of the black counternarratives we have struggled to voice.

Filtered throughout Hall's brief definition of "black popular culture" are at least five components that not only define the parameters of the 1991 Black Popular Culture Conference, but demarcate and explain the core factors in this present investigation into visual representations of black diasporal cultures in the twentieth century. First of all, these cultures constantly struggle against claims, from both within and without, of racial quintessence, as well as against dominant (and often hegemonic) cultural and political forces. As argued earlier, the intrinsically hybrid nature of blackness complicates these arguments. However, black culture has emerged from clusters of West and Central African cultural sensibilities (which are not reducible to a definitive set of characteristics or traits) and has a common wellspring in the transatlantic slave trade and colonialism. The cultural products of the various black diasporal peoples deserve, therefore, a comparative indexing and critical analysis.

Secondly, black diasporal cultures are defined by having the sufficient demographic numbers and critical mass to proclaim common beliefs, value systems, and goals toward building community-based institutions and products. For example, by the 1980s more than thirty million people of African descent in the U.S.A. had forged a separate identity that was frequently referred to by its institutional keystones (that is, African American churches, voluntary organizations, service sector businesses, and schools of higher education). Although indistinguishable at times from the cultural forms of other U.S. ethnic groups, African American styles of religious worship, performance, and verbal and literary expression stand out among U.S. cultural products, representing a shared vision that often resonates with black diasporal counterparts in the Caribbean, Central and South America, Europe, and Africa.

Another characteristic of black diasporal cultures is their structural dependence upon an acknowledged collection of life experiences, social encounters, and personal ordeals, the sum of which promotes a solidarity and camaraderie that creates community. This notion of a collective life-experience—racial and cultural discrimination, segregation, recognition, and identification—should not be viewed as a litmus test for blackness *per se*, since many peoples of African descent have experienced these to varying degrees. Still, the admission that these social assays are fundamental to black culture, if not actually experienced, is important to its conceptualization and realization.

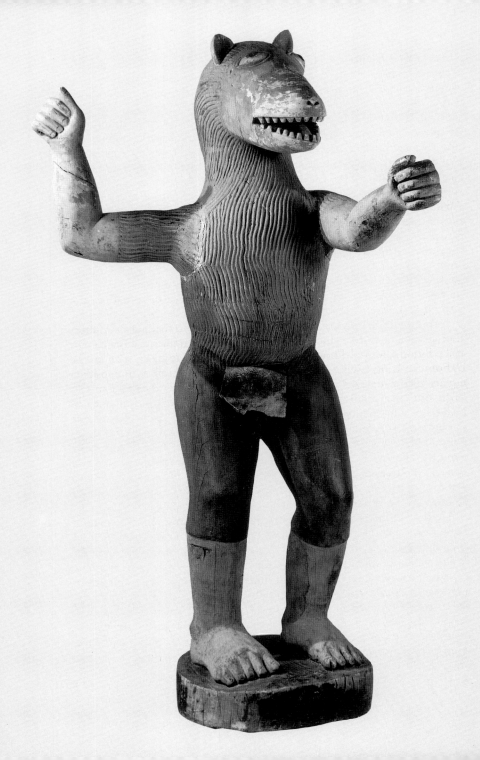

Stuart Hall's reference to a "black aesthetic," despite the concept's oft-disputed existence, is a fourth characteristic of black diasporal cultures. Because of the modern (and postmodern) derivations of a black diaspora —and the hybrid and complex nature of its various human and cultural products—critics have resisted the perceived "lumping together" of assorted art forms, stylistic approaches, and aesthetic sensibilities under one, seemingly intractable banner, and rightly so. Yet, when explored by Hall as "distinctive cultural repertoires," it is clear that, rather than something singular and unrealistically all-inclusive, a "black aesthetic" is the name for a collection of philosophical theories about the arts of the African diaspora: an aesthetic grounded in the idea of a new, that is, a post-Emancipation and post-colonial, black identity which, from Jazz-Age Harlem and Montparnasse, to the "sound system" societies of west Kingston, south London, and south central Los Angeles, thrives in black communities where artistic creativity and performance are the basic cultural currencies.

Finally, black diasporal cultures are characterized by forms that are not only alternative to mainstream counterparts, but proactive and aggressive in their desire to articulate, testify, and bear witness to that cultural difference. Although usually discussed in the context of traditional African art and religion, the well-known wooden sculpture (or royal Fa-*bocio*) of the Dahomean King Glele (1858–89) introduces the possibility of considering an African-derived work of art in this larger, black diasporal context. Born out of a cosmopolitan period in the West African kingdom of Dahomey, this visually hybrid sculpture of the late nineteenth century by the artist Sosa Adede appropriates imagery from selected West African sculptural traditions, Fon divination signs, European heraldry, and the world under observation, in order to invoke King Glele's strength and ferocity in battle. Adede's king-in-the-guise-of-a-lion motif, rich in metaphor and allusion, directs its argument for King Glele's power and potentiality to residents and outsiders alike, creating a kind of visual and verbal counternarrative; it embodies an artistic departure from the West African norm that recalls the creolized art works of enslaved Dahomeans and their descendants in Haiti, Cuba, Brazil and other black diasporal sites.

Therefore, with Stuart Hall's description of "black popular culture" as a point of departure, "black diasporal culture" is defined here as the things that significant numbers of black people do. "Things" that black people "do" can be defined as virtually all that is constructive, inventive, crafted, and produced in various black communities, such as making works of art, participating in religious ceremonies, performing on the

4

4 SOSA ADEDE *King Glele in the Guise of a Lion* late nineteenth century

stage, in concert, or on athletic fields, or simply eking out an existence in the most humble of circumstances. And again, what is meant by "black people" are the women, men, and children of African descent who because of the transatlantic slave trade, European colonialism, Western imperialism, and racism are globally dispersed, culturally hybrid, and narratively engaged in multilingual, Pan-African polemics with each other and with the world-at-large.

BLACK CULTURAL SUBJECTIVITY

In *Emancipation and the Freed in American Sculpture: A Study in Interpretation* (1916), the pioneering African American art historian and critic Freeman Henry Morris Murray revealed an uncharacteristic and refreshing cynicism in the section of the book that discussed general impressions of enslavement and emancipation. "The fact is," wrote Murray, "the conditions of being exploited, held down, even enslaved in one form or another, are so common and so old, that people, the victims included, come to regard these conditions as natural if not right; at any rate, as necessary and unavoidable." Murray continued his reflections with this observation:

> Emancipation—even under the circumstances through which it came about in this country—is conceived and expressed nearly always as a bestowal; seldom or never as a restitution. Hence American art—and foreign art, too, it seems—usually puts it: objectively, "See what's been done for you"; or, subjectively, "Look what's been done for me."

Contained in Murray's comments about slavery and freedom—and in their artistic (and often patronizing) manifestations—was his unabashed concentration on African American concerns, perspectives, and voices in the study and interpretation of art. With the furor over the misrepresentation of black people in D.W. Griffith's 1915 film *The Birth of a Nation* as a likely reminder and concurrent backdrop, Murray believed that the "subject" of art—especially when that subject was "Black Folk"—eclipsed the "art for art's sake" sentiment that many members of the European and Euro-American art *cognoscenti* espoused. For Murray, black subjectivity (as the African American philosopher Alain Locke would affirm in his groundbreaking book, *The Negro in Art*, almost twenty-five years later) presupposed that there was a world in which black peoples and their cultures, rather than always being filtered through white supremacist eyes and mindsets, could be seen and represented differently: either through the non-racist (or at least, multi-dimensional)

15

16

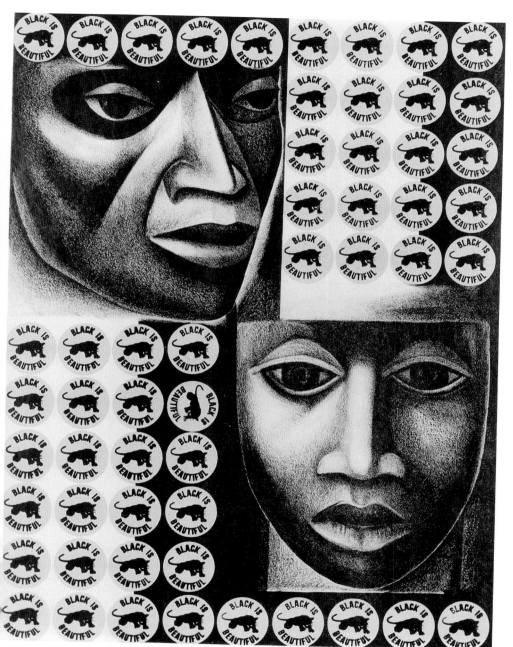

5 ELIZABETH CATLETT *Negro es Bello II* 1969

lens of whites, or through the knowing and racially self-conscious eyes and imaginations of blacks themselves. Unlike other art historians, whose cultural capitals were Florence, Paris, Berlin, or Athens, Murray's mecca of black subjectivity had no single, geographic seat. Given the dispersed, institutionally fragile, and often rootless nature of black lives around 1916, Murray's "dark center" was conceptual: as potentially global and established as it was local and nomadic.

This present investigation continues Murray's "study in interpretation" of black culture by focusing on the exploration of this identity by artists during the twentieth century. Many cultural historians would probably agree with the assessment that the twentieth century has been an unprecedented time for redefining and creating a new image for black culture. In a period rich in historical significance for peoples of African descent, chroniclers of the twentieth century can point to the disenfranchisement (and the eventual reenfranchisement) of blacks; the political and cultural imperialism from outside practiced on various black communities; questions of alliances from both within "the race" and beyond; mass migrations of African peoples to Western metropolises; the flowerings of assorted black cultural "renaissances"; and *ad infinitum* debates over racial discrimination. All of these are proof of this century's importance to the development of black identities, both authentic and collusive. These and other historical developments all contribute to make this era an ideal, chronological period to contain a discussion on black cultural subjectivity in art. A work like Elizabeth Catlett's *Negro es Bello II (Black is Beautiful)* of 1969—created in the midst of an ideological and political revolution among African Americans—is emblematic of a black cultural focus in twentieth-century visual arts that not only reflects its particular moment of creation; it also conveys something of a general, modernist-informed African formalism in its idolatry of black physiognomy, as well as a fascination with black culture as a commodity in its Pop Art-like repetition of "Black Panther Party" buttons.

Because this book traces through time the changing visual representations of black culture, it could be considered as a survey. But where it departs from the standard surveys of "black art" is in its approach, which is thematic, object-focused, and examines black subjectivity across perceived regional and racial boundaries. In six chronologically arranged chapters, the theme of twentieth-century visual representations of black culture is developed by looking at specific works of art, and at how those works of art signify: (1) the "souls of black folk" (2) the persona of the "New Negro" (3) a black proletariat (4) race pride and

cultural assimilation (5) aesthetic variants on the concept of blackness, and (6) the artistic commerce in black cultural identities.

For the purposes of this particular investigation, the routine regional, ethnic, and racial demarcations of most surveys have been minimized, in order to focus on the thematic implications of black culture in twentieth-century artistic production. Although anyone familiar with a full range of twentieth-century art and artists will see that the majority of examples in this study are African American (that is, people of African descent, whose lives and careers are based largely in the United States), this is truly more a consequence of an inordinate African American interest through-out the twentieth century in black cultural subjectivity than it is an African American research bias. Many twentieth-century African artists in the colonial and post-colonial periods have consciously rejected their particular ethnic approaches to art-making (for instance, "Yoruba," "Wolof," "Amhara,") and have replaced these with a Pan-African and/or international art language. African American artists, however, by virtue of a social infrastructure that has included access to training, exhibition opportunities, limited patronage and exposure to serious criticism and reviews, still figure significantly among black diasporal artists in their visual self-interrogations and introspective studies of black culture. Beyond any perceived territorialism in this study, the guiding spirit is the claim for black subjectivity, irrespective of, though not totally disre-garding, regional, ethnic, and racial categories. In other words, race, nationality, and ethnicity matter (to paraphrase the African American cultural critic Cornel West), but they do not function as omnipotent agents of dismissal, omission, or elucidation. As shown by my selection of works not only by African American artists, but also by European, Asian American, European American, and African artists, and Caribbean, Latin American, and European artists of African descent, twentieth-century black subjectivity is, first and foremost, a choice that, while frequently influenced by the artist's personal identity, is not solely dependent upon it.

Another departure from previous studies is the recognition of artistic media not traditionally discussed in the context of black diasporal arts. Beyond painting and sculpture, a wide range of graphic art techniques, photography, film, video, computer-assisted imagery, and body-centered performance art provide a more complete picture of black culture in the twentieth century. Especially with photography and the advent of film (and, later, television, video, and other electronic forms of visual representation), the twentieth century introduced elements of the docu-mentary and the virtual, which (as discussed in the Conclusion) bring

issues of black spectatorship, racial stereotypes, and divergent cultural perspectives to the fore.

Methodologically, this study has been inspired not only by the black subject-based investigations of others (Murray, 1916; Locke, 1940; Parry, 1974; Honour, 1989; Wardlaw, 1989; McElroy, 1990; and Pieterse, 1992), but by notions of an African diasporal culture developed by visual artist Jeff Donaldson (1970 and 1980), cultural theorist Paul Gilroy (1993), and art historian Robert Farris Thompson (1969, 1981, 1983, and 1993). With roots in earlier, Pan-African-informed political and cultural movements, these theorists of the late twentieth century have revised the image of the African continent, its many peoples, and its dispersed populace as historically grounded yet modern entities, products of socio-political change and cultural self-affirmation in black communities world wide. Despite the ideological differences between these three theorists, Thompson's many exhibitions and publications on a "transatlantic" visual tradition, Donaldson's published writings on "TransAfrican art," and Gilroy's thinking around the highly provocative notion of a "Black Atlantic," all share an understanding that the African diaspora is not so much a monolith as an "infinite process of identity construction" that, in the face of European cultural hegemony and Western technocracy, moves toward an open-ended, "black political culture."

6 In his *Victory in Zimbabwe* (1977–80), Jeff Donaldson committed to relief collage and acrylic paints what he has described in various writings as an "awesome" or "sublime" black diasporal image. With the restored ancient name of the previous British colony of Rhodesia centered and framed by Afrocentric zig-zags, Egyptian-like figures, and contrasting colors, this "TransAfrican" artist and theorist has put black cultural sub-jectivity literally at the core of his work. But in addition to the themes of African independence and the linking of black figures across millennia and continental ranges, the subject of *Victory in Zimbabwe* is also black diasporal rhythm: a visual, oral, and performative factor that Paul Gilroy (partially quoting historian Sterling Stuckey) has identified as most expressive and discernible in "the ubiquity of the antiphonal, social forms that underpin and enclose the plurality of black cultures in the western hemisphere." Black cultural subjectivity in art moves beyond a depicted black icon (or illustrative polemic) and, instead, becomes design, word, act, attitude, or what Robert Farris Thompson (in his explanation of Kongo notions of the altar) has characterized as "where the pure power of the dead brings its radiance to the present."

In addition to those texts of art history and cultural studies that focus on issues of identity, culture, and the ever-evolving definitions of an

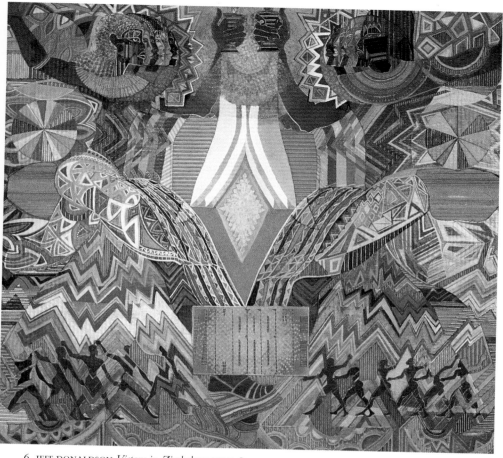

6 JEFF DONALDSON *Victory in Zimbabwe* 1977–80

African diaspora, this book has also benefitted from feminist writings of the late twentieth century that, in the aftermath of a period abundant in published works on gender, sought alternative critical strategies related to cultural representations of *woman*. Examples of these theoretical models are works addressing female subjectivity (de Lauretis, 1984, and Trinh T. Minh-ha, 1989), the theory of "cultural positionality" (Alcoff, 1988), the meshing of different female experiences (King, 1988, and Crenshaw, 1989), and alternatives to representational formulas (hooks, 1992).

21

Conventional art histories have often separated the critical practices of feminists from those of black cultural advocates, yet it is in a provocative, multidimensional, and circumstantial re-examination of identity in art where more possibilities for understanding and seeing things differently reside.

With these methodologies, theories, and an ecumenical perspective, black cultural subjectivity has the potential of opening up and invigorating some of the more pedantic and conservative directions in the humanities. Even African American art history (which has long been restrained—and shrouded—by the requirements of a biographical and strict chronological approach) takes on a new character that, rather than being intellectually bound by the perceived race or nationality of a creator, looks instead to the art object itself, its multiple worlds of meaning, and its place in the social production of black identities.

To sum up, this book is a thematic examination of black cultural subjectivity in twentieth-century art, with a broad (but not exhaustive) selection of art works, references, discussions, and representative artists. Despite the limits of such an investigation, readers can still obtain a comprehensive understanding of the major art-historical issues that surround an African diaspora, as well as enjoy an introduction to black culture and art in the twentieth century. In addition, it is hoped that this volume will inaugurate further study and in-depth research into the *oeuvres* of individual artists, the significance of specific works of art, and the implications of particular orientations and attitudes about black subjectivity.

Returning to Fanon, his admonition concerning the completeness and self-sufficiency of his black consciousness, underscores the importance—and even the necessity—of finding one's own "dark center." In the years before his published declaration, and throughout the second half of the twentieth century, social activists, intellectuals, and artists joined him in a seemingly endless struggle against an imposed necessity, an implied lack, and an assumed incompatibility between being black and being universal: a cultural conflict that drives the soul out of a people and shatters their "unreflected position." If there is a complementary message to Fanon's mid-century "riddle" in this present investigation, it is that the interpreters of black diasporal cultures not only assume control of the language and subject of the discourse, but that they, along with the creators and practitioners of black diasporal arts, must operate from an *a priori* position of cultural wholeness, conscious historicity, and an inherent and unapologetic humanity.

Art, Culture, and "the Souls of Black Folk "

TURN-OF-THE-CENTURY REPRESENTATIONS

At the end of the nineteenth century a proposal for a gathering of men and women in London to discuss the status of peoples of African ancestry living in Europe, North and South America, the Caribbean, and on the continent of Africa captured the imaginations of black intellectuals and activists the world over. In France the Haitian diplomat Benito Sylvain had initially hoped that the assembly would denounce the scientific community and its allegations of "Negro inferiority": an issue that was being hotly debated among many white ethnologists during this period. In the United States the famous African American educator and spokesperson Booker T. Washington, although generally unsympathetic to political agitation and assertiveness by blacks, gave his tacit approval for such a conference and urged those "colored Americans" who were able to attend to do so. And in England the Sierra Leonean Anglican cleric, Bishop James Johnson, leaving to take up his appointment as the church's spiritual leader in the Lower Niger Delta area of West Africa, proclaimed that the "Pan-African Association" and its congress of black people from all over the world was "the beginning of a union I had long hoped for, and would to God it could be universal!"

This call for black people throughout the world to meet and discuss their collective condition at the dawn of the twentieth century was an extraordinary event. The 1900 Pan-African Conference and the context which produced it—the cultural and psychological colonization of African peoples worldwide, their economic exploitation, and rampant racism and genocide from the Belgian Congo to the southern United States—all suggested that at this early stage in the formation of a post-Emancipation black identity, there was the sense among many peoples of African ancestry that they had certain concerns, fears, aspirations, and even cultural values in common.

Indeed, in the months just prior to London's Pan-African Conference the Exposition Universelle in Paris had rallied scores of black visitors to see and take pride in the "American Negro Exhibit" on the Rue des

Nations. Comprising photographs, books, industrial and fine arts products, handmade objects, miniature architectural models, machine patents, and other materials made by independent black artisans and students from historically-black U.S. schools, this display served as a shining example of what was possible for any oppressed people, whether in Africa, Europe, or the Americas, once the veil of slavery had been lifted, and they had a chance to do something for themselves.

The belief that black people, apart from physiognomic and genealogical ties with the inhabitants of Africa, had comparable experiences, identical struggles for full acceptance in society, and shared destinies, was widely held by social commentators and thinkers in the second half of the nineteenth century. For ethnographers the lowly status of black peoples in the United States, the Caribbean, and Latin America, and what was considered the "primitive" culture of their African forebears, were "evidence" that all blacks were cut from the same coarse "biologically-determined" cloth, and that the policies of white paternalism and social control were necessary for world order and Western progress.

In contrast, there were a few nineteenth-century thinkers who took a position that might be described as "Pan-Africanist" or "black nationalist." For them, the same historical "facts"—the shared African origin, the social dissolution which afflicted African peoples through the transatlantic slave trade, the hope (and, in many instances, the futility) of universal emancipation, and the social/economic vacuum which resulted from Western imperialism and white racism—all suggested that the world's African peoples, in spite of having experienced different forms of slavery, dispersal, and economic exploitation by the West, had more in common with one another than with their white brethren. These various interpretations of an African-derived presence in the world created particular stereotypes and perceptions of black people and their cultures which differed dramatically from either earlier pre-Emancipation representations of blacks or images of indigenous African peoples.

Several approaches in representing this African-derived, but new and distinct "black culture" reveal both the possibilities and the limitations of black life as perceived during this period. One tendency developed around a burgeoning African-American performance tradition. Its roots in slave plantations, and in parodies of this culture by white blackface minstrels, and also in post-Civil War politics and social customs, spawned a whole commerce in comic, music-and-dance-oriented, and racist representations of black people.

Like many literary and visual portrayals whose principal incentive is a satirical or "humorous" view of "the other," these images took the form

of outrageous characterizations of blacks, their communities, and their alleged cultural practices. These grotesque, garishly dressed beings, with black skins, protruding red lips and bulging eyeballs, were usually shown in impoverished settings with yard fowl, watermelons, and so on. Alternately backward, shiftless, ridiculous, childish, criminal, these characterizations faithfully appeared in turn-of-the-century European and American theatrical productions, popular literature, advertisements, children's toys, and other cultural documenta. Countless graphic artists and illustrators established themselves in this field of commercial art. Edward W. Kemble, literally created his own one-man Negro-stereotype industry, with dozens of racist illustrations for books and journals, including his 1896 "classic," *Kemble's Coons.*

Ironically, among those most responsible for putting the pejorative word "coon" into common usage was the black American vaudeville performer and composer Ernest Hogan. His celebrated (and notorious) 1896 song, "All Coons Look Alike to Me," catapulted the "coon" craze and racist representations of blacks into worldwide popularity.

7 Cover of sheet music for "All Coons Look Alike to Me" by Ernest Hogan, 1896

An entirely different approach invested black people with a more truthful humanity, as in the novels of French and American writers, such as Emile Zola, Guy de Maupassant, Henry James, Stephen Crane, and Theodore Dreiser. American visual artists such as Thomas Hovenden, Thomas Eakins, Winslow Homer, and Henry Ossawa Tanner, developed a similar realism which also challenged the prevailing assumptions of black inferiority, shallowness, and bestiality.

Tanner, who based himself in Paris, was one of a small number of African American artists, including sculptor May Howard Jackson, painter Alfred Stidum, and photographer C. M. Battey, who were producing new images of black life at the turn of the century. Tanner's early training at the Pennsylvania Academy of the Fine Arts (under Thomas Eakins) and in Paris at L'Académie Julien (with John-Joseph Benjamin-Constant and Jean-Paul Laurens) gave him the painting skills and realist credentials which, with his innate talent, imagination, and interest in morally charged subject matter, led to the creation of such

8 early masterpieces as *The Banjo Lesson* (1893). In Tanner's hands this familiar scene of an old man teaching a young boy how to play the banjo, set in the domestic warmth and genteel poverty of a hearth-lit cabin, was transformed into a painted Negro spiritual: a luminous, pictorial narrative about learning, cultural nourishment, and cross-generational affection. Tanner was principally a painter of Biblical allegories, and during the fifty-odd years of his career only intermittently explored these sympathetic themes featuring black subjects. Yet these loving and remarkably sober images of blacks have long been paragons of positivism for the African American popular imagination in the welter of cultural stereotyping and ridicule.

A third source of representations of black culture at this time was what Richard A. Long has described as the "folk-rural" tradition. Both the racist and realist/idealist strains of black imagery emerged from artists and perceptions outside typical black communities; in contrast, the folk-rural orientation developed from within them. The memory of an African legacy, the institution of slavery, confinement within a socially-instituted caste system, and a position on the margins of the economy—all these influenced the self-taught and vernacular style, like many of the crafts that were on display in the "American Negro Exhibit" for the 1900 Exposition Universelle in Paris.

9 The *Bible Quilt* (*c.* 1895–98) by the Georgia seamstress Harriet Powers had its genesis in this culturally insular, folk-rural world, conditioned by Bible stories, subconscious affinities for West African design sensibilities, and the politics of race, gender, and class. Powers did not

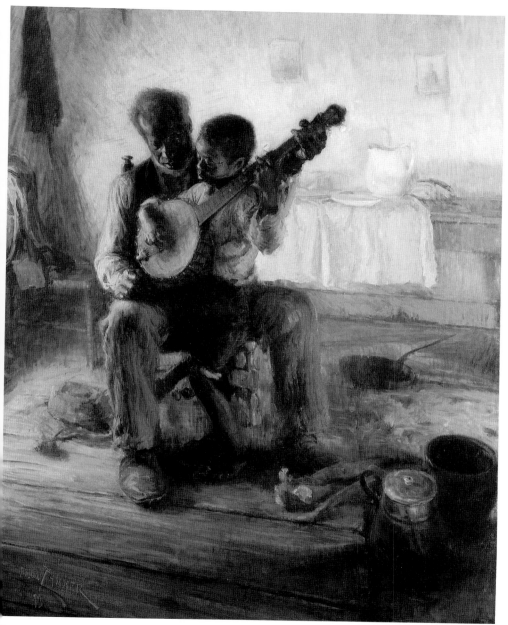

HENRY OSSAWA TANNER *The Banjo Lesson* 1893

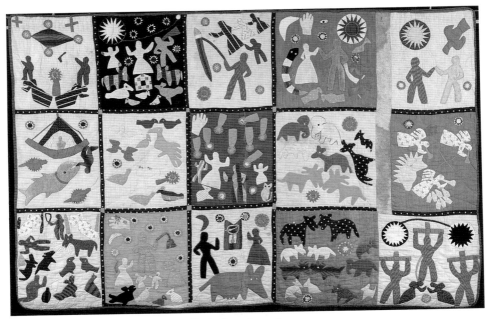

9 HARRIET POWERS *Bible Quilt c.* 1895–98

explicitly portray black culture or black people, but expanded the representational discourse through sign-like, heraldic emblems and her own description (written at her dictation) of each appliquéd panel of the quilt. Although masked by standard Biblical narratives, Powers's *Bible Quilt* and her earlier version of 1886, covertly interrogated the worldly affairs of women and men who, like those in Powers's tiny community outside Athens, Georgia, had their own share of Old and New Testament-like temptations, trials, betrayals, and sacrifices.

The clashing and colliding sentiments in Hogan's "coon" imagery, Tanner's impressionistic scenes of black life, and Powers's rural folk artistry showed what was being flaunted by 1900 in the popular imagination as "Negro." What was harder to discern were the underlying significations of black culture, both in its actual forms and in its representational constructs.

LIFTING EVERY VOICE

Part of the answer surfaced at this time in the writings of the African American educator, attorney, diplomat, and author James Weldon

Johnson, who is best known for his 1900 song "Lift Ev'ry Voice and Sing" (commonly referred to as the "Negro National Anthem"). His 1912 novel, *The Autobiography of an Ex-Colored Man*, published anonymously and remaining so until 1927, traced the racial and cultural evolution of the protagonist, from his "illegitimate" and mixed racial beginnings in the segregated South, to his equally "illegitimate" end as an African American who tragically "passes" for white at the novel's conclusion. The ex-colored man's anxieties about having sold his birthright "for a mess of pottage" are framed by his admiration for the various African American cultural idioms of the day—ragtime music, Negro spirituals, African American religious oratory, and the popular black dance known as "the cakewalk." He saw them as ultimately on a par with the very best of European art, and felt that their originality, evocative nature, and universal appeal (as indicated in the revealing caption of H. M. Pettit's 1899 photomontage of cakewalkers for *Leslie's Weekly*) gave "evidence of a power that will someday be applied to the higher forms." 10

But how does one reconcile Johnson's eloquently articulated celebration of black popular culture with the legion of racist "coon" images that usually accompanied the era's ragtime music and cakewalking black dancers? Can the black theater scene of this time, with its roots in blackface minstrelsy and background of post-Civil War disenfranchisement

10 H. M. PETTIT *Close Competition at the Cake Walk* 1899

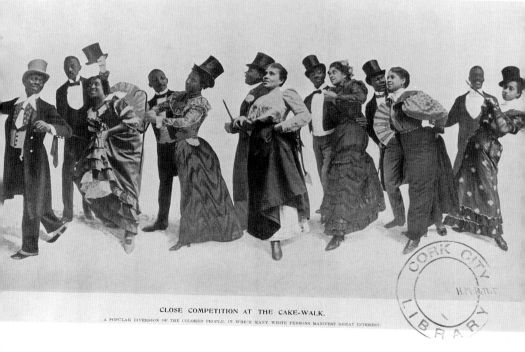

CLOSE COMPETITION AT THE CAKE-WALK.
A POPULAR DIVERSION OF THE COLORED PEOPLE, IN WHICH MANY WHITE PERSONS MANIFEST GREAT INTEREST.

and white-on-black violence, be redeemed with the universalizing and humanizing language of art and cultural relativism?

The black cultural demimonde with its stereotypes, portrayed in *The Autobiography of an Ex-Colored Man,* was well known to Johnson. As the lyricist for such ragtime hits as "Under the Bamboo Tree" and "Congo Love Song," Johnson used many of the standard black clichés of the day, seeing great mastery in the cakewalk and ragtime music, and praising a range of cultural expressions from the "racist" to the "authentic."

Of course, Johnson did not view his theatrical activities and those of his fellow black vaudevillians as "racist" or necessarily disparaging to black people. Rather he recognized the importance of the African American musical and performance tradition, and understood its major contribution to the transformation of American art from a mere imitation of older European models to a significant, world-class statement of artistic modernism in its own right. In spite of the broad dramatizations, crude jokes, and outrageous portrayals in black popular music, theater, and dance of this period, the musical richness, rhythmic complexity, highly stylized treatments, and multi-layered messages were evidence of an artistry and creative genius whose source was a black vernacular.

Several visual artists joined James Weldon Johnson in his curious fusion of seemingly stereotypical imagery from the black theatrical scene with profound, telling representations of black popular culture. Stuart Davis, a future proponent of a school of indigenous, American abstraction in painting, began his career as a newspaper illustrator, drawing various aspects of urban life in the Northeastern United States. One of those early drawings, *Negroe Dance Hall* (1913), depicted the unrefined black folk who frequented disreputable barrelhouses and nightclubs to gamble, dance, fraternize, and listen to the latest piano rags. In this quickly sketched, gestural drawing, his black subjects are invested with a contradictory yet provocative range of characteristics, from the dreamy, contemplative woman in the picture's foreground, to the lasciviously squatting wisp of a woman in the picture's central middleground.

A year later and across the Atlantic, in the garish stage lights and outrageous milieu of Berlin's lively cabaret scene, the German Expressionist artist Ernst Ludwig Kirchner too turned to African American performers as part of his wider quest to visualize the primitive energy of modern life. In one of Kirchner's lithographs, *Tapdancing Negro* (1914), the gestural drawing techniques which appeared in Davis's *Negroe Dance Hall* have been taken to extremes, with jagged scrawls and heavy, built-up markings echoing the rapid-fire movements and staccato dance steps of the black

11

12

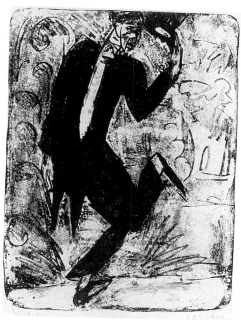

11 STUART DAVIS
Negroe Dance Hall 1913

12 ERNST LUDWIG KIRCHNER
Tapdancing Negro 1914

performer. Kirchner's subject, while on the surface nothing more than a "tapdancing Negro," embodied an artistic spontaneity and "Nietzschean vitalism" which many European artists thought would further propel their work into a modernist trajectory.

While these artistic overtures to black popular culture can be viewed as part of a bigger, international movement in modern art away from bourgeois, academic conceits and toward expressive, emotionally liberating sources of artistic inspiration, many African American artists opposed this view. In sharp contrast to James Weldon Johnson, most educated blacks of this period rejected those aspects of black culture which perpetuated certain notions of black servility, racial jokes, derogatory pictures, and other disparaging displays. Black vaudeville, representations of the black working class, and their shared nineteenth-century slave

lineage were considered throwbacks to an inglorious past, vulgar, and embarrassing to "the race." Literary critic Henry Louis Gates Jr. has argued convincingly on the subject of this rejection of the so-called "old Negro" and a fixation on the so-called "new Negro" by members of the black élite of the time, and how these choices, despite the progressive nomenclature, often prevented them from confidently articulating a broad and nuanced African American self.

One exception among the conservative black élite in this rejection of the past can be found in the writings of the sociologist, historian, and black activist William Edward Burghardt Du Bois. At the beginning of Du Bois's 1903 classic, *The Souls of Black Folk*, he described his intended literary goal as a delineation "in vague, uncertain outline" of "the spiritual world in which ten thousand Americans live and strive." In the fourteen chapters that follow, Du Bois's objective is fully realized through a poetic, historically rooted, and highly literate voice of reason, authority, and appeal. He introduced cultural metaphors such as a "double-consciousness" and living one's life within "the Veil" of racial segregation, and he directed one of the most persuasive and fearless arguments against the then powerful Booker T. Washington and his racially submissive "Atlanta Compromise" speech of 1895. *The Souls of Black Folk* branched out into previously uncharted territories for black scholarship, fusing psychology, philosophy, ethics, and old fashioned political debate.

Du Bois embraced the historical past, while renouncing contemporary black popular culture; this is evident in his poignant treatise on African American spirituals, or what he termed "the sorrow songs." "The Music of Negro religion," he wrote in *The Souls of Black Folk*, "is that...which, despite caricature and defilement, still remains the most original and beautiful expression of human life and longing yet born on American soil." For Du Bois, the spiritual life and cultural expressions of black people—inherently fundamentalist, ethical, and born of a great, social injustice—are the guiding lights in the vast gloom and darkness of the years after the American Civil War. Like the similarly idealized representations of black life found in Tanner's *The Banjo Lesson*, or in the photographic frontispiece for Paul Laurence Dunbar's 1901 book of verse, *Candle-Lightin' Time*, Du Bois allowed African Americans a metaphysical reality and an inner being which refuted the absurdities of everything which was then commonly touted as "Negro," from popular culture's "coon" imagery to Booker T. Washington's widely sanctioned message of black acquiescence.

The sophisticated frontispiece for *Candle-Lightin' Time* was taken by a member of Hampton Institute's Camera Club. The Institute had been

8

13

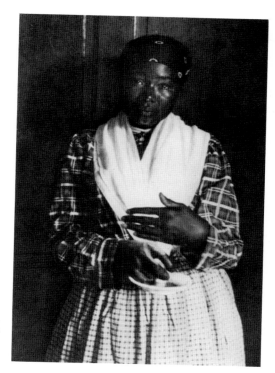

13 LEIGH RICHMOND MINER
frontispiece for
Paul Laurence Dunbar's
Candle Lightin' Time 1901

founded in 1868 in Hampton, Virginia, for the children of ex-slaves and reservation-bound Native Americans, and by the year 1900 it had almost one thousand students enrolled; photography was only one among the many trades and industrial art forms taught there. This frontispiece was photographed in dramatic chiaroscuro by Institute faculty member Leigh Richmond Miner following the pictorialist tradition of Edward Steichen. It implicitly communicated an image of African Americans that stressed both their slave heritage and what Du Bois described in the African American psyche as "that transfigured spark of divinity."

Like Du Bois, many other black artists were harsh critics of a white and largely racist *status quo* in the United States. John Henry Adams Jr., a Professor of Art and Drawing at Morris Brown College in Atlanta, Georgia, and a contributor to the Atlanta-based monthly, *Voice of the Negro*, frequently lent his talents to a biting, visual analysis of Du Bois's notion of life "within the Veil." Adams's *The Modern Cyrenian's Cross, or the Black Man's Burden* (1907) presented to *Voice of the Negro* subscribers a rogues' gallery of political and literary "deities" whose anti-black

14

33

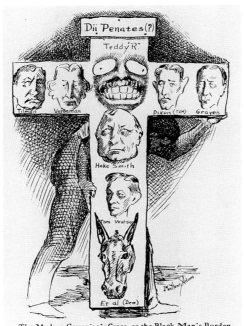

The Modern Cyrenian's Cross, or the Black Man's Burden

14 JOHN HENRY ADAMS JR.
*The Modern Cyrenian's Cross,
or the Black Man's Burden,*
1907.

rhetoric or neglect of African American social and political concerns qualified them for this ignoble status.

Adams's perception that many influential white Americans—from Thomas Dixon, the author of the notorious bestsellers *The Leopard's Spots* (1902) and *The Clansman* (1905), to Theodore Roosevelt, the twenty-sixth president of the United States—were the main barriers to black advancement was shared by other radical black thinkers of the day. In response to President Roosevelt's decision to discharge with dishonour, and without legal recourse, an entire battalion of black soldiers in Brownsville, Texas, Du Bois boldly wrote in the African American monthly *The Horizon: A Journal of the Colored Line,* "...Mr Roosevelt by his word and deed...has slammed [the door of opportunity] most emphatically in the black man's face."

Roosevelt's successors in the White House, William Howard Taft and Woodrow Wilson, proved equally unsympathetic to African American concerns. Taft's call in 1912 for African Americans to accept their fate "under the guardianship of the South," and Wilson's abject silence in the face of a rash of racially motivated lynchings throughout the United States caused many African Americans in the years just before World

34

War I to doubt that there was any hope of justice from the federal government.

In these years, the social policy of segregation and the rise in white-on-black violence precipitated images of blacks in the visual arts that conformed to the worst stereotypes imaginable. Interestingly it was the literary racism of novelist Thomas Dixon that inspired the pioneer movie maker D.W. Griffith to create the period's most scathing depictions of blacks. *The Birth of a Nation* (1915)—Griffith's cinematic adaptation of Dixon's two novels about the Civil War, the Reconstruction period, and the rise of the Ku Klux Klan—transformed racist pronouncements and injurious words into larger-than-life, moving truisms for predisposed audiences. President Wilson's widely reported endorsement of *The Birth of a Nation*, saying that it was "like writing history with lightning," prompted Du Bois to organize a nationwide protest against the film, but it was not successful.

Almost simultaneously with this culture of ridicule and slander, an African American élite (especially in New York, Philadelphia, and Washington, D.C.) began to defend itself with its own ammunition—"colored" literary societies, industrial fairs, and art exhibitions featuring the creative talents of its best and brightest. Even on the racial killing

15

15 D. W. GRIFFITH *The Birth of a Nation* 1915

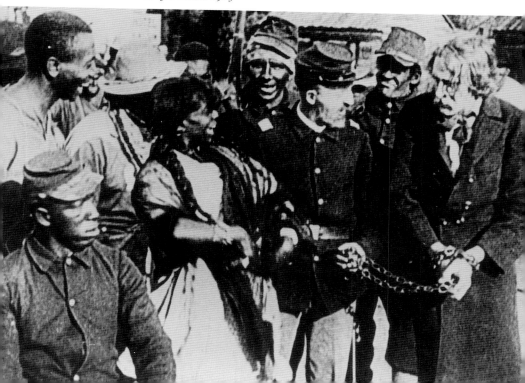

fields of the segregated south, the Arkansas-based African American sculptor Isaac Scott Hathaway, waged his own campaign. He created larger-than-lifesize commemorative plaster busts of educator Booker T. Washington; the nineteenth-century antislavery activist Frederick Douglass; poet Paul Lawrence Dunbar; and the founder of the African Methodist Episcopalian Church, Bishop Richard Allen. He sold casts of his four heroic heads ("$1.50 each/4 busts for $5.00") by mail order and through local agents. He combined the need for more uplifting, positive black images with a quintessentially American, entrepreneurial approach, advertising "The Isaac Hathaway Art Company" in *The Crisis*, the monthly journal published by the National Association for the Advancement of Colored People (NAACP).

In contrast to Hathaway's homage to four historic black achievers, Meta Vaux Warrick Fuller developed a more allegorical approach to black culture. Following studies in her native Philadelphia and in Paris at L'Ecole des Beaux Arts, Académie Colarossi, and privately with Auguste Rodin, Fuller embarked on a series of sculpture projects which documented her evolving racial consciousness, as well as her expanding artistic talent. Her experimental, fourteen-part tableau for the Jamestown Tercentennial Exposition, illustrating the "Negro's progress" from Africa to Afro-America (1907), was followed some years later by a more accomplished group of figures entitled *Emancipation* (1913), created for a New York City exposition on the same theme, and echoing the style of Augustus Saint-Gaudens, the Irish-born American sculptor.

Fuller's most important sculpture, *The Awakening of Ethiopia* (c. 1914), depicts a woman of African ancestry dressed in the classical headgear and apparel of an ancient Egyptian pharaoh, turning, gesturing, and extracting herself from the mummy-like bandages that wrap the lower half of her body. There are obvious allusions to similar subjects in mid-nineteenth-century neoclassical statuary, and to Rodin's legendary *Balzac* portrait of 1893–94, but, according to art historian Judith Wilson, an important source of inspiration for *The Awakening of Ethiopia* may also have been the utopian, Pan-Africanist novel *Ethiopia Unbound* (1911) by the Gold Coast activist and newspaper publisher J. E. Casely Hayford. Both Casely Hayford and Fuller (who had ties to the Pan-Africanist movement) employed the metaphor of an enshrouded and awakening "Ethiopia" (synonymous with Africa and also with the greater black diaspora). Physically restrained yet emotional and visually rich, *The Awakening of Ethiopia* served the representational needs not only of a disillusioned but hopeful black élite in the years 1914–17, but also of successive generations of "race" men and women.

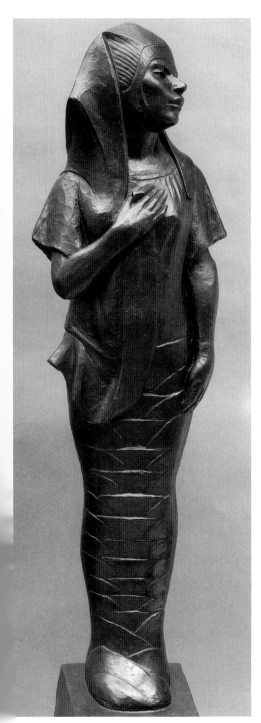

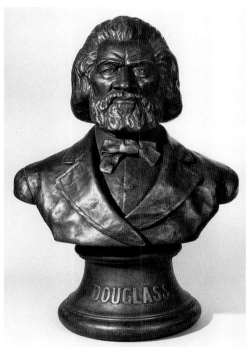

17 ISAAC SCOTT HATHAWAY
Frederick Douglass 1919

16 META WARRICK FULLER
The Awakening of Ethiopia c. 1914

On the global front, the years between the outbreak of war (1914) and Germany's ultimate defeat (1918) was a period of consternation for peoples of African ancestry. The African continent was further partitioned by France and Great Britain, and the island republic of Haiti, the first black independent nation in the Americas, fell under the humiliating occupation of the U.S. Marines in 1915. That same year saw the death of Booker T. Washington, arguably the most influential black man in the world, leaving a major void in black leadership. Thousands of black soldiers—largely from the United States and the continent of Africa—joined forces on European battlefields to fight, risk injury, and die for the democratic ideals and liberties of others that were unavailable to them.

Representations of black soldiers revealed the ambiguities and conflicts of their position. The image of a smiling Senegalese artilleryman, or *tirailleur*, in the advertisements for Banania (1917), a popular French breakfast cereal, conveyed, in equal proportions, a sense of good humor, comfort, the exotic, and the savory (as voiced in the picturesque Afro-French caption, "Y'a bon"). To the French, these subliminal messages were further colored by (1) the positive propaganda surrounding the

18

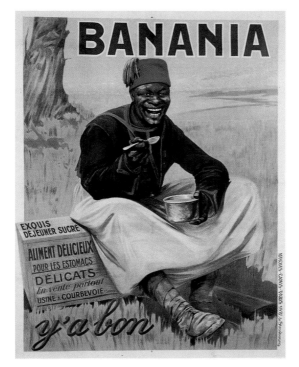

18 Advertisement for Banania, 1917

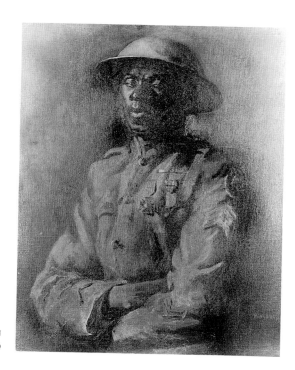

19 EDWIN A. HARLESTON
The Soldier 1919

contributions of the Senegalese *tirailleurs* to the French war effort, and (2) France's colonial relationship to Senegal and its legacy of exploiting West African agricultural products, as in bananas and cocoa, Banania's main ingredients.

In sharp contrast, Edwin A. Harleston's *The Soldier* (1919) presented a portrait of the black soldier—proud, undaunted, admirable, and disquieting—that embodied much of what African Americans felt about their wartime service. Like Fuller's *The Awakening of Ethiopia*, Harleston's enlisted man expresses the frustration and simmering anger of knowing that duty to God and country will not be sufficiently acknowledged or rewarded. Harleston, a product of The School of the Museum of Fine Arts in Boston, was certainly familiar with the story of Colonel Charles Young, a West Point graduate and one of the highest ranking black officers in the country who, because of the Army's reluctance to promote black officers into the brigadier general's ranks, was forced to retire in 1917. Harleston's black veteran, wearing medals, insignia, and an expression which tells of campaigns against both the Germans and his fellow white Army officers, epitomized the growing realization among many blacks that World War I was merely a prelude to greater and more

19

16

overwhelming battles on the home front. For instance, the promise of racial equality which was symbolized in the triumphant February 1919 promenade up New York's Fifth Avenue by the all-black, 369th Regiment, was resoundingly negated (beginning that June) by a wave of lynchings, race riots, and other forms of racial violence across the U.S.A., infamously referred to as the "Red Summer" of 1919.

However, at the beginning of 1919—a moment of optimism for many people in the world—a second international gathering of peoples of African ancestry took place, this time in Paris, and concurrent with the Versailles Peace Conference. Unlike the 1900 Conference, this "Pan African Congress" was organized through the efforts of Du Bois, who was in Paris as part of the Peace Conference press corps, and Blaise Diagne, a Senegalese member of France's Chamber of Deputies. While the primary topics of discussion revolved around the current conditions and future of the "Mandated Colonial Territories" in Africa, there was the belief among the participants that these African concerns, in spite of their distance from Europe and the Americas, had serious ramifications for blacks everywhere. Du Bois boldly articulated this position in the pages of *The Crisis* that same year: "The African movement means to us what the Zionist movement means to the Jews, . . . the centralization of the race effort and the recognition of a racial fount. "

Du Bois's notion of a common, Africa-centered "racial fount," though dangerously moving toward a kind of essentialism through identity politics, acknowledged (through his example of Zionism) the importance of the shared experiences of oppression, economic exploitation, and discrimination in the construction of such an ideological wellspring. By the end of 1919, with colonialism fully installed and racism endemic to much of the world, the quest for this "racial fount," or, to use another Du Bois metaphor, "the souls of black folk," drifted between romantic platitudes and "Red Summer" realities. In the world of art, Romanticism and Social Realism were the hallmarks of largely European, mid-to-late nineteenth-century aesthetics and, consequently, only capable of representing black "souls" within those cultural and theoretical strictures. It would not be until the early 1920s—with the rediscovery of what James Weldon Johnson described as the folk-inspired "creative genius of the Negro"—that Du Bois's racial fount would be located to a manifest "Ethiopia," (that is, Chicago's Southside, New York City's Harlem, and Paris's Montparnasse) and then, like an oasis to the parched in spirit, wholly absorbed.

Enter and Exit the "New Negro"

ETHIOPIA: REBORN AND RE-PRESENTED

In *Making the Modern: Industry, Art, and Design in America* (1993), art historian Terry Smith traced the American obsession in the 1920s and '30s with the creation of a contemporary aesthetic: a sensibility that he described as polished, efficient, progressive, democratic, and pure, as well as one which functioned with "only the newest structures" in mind. What Smith's investigation of modernism revealed was the deliberate construction of modernity out of an American marketplace of ideas, dreams and, in many instances, distinct winners and losers.

With this American compulsion as a backdrop, one can look at Henry Louis Gates Jr.'s "trope of a New Negro" and compare the applications of the twin concepts of the New and the Modern to the larger black cultural endeavor of this period. This phenomenon, variously called the "New Negro Arts Movement," a "Negro Renaissance" or the "Harlem Renaissance," was a myriad of different things to different people. For Alain Locke, Howard University professor of philosophy, and Charles S. Johnson, sociologist and director of research and publicity for the National Urban League, the "New Negro Arts Movement" was their carefully orchestrated effort to place African American social issues at the forefront of the national agenda. They used African American arts and culture as the vehicles for promoting "the race," and directed their publicity toward various philanthropic organizations and social agencies.

For composer George Gershwin, publisher Frank Crowninshield, theatrical agent and music publisher Irving Mills, and mobster and nightclub owner Owney Madden, the Harlem Renaissance was, to use American slang, "the hook": a marketing strategy for New York's publishers, theatre producers, nightclub and cabaret owners, and other business people in the 1920s and 1930s. For black artists like Paul Robeson, Langston Hughes, Duke Ellington, and Ethel Waters, as well as black intellectuals like Locke, Du Bois, James Weldon Johnson, and others, this "Negro Renaissance" was an auspicious moment in American cultural life: African Americans had unprecedented access to and an

active role in the organizations of the mass media, the venues of main-stream entertainment, and other cultural institutions.

Finally, for many people this "New Negro" entity was not so much a movement, a moment, or even an actual person, as a mood, or a senti-ment in which black culture and its practitioners were seen as a valuable part of the larger cultural scene. In a society that had recently suffered a war of tremendous proportions, and was increasingly changing into an urban, impersonal, and industry-driven machine, black culture was viewed, interchangeably, as life-affirming, a libidinal fix, an antidote for *ennui*, a sanctuary for the spiritually bereft, a call back to nature, and a subway ticket to modernity. The "New Negro" was the perfect metaphor for this moment of great social rupture because, like a medicine-show elixir, it was perceived as the cure for everything.

The term "New Negro," meaning an enlightened, politically astute African American, sprang from the turn-of-the-century, progressive race rhetoric of Booker T. Washington, of Fannie Barrier Williams, advocate of black women's rights, and from the illustrations for *The Crisis* and *Voice of the Negro* of artist John Henry Adams Jr. As a cultural movement, the term "New Negro" entered into popular usage with two, influential publications in 1925: a special edition of the magazine *Survey Graphic*, entitled *Harlem: Mecca of the New Negro*; and an anthology of essays, short fiction, photographs, drawings, and a short play, entitled *The New Negro: An Interpretation*. Alain Locke, the driving force behind these two publi-cations, dislocated the "New Negro" concept from its original socio-political connotations to an aesthetic of progress and race redefinitions.

Of course, comparing Smith's modernist iconology of the newest structures (that is, skyscrapers, department store displays, and Cadillacs) to the large cast of characters who comprised the "New Negro" arts movement might at first seem incongruous. Yet the classic images of this period—for instance, Winold Reiss's portrait of the twenty-three-year-old poet Langston Hughes (*c.* 1925)—perfectly captured the common ground from which these newest structures and racial pre-occupations sprang.

Winold Reiss, a product of Munich's Academy of Fine Arts and School of Applied Arts, came to the United States in 1913 and very soon opened his own Art School and Design Studio in New York City. Reiss divided his talents between commercial graphic and interior design projects, and his renowned pastel renderings of "representative" world racial types. The creation of a modern design look and the study of the world's races through their exterior cultural expressivity were clearly evident in the Hughes portrait. From the painstaking delineation of Hughes's face, to

42

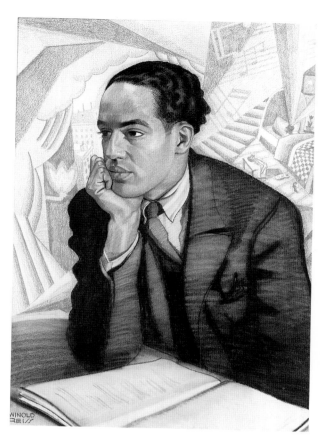

20 WINOLD REISS
Portrait of Langston Hughes
c. 1925

the cubistic background of Art Deco marginalia, musical notes, and
whimsical "Negro" decorations, Reiss situated the "New Negro" in the
world of product and display, where the commodity (Hughes) was clearly
placed between modernity and a persistent, pliable folk temperament.

Was it ironic that Alain Locke and the other promoters of the "New
Negro" chose Winold Reiss—a Caucasian artist of German nationality—
to portray this modern, black persona? Perhaps, but, on another level, the
choice made sense given Reiss's cultural distance from the assorted forms
of American racism. He had artistic affinities with both pictorial realism
and modern industrial design, qualities that Locke and the other creators
of the "New Negro" considered essential for constructing an African
American identity in art. This no doubt inspired them to arrange for
Aaron Douglas, a twenty-six-year-old African American artist who had
recently arrived from Kansas City, to receive art instruction from Reiss.

Reminiscing about his apprenticeship, Douglas recalled that Reiss constantly urged him to explore "that inner thing of blackness." That Reiss, a European, encouraged Douglas, an African American, to explore a black identity was, again, not surprising given Reiss's earlier explorations (in the U.S., Germany, Sweden, and Mexico) into the visible manifestations of racial identity. Douglas's investigations took him into Harlem's cabarets and soirées where the proponents of the "New Negro" displayed their talents, into the Brooklyn Museum's gallery of African art where he could study black classical forms, and into the cogwheels of his own mind where he attempted "to objectify with paint and brush what [he] thought [were] the visual emanations...that came into view with the sounds produced by the old black songmakers...." Judging from a photograph of a Douglas mural, *Dance Magic* (1929–30), created for the Sherman Hotel's College Room Inn in Chicago, Illinois, Douglas's investigations transformed him from skeptical art student to nationally recognized black modernist.

While indebted to Winold Reiss and his experiments with a kind of "Afro-Deco" art vocabulary (chevrons, mask-like designs, and bold color

44

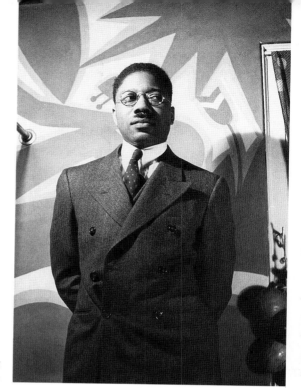

21 AARON DOUGLAS *Dance Magic*
1929–30. Mural in the College Room
Inn, Sherman Hotel, Chicago
(destroyed)

22 CARL VAN VECHTEN
Aaron Douglas 1933

juxtapositions), Douglas eventually evolved his own style. For example, Douglas's mural *Harriet Tubman* (1931), celebrating the nineteenth-century antislavery activist, showed his signature use of silhouetted figures, overlaid and gradated chromatically with diagonal and concentric bands of color. His paintings were color abstractions, punctuated by environmental forms and action figures, and portrayed like figures from ancient Egyptian wall paintings and reliefs; they conveyed inspirational messages which, in the spirit of the "New Negro," fused modernism with historical and vernacular themes. In 1925 Douglas said that he wanted to create an art that was, "Transcendentally material, mystically objective. Earthy. Spiritually earthy. Dynamic." This desire provided his *Harriet Tubman* mural, and his other works in this distinctive style, with a fluid, metaphysical framework.

 A photograph of Aaron Douglas (1933) taken by New York theater critic, social gadfly, and "New Negro" patron Carl Van Vechten showed the artist standing in front of one of his hard-edge, modernist murals (painted in Van Vechten's bathroom). As with Reiss's portrait of Hughes, Van Vechten's portrait of Douglas captured the impetuous, brazen spirit

36

45

of this black cultural moment, when younger African American artists, without excuses or apologies, presented their work to the wider public with the declaration that, "If white people are pleased we are glad. If they are not, it doesn't matter.... If colored people are pleased we are glad. If they are not, their displeasure doesn't matter either. We build our temples for tomorrow, strong as we know how, and we stand on top of the mountain, free within ourselves."

This exultation, penned by poet Langston Hughes as part of his essay "The Negro Artist and the Racial Mountain" (1926), ventured far beyond the theoretical musings presented in Locke's 1925 anthology *The New Negro*. Hughes confronted those critics who would limit the artistic expressions of African Americans to narrowly defined, skewed notions of what was beautiful, appropriate, uplifting, or "authentically Negro." Although the visual arts occasionally provided these debaters with examples of what they liked or disliked, the literary arts were more frequently interrogated in regard to "representative racial types." For example, Langston Hughes often came under attack for his literary portrayals of working-class black subjects. In many poems, such as "The Weary Blues," "Jazzonia," "Elevator Boy," and "Red Silk Stockings," Hughes painted with words his vivid, moving portraits of blues singers, jazz musicians, common laborers, and street hustlers: hardly the types of black people conservative African Americans wanted as cultural representatives for the race.

With the multitude of artistic products by and about African Americans that were available to consumers of culture, it was natural that critics like Locke and more established commentators like Du Bois and James Weldon Johnson would address the merits of certain works of art in regard to race relations and the more thorny question of racial representations. The breadth of what constituted the "New Negro" was staggering, with everything from depictions of the urbane and affluent, of the black poor and working class, of those in the high-profile world of entertainment, to visions of a kind of idyllic, black Arcadia. Although that part of the "New Negro" concept that emphasized urbanity, progress, and youth dictated the form and content of much of the art and rhetoric of the period, the "New Negro's" associated, often glossed-over message of rediscovery, growth, and rebirth also informed much of the movement's subject matter, as seen in works as varied as Oscar Micheaux's motion picture *The Homesteader* (1918), Jean Toomer's book *Cane* (1923), DuBose Heyward's hit play *Porgy* (1927) and, of course, Doris Ulmann's dreamlike, otherworldly photographs of blacks, such as *Baptism in River, South Carolina* (1929–30).

23

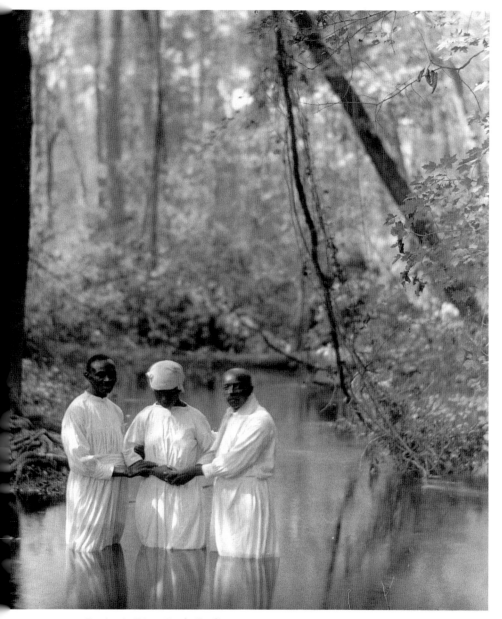

DORIS ULMANN *Baptism in River, South Carolina* 1929–30

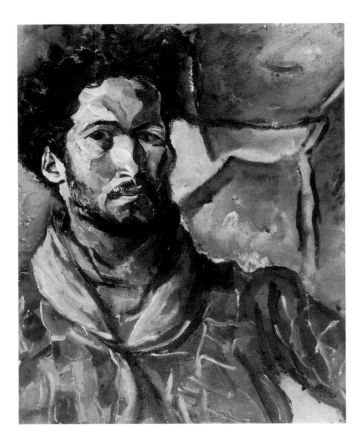

24 WILLIAM H. JOHNSON
Self-Portrait 1929

One could argue that the concept of the "New Negro" was meaningful only in relationship to the "Old Negro" or to an eternal, primordial "blackness." The "New Negro" was a metaphor of self-discovery for blacks (as well as for whites) in that the black vernacular was viewed as the panacea for centuries of stagnant, European cultural hegemony and the "zoo restrictions" (to quote from Jean Toomer's *Cane*) of a rigid, Victorian code of morality. By the mid 1930s, with the social demands of a worldwide economic Depression, this emphasis on the black vernacular eclipsed the fixation on the "progressive" and the "uplifting," ushering in an altogether different ideological movement among artists.

The representational extremes of the "New Negro" were present in two of the period's better-known African American portraits. The Philadelphia-based artist Laura Wheeler Waring incorporated impressionistic brushwork and an illusionistic background into her award-

48

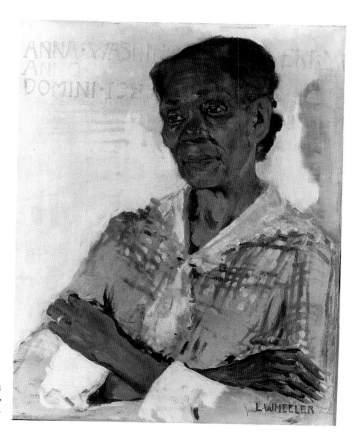

25 LAURA WHEELER WARING
Anna Washington Derry
c. 1927

winning portrait of *Anna Washington Derry* (*c.* 1927), the elderly mother 25
of one of her friends. Waring's painting style—the conservative product
of her years of academic training—resulted in the creation of this
sentimental tribute to a proud black matriarch. An obvious departure
from Waring's nostalgia was William H. Johnson's much reproduced
Self-Portrait (1929): an image of the artist in the guise of a "New Negro" 24
bohemian. Johnson's formative years at the National Academy of Design
in New York, and three years in France (between 1926 and 1929) gave
his art a more expressionistic style.

In spite of their very different approaches to painting, both Waring and
Johnson received gold medals and monetary awards from the William E.
Harmon Foundation, a New York-based philanthropic organization that
served as the principal patron for many African American visual artists
between 1926 and 1933. Although the Harmon Foundation continued

to provide limited support for many black artists after this period, the 1933 termination of their juried exhibitions and awards (coinciding with the shift in U.S. art patronage to the government's Public Works projects) essentially ended the "New Negro" arts movement as it was known in America.

HARLEM: MECCA AND METAPHOR

This historic moment—when black culture flourished and received wide, interracial and intercultural recognition—had several descriptive names beyond the more germane "New Negro Arts Movement." In a 1927 essay, literary scholar and cultural historian Benjamin G. Brawley referred to the proliferation of important creative writing in this period as a "Negro Literary Renaissance." In his autobiography *The Big Sea* (1940), Langston Hughes used the phrase "Manhattan's black Renaissance," to describe the black literary talent that was centered in and around the predominantly African American, New York City neighborhood of Harlem. Historian John Hope Franklin, in the first of several editions of his classic history, *From Slavery to Freedom* (1947), called his chapter on New York's burgeoning black arts scene—largely literary, but also theatrical and visual—"Harlem Renaissance." Almost twenty-five years later, historian Nathan Huggins entitled his ground-breaking book on this important moment and place in American cultural history *Harlem Renaissance* (1971). And sixteen years later, with the art exhibition "Harlem Renaissance: Art of Black America", and its accompanying publication of the same name (1987), the concept of the "New Negro" was further rooted in the idea of a Harlem-based racial fount of artistic accomplishment.

This brief account of the term "Negro Renaissance"—and the more frequently employed "Harlem Renaissance"—is useful if only as a demonstration of how, over time and depending upon the operative disciplines and methodologies employed, the significance of the concept has subtly shifted. In these several transformations from a literary term to a generic designation, from a generic designation to a visual arts phenomenon, and from a cultural motif to one defined by race, culture and, most significantly, location, "Harlem Renaissance" has come to define the "New Negro" movement as a broad-based, multidisciplinary program, concentrated in New York's black community. The problem is that the term "Harlem Renaissance" is wanting as an accurate yet elastic description of the levels and range of black creativity in the 1920s and early 1930s.

50

Before entering further into a critique of the term, it is worthwhile looking at the historical and cultural factors that have led some scholars to locate this regenerative impulse in Harlem. Of primary importance was Harlem's large and growing black population. In 1925, it numbered about 175,000; by 1930, with steady migration from the southern States and immigration from the Caribbean and other parts of the black diaspora, it had expanded to over 200,000, making it the largest African American urban community of its kind. The new arrivals found advocates for their collective interests among several major black organizations with headquarters there. The NAACP, the National Urban League, the Universal Negro Improvement Association, and literally dozens of churches, fraternal organizations, sororities, social clubs, weekly newspapers, and businesses helped define and shape this Harlem-based "Renaissance."

Harlem was, of course, a racially and culturally distinctive community within New York City, yet one should resist the temptation to isolate Harlem's fame and fortunes in the 1920s and early 1930s from those of greater Manhattan. New York City's flamboyant Mayor in the second half of the 1920s, Jimmy "Beau James" Walker, encouraged the economic development of cultural forces in the city—radio broadcasters; book, magazine, and newspaper publishers; concert promoters; Broadway producers; song writers; cabaret owners; and various other entrepreneurs, legitimate and underworld—who, in their own way, helped to stimulate the vogue for Harlem. The roster of Harlem-based writers, actors, and musicians whose talents were advanced by these assorted cultural forces in New York City was a *Who's Who* of African American arts and letters around 1925. Similarly, the mystique and symbolic status that New York enjoyed from the late nineteenth century—as a destination full of opportunity for immigrants, as an escalating architectural wonder, and as a city that thrived on the extraordinary and "the New"—was increasingly shared with Harlem as its own reputation grew.

In contrast to the factors which enhanced Harlem's undeniable status as a cultural capital, its importance as the site of a renaissance in the visual arts in the 1920s and early 1930s is questionable. The "renascence in Negro art" that was promised by a small, Harlem-based exhibition (held in 1921 at the 135th Street branch of the New York Public Library) was, revealingly, not realized until 1927 when the important exhibition "The Negro in Art," opened, but this was in Chicago rather than in New York.

Apart from the artistic presence in Harlem of Aaron Douglas, James VanDerZee, and painter Malvin Gray Johnson, its place in African American art history during the 1920s is incompatible with the notion

of a major artistic groundswell. James Weldon Johnson argued in his book *Black Manhattan* (1930) that Harlem had not yet produced a Negro painter of the stature of a Henry Ossawa Tanner. Similarly, art historian James A. Porter noted that, despite the local acclaim of Harlem sculptor Augusta Savage, her commitments to teaching and her own artistic training significantly compromised her work during the "renaissance."

Although Harlem's artists and patrons benefitted from their proximity to the annual Harmon Foundation art exhibitions, these traveling shows (as well as the Foundation's overall support for the visual arts) affected black communities and artists not just in Harlem but across the nation. Of the top award winners in the Harmon Foundation's annual art competitions between 1926 and 1933, only Malvin Gray Johnson could be considered a true Harlem-based artist. The rest represented black artists across the U.S.A., such as Hale Woodruff in Indianapolis, Laura Wheeler Waring in Philadelphia, Sargent Johnson in San Francisco, Archibald J. Motley Jr. in Chicago, and James Lesesne Wells in Washington, D.C. The two other Harmon Foundation award winners who have often been linked with Harlem—artists Palmer C. Hayden and William H. Johnson—spent the most important parts of their careers during this period in Europe, and were not substantially involved with Harlem's arts scene until the second half of the 1930s, just after the so-called Harlem Renaissance period.

Besides the Harmon Foundation exhibitions, the other major "New Negro" art shows in Manhattan during this period were the two critically acclaimed 1928 solo exhibitions by the Mexican caricaturist Miguel Covarrubias and Chicago painter Archibald J. Motley Jr. Like their literary counterparts, Sterling Brown and Zora Neale Hurston, Covarrubias and Motley related to Harlem not in a documentary way but in more subliminal ways, with an emphasis in their work on African American folklife rather than on a distinct Harlem topology. Although sculptor Richmond Barthé (who moved from Chicago to New York in 1929) had two solo ventures in the early 1930s, these shows were largely harbingers of greater things to come during Barthé's more accomplished post-"Renaissance" phase.

While Harlem was extremely important as a cultural center for many people—and especially writers—during the period of the "New Negro," to imply that it was also the cradle of that period's visual arts scene—as the designation "Harlem Renaissance" is often taken to mean—is an exaggeration. While several visual artists certainly emerged with artistic authority from that community during this period, they had equally accomplished counterparts in other metropolitan cities. The most

26 JAMES VANDERZEE *Couple wearing racoon coats with a Cadillac, taken on West 127th Street, Harlem, New York* 1932

notable of the Harlem artists, painter Aaron Douglas and photographer James VanDerZee, used Harlem in their respective works not merely to map it out or to illustrate it for the thrill-seeking tourist but, rather, to make Harlem a modern, racial motif that transcended a specific black place or black people. The degree to which they succeeded in making Harlem what literary critic James de Jongh called "an ethos of race renewal" was demonstrated in the breadth of the community's patronage: the Harlem institutions that sponsored Douglas's earliest murals; the countless literary figures—Locke, Johnson, Van Vechten, and Hughes, among others—who commissioned Douglas to illustrate their Harlem-centered texts; and the ordinary people of Harlem who dressed up, posed for and bought VanDerZee's photographs. As can be seen from VanDerZee's well-known *Couple wearing racoon coats with a Cadillac, taken on West 127th Street, Harlem New York* (1932), it was important even in the

26

depths of the Depression for "commoners" and "high society" alike to maintain Harlem's image as a "black mecca" and symbol of material wealth and glamour in order to advance community, culture and "the race" in general. Still, these artists, their works and patronage, as important as they were, did not alone constitute a "renaissance." As an art-historical term, "Harlem Renaissance" works best when removed from its regional connotations and is placed within the more inclusive concept of a metaphoric racial landscape, where this born-again black culture is realized in a range of art works, visual artists, and artistic meccas.

REVUE NEGRE

27 The almost hallucinatory energy that the anonymous illustrator for Paramount Records poured into an advertisement for Memphis Julia Davis's blues recording, "Black Hand Blues" (1925), evoked the "black magic" that consumers of black popular culture felt in the "New Negro" arts movement. Here the artist used Davis's blues narrative about a female philanderer receiving her just deserts, in the form of anonymous, threatening "black hand" letters, as a discursive overture on African American superstition and on the omen-like potency of "blackness." Carl Van Vechten, in a memoir of another performer from Memphis, the blues diva Bessie Smith, used imagery that was similarly supernatural in tone:

> Her face was beautiful with the rich ripe beauty of southern darkness, a deep bronze, matching the bronze of her bare arms. Walking slowly to the footlights, to the accompaniment of the wailing, muted brasses, the monotonous African pounding of the drums, the dromedary glide of the pianist's fingers over the responsive keys, she began her strange, rhythmic rites in a voice full of shouting and moaning and praying and suffering, a wild, rough Ethiopian voice, harsh and volcanic, but seductive and sensuous too, released between rouged lips and the whitest of teeth. . . .

For Carl Van Vechten, Bessie Smith's physical presence as well as her artistic talents invited this atavistic interpretation of her 1925 performance at the Orpheum Theatre in Newark, New Jersey. The expressive power of black performance—whether incorporated into an advertisement for a blues recording, or reported by someone as *au courant* as Carl Van Vechten—was an important theme in the culture of the "New Negro," and an aesthetic issue which has yet to receive its deserved analysis in art-historical research.

27 Advertisement for Memphis Julia Davis's "Black Hand Blues," 1925

Although in 1912 James Weldon Johnson had already drawn attention to the importance of black dancers, singers and musicians in the construction of a modern American cultural identity, it was the writers and visual artists of the "New Negro" arts movement who placed these black performers at the theoretical center of the culture. In a profusion of art forms, they cast the entertainers as cultural intermediaries who articulated in their acts the problems, hopes, desires, and aspirations of the "New Negro."

This sense of the oracular powers and "race" advocacy of the black entertainer figured strongly in many of the paintings and prints by the Paris-based, African American artist and jazz musician Albert Alexander Smith. Smith's *A Tap Dancer* (c. 1928), featuring a young black vaude-villian, wearing a top hat and oversized tuxedo, on stage and under the intense glare of a spotlight, could be interpreted as simply a homage to a

29

fellow black trouper. But the nature of Smith's parallel work—as an illustrator for *The Crisis*, *Opportunity*, and the Harlem-based, African American bibliophile Arthur Schomburg—could also lead one to see *A Tap Dancer* as an allegorical statement about the preparedness and "performance" capabilities of "the race."

Smith was just one of many black artists who lived and worked in Paris in the 1920s and '30s. Like Smith, many African Americans had their first encounter with French culture during World War I when black soldiers quickly realized that there was a personal freedom in France that was inconceivable back home. Following World War I and spurred on by economic prosperity and a spirit of optimism, Paris began to attract people from all parts of the globe, including significant numbers from the United States. Many of the African American newcomers were stage and nightclub performers, eager to take advantage of Paris's international reputation as Europe's entertainment capital.

The French novelist Paul Morand, reflecting on Paris as an ideal site for a critique of black performance as art, wrote in 1928:

> So sublime, so heartrending, are the accents of jazz, that we all realize that a new form is needed for our mode of feeling. . . . Sooner or later . . . we shall have to respond to this summons from the darkness, and go out to see what lies behind this overwhelming melancholy that calls from the saxophones. How can we stand still while the ice of time is melting between our warm hands?

About a year after Morand's plaintive, surrealistic call for an acknowledgment of the power and presence of jazz, the Chicagoan Archibald J. Motley Jr.,—no stranger to the calls from the saxophone himself—painted several canvases on the subject of Paris's lively black music scene. *Jockey Club* (1929), Motley's painting of the famous, American-owned nightclub where the international art crowd gathered, responded to Morand's challenge in its shadowy, unsettling portrayal of the club. Clearly, Motley had decided in *Jockey Club* to turn the discriminating spotlight away from the black performers (the subject of *Blues*, his other, well-known painting of that same year) and toward the club's clientele, with their affectations, trysts, and voyeuristic tendencies.

French filmmaker Jean Renoir (son of the famous Impressionist painter, Auguste Renoir) also turned to the period's black performance tradition in his short film, *Sur un Air de Charleston* (1926). But, like Motley's painting, Renoir's film fantasy about the mesmerizing, redemptive power of the popular black dance step, the Charleston, shifted the focus; it is a white dancer (played by Renoir's wife, actress Catherine

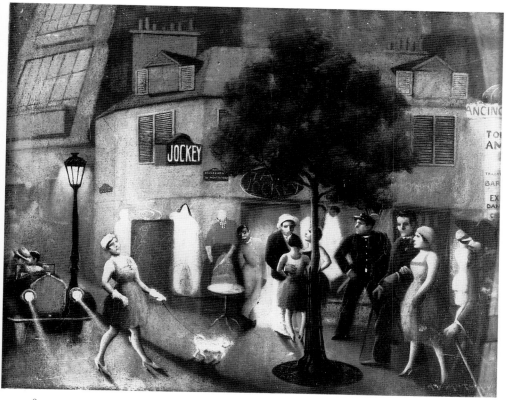

28 ARCHIBALD J. MOTLEY JR. *Jockey Club* 1929

Hessling) who, in a post-Armageddon Europe, teaches the moves to a visiting African astronaut (played by the African American mime and blackface minstrel, Johnny Hudgins).

Renoir's implicit message in *Sur un Air de Charleston*—that black creativity was modern society's only salvation and hope for human perpetuity—was influenced by the looming presence in Paris of the African American dancer Josephine Baker. When this nineteen-year-old dancer from St. Louis appeared on the stage of the Champs-Elysées's Music Hall in the 1925 stage show, *La Revue Nègre*, virtually nude and carried upside down, like a wounded gazelle, on the back of the robust, Martiniquan dancer Joe Alex, even the most cosmopolitan Parisians were stunned. When, in the following year, she appeared on the stage of the world-famous Folies Bergère, wearing nothing but a *cache-sexe* made of

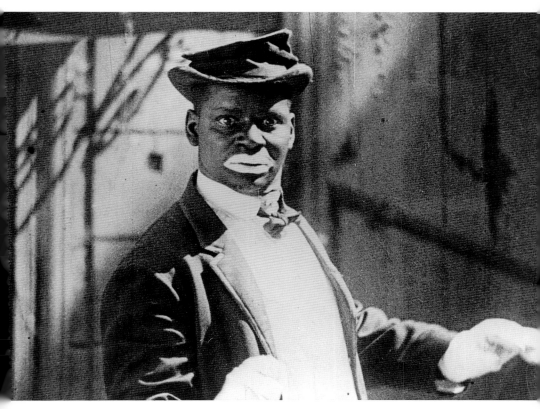

30 JEAN RENOIR *Sur un Air de Charleston* 1926

rubber bananas, and dancing a frenetic Charleston, she single-handedly defined the "New Negro" in Paris.

Theatre critic Andre Levinson's exclamation that Josephine Baker and Joe Alex's "*pas de deux sauvage* reaches the heights with wild and superb bestiality" epitomized the primitivist response to black culture exploited by both black and white, not only in France, but in much of the Western world. Despite the racism and sexism of images like Paul Colin's lithograph of a caged and simian-like Josephine Baker (from the *c.* 1927 portfolio *Le Tumulte Noir*), one should not forget that, for all the aspirational elements of the "New Negro" arts movement, there was another side of the "race renewal" agenda: one that probed uninhibitedly the more sordid and often stereotypical terrains of a black identity. Josephine Baker, as a willing subject and participant in this forbidden exploration,

32

59

was joined by a long list of cultural primitivists, including Hughes, Covarrubias, the Jamaican writer Claude McKay, and (as seen in the previous literary examples) Carl Van Vechten and Paul Morand.

Unfortunately, the peoples and cultures of Africa were the principal objects of this primitivist mindset. An almost universal ignorance of Africa, coupled with a legacy of exploitation of African peoples, created an atmosphere in which Westerners—usually taking their cues from Edgar Rice Burroughs novels and Hollywood jungle movies—saw "Africa" as either exotic and passionate or dangerous and fearsome. Both attributes—the sensual and the sinister—were frequently combined, as in

33 Alfred Janniot's sculptural reliefs covering the entire façade of Paris's Museum of African and Oceanic Arts (1931) and in Richmond Barthé's
31 *African Dancer* (1933). Both works relied on stylized and animated

31 RICHMOND BARTHÉ
African Dancer 1933

32 PAUL COLIN,
from *Le Tumulte Noir*
c. 1927

33 ALFRED JANNIOT, sculptural relief, 1931, for the façade of the Museum of African and Oceanic Arts, Paris

renderings of nature to convey impressions of African peoples that, apart from an undeniable beauty, stressed savagery and carnality.

Of course, there was also a movement during the period of the "New Negro" to redefine Africa and to make it a symbol of pride and accomplishment for the world's darker peoples. In the forefront was the Universal Negro Improvement Association (UNIA), founded by the Jamaican activist and visionary Marcus Garvey. Although the rhetoric of the Garveyites often yielded to images of a despotic black world,

their message of black pride and economic self-sufficiency was followed in black communities throughout the northeastern United States and the English-speaking Caribbean.

Beyond Garvey's domain, what philosopher V. Y. Mudimbe described as "the invention of Africa" took place in another "New Negro" laboratory of cultural and economic revitalization: namely, Chicago. There, artist Charles C. Dawson created several African-inspired emblems for products targeted at African Americans. For his 1925 advertising campaign for Madagasco, a hair straightener of "no regrets" that softened the "naturally" kinky hair of blacks, he chose a blend of Ancient Egyptian motifs, East and West African references, and industrial-era "product efficiency" allusions, which urbanized and deprimitivized "Africa" for the "progressive" black consumers.

Despite Alain Locke and Marcus Garvey's celebration of Africa as an important source of inspiration for African Americans, many members of the "New Negro" rank and file were still challenged by the very notion that Africa could mean something significant to them. Like the anxieties about an African past posed in Countee Cullen's 1925 poem "Heritage" ("...Africa? A book one thumbs, Listlessly, till slumber comes..."), most African Americans could not (or perhaps refused) to acknowledge their

34 CHARLES C. DAWSON advertisement for Madagasco Hair Straightener 1925

racial and cultural ties with Africa. Artist Miguel Covarrubias, in a 1929 cartoon for *Vanity Fair*, expressed the inability of the typical African American to see him or herself in Africa's sculptural arts (or, in Covarrubias's primitivist thinking, "the Mirror"). But what Covarrubias had lost sight of was that, while some people were content to continue looking for the most racially representative image of the "New Negro" (the "primitive," the urban sophisticate, and so on), for many more the search had long been abandoned, and replaced by explorations of a more political, class-based nature. Even Locke came to believe that the so-called "Renaissance" was succeeded by a "Reformation" of sorts, characterized by "more penetrating," "even handed," and "less illusioned" portrayals of black life.

Claude McKay, creator of a range of "New Negro" types in his poetry and fiction, eventually felt that the necessity for African Americans, especially in the midst of the Great Depression, was the acquisition of

GENTLEMAN, for the first time viewing a work of African
sculpture: "What sort of a woman is that?"

"To Hold, as t'Were the Mirror Up to Nature"

35 MIGUEL COVARRUBIAS,
"To Hold as t'Were the Mirror
Up to Nature" 1929

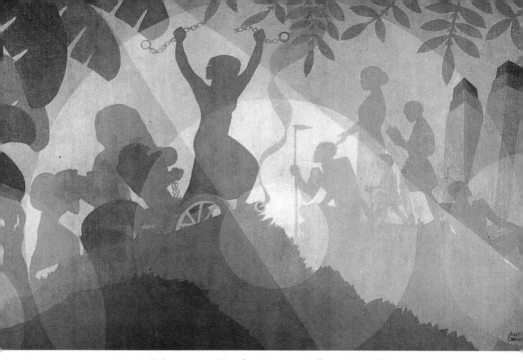

36 AARON DOUGLAS *Harriet Tubman* 1931. Mural at Bennett College, Greensboro, North Carolina

"a group-soul." But unlike Du Bois's rarefied, romantic notion of "the souls of black folk," McKay's group-soul was structured around the day-to-day issues of race solidarity and labor: themes that took on a life of their own as the "New Negro" gave way to the plight of the world's black masses. What art audiences increasingly encountered was not so much a denunciation of modernity, primitivism, and the explorations of the urban versus rural paradigm, as an attempt to place these "New Negro" themes in a broader social context. Sensing that the Depression and its aura of dispossession and a renewed social activism would usher in yet another aspect of the "New Negro," the movement's advocates increasingly abandoned its sensational and more commercial trappings and, in their place, adopted other, more altruistic icons: specifically those of the "people," the "worker," and the ever-ambiguous "folk."

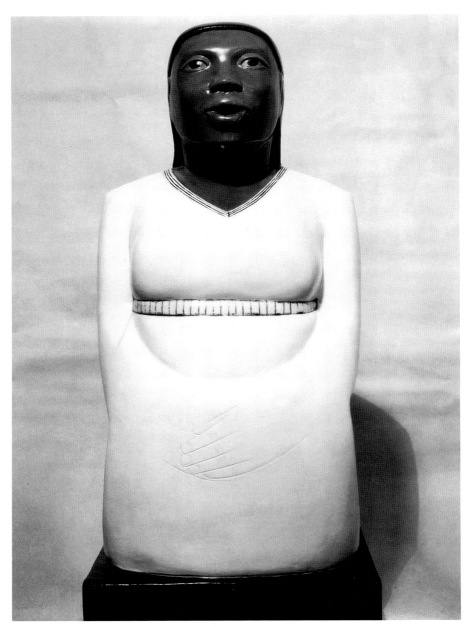

37 SARGENT JOHNSON *Negro Woman* 1933

The Cult of the People

FROM "NEW NEGRO" TO "NEW DEAL"

In 1933, the same year that Richmond Barthé created *African Dancer*, the San Francisco Bay Area sculptor Sargent Johnson created *Negro Woman*. Although both artists were products of the "New Negro" arts movement, in this particular instance their respective sculptures—both representing women of African ancestry—could not have been more dissimilar, stylistically as well as in emotional content. As discussed in the previous chapter, Barthé's *African Dancer* grew out of a European and American fascination with "the dark Continent," a Western conceit that frequently employed exotic, sexually-charged representations of Africans and their cultures. By contrast, Johnson's *Negro Woman* portrayed the black female subject as modern, unpretentious, and devout: a stereotype of another kind, but free of the more degenerate connotations.

Of course, in any historical period, one is bound to find artists simultaneously pursuing different artistic directions. But by 1933, the primitivist attitudes of much of the art produced under the auspices of the "New Negro" arts movement were gradually being supplanted by more sober and prosaic perspectives on black representation. While Barthé's *African Dancer* certainly had its champions—it was acquired in 1933 by the Whitney Museum—Johnson's *Negro Woman* showed a heightened emphasis on the black vernacular in the arts; during the Depression, people found this not only relevant to their social situation, but also marketable in a culture of idealized working-class images.

The reasons for this ideological shift were varied. In Europe and the United States, the stock market crash of 1929 and the ensuing world economic Depression created an atmosphere in which the concerns of working-class people dominated the international agenda. The rise of several Fascist governments during this period (in Germany, Italy, and Spain) also sparked populist political movements in Europe and America. For some, the political and economic programs of Socialism and Communism seemed to be the way to resolve the plight of the proletariat. Many others, especially in the U.S.A., questioned the

effectiveness of Socialism and Communism in providing meaningful employment for the masses and in saving a collapsed, free market economy. After Franklin Delano Roosevelt's election as U. S. president in 1932, his administration's "New Deal" (massive welfare and work-relief programs) made the U.S.A. one of the world's major laboratories for social and economic planning and a hub of social consciousness.

Among Roosevelt's various job creation measures was the establishment of the Federal Art Projects (1935–43) which employed artists to create easel paintings, sculptures, photographs, motion pictures, posters, graphics, and murals, as well as to provide arts-related services to the federal, state, and municipal branches of the U.S. government. Most government art patronage was humanitarian, didactic, and propagandist in purpose, and so, despite the array of American artists from different cultural, social, and ethnic backgrounds employed by the WPA/FAP (Works Progress Administration's Federal Arts Projects), the predominant artistic style was figurative, naturalistic and narrative-driven. While neither *African Dancer* nor *Negro Woman* was made under the auspices of the WPA/FAP, both, but especially *Negro Woman*, reflected the government's implicit "style" prototype: the human figure conceptually placed within a "social" narrative.

What were the narratives that visual artists most often utilized in creating an art of "social consciousness"? Scenes of both rural and urban communities at work or at leisure, family groupings, and historical themes were the most frequent, both under the auspices of the WPA/FAP and in independent projects.

Contrary to the conventional wisdom which would have predicted a pessimistic world view during the Depression, painters Archibald J. Motley Jr., and Palmer C. Hayden saw the world as teeming with life, leisure, and a touch of the lowbrow. *The Picnic* (1936), which Motley painted while employed by the WPA/FAP in Chicago, mixed the period's interest in common folk with his modernistic uses of color and compositional density. *The Picnic* certainly recalls the chromatic warmth and easy intelligibility of content found in works by contemporaries such as Thomas Hart Benton, but Motley's forms—colorful, organic, and provocatively situated to fit the artist's own logic and sense of rhythm—subverted the standard label of "American scene" often attached to his work, and replaced it with something far more metaphysical.

Motley's fanciful, densely-packed composition had similarities with Palmer C. Hayden's *Midsummer Night in Harlem* (1936): another brash, expressionistic scene of blacks relaxing in an outdoor, urban setting. Numerous other works of the Depression era took as their subject

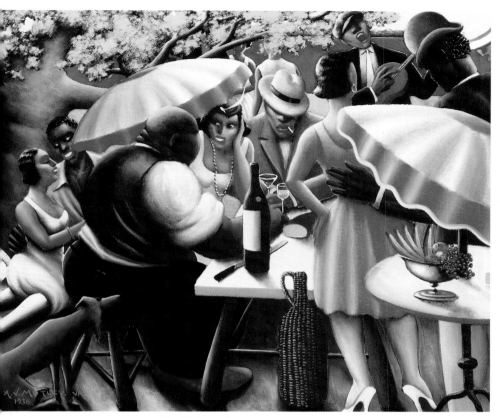

38 ARCHIBALD J. MOTLEY JR. *The Picnic* 1936

people at leisure, such as Philip Evergood's *Dance Marathon* (1934) and
Reginald Marsh's *Twenty-Cent Movie* (1936), but Hayden's use in
Midsummer Night in Harlem of the stereotypes of wide-eyed and grinning
blacks gave his work a troubling air, especially in its visual corroboration
of common racist sentiments. Yet Hayden was not alone during this
period in representing blacks irreverently; we see the same treatment in
the bawdy, culturally contentious works of such "progressive" artists as
novelist Richard Wright in the manuscript of *Lawd Today,* written around
1936, and actor Paul Robeson in his 1938 film *Big Fella.*

 In his book *Blues and Evil* (1993), African American cultural critic
Jon Michael Spencer described the Dante-like journey of Depression
artists into the deep recesses of a mentality inveterately demarcated
by race and class: a realm, like Hayden's outrageous black world in

69

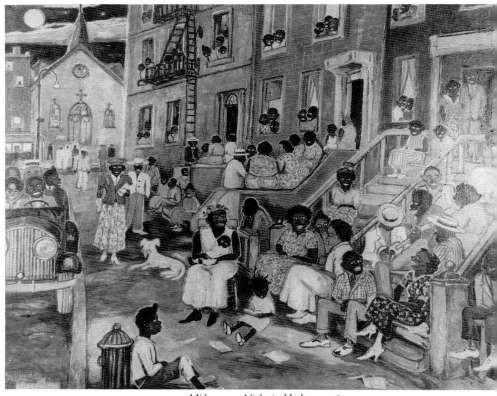

39 PALMER C. HAYDEN *Midsummer Night in Harlem* 1936

Midsummer Night in Harlem, fraught with real-life absurdities, insults, horrors, and hyperboles. The cultural spokespersons for the black masses in the 1930s—blues musicians, gospel singers, number runners, exhorting preachers, and "soap-box" radicals—painted their own pictures of black life that were just as absurd as Hayden's midsummer scene under the full moon.

Because economic issues were of central importance during the Great Depression, these pictures of communities and leisurely activities were overshadowed by other more serious images that explored the world of work. Even Hayden's *Midsummer Night in Harlem*, appearing just one year after Harlem experienced its first major riot, could also be interpreted as a satirical response to that community's real anxieties in the face of high unemployment and economic hardship. Consequently, representations of industry, agriculture, employment, and the associated problems that these

issues brought were of particular interest to socially-committed artists and audiences alike.

Even during the more optimistic years of the "New Negro," labor issues and their impact on black communities captured the imaginations of several writers and visual artists. Publications like *The Crisis*, *Opportunity* and the leftist monthlies *The Messenger* and *New Masses* featured articles and art editorials on the subject of black labor by such "New Negro" figures as W.E.B. Du Bois, Charles S. Johnson, Aaron Douglas, and James Lesesne Wells. Wells's book jacket for Lorenzo J. Greene and Carter G. Woodson's *The Negro Wage Earner* (1930) antici- 40 pated the appeal of the black worker theme that preoccupied artists and intellectuals throughout the 1930s. In the details of Wells's stark black-and-white design, the black worker was, at once, agriculturist and industrialist, a professional as well as a blue collar worker and, at his most metaphorical level, a waiter, balancing (or serving) the city, while bestraddling "progress" from ancient pyramids to modern skyscrapers. By 1930 Wells had clearly taken the "New Negro" movement's quest for racial progress to a higher plane: one that rejected superficial barometers of success and class-based privileges for black economic development across class lines.

Agitation on the economic front was often combined with political activism. The battles fought in the U.S. over such issues as full employment, optimum on-the-job environmental conditions, and union representation were frequently associated with political efforts to combat

40 JAMES LESESNE WELLS, book jacket for *The Negro Wage Earner* 1930

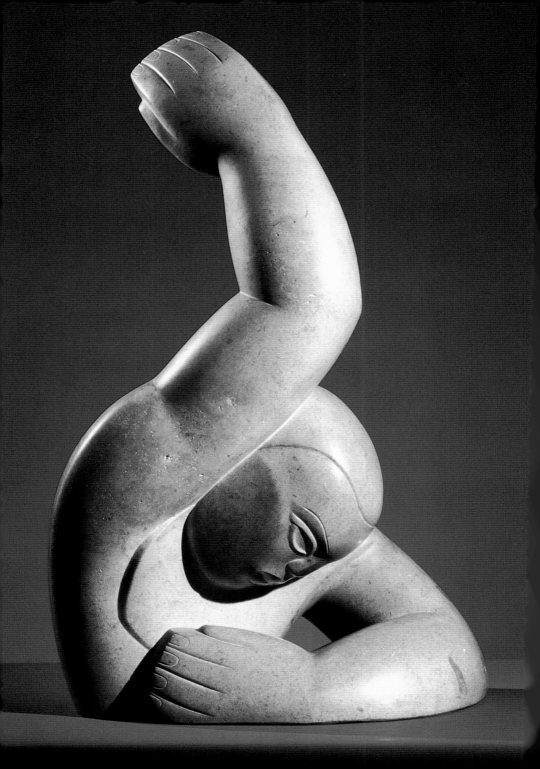

racism and job discrimination. The John Reed Clubs, the Artists' Union, and the American Artists' Congress were the principal organizations through which American artists participated in political activities— protesting against American racism and world Fascism, picketing employers who engaged in unethical hiring and firing practices, conducting voter registration drives, and persuading workers to join trade unions.

As subjects for visual artists, labor struggles and racial inequity surfaced in a variety of art forms, from Diego Rivera's widely seen mural cycle, *Portrait of America* (1933), created for New York City's New Workers School, to Margaret Bourke-White's *Life* magazine photograph of unemployed blacks lined up for food supplies in front of a billboard which ironically proclaims, "There's no way like the American Way" (1937). In African American artists' circles, the most celebrated example of a work of art created with a critique of U.S. economic and racial realities in mind was Aaron Douglas's *Song of the Towers* (1934), one of four panels from his *Aspects of Negro Life* mural (commissioned by the 135th Street branch of the New York Public Library). Ernest Crichlow, while working alongside Douglas on the New York City WPA/FAP, contributed to this growing body of protest imagery with *Lovers* (1938): 42 a politically-charged yet voyeuristic depiction of a hooded Klansman sexually assaulting a black woman.

While images like Crichlow's *Lovers* were dismissed as hopelessly "ideological" and "propagandist" by succeeding generations of art critics, the art reviewers of the 1930s could neither deny nor escape the expressive power and validity of such works. For example, the 1935 NAACP-sponsored exhibition, "Art Commentary on Lynching" (exhibited at the Arthur U. Newton Galleries in New York City), received a review in *Parnassus* magazine concluding that the works (by artists like Benton, Marsh, Paul Cadmus, and Isamu Noguchi, among others) were "chosen not merely for the clarity and intensity with which they state their case or plead their cause but with an eye definitely set for their artistic value." The socially explosive realities of U.S. race relations in the 1930s— exemplified in the decade-long, international *cause célèbre* surrounding the trumped-up rape charges against nine young black men in Scottsboro, Alabama—created a whole new school of artists informed by African American culture who, even under the sponsorship of the WPA/FAP, found their own, independent voices.

One such artist was Augusta Savage. In 1932, after several years of studying, exhibiting, and traveling throughout Europe, Savage returned to Harlem where she opened the first of several of her community art

schools. Savage, taking on the colossal role of art educator and community activist in Depression-era Harlem, renounced the élitist advantages of an artist's life in favor of its more altruistic aspects. Although this meant channeling her creative energies away from her own work and toward teaching, the achievements of many of those whom she taught and advised (Crichlow, William Artis, Gwendolyn Knight, Jacob Lawrence, and Norman Lewis, among others) demonstrated her tremendous, long-term impact on Harlem's visual arts scene.

That Savage's commitment to Harlem's artistic future was not a complete obstacle to her own art was confirmed by her last major commission: the sixteen-foot (five-meter) tall plaster sculpture *Lift Every Voice and Sing* (also known as *The Harp*), created for the 1939 New York World's Fair. Savage's sculptural homage to the illustrious author, composer, and fellow Floridian James Weldon Johnson (who had died the previous year) was a radical departure for her, with its figural distortions and part anthropomorphic, part architectonic symbolism. The community spirit in this piece—a by-product of Savage's years as a Harlem art teacher and workshop director—clearly resonated with Claude McKay's expressed notion of an African American "group-soul" and prophetically looked ahead to the flowering of black culture in the early 1940s.

43

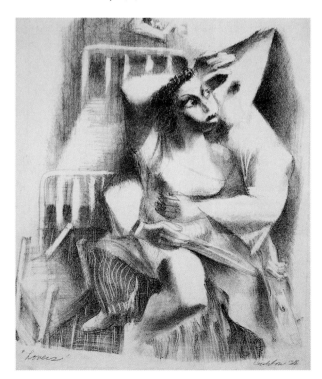

42 ERNEST CRICHLOW
Lovers 1938

43 AUGUSTA SAVAGE
*Lift Every Voice and Sing
(The Harp)* 1939
(destroyed)

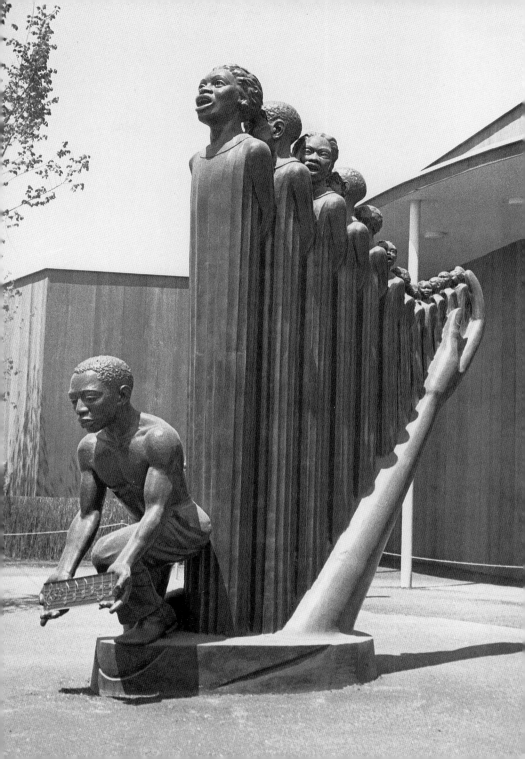

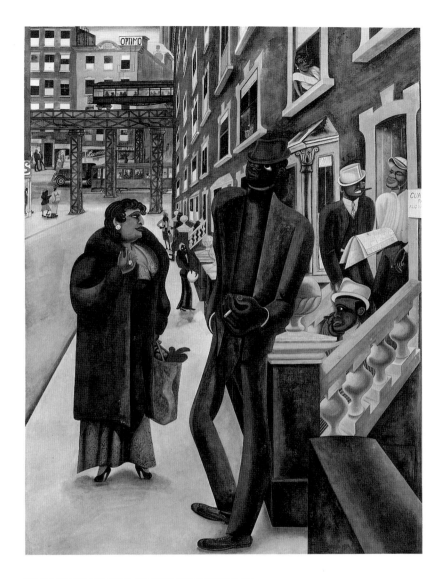

IN SEARCH OF THE BLACK PROLETARIAT

A preoccupation with representations of the black working class during the 1930s was not confined only to artists of African American or European American backgrounds. In the early 1930s, British painter Edward Burra spent almost a year in New York City, feverishly jotting

down (in a style similar to that of Miguel Covarrubias and George 35
Grosz) quick impressions of everyday African American life which he
later developed into larger, finished watercolors. Burra's *Harlem* (1934), 44
with its perspectival view of brownskinned pedestrians and brownstone
buildings, represented the community and its inhabitants as a study in
urban harmony. Indeed, in a letter of 1934 to a friend in England, Burra
described Harlem as "lovely, rather like Walham Green gone crazy."

Burra's *Harlem* was also like a mosaic of several street scenes including
blacks by the U.S. photographer Walker Evans, most notably Evans's *42nd*

44 EDWARD BURRA
Harlem 1934

45 WALKER EVANS
Havana Citizen 1933

45 *Street* (1929) and *Havana Citizen* (1933). The black man dressed in a
44 brown suit and green hat in *Harlem* recalled the pose and demeanor of
 the black man in a white suit and straw hat in *Havana Citizen*. In both
 works, these urban sentries pictorially anchored the compositions, exalt-
 ing a kind of working-class archetype which, from Harlem to Havana,
 was the object of much concern from both the left and right of the
 political spectrum.

 Cuba, where *Havana Citizen* was photographed, was in the throes of a
 social and cultural uprising by the time Walker Evans arrived there in
 1933. The dictatorship of Cuban President Gerardo Machado, largely
 supported by U.S. business interests, prompted great political unrest,
 from massive student demonstrations to police attacks against academics,
 journalists, and union organizers. On the cultural front, Cuban artists had
 begun to embrace their African and, by extension, vernacular roots,
 resulting in a kind of renaissance in Cuban literature, visual arts, and
 performing arts not thematically different from the recent "Negro
 Renaissance" in the U.S. Although Evans's documentary manner in
 Havana Citizen initially orients the viewer away from a consideration of
 these social and cultural upheavals, a closer look at this photograph—and
 especially Evans's use of media and popular culture imagery—presents
 the possibility here of a covert, socio-cultural critique: one that places
 Cuba's non-white masses in conflict with imperialism and cultural
 dominance from abroad.

 The theme of a social and cultural uprising inspired by the black
 working class also shaped much of the art of black artists and intellectuals
 in France and the French-influenced Caribbean. One strain of this dis-
 tinctly francophone artistic phenomenon—known as *Negritude*—inad-
 vertently grew out of Paris's 1931 International Colonial Exhibition,
 which brought public attention to the affairs of France's African, Asian,
 and Caribbean colonies. Although in many instances this exhibition
 perpetuated exotic and primitivist representations of black cultures
33 (for instance, Alfred Janniot's cast reliefs for the exhibition's newly
 constructed Museum of African and Oceanic Arts), the event also
 encouraged black intellectuals from Africa, the Caribbean, and the U.S.
 to come together, discuss the exhibitions and related programs, and, most
 importantly, to mobilize their various talents toward reporting their own
 firsthand accounts of "the black world."

 With the exception of an Aaron Douglas illustration which appeared
 in the first issue of the *Negritude* journal *La Revue du Monde Noir*, the
 artists of African ancestry who figured most prominently in the *Negritude*
 movement were literary. It would not be until 1937, when the African

46 LOIS MAILOU JONES *Les Fétiches* 1938

American painter Lois Mailou Jones arrived in Paris, that painting would provide an important visual link to the writings of such *Negritude* authors as Aimé Césaire, Léon Damas, and Léopold Sédar Senghor. Jones was an accomplished academician, trained at the School of the Museum of Fine Arts in Boston, but during her year's stay in Paris she broke free from this training with her painting *Les Fétiches* (1938): a post-Cubist and post- primitivist study of African masks. In her pictorial gathering of assorted African personae—ethnographic and imaginary—Jones prefigured the

46

declamatory yet surrealistic visions of the Martiniquan poet Aimé Césaire who wrote that his *Negritude* "plunges into the red flesh of the soil,...into the blazing flesh of the sky,...[and] riddles with holes the dense affliction of its worthy patience." In spite of the fact that Jones, like Césaire, relied on an illusory rather than documentary passage into African culture, *Les Fétiches* displayed its *Negritude* with an urgency and definitiveness that was unprecedented among the artists of the Depression.

Haiti, the world's first independent black republic and occupied by the U.S. Marines between 1915 and 1934, was the site of the other franco-phone, proletariat-inspired cultural phenomenon, known as the *Indigenist* movement. With a history of achievements in the literary and visual arts dating back to the late eighteenth century, Haiti reemerged in the late 1920s with a spirited, folk-inspired arts scene that was largely instigated by the ethnographic writings of Jean Price-Mars and the literary efforts of a group of younger Haitian writers. A black American academic painter, William Edouard Scott, visited Haiti in 1931 and lived there for a year, teaching the fundamentals of painting to a whole generation of aspiring artists.

Like the contemporary black cultural activities in the U.S.A., France, and Cuba, Haiti's *Indigenist* movement had political implications. In the novel *La Case de Damballah* (*Damballah's Hut*) of 1939, Haitian author and visual artist Petion Savain voiced subtle criticisms of the Haitian élite and governmental authorities, while endowing Haiti's large peasant class with creole-inflected spiritual entitlements. Savain's accompanying illus-trations, although shaped by his 1931 apprenticeship with Scott, adopted a straightforward, slightly untutored look that responded to his fellow *Indigenist* artists and to the overwhelmingly illiterate Haitian masses.

The main protagonist of Petion Savain's novel—the West African-derived serpent deity Damballah—is a key component of the popular Haitian religion known as *Vodun*. During the 1930s numerous writers and scholars looked closely at heterodox black religions like *Vodun* in their attempt to understand the spiritual and ethical dimensions of the black peoples of the whole African diaspora. Studies conducted by Charles S. Johnson, Zora Neale Hurston, and Melville Herskovits, among others, explored topics such as the emergence of African-based religions in the New World, the sundry characteristics of black religious expres-sion, and the high frequency within many black religions of "spirit possession." These sociologists, anthropologists, and artists found that black religions had a powerful, all-encompassing authority over their followers: an authority that even the political panaceas of Communism and Socialism could not override.

47

47 PETION SAVAIN, untitled block print from *La Case de Damballah* 1939

Pocomania (1936), a work of sculpture created by the Jamaican artist 41
Edna Manley, took its name from the revivalist Jamaican religion, partly
African and partly Christian, that by the early 1930s had come to
symbolize that Caribbean island's fundamental, non-European cultural
identity. Although the dynamic figure in *Pocomania* certainly echoed
the actual "jumpin' and trompin' " of its ecstatic, religious devotees,
the figure's bowed head, raised arm, and hand-on-chest gesture were
allusions to the making of oaths and the pledging of allegiances: national-
ist displays that Manley knew as the wife and political partner of N.W.
Manley, one of Jamaica's leading advocates of abolishing British colonial
rule. In contrast to the viewpoint that religion thwarted the revolution-
ary aspirations of its followers, Manley's *Pocomania* suggested that black
religion was capable of invigorating the black masses and inspiring them
toward real political change.

That the enthusiastic dance—or battle—against evil forces in Manley's
Pocomania had both spiritual and political implications could be argued
from the perspective of another black proletarian image from the 1930s.
Robert Riggs's painting (1939) of the Joe Louis and Max Schmeling fight 48
of 1938 was also dependent upon cultural symbolism for its multiple
connotations. Louis, the best heavyweight boxer since Jack Johnson, was
an American hero during the Depression era, with a string of boxing

81

victories and a stoic, humble demeanor that endeared him to blacks and whites alike. Louis's larger-than-life stature in the American imagination made his defeat in 1936 by the German heavyweight Max Schmeling more than a disappointment: it was an American tragedy for the already demoralized, economically beleaguered nation. In addition, the U.S. government's apprehensions concerning Adolf Hitler's Germany added a socio-political dimension to the 1936 Louis/Schmeling fight, and (as seen in the Robert Riggs painting) to their much anticipated 1938 rematch.

The title of Riggs's painting—*The Brown Bomber*—makes clear the degree to which Americans used the African American boxer Joe Louis as a metaphor for their own fantasies on the economic, political, and racial front. For some, Louis was the ultimate working-class hero: of common origins but equipped with a grace and physical prowess that made him exceptional. For others, Louis was Nazi Germany's worse nightmare: a Negro weapon, ready to prove to the world that democracy, in spite of inconsistencies, would prevail. For many blacks, Louis embodied racial and cultural vindication after centuries of abuse, discrimination, and ridicule on their native soil. Riggs's photographically inspired work, depicting those initial minutes following Louis's famous one-round knock-out punch, presented the boxer as an avenging angel, body arched and tightly drawn, and miraculously suspended in space over his fallen opponent. In Riggs's dark arena, the photographers, reporters, and other spectators—visible in the foreground and along the boxing ring's distant, artificial horizon—played awe-struck eyewitnesses as Louis became the symbol of the apotheosis of the black proletariat. President Roosevelt's modest, pre-fight admonition to Louis that the people "were depending on those muscles for America" underscored just how pervasive was the tendency to objectify black people in this populist, morale-boosting era.

Yet the spiritual core of the black masses—as articulated in works as diverse as Manley's *Pocomania* and Hurston's black vernacular novel *Their Eyes Were Watching God* (1937)—separated them from the rest of the proletariat of the period, and sustained them through these difficult years. It would not be very long before this interest in a spiritually endowed black proletariat led many American artists and intellectuals to musical, oral, and visual arts that (in their estimation) were the "authentic" creative expressions of "the folk." In addition to satisfying the societal desire to understand more fully the mind and imagination of the "preindustrial" segments of the population, the documentation, assembly, and study of a range of American "folk" arts fueled an often nationalistic sentiment concerning America's cultural roots.

48 ROBERT RIGGS *The Brown Bomber* 1939

This celebration of "the folk," however, did not come without its critics. Harold Preece, in his 1936 essay "The Negro Folk Cult," questioned the value of celebrating the black vernacular without an associated examination of the political, economic, and social issues that affected black practitioners and audiences of this culture. Preece specifically objected to Zora Neale Hurston's excavations of the colorful lore and language of poor, working-class blacks, seeing her largely uncritical efforts as those of a naive, black sycophant or, worse, of a duplicitous, "literary climber." To Hurston's credit, her motives for exploring black folklore did have a political agenda, and that agenda was to remove the pathological stigma (as promulgated by social scientists like E. Franklin Fraizer and others), and to invest black folk culture with an artistic worth and universal importance which it had been long denied. "Hurston rejected the pathological stereotype," wrote her biographer Robert E. Hemenway in 1977, "because she knew that material poverty and ideological poverty were distinct entities...." Hurston tried to show in her

writings and research that "normality is a function of culture, that an Afro-American culture exists, and that its creators lead lives rich with ideological and esthetic significance, a fact demonstrated by their folklore."

Harper's Bazaar photographer Louise Dahl-Wolfe's "discovery" of the African American, Tennessean "folk" sculptor William Edmondson, and her successful lobbying to have his work exhibited in 1937 at New York's Museum of Modern Art, attested to the aesthetic appeal of this art from the racial and cultural margins. Works like Edmondson's *Angel* (*c.* 1932–37)—originally created as grave markers and garden ornaments for the impoverished yet art-loving members of Nashville's black community—became coveted "folk art" collectibles once Edmondson was given the imprimatur of a MOMA solo exhibition. *Angel* and other sculptural products of Edmondson's "God-given" vision fueled the modernist nostalgia for an existence that was simpler and morally uncomplicated, and the modernist fantasy about the "primitives" among them.

Scholarly studies on the spiritual lives of the black masses showed that their relationship to God was anything but simple and uncomplicated. In the mid-1930s, a sociological study examining the religious conversion experiences of ex-slaves concluded that one of their striking characteristics was the process of discerning the presence of the holy spirit and, then, coming to terms with the "reborn" self. For Edmondson, the answer was to let his art become God's vehicle for spiritual renewal. For

49 WILLIAM EDMONDSON
Angel 1932–37

50 ANONYMOUS *Elijah and Cornelia Pierce c. 1935*

Elijah Pierce, artist, barber and itinerant preacher, based in Columbus, Ohio, it was to dedicate his carved and painted wooden panels to the literal teaching of God's word. These two examples of a folk aesthetic springing out of black communities extended the image of an art "of, by, and for the people" beyond governmental and other proletariat-inspired artistic orientations and into a broad-based representational enterprise that was unimaginable for the proponents of the "New Negro." 50

Many of these works of the Depression era were included in the debates in the art world on nationalistic tendencies in modern art and the threats of politically imposed artistic boundaries. Ranging from Social Realism to Regionalism, these boundaries were described by New York painter Romare Bearden as "profoundly social," or, rather, indicative of African American artists succumbing to the aesthetic tyranny of an art based solely on lived "experience." What none of these artists or theorists anticipated was that this humanistic impulse would carry them and their art toward mid-century and a shifting fascination in the art world between racial distinctiveness and the total disappearance of race, cultural markers, and figural representations.

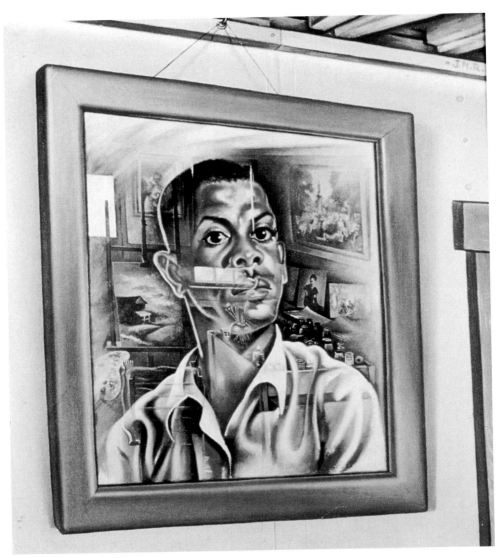

51 JOHN ROBINSON *Self-Portrait c.* 1945

Pride, Assimilation, and Dreams

AN OVERVIEW

Between 1940 and 1963, the image of black culture underwent several major transformations. The year 1940 was the seventy-fifth anniversary of the ratification of the Thirteenth Amendment which abolished slavery; in 1963 over 200,000 people converged on Washington, D.C., to protest against restricted job opportunities for African Americans and *de facto* segregation in housing and education. Throughout this period, which was also a time of war and major political change, black culture alternately shifted from the spotlight, to the periphery and, ultimately, to the center of the world's stage: shifts that were analogous to black people's changing social status.

In one sense, World War II fueled an international desire for political freedom and individual self-determination that many of the world's peoples took to heart during the 1940s. For some there was the belief that with an Allied victory African Americans would attain full citizenship and finally reap the benefits of living and working in a model democracy. For blacks in Africa and the Caribbean, the liberation of Europe also kindled hopes for the collapse of colonialism and a chance at self-rule. Many saw Fascism as a not-so-distant relative of racism and colonialism, and, consequently, also something that blacks needed to fight against. This view was underscored by the fact that black soldiers, particularly from the U.S.A., Africa, and the Caribbean, were fighting in the war against Germany, Italy, and Japan.

In England the numbers of black residents from the Caribbean and Africa grew during and after World War II. At least 7000 men from the Caribbean served in the Royal Air Force alone. After the war, many of these veterans and their families (both "nuclear" and "extended") made their way to England in hopes of finding jobs, decent housing, educational opportunities, and a future for their children. Instead what they frequently encountered were unemployment, overcrowding, discrimination, and physical attacks (as experienced during the infamous riots in London's Notting Hill in 1958). The thousands of North African and

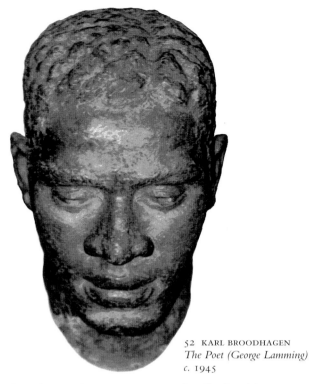

52 KARL BROODHAGEN
The Poet (George Lamming)
c. 1945

Southeast Asian immigrants in postwar France hardly fared better, with the escalating tensions between the French government and its overseas territories making life in Paris and other French cities especially intolerable for Algerians, Tunisians, Vietnamese, and other colonial subjects.

However, as journalist Roi Ottley suggested in *New World A-Coming* (1943), his book on contemporary black life, African American expectations for a promising future were at least initially high during this period. In Washington, D.C., John Robinson conveyed this decidedly optimistic racial mood in his *Self-Portrait* (*c.* 1945), where painter, artworks, environs, and reflections in glass formed a picture in which creativity and introspection are paramount. Thousands of miles away, in Barbados, sculptor Karl Broodhagen, ventured into his own brave new world with his portrait bust of the local budding poet (and future novelist) George Lamming. Broodhagen's *The Poet* (*c.* 1945) shared with Robinson's *Self-Portrait* an introspective quality of young manhood, as well as an exploration of the African facial characteristics of his subject that, in both works, made "blackness" an irrefutable, fixed reality and badge of honor.

88

By the end of the 1940s, however, Robinson and Broodhagen's images of progressive, idealized black youth were superseded by more pessimistic or ambivalent racial themes. In literature, blackness as an insignia of social estrangement first emerged in the writings of novelist Richard Wright but, increasingly, Wright's voice of protest was joined by the more troubled writings of novelists Chester Himes, Ralph Ellison, James Baldwin, and even Broodhagen's George Lamming, author of *In the Castle of My Skin* (1953). In 1949, the artist Harlan Jackson—born in Texas, based in New York City—applied this notion of a problematic black identity to his painting *Mask No. II*. Split between a racial pride that was embodied in a "tribal" mask and a desire to assimilate that black identity within the "white" cultural practice of abstract painting, *Mask No. II* illustrated the contradictions that were increasingly felt by proponents of black culture. Toward the end of this period the options for black cultural expression and its reception went beyond a simple dialectic of "pride" versus "assimilation" and, instead, embraced models that were either inclusive of both, or were derived from an entirely different set of social and aesthetic values. These new options emerged just at the moment when black cultural groups became conspicuous, cosmopolitan, and candid about their universality and growing political importance in world affairs.

53

53 HARLAN JACKSON
Mask No. II 1949

Precursors of a vibrant, black cultural scene were already evident during the final years of the Great Depression. African American artists and their creations were key elements in America's cultural fare around World War II, from the literary works of Richard Wright to the theatrical performances of Paul Robeson. Well into the 1940s, these artists and others in literature, theatre, music, dance, and motion pictures, helped shape perceptions of a black identity that were especially diverse. Lionel Hampton's swinging persona in his jazz recording "Flying Home," Marian Anderson's dignified presence in her classical interpretations of Negro spirituals and German *lieder*, Eddie "Rochester" Anderson's light-hearted, gravel-voiced, radio respondent to Jack Benny, choreographer Katherine Dunham's ballets influenced by Afro-Caribbean dance and jazz, and novelist Richard Wright's brooding, angry characterizations of black men all figured prominently in the American popular imagination.

In the late 1930s and early 1940s the visual arts experienced an explosion comparable to the "Negro Renaissance." Beginning with the show that was organized for the Texas Centennial Exposition's "Negro Building" in 1936, there were at least ten other major "all Negro" art exhibitions in the following decade, ranging from the widely discussed "Contemporary Negro Art" at the Baltimore Museum of Art (1939), to the much heralded "The Negro Artist Comes of Age" at the Albany Institute of History and Art (1945). In contrast to the earlier, "all Negro" art shows sponsored by the Harmon Foundation, these exhibitions received endorsement and critical analysis from two of the period's leading art critics: Alain Locke, the author of *The New Negro* and that movement's elder statesman, and James A. Porter, Master of Arts from New York University's prestigious Fine Arts Graduate Center and a professor of studio arts and art history at Howard University. Both Locke and Porter published important books on the subject in the early 1940s, thus contributing to this period's growing enthusiasm for African American themes and subjects in art.

Locke's theoretical premise in *The Negro in Art* (1940) was that work by black diasporal artists, as well as work by white artists who explored black subject matter, formed a body of cultural evidence worthy of close study. In addition to tracing just how ubiquitous black subjects had been throughout Western art history, Locke's *The Negro in Art* was ahead of its time in that it addressed the issue of race and its catalytic role in cultural representations.

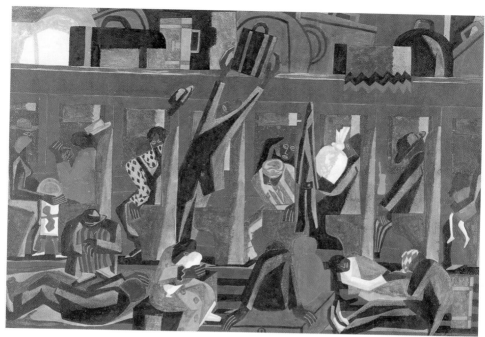

54 JACOB LAWRENCE *Going Home* 1946

Porter's *Modern Negro Art* (1943), although less prophetic than Locke's book, was perhaps the more historically important work, both in its own day and later. Solidly researched and painstakingly documented, this pioneering study traced the art-historical record of African Americans from their colonial beginnings to the "Negro art" boom of the early 1940s. What pushed Porter's study beyond the boundaries of a standard text was his willingness to criticize, question, and evaluate the works of African American artists without succumbing to racial favoritism. As a traditionalist and aesthetic conservative, Porter made harsh but informative criticisms of artists Aaron Douglas, Archibald J. Motley Jr., Palmer Hayden, and William H. Johnson. However, Porter also exhibited a remarkable tolerance in his favorable critiques of the works of such "naïve" artists as William Edmondson, Horace Pippin, and of the twenty-six-year-old "popular" artist and "virtuoso" Jacob Lawrence.

Lawrence, a product of New York's American Artists School and Harlem's community art centers of the Depression era, painted local, contemporary scenes as well as historical subjects with an unusual eye for overall design, small details, and thematic essences. These attributes—

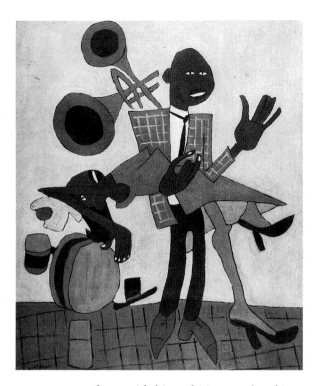

55 WILLIAM H. JOHNSON
Jitterbugs (V) c. 1941–42

56 VINCENTE MINNELLI
Cabin in the Sky 1943

along with his ambitious undertaking of several multi-paneled, gouache and tempera works on black history—singled him out among his peers as early as 1938, and championed a radical way of visualizing black culture. Lawrence's strategy of imposing high-key color contrasts and spare, planar treatments on his pictorial vignettes of African American life
54 (as seen in his 1946 painting *Going Home*) elicited enthusiastic responses from a broad spectrum of viewers during the 1940s which, in turn, helped to facilitate an interest in visual representations of a black culture that was both modernist and folkloric.

William H. Johnson, after his auspicious New York début in 1929, abruptly departed for a long stay in Europe. On his return to New York in 1938, he soon encountered Lawrence's expressive work. This visual meeting, combined with Johnson's own distillation of European Post-Impressionism and African American folk culture, resulted in works like
55 *Jitterbugs (V)* of *c.* 1941–42: a *faux-naïve* yet modernistic interpretation of a Harlem couple performing the fast urban dance known as the Jitterbug.

Johnson's folk/modern art fusion—couched within the over-arching presence of Jacob Lawrence, and Johnson's attempt to articulate some-

92

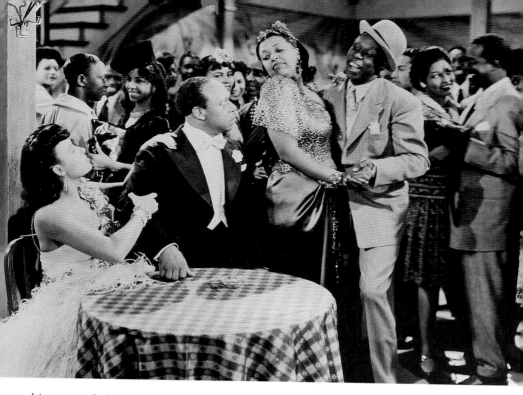

thing special about contemporary African American life—was clearly in the air, as seen in the popular "all Negro" movie musical *Cabin in the Sky* (1943). Film director Vincente Minnelli, who had previously forged close working relationships on Broadway with some of the leading black entertainers of the day, brought those experiences to this film fantasy. Ostensibly about a humble, black couple (played by Ethel Waters and Eddie Anderson) struggling between the forces of good and evil, *Cabin in the Sky* was, in truth, a Hollywood discourse on the reconciliation (rather than the struggle) between spirituality—folk culture and traditional black values—and materialism—the trappings of modern society and black urban lifestyles. The extraordinary cast of black performers (with Waters and Anderson joined by Lena Horne, Kenneth Spencer, Rex Ingram, and Louis Armstrong, among others) did not so much play on standard stereotypes as operate in their own, customarily sophisticated and theatrical manner. The end results, in keeping with Minnelli's cinematic interest in show business splendor and illusionism, depicted black culture as eternally bound to an invented folk past, even under the dazzling lights of the city (and of the MGM studios).

56

The construction of this pictorialized folk past—whether codified in the expressionist shacks, hair braids, and gnarled human features in a work like John Biggers's *Manda* (c. 1945), or built into the folkloric mien and stylized gestures in a painting such as Robert Gwathmey's *Work Song* (1946)—proclaimed an aspect of U.S. culture that, though light years from the aesthetic rumblings of Abstract Expressionism, fulfilled the desire among members of a polarized arts scene to seek identification with America's roots. African Americans, in spite of their slave legacy and in spite of being the epitome of everything undesirable in white America, embodied at the end of World War II the social conscience of the U.S.A. and the country's test case for true democracy.

Artist Eldzier Cortor understood black America's role as a social catalyst and a reminder of promised freedoms, as seen in *Americana* (1947), his painting of a nude black female emerging from her bath in an interior with newsprint-lined walls and chipped linoleum tiles on the floor. Singled out and vandalized upon its arrival at the Carnegie Institute Annual Art Exhibition of 1947, *Americana* apparently touched a raw nerve, with its jarring mix of black sensuousness, hardcore poverty and,

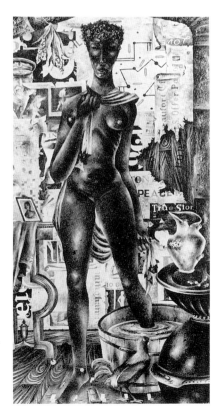

57 ELDZIER CORTOR
Americana 1947
(destroyed)

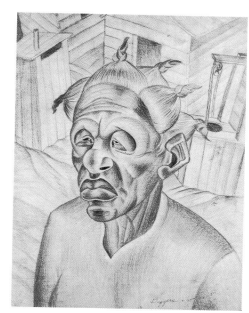

58 JOHN BIGGERS
Manda c. 1945

59 ROBERT GWATHMEY
Work Song 1946

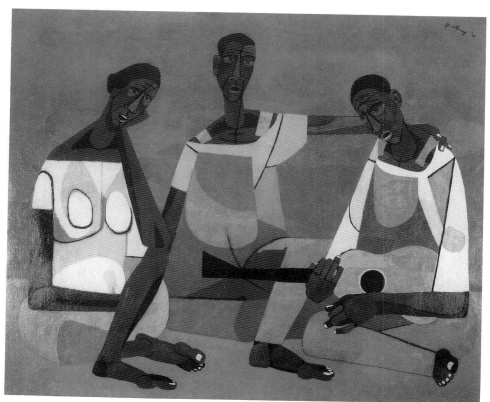

most notably, a folk-derived collage whose sarcastic commentaries on the American dream literally shouted from the walls.

Cortor's travels in 1944 and 1945 among blacks who lived on the largely isolated Sea Islands off the coast of South Carolina and Georgia (sponsored by the Julius Rosenwald Fund) strongly influenced his vision which was partly folkloric and partly surrealistic. In this respect, Cortor joined scores of other Americans and Europeans in their emulation of artists who worked beyond the art scene's borders. As with the latter-day reverberations of the "New Negro" arts movement, the vogue around 1940 for "Negro folk art" had its beginnings a decade earlier, in the "discovery" of artists like William Edmondson and Horace Pippin, and in the WPA/FAP's efforts to research, document, and promote America's homespun arts and "folkways." By the 1940s, this passion for "the folk" intensified, with "folk art" receiving accolades from the American and European avant-garde.

In 1949, Cortor received a Guggenheim Fellowship to conduct research in Jamaica, Cuba, and Haiti: three sites in the Caribbean where, as in his Sea Islands sojourn of several years earlier, he hoped to encounter black people "whose cultural tradition had been only slightly influenced by whites." Interestingly, art works by John Dunkley, Jamaica's foremost intuitive painter during this period, challenged the common misconceptions that artists like Cortor and other "folk art" enthusiasts took from this kind of work. Dunkley's *Back to Nature* (1939), which transformed the Jamaican landscape into a dark, organic, and symmetrical valentine, had a lot in common with Cortor's *Americana* and other modernist art in spite of Dunkley's cultural distance and social isolation from the contemporary arts scene. Yet one could also argue that it was precisely this enigmatic quality in "folk art" that made it both perplexing as well as fascinating to viewers in the 1940s.

During Cortor's stay in Haiti (where, coincidentally, he was accompanied by abstract painter Harlan Jackson), he became aware of this sympathy between the "moderns" and the "primitives." This artistic bond, appearing first in the 1930s with the Haitian *Indigenist* movement, was later strengthened by the American art teacher, DeWitt Peters, and his founding of the Centre d'Art in Haiti in 1944. It was perhaps best characterized in the visit of the Surrealists André Breton and Wifredo Lam in 1945. Breton, the Surrealist movement's leading theorist, and Lam, a Surrealist painter of Chinese and African Cuban ancestry, became enamored with the paintings of Hector Hyppolite: a self-taught artist, ex-merchant marine, and *Vodun* priest. Hyppolite painted wondrous, symbolic compositions, like *Pan de Fleur (Basket of Flowers—Voodoo)* of

61

57

60

96

60 HECTOR HYPPOLITE *Pan de Fleur (Basket of Flowers—Voodoo)* 1947

61 JOHN DUNKLEY *Back to Nature* 1939

1947, which employed dramatic juxtapositions and thematic leaps in a manner similar to the Surrealists. In an essay of 1947, published in his book *Surrealism and Painting*, Breton described Hyppolite's artistic integrity as "entirely unalloyed, ringing as clearly as virgin metal," and Hyppolite as the guardian of a universal, all-important secret.

What Breton did not understand was that Hyppolite—through the discursive strategies of art and religion—created an alternative universe for himself and his people which seemed to be surreal and secret but was, in fact, (to paraphrase the Martiniquan critic Edouard Glissant) a picture of "a seldom-seen side of reality." For Hyppolite and the other artists who were neither academy-trained nor a part of the art scene proper, these representations of a fantastic world and their innermost visions were more intellectually tangible and functional than Breton and the Surrealists could have ever imagined.

For example, James Hampton's glittering, monumental assemblage, *The Throne of the Third Heaven of the Nations Millennium General Assembly* (*c.* 1950–64), was meant to be a liturgical display within his "all black" church in Washington, D.C. But its public unveiling after this reclusive artist's death in 1964—and its artistic première a few years later in the Smithsonian Institution—cloaked its devotional and culture-specific purpose. Paintings by the self-taught black artist Minnie Evans,

98

apparently spiritual and cathartic works of the subconscious, actually spoke volumes about the effects of racism and segregation on black aspirations and dreams in Jim-Crow era North Carolina. The white angelic choir in Minnie Evans's *A Dream* (1959) was entirely conceivable in a society where, for blacks as well as whites, a spiritual and divine realm—and all that was considered "good" and "beautiful" in the culture—had to be white. The creations by these artistic "outsiders," while highly praised in this period, were routinely misunderstood, removed from their aesthetic and social contexts, and inserted into a catch-all "folk art" category that accommodated the mainstream art world's unwritten policy based on exclusion by race and class. It would not be until the late 1970s, with a diversified, highly profitable U.S. art market, that these popular works and their artists would stand as equals beside the works and practitioners of the so-called professional art world.

62

62 MINNIE EVANS *A Dream* 1959

63 JAMES HAMPTON *The Throne of the Third Heaven of the Nations Millennium General Assembly c.* 1950–64

FREEDOM THROUGH ABSTRACTION

Like Eldzier Cortor a few years earlier, Rose Piper, a New York City artist, received Rosenwald Fellowship funds (in 1946 and 1947) to travel throughout the southern U.S.A. and conduct research on African Americans, in order to create a series of paintings on "the folk Negro." One of Piper's works from this series was *Slow Down Freight Train* (1946): a semi-abstract, colorful figure study executed in a style similar to that of the American precisionist painter Ralston Crawford. The catalyst for Piper, however, was the African American musical form, the blues; her paintings therefore presented a rebel strain of abstract art in the late 1940s.

Through the sometimes fracturing, blurring, subtracting or interactive practices of painterly abstraction, Piper created impressions rather than illustrations of what she described as "the imaginative experiences evoked by the world of Negro folk song." In *Slow Down Freight Train*, bands, arcs, and fields of color, punctuated by thin, black outlines, made oblique yet germane references to the images, sounds, and sensations that the blues conjured. Piper's technique and impetus, similar to those of painters William H. Johnson and Robert Gwathmey, reconstituted the black folk experience, making it discernible and evocative, yet also condensed and abstract.

64 ROSE PIPER *Slow Down Freight Train* 1946

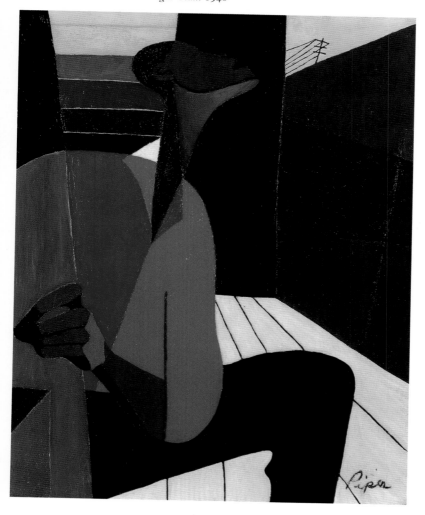

By the mid-1940s, many U.S. artists were abandoning figurative and narrative subjects and shifting to abstraction. Apart from those who simply saw abstraction as the latest trend, many artists genuinely believed it was the only viable route away from the formal and ideological limitations of Social Realism: a tradition that, since the American Artists' Union and Popular Front days of the 1930s, was increasingly viewed as constrained by politics, various schools of cultural nationalism, and an overwhelming social agenda. With significant numbers of European Surrealists and abstract artists settling in the U.S.A. before and during the war years, American artists also felt this current from abroad, especially with regard to non-figurative art and Surrealism's fondness for irrational, accidental, and subconscious impulses in art. In summary, abstraction offered American artists a sense of personal freedom and creative license that was virtually alien in U.S. visual culture.

While many African American artists gravitated to abstraction for these reasons, for others abstraction took on a larger and more complex meaning. Historically confined to exhibiting their works in "all Negro" art exhibitions and left out of the national forums on American art, several African American artists extended abstraction's call for individual and artistic freedom to the art world's racial front. Beyond an aesthetic affinity for abstraction, some African American artists also saw their move to abstraction as a personal and professional step toward artistic integration: a step that symbolized their willingness to subordinate blackness—and all that was associated with it—and to place themselves and their work in a larger, wider and, ultimately, whiter art world that provided more opportunities to exhibit, sell, and enter into artistic dialogue with others. In 1958, *Ebony* (a monthly magazine founded in 1945 by publisher John H. Johnson and directed toward an expanding African American readership), carried an article remarking on this shift to abstraction among younger black artists, speculating (based more on wishful forecasts than actual demographics) that the turn from "Negro subject matter" was "a natural consequence of living in a more integrated world."

Abstraction was only a partial stylistic presence in the work of Piper and Jackson, but for Norman Lewis and Hale Woodruff, both African Americans, abstraction was an important pathway to artistic freedom and individual self-discovery. As early as 1945, Norman Lewis painted colorful, linear compositions that alluded to the riotous sounds of bebop, or the throngs of pedestrians, rushing aimlessly down crowded New York City streets. However, other paintings like *Every Atom Glows: Electrons in Luminous Vibration* (1951) revealed Lewis's more iconoclastic side, moving beyond the typical issues centered in black culture, and instead tackling

65

65 NORMAN LEWIS
*Every Atom Glows: Electrons in
Luminous Vibration* 1951

such "universal" themes as atomic energy and nuclear fallout. Indeed, Lewis was a product of a divided, contradictory world view: painting abstractly and participating in the mainstream art scene of the 1950s, yet also maintaining close ties with the Harlem scene and its mid-century mood of social separateness and cultural bravado (best exemplified in Ollie Harrington's cartoons and Langston Hughes's short stories that appeared in the black press during this period). Because Lewis based his paintings on more social and, by extension, culturally informed themes, his works were frequently in conflict with the more enigmatic, private mythologies of much American abstract art. Consequently, Lewis's abstractions reveled in an aesthetic predicated on painted gestures that, while camouflaged by artistic overtures to Abstract

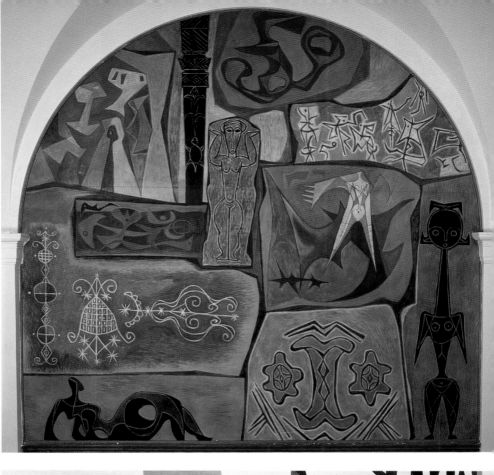

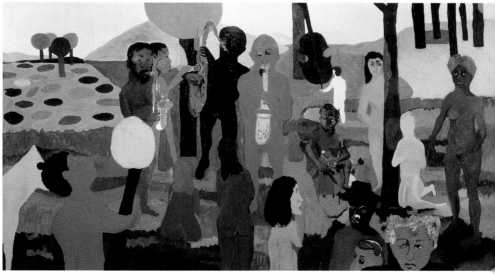

Expressionism, made analogous overtures toward a Harlem-inspired art of visual and verbal "signifying."

Hale Woodruff—who had made forays into a School of Paris modernism, a Mexican-influenced historicism, and an African American brand of southern U.S. regionalism—also embraced painterly abstraction in the late 1940s, seeing in it not only another kind of visual authenticity, but an occasion for "extending [one's] vision" beyond the ordinary scope of comprehension. *Art of the Negro* (1950–51), Woodruff's six-paneled mural for the Trevor-Arnett Library at Clark Atlanta University (formerly Atlanta University), conceptualized the history of the visual arts within the black diaspora in terms of six thematic groupings, each occurring at selected historical junctures over several millennia. Panel Five, subtitled *Influences*, examined the enduring, potent nature of African art and design in imagery as diverse as the paintings of Amedeo Modigliani and the sculptures of Henry Moore, the ground drawings (or *vèvè*) of Haiti, and other abstract and semi-abstract forms. Woodruff had been interested in African art throughout his career; in *Influences* he recorded abstract art's debt to Africa, and abstraction's fundamental position in world visual culture.

In 1947, Woodruff—with sculptor Richmond Barthé, Howard University art professor James V. Herring, and abstract artist Romare Bearden—convinced the International Business Machine (IBM) Corporation to remove all racial references in the catalogue of their art collection, and to abolish all racial preferences in their art acquisition policies. "In light of the Negro artist's present achievements in the general framework of American art today," wrote Woodruff to another artist involved in the 1947 IBM venture, "there does not exist the necessity to continue all Negro exhibitions which tend to isolate him and segregate him from other American artists." Behind the righteous tone of this group's call for integration was the faint hope that black artists would be brought into the larger fold of the American art scene. These were optimistic years after World War II, when President Truman established his Committee on Civil Rights in 1946, and Jackie Robinson made the giant, symbolic step in 1947 of becoming the first African American to play major league baseball. Yet, as art historian Ann Gibson suggested in her study of African American abstract painters, this proclamation of "belonging" by Woodruff and the others was essentially ignored with a continuing, if not escalating, neglect. When Harold Rosenberg, one of Abstract Expressionism's most articulate spokespersons, was asked in the early 1960s to name a few of the leading African American artists, he allegedly brushed off the request, saying that he did not know of any.

66

66 HALE WOODRUFF *Art of the Negro* Murals, Panel 5: *Influences*, 1950–51

67 BOB THOMPSON *Garden of Music* 1960

By the mid-1950s—and continuing well into the early 1960s—abstract art functioned for several black (as well as white) artists as a passport into mainstream acceptance and—for a very select few—artistic renown. Chicago sculptor Richard Hunt was one of the period's more successful abstract artists, with improvised, open-form works like *Arachne* (1956) revisiting and updating the experiments in iron-welding and metal assemblage by the early twentieth-century Spanish artist Julio González. Around the same time that Hunt was becoming better known, abstract painter Aubrey Williams was exhibiting his dense, chromatic canvases in various galleries and exhibition spaces in London. However, unlike Hunt in the 1950s, Williams did not get recognition until 1965, almost a decade later, when he was awarded the prestigious Commonwealth Prize for Painting, and exhibited his latest, abstract composition, *Guyana* (1965), in London's Royal Academy of Arts.

In 1959 in an article about Williams's paintings, Jan Carew, a London-based journalist and writer (like Williams, from Guyana) wrote that "superimposed" on Williams's nature-inspired art were "the new images of science, shapes under a microscope, pictures of nebulae in popular

68

69

68 RICHARD HUNT
Arachne 1956

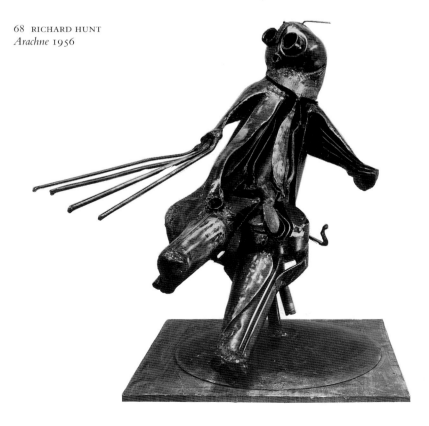

69 AUBREY WILLIAMS *Guyana* 1965

magazines, the bright blurs of trick photography, and *the torment of a uprooted man searching for an image of himself and his people"* (author's emphasis). In this description, Carew's juxtaposition of scientific and technological analogies with an allusion to Williams's personal ordeal as a social and political being illustrated just how malleable abstract art could be, especially when the artist was black or the context of the work evoked blackness and, thus, fit into an observer's preexisting, social interpretation.

Still, abstract art had its black opponents as well as its black advocates, as demonstrated in Ollie Harrington's cartoon on the subject from the *Pittsburgh Courier,* "No, it dont make sense to me niether [*sic*], Bootsie..." 70 (*c.* 1957). In framing abstract art as nothing more than "The Emperor's New Clothes," Harrington—along with the cartoon's largely sympathetic black audience—saw his black artist as an ignoble "con artist," yet

" No, IT DONT MAKE NO SENSE TO ME NIETHER BOOTSIE. BUT WHITE
FOLKS JUS' WONT BUY NOTHIN' IF IT MAKES SENSE ! "

70 OLLIE HARRINGTON
"No, it dont make no
sense to me niether [*sic*]
Bootsie..." *c.* 1957

with plenty of common sense, putting "a big one" over on a mercurial
and gullible white clientele. As reactionary as Harrington's cartoon was, it
raised the critical issue of accountability and communication in cultural
production: a problem that all black artists, abstract as well as representa-
tional, would continue to ponder and debate in the future.

BLACK ORPHEUS

Since 1951, Ollie Harrington had lived and worked in Paris, France.
There, he joined a group of African American artists who, having been
stung once too often by American racism, chose to live in the racially
tolerant and intellectually stimulating community in and around Paris's
Saint-Germain-des-Prés. These artists, in addition to the many African
and Caribbean artists who already lived in Paris, and the many African
American artists who passed through the city during these years (includ-
ing Romare Bearden, Edward Clark, Bill Rivers, and others), established
their own, black expatriate community which forged important alliances
with Paris's influential intellectuals and philosophers.

The philosophy of Existentialism—with its emphasis on the predicament of being, and the crises of social action and personal responsibility—resonated strongly with black artists during these post-war years. For African American artists, Existentialism articulated their feelings of isolation in a society that was largely deprecating of or blind to black humanity. For African and Caribbean artists, Existentialism addressed these same emotions, in addition to voicing strong arguments against colonialism. But what Existentialism and its French advocates especially communicated to black artists was black culture's affinities with other creative forces in the world. For example, in 1947 three prominent French writers—André Gide, Albert Camus, and Jean-Paul Sartre—served on the advisory board of *Présence Africaine*, a publishing house and literary journal devoted to the writings of black intellectuals working in Africa, Europe, and the Americas. The stated mission of *Présence Africaine*—"to define African originality and hasten its entrance into the modern world"—reverberated with Sartre's theory that the black man "wants to be both a beacon and a mirror; the first revolutionary...who will tear Blackness out of himself in order to offer it to the world...."

Sartre's thoughts on black culture, first published in his widely-discussed essay "Orphée Noir" ("Black Orpheus," 1948), fused the creative genius of such black writers as the Martiniquan Surrealist Aimé Césaire and the Senegalese literary critic Léopold Sédar Senghor with: (1) the revolutionary aspirations of Marxist ideology; and (2) the all-embracing, universal impulses of Western civilization. In his analysis of Césaire's poem "Return to My Native Land" (1939), Sartre observed that "negritude..., inserted into Universal History, ... is no longer a *state*, nor even an existential attitude" but, rather, "a *Becoming*," or a kind of in-process experience which leads black intellectuals to form alliances with other oppressed peoples throughout the world. "Like the Dionysian poet," remarked Sartre, "the Negro attempts to penetrate the brilliant phantasm of the day, and encounters, a thousand feet under the Apollonian surface, the inexpiable suffering which is the universal essence of man." Although Sartre's universalizing objective for *Negritude* signaled its eventual death and (as argued in 1952 by the Martiniquan psychiatrist Frantz Fanon) the destruction of "black zeal," Sartre also seemed to believe that the only viable place for this blackness to exist and live out its purpose in the interim was in poetry and the arts in general.

This notion of a volatile, dynamic, black presence in the world (with revolutionary and redemptive implications), although directed toward Césaire's writings, could equally have been a caption for Wifredo Lam's painting *The Eternal Presence* (1945). Lam, an associate of Césaire, shared

his colleague's fascination with the "black epic," as revealed by the carnival of African Cuban deities, Caribbean flora, and other life and death forces on display in this painting. Transcending his youthful infatuations with Picasso and a second-hand appropriation of African art, Lam demonstrated in *The Eternal Presence* and other works from his post-1941 period (during which he lived and worked mostly in his native Cuba) his acknowledgment of a black diasporal "self," via Sartre's duly-termed "Orphic" descent into a "black substratum" of religion, music, and poetry.

Sartre's betrothal of *Negritude* with the universalizing philosophies and symbols of the ancients—especially those associated with the musician and poet Orpheus—was a thesis that a number of artists explored during the post World War II period. Richard Hunt's *Arachne*, James Wells's and Romare Bearden's various classical subjects of the 1940s, and Ralph Ellison's sweeping, Homeric novel *Invisible Man* (1952) all contributed to this cross-over impulse in black diasporal arts. But the work of art from this period that established the penultimate accord between blackness and the universality of the Western world's classical heritage was the 1958 film *Orfeu Negro (Black Orpheus)*.

Adapted for the screen from the stage play *Orfeu da Conceição* (by the Brazilian poet Vinicius de Moraes), *Black Orpheus* transplanted the

68

72

71 WIFREDO LAM
The Eternal Presence 1945

72 MARCEL CAMUS *Orfeu Negro (Black Orpheus)* 1958

ancient Greek legend of the ill-fated lovers Orpheus and Eurydice to modern-day Brazil and its mostly poor and illiterate descendants of African slaves. Director Marcel Camus placed this archetypal story about love, death, fate, and perpetuity in Rio de Janeiro during Carnival week. With the added attractions of an irresistible Afro-Brazilian music soundtrack, a talented and handsome cast of black actors, and a part documentary/part theatrical format filmed in dazzling Eastmancolor, Camus turned *Black Orpheus* into an instant film classic and a huge commercial and critical success with international audiences. Camus's borrowing of the title and tenor of Sartre's 1948 essay, along with his unprecedented celebration of both racial and cultural blackness (culminating in his remarkable documentary film footage in *Black Orpheus* of an Afro-Brazilian *Macumba* ceremony), transformed black culture into an entity with world-wide appeal and an aesthetic integrity of its own.

Camus's realization of Sartre's Afro-Orphic excavation of the black soul—largely accomplished through his innovative mix of sound, movement and color—had its counterpart during this period in the figurative expressionist paintings of the African American artist Bob Thompson. Although Thompson did not directly encounter this Sartrean rationale until he traveled to Paris in 1961, by 1959 (the year of his move from

73 BEAUFORD DELANEY
Self-Portrait 1962

Kentucky to New York City) he was already incorporating into his large color canvases an Orpheus-like sense of fatality, mystery, and spirituality. Thompson's *Garden of Music* (1960), his homage to New York's avant-garde jazz scene, accentuated the hallucinatory, transfigurative states that jazz musicians like Ornette Coleman, John Coltrane, and others invoked in their audiences. Like a mid-twentieth-century, black Hieronymus Bosch, Thompson introduced chromatic brilliance and moral enigma into American figurative painting and, like his intellectual comrades Lam and Camus, created an artistic bridge between black cultural expression and the elusive notion of universality.

Among the Paris-based black artists whose paths may have crossed Thompson's in the early 1960s were the African American painter Beauford Delaney and the Ethiopian painter Alexander "Skunder" Boghossian. Delaney, the eldest of the three and a resident of France since 1953, arrived at a similarly colorful, mysterious, and universal place in his work as Thompson, but by an entirely independent route. Around 1944, after many years of fairly traditional portrait painting in New York's Greenwich Village, Delaney, like so many American painters, began to imbue his compositions with more paint and less realistic form, so that, by the time he left for Paris in 1953, his work had taken on the appearance of textured, swirling topologies. Ironically, Delaney's approach, rather than taking him further away from the humanistic concerns of his earlier work, actually brought him closer to a heartfelt, universal statement and (when applied to black subjects like his 1962 *Self-Portrait*) an

67

73

all-encompassing declaration of what the American writer Henry Miller in a broadside of 1945 described in Delaney's work as displacing metaphoric "blackness" with divine "solar radiance."

Skunder lived and worked in Paris from 1957 until 1966, where he found himself, like Thompson and Delaney, in the midst of a lively international arts scene. He had access to a whole range of black expressive culture: *Présence Africaine*; Camus's *Black Orpheus*; the music of Paris-based African American jazz musicians such as Kenny Clarke; Jean Genet's influential, absurdist play *The Blacks*; and the city's major collections and archives of African art. All this significantly altered his work, curiously making it both "Pan-African" and "universal." Skunder reworked a calligraphic approach reminiscent of Paul Klee, of the European proponents of action painting, and of the illuminated scrolls and manuscripts of the artist's native Ethiopia. This reworking functioned in paintings like *The Moon and the Valiant* (*c.* 1964) as cross-cultural markers: characters and figures whose symbolism leapt over conventional boundaries and 74

74 SKUNDER BOGHOSSIAN
The Moon and the Valiant
c. 1964

became a kind of multi-signifying *lingua franca*. Exhibitions on three continents during this period, as well as acquisitions by art institutions as divergent as New York's MOMA and Virginia's Hampton University Art Museum illustrated Skunder's successful—and largely indiscernible—merging of cultural specifics with philosophical abstractions: an artistic balancing act that he, along with his fellow universalists, had perfected, and one that Sartre believed would push them out of "past particularisms" and into "future universalisms" which, in turn, would ultimately enact "the twilight of [their] negritude."

THE OTHER MOVEMENT

For artist Gerard Sekoto, Sartre's philosophical platitudes about black culture and universalisms could not have been more foreign or more fanciful. Although Sekoto was a contributor to *Présence Africaine* and a participant (as was Skunder) in the Second Congress of Negro Writers and Artists in Rome in 1958, his firsthand experience of racial oppression in South Africa—initially in his native, rural Transvaal and later in Johannesburg and Cape Town—limited his appreciation of Sartre's idea of a white recognition of black humanity. Sekoto had arrived in Paris in 1947, just after South Africa's white minority government first formulated the concept of *apartheid*, and had been painting under

75 the exigencies of racial discrimination for a number of years. *Woman Ironing* (c. 1940–41), one of several paintings inspired by Sekoto's stay in Sophiatown (a poverty-stricken black township in Johannesburg), revealed his understanding of black life under white racism, as seen in his evocation of that township's murky, claustrophobic atmosphere, with a torch-like candle providing the scene's only source of light and, by poetic association, its only rays of hope.

Yet many artists and intellectuals, sensing that racism and oppression were not disappearing but, rather, becoming more entrenched, responded in fiercer ways than shown in Sekoto's *Woman Ironing*. Unlike the expressions of universal goodwill or the circumventions of politics and race in much of the work from the post World War II period, several U.S. artists adopted a humanitarian stance in their work and, reminiscent of the activist politics of artists in the 1930s, directed their efforts toward an art of social engagement and protest. These artists, frustrated rather than heartened by race relations in the post-war years, joined organizations like the NAACP and the National Negro and Civil Rights Congresses; they exhibited in galleries and art venues that—in this period of abstraction and thematic disengagement in the arts—promoted

75 GERARD SEKOTO *Woman Ironing c.* 1940–41

figurative or social realist work; and they aligned themselves with like-minded, civil rights activists both in the U.S. and abroad, risking from right-wing factions the dreaded "Communist" label.

In spite of legitimate concerns about being "blacklisted" for one's political beliefs, or anxieties about one's work being considered irrelevant by an increasingly abstract art-oriented scene, several socially engaged African American artists persevered in the late 1940s and throughout the 1950s, producing work that not only challenged a racially biased, white *status quo*, but reinvigorated the black subject in American art. In her *Negro Woman Series* (1946–47), Elizabeth Catlett extended the historical dimensions of her pictorial study of black women's experiences into an impassioned yet lucid, first-person affidavit against racism. One of the most riveting images from the series was *I Have A Special Fear for My Loved Ones* (1946). This linocut print revisited a grisly theme that so many American artists had explored a decade earlier, and took on a new urgency from Catlett's inclusion of three, cropped-off pairs of feet, so placed as to suggest either spectators, standing in perspective, or more lynch mob victims, hanging above the body that had already been cut down.

76

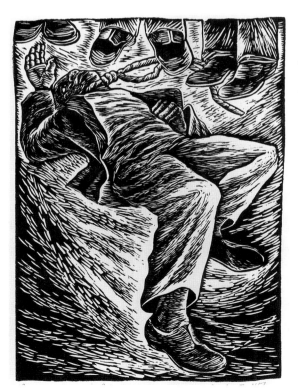

76 ELIZABETH CATLETT
... *I Have A Special Fear for My Loved Ones* 1946

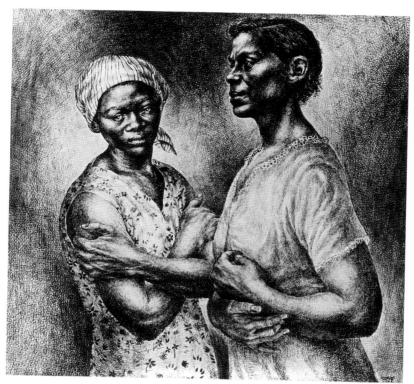

77 CHARLES WHITE *O, Mary, Don't You Weep* 1956

Like Elizabeth Catlett's work, the drawings of Charles White (her
former husband) emerged during this period of the artistic "triumph" of
Abstract Expressionism. But unlike Catlett (who found an ideological
refuge and a more fulfilling, personal existence for herself in Mexico),
White not only survived in the U.S.A. in this 1950s atmosphere of action-
painting and "red-baiting," but blossomed into a major figure of the New
York art world. White's drawings of black people were large-scale,
moderately expressionistic, and meticulously rendered. Much of their
success hinged on their being seen within the larger cultural context
of black life in the 1950s. Lorraine Hansberry, author of the Broadway
play *A Raisin in the Sun* (1959), the catalogue essayist for White's 1961
exhibition at New York's ACA Gallery and, like White, from Chicago,
recognized this requirement, observing that she and White were "of
the same sidewalks and acres of 'rocking storefront churches' " and that

117

they both "drew breath hearing certain music, watched by certain eyes,
chastised and comforted again by certain voices." In White's *O, Mary,
Don't You Weep* (1956), Hansberry's allusions to stalwart, church-going
black mothers became concrete, resonating with real images of black
women, and extending those images into a sympathetic display of human
emotion, frailty, and strength.

These dramatic images by Catlett and White—of black men dying and
black women comforting one another in dignified anguish—became all
too common as American race relations began to receive greater media
attention and public scrutiny. Beginning in 1955 with the bus boycott in
Montgomery, Alabama, after Rosa Parks, an African American woman,
was arrested for refusing to give her bus seat to a white male passenger,
the African American struggle for full citizenship increasingly took
center stage in the cultural consciousness of the U.S.A. Catlett and
White's works, along with those by artists Philip Evergood, Robert
Gwathmey, Jacob Lawrence and others, raised the specter of inequality
in a so-called American democracy, drew attention to the frightening
truths about white-on-black violence, and focused on examples of
endurance and moral tenacity in the face of these obstacles.

In spite of the contributions that Catlett, a printmaker and sculptor,
and White, a draughtsman, made on behalf of an art of social conscious-
ness, the medium of photography seemed to be the ideal and most
frequently used art form for addressing these social issues. Perhaps it
was the misconception that photography was primarily a journalistic
endeavor rather than an art form that made these photographic images of
the American racial landscape more acceptable, or at least allowed them
within the margins of the art world. Gordon Parks's *Life* magazine
photo-essays on racial issues, Roy DeCarava's collaborative portrait (with
author Langston Hughes) of the "Negro experience" in *The Sweet
Flypaper of Life* (1955), and Robert Frank's penetrating look at an often
myopic, racially-polarized society in his book *The Americans* (1958) were
a few of the more noteworthy, social documentary photographic projects
during this period.

Ernest C. Withers, although not as well known as Parks, DeCarava,
and Frank, worked as a freelance photographer in Memphis, Tennessee.
His twenty-page, self-published *Complete Photo Story of Till Murder
Case* (1955) was created in response to the notorious incident involving
Emmett Till, a black teenager who, having casually spoken to a white
woman in Mississippi, was abducted from his house by two white
men and brutally murdered. Sold in African American communities for a
dollar and prominently featured in *Jet* magazine (Johnson Publishing

COMPLETE PHOTO STORY OF TILL MURDER CASE

FIRST AND ONLY

COMPLETE, FACTUAL

PHOTO STORY

OF TILL CASE

AUTHENTIC PICTURES

TAKEN ON THE SPOT

DESIGNED TO MEET

PUBLIC DEMAND

Send Check or Money Order
With Your Name and Address
Payable To

WITHER'S PHOTOGRAPHERS

P. O. Box 2505
Memphis, Tenn.

price: $1.00

Per Booklet

78 ERNEST C. WITHERS, cover of *Complete Photo Story of Till Murder Case* 1955

Company's small format, news and photo weekly), Withers's *Complete Photo Story of Till Murder Case* was a powerful, graphic example of photo-journalism, and helped to galvanize the burgeoning civil rights movement throughout the country. Even a conservative artist like Norman Rockwell—after a decade of boycotts, sit-ins, marches, efforts to desegregate schools, and often ugly, violent retaliations against these actions—eventually had to bring the race issue to the attention of his audiences, as seen in his 1964 *Look* magazine cover, *The Problem We All Live With,* a painting of U.S. marshals assisting an act of school desegregation. 79

More revealing than Rockwell's photographic-like scene was the painting's title which, with perhaps intended ambiguity, did not make clear exactly where "the problem" resided. Was the problem simply the evils of racism and bigotry, or was it (from the vantage point of the white, homogeneous, self-righteous "We" of the title) an African American population, no longer invisible and demanding civil rights? Even if one conceded that his sympathies rested with this brave little girl, there's no denying that, in the larger scope of things, Rockwell

regretted the entry into his escapist, "problem" free, *Saturday Evening Post* world of an indelible presence, whose very being was defined in stark "black and white" terms. By the mid-1960s, this presence would do more than merely provide "local color": it would transform the Reverend Martin Luther King's dream of racial integration into a reality, insist upon a permanent place within the cultural landscape and, eschewing the racial and cultural ambivalences of the past, declare itself "Black."

79 NORMAN ROCKWELL *The Problem We All Live With* 1964

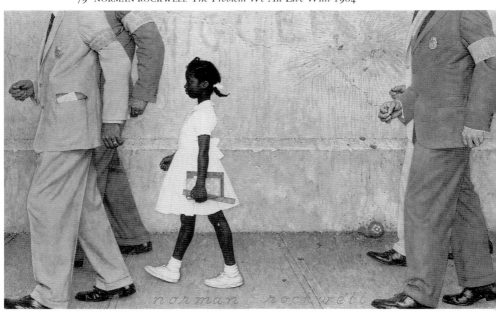

"Black is a Color"

THE NAME GAME

Around 1965, African Americans began to find the racial and cultural designation "Negro" not only antiquated, but suggestive of a less transcendent and revelatory time than the one in which they were currently living. In those first few years of the 1960s, African Americans had already experienced a significant number of political and cultural firsts, as well as moral encouragement from the society-at-large. Still, there were times when race relations seemed far from hopeful, as in 1964, when the slain bodies of three civil rights workers were discovered in a shallow grave outside Philadelphia, Mississippi, or, in 1965, when the Los Angeles community of Watts erupted into a major civil unrest following clashes between its African American residents and a mostly white police force. But even at such times, many African Americans were in accord with the opinion of the poet and playwright LeRoi Jones (soon to be renamed Amiri Baraka) that "there are some of us who will not be Negroes, who know that indeed we are something else, something stronger...." Although this shift from the purportedly acquiescent "Negro" to the seemingly assertive "Black" was viewed by many older, more conservative African Americans with confusion, suspicion, and amusement, the younger and more outspoken members of the race saw the change as not only symbolic, but an emphatic proclamation of an oppressed people's psychological reorientation.

In the art world, this rejection of being "Negro" and the embracing of "Blackness" was embodied in the professional and aesthetic transitions of New York artist Romare Bearden. In 1963, after almost two decades of painting abstractions, Bearden joined forces with a group of other New York-based African American artists (who adopted the name "Spiral") to explore ways in which they could respond to the issues and needs of African Americans. In spite of the group's indifference to Bearden's proposal to collectively create a collage of cut and torn magazine images, Bearden took on the project himself and—in a stark departure from his totally abstract, stained and dripped paintings of the

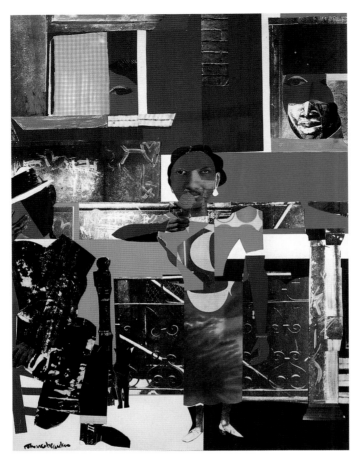

80 ROMARE BEARDEN
Summertime 1967

1950s and early 1960s—began assembling disparate bits from *Look*, *Life*, *Ebony*, and other photo-magazines into loosely-structured compositions on various "Negro" themes (the urban experience, the rural south, black music and musicians, African American spirituality, and so on).

When photographed and blown-up versions of these collages were first exhibited in 1964 (under the title "Projections"), critics responded enthusiastically, prompting Bearden to all but forget his previous life as an abstract painter and to embark upon a new career as a collagist, inspired by "the innerness of the Negro experience." In interviews Bearden resisted the critical tendency to align his collages with what Americans were seeing on television and reading in books and newspapers about "the Negro's struggle for civil rights," but the analogy took shape anyway

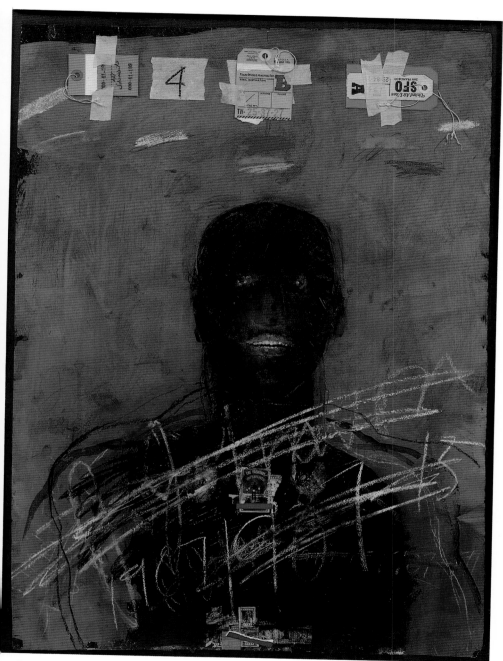

81 RAYMOND SAUNDERS *Jack Johnson* 1972

and often to Bearden's advantage. By the time many African Americans had espoused the tenets and rhetoric of "Black Power," works like Bearden's *Summertime* (1967) perfectly articulated the period's racial moods, swinging between a sentimental, four-part harmony about brownstone stoops and syrup-laden ice cones, and a tabloid-style exposé of an impoverished and potentially explosive black inner city.

80

In Paris, amid the political and intellectual furor triggered by the war in Vietnam, the anticolonial rumblings in Algeria, and the student revolts at the Sorbonne, African American sculptor Barbara Chase-Riboud also encountered an emerging black consciousness. Born in Philadelphia, trained at the Yale School of Art, widely traveled and a resident of Paris since the early 1960s, Chase-Riboud was perhaps the quintessential Sartrean "universalist." Yet her work of the early 1970s—bronze and aluminum castings of layered, semi-geometric forms, in combination with cascades of wool and silken cords, braids, and knotted ropes—subverted the art world's emphasis on a detached minimalism, and also undercut Sartre's theory of an in-process, but doomed, *Negritude*.

82

In sculptures like *Confessions for Myself* (1972), Chase-Riboud's black bronze and mane-like extensions of black wool appropriated the process-oriented "anti-form" strategies of artists like Eva Hesse and Robert Morris, but in a completely self-referential, introspective manner. Chase-Riboud's interjection of the autobiographical into this usually soulless mode of object-making, and her subtle yet unmistakable allusions to gender and race, strongly resonated with the then popular writings of Frantz Fanon. In Fanon's *Black Skin, White Masks* (1952; English translation, 1967), his declaration that he was "not the potentiality of something," but rather, wholly himself and the product of a universal, self-evident, black consciousness, bore comparison with Chase-Riboud's emphatic, resolutely "black" *Confessions for Myself.*

The San Francisco Bay artist Raymond Saunders, although sympathetic to individual quests for an alliance between the "artistic" and the "personal," had little or no tolerance for the misguided uses of race or ethnicity in the formulation, creation, and interpretation of art. In his self-published pamphlet, *Black is a Color* (c. 1968), Saunders lashed out at the "uptown critics" and "politico-sociologists" who, in this era of the heightened black conscience, burdened African American artists with civil rights battles, an eternal pessimism, and narrow inquiries that led nowhere. The pamphlet—with its vibrating, Op Art-like white letters on black pages—chided both the black nationalist and minimalist schools of thought with its clever word play on the conceptual—and thus, subjective—implications of the term "black."

82 BARBARA CHASE-RIBOUD
Confessions for Myself 1972

When Saunders, at the end of his essay, questioned the feasibility of rising above "racial-hang-ups" in order to "recognize the wider reality of art, *where color is the means and not the end*" (author's emphasis), one is still confronted with the question of what was the perceived role of color—specifically blackness—in the production of art? Was it purely political, a cultural presence, a chromatic affair, or (like Bearden's *Summertime*) subject to a multiplicity of meanings?

If one looks at Saunders's art, it was clear, in spite of his disdain for political and racial formulae, that "black," in addition to being a "color," was much more. Saunders's *Jack Johnson* (1972) was a portrait of the boxer 81

who became the first black heavyweight world champion in 1908, and was known for his flashy demeanor and life-long defiance of the white *status quo. Jack Johnson,* transcending conventional portraiture, represented Johnson as a black chimera, placed against a red backdrop and "identified" by airline luggage tags, crayon erasures, foreign stamps, and advertising labels. By insisting on the material nature of things and on the malleability of content, in *Jack Johnson* Saunders lifted blackness out of a purely political category, and deposited it within his "wider reality" of visual perception, racial illusion, and an improvisational space that put artistic risk-taking and process in the forefront.

The strategies for visualizing blackness that artists like Bearden, Chase-Riboud, and Saunders developed represented only three of the many approaches available to artists in the 1960s and '70s. The emphasis within the larger American society on the goals of the civil rights movement, the problems of the mostly black inner cities, and the historically under-

83 SAM
GILLIAM
*Lion's Rock
Arc* 1981

valued position of African Americans in mainstream life fueled a dramatic change in contemporary culture that, in conjunction with other societal shifts, made black peoples and their cultures pivotal. The relative affluence of the U.S.A. before the oil crisis, the ever-expanding and influential mass media, the burgeoning youth culture, political unrest, and a social atmosphere of moral leniency, formed a backdrop for the emergence and rise to prominence of a partially autonomous black culture. From African American dance crazes to African American inspired acts of political agitation, blackness became a cultural lightning rod that attracted controversy, commentary, and acclaim. Visual corollaries for these representations of black culture during the 1960s and '70s took the form of abstractions, artistic expressions of social and political realities, and testaments to the metaphysical aspects of blackness, and can also be seen in the documented careers and personal experiences of artists who persevered during these two decades of major social change.

82 In spite of the history surrounding Chase-Riboud's *Confessions for Myself*, the sculpture essentially remained an enigma: a mass of metal and fiber that challenged eye and mind with its mysterious, intractable form. By the mid-1960s, art audiences had resigned themselves to the realization that the main ingredient in abstract art was its obscure and elusive nature. Yet mystery did not denote senselessness. Any work of abstraction is a multileveled store of interpretative possibilities, accessible to anyone with attuned senses and a desire to respond to its labyrinthine character.

Although abstraction was perceived to be in an antithetical relationship to such issues as race and ethnicity, several artists in the 1960s and '70s experimented with forms of abstraction that, if not explicit in their aesthetic or ideological ties with social themes, were engaged in an implicit discourse about a black consciousness. The crux of this conceptualization was that the identity in question was not the monolithic, political notion of a black consciousness (most often represented through Social Realism and cultural nationalism) but, rather, one that could conceivably embrace a multiplicity of personae or states of blackness.

Alma Thomas and Sam Gilliam, for example, the two African American "members" of the renowned "Color School" of Washington, D.C., both painted brilliant, fractured abstractions in the second half of the 1960s. While conversant with the works of fellow Washington Color School artists (Gene Davis, Morris Louis, and Kenneth Noland), they also addressed, through rhythmic and high key color abstract painting techniques, the social aspirations of Washington D.C.'s African American middle class. Thomas was Howard University's first fine arts graduate in 1924 and, until her retirement in 1960, had been a teacher in D.C.'s public schools. She turned her back on an earlier representational style that, by the late '60s, would have been seen by D.C.'s art community as ideologically conservative. Instead, with the encouragement of the Washington colorist Jacob Kainen, she embraced an abstract style inspired by horticulture, scientific color theory, and music. Thomas's *Red*

84 *Azaleas Singing and Dancing Rock and Roll Music* (1976) proffered a literate and moderately expressive mode of abstraction that, skillfully negotiating the slippery pathways between nature and society, epitomized the integrationist mood of the times.

Sam Gilliam settled in D.C. in 1962 and, like Alma Thomas, taught in the District's public schools. By 1966 Gilliam had expanded his professional vistas, regularly exhibiting and experimenting with a

128

84 ALMA THOMAS *Red Azaleas Singing and Dancing Rock and Roll Music* 1976

painting technique involving acrylic stains and drips on folded and draped canvas. Viewing the figurative, explicitly race-conscious works of many African American artists as the products of an "aesthetic conservativism," Gilliam represented a perspective in this era of black consciousness that was rarely acknowledged: dissatisfaction with the reigning figurative or explicitly political black art *status quo* and the subsequent creation of an alternative. Like the revolt among avant-garde musicians and the proponents of "jazz fusion" during this same period, Gilliam's abstractions articulated the emotional and cerebral musings of an intelligentsia, black and white, as they rebelled against politically prescribed and aesthetically bound art conventions. Even in works as late as the 1981 triptych *Lion's Rock Arc*, Gilliam sought a redefinition of blackness that (through abrupt breaks in form and color contrasts visible through scored, impasto surfaces) was more evocative than a painted black figure or a cultural slogan.

83

Beyond experiments with color and pigment, implied gesture and movement dictated the direction of much abstract art during the early 1960s. Jagged, twisted forms in sculpture, or sweeping, flailed brush strokes in painting, reminded viewers of this work's aesthetic debt to the gestural paintings of the Abstract Expressionists of the 1950s. Yet, as a black consciousness grew more popular, two questions arose: (1) was there such a thing as a black gesture, or forms of expressive movement that could be classified under what Bearden had described as the "innerness of the Negro experience," and (2) if black gestures existed, how could one reconcile them with abstraction?

86 AL LOVING *Self-Portrait No. 23* 1986

Painters Hervé Télémaque and Emilio Cruz supplied answers to both questions. In Hervé Télémaque's *Othello No.1* (1960), his brushwork—frenetic, disjointed, and covering the whole surface—camouflaged an underpainting of cartoonish forms that, while not immediately seen as black, used heads, skulls, and the name of William Shakespeare's Moor as the potential components for a cultural meaning. Similarly, New Yorker Emilio Cruz's *The Dance* (1962)—with several loosely painted, racially non-specific figures in poses that evoked crouching, genuflecting, and choreographed movement—had links to an array of performative acts in the early 1960s, from the vogue for experimental theater and modern dance, to the fad for popular black dance steps like the African American "twist" and the Afro-Cuban "mambo." Both Télémaque and Cruz represented examples of gestural artists whose paintings, while profoundly psychological, included within their respective ranges of interpretation cultural aspects that provided oblique yet definite allusions to race. In contrast, the inheritors of this gestural tradition embraced these socially rooted tendencies in non-objective art with far less ambiguity or secrecy about their role in the creation of a race-conscious, rather than a

87

88

131

85 JOHN T. SCOTT. View of the Ruggles Street Station Installation, Boston, 1986

87 HERVÉ TÉLÉMAQUE *Othello No. 1* 1960

89
85　race-consumed, art. This can be seen in the works of artists like Sylvia Snowden, the Washington figurative expressionist, and John T. Scott, the New Orleans kinetic sculptor.

　　In a similar push towards a visual and cultural radicalism in abstraction beginning in the 1970s, Joe Overstreet combined painted geometries with stretched and tied expanses of canvas, while Al Loving assembled small, geometrically shaped pieces of painted canvas into larger, wall-mounted installations. These works—building on the experiments with non-rectangular paintings during the 1960s by Gilliam and Frank Stella —were a dramatic departure from these earlier reformulations, and were based on thematic and perceptual echoes of non-European prototypes, such as Native American tent structures for Overstreet, and West African masquerades and textile arts for Loving. Yet, for all their cultural refer-
90
86　ences, works like Overstreet's *Saint Expedite* (1971) and Loving's *Self-Portrait No. 23* (1986) maintained abstraction's mysterious, anti–illustrative position, much like the innovative writings during this period by novelist Ishmael Reed, or the "new black music" by jazz performers such as the Art Ensemble of Chicago.

132

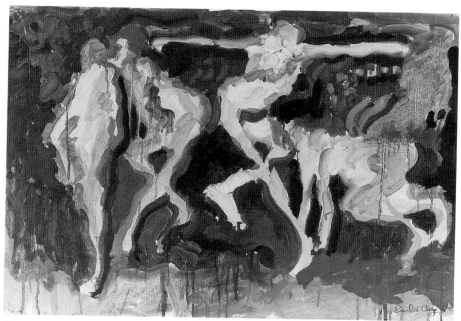

88 EMILIO CRUZ *The Dance* 1962

89 SYLVIA SNOWDEN *Mamie Harrington* 1985

90 JOE OVERSTREET *Saint Expedite* 1971, from the *Flight* series

91 EDWARD CLARK *Ife Rose* 1974

2 FRANK BOWLING *Night Journey* 1968–69

93 JACK WHITTEN
Dead Reckoning I 1980

What was perhaps most significant about these forays into abstraction by black painters, beginning in the mid-1960s and culminating in the 1970s was their sense of a shared language, especially in the face of popular, politically explicit art. Al Loving, reminiscing about those years, stated: "When we showed together at the Studio Museum in Harlem in the early 1970s we could see that we all had arrived at a kind of abstraction that emphasized materials.... We didn't talk about it, didn't write it down, but it was a common link and it was there." The "we" that Loving referred to—Gilliam, Overstreet, Frank Bowling, Edward Clark, Bill Hutson, Howardena Pindell, Jack Whitten, William T. Williams, and himself—were all black painters, exhibiting in New York, and (as Loving suggested) engaged in an intra-disciplinary dialogue with one another, whose aesthetic thesis (if not about blackness) was that abstraction had the breadth and ability to convey the moods, ideas, and strategies of all artists, but especially of black painters.

Edward Clark and Jack Whitten, two of the period's practitioners of non-figurative painting, employed techniques and compositional formats that, in addition to re-energizing an art of geometries and gestures, were influential in their circle of New York-based abstractionists. In the 1974 painting *Ife Rose* (named in part after the historic Nigerian city that Clark visited in 1973), the novel use of a pushbroom over an elliptical, horizon-like perimeter was a reminder that as early as 1957 Clark had

worked with large, sweeping passages over shaped canvases. In Jack
Whitten's *Dead Reckoning I* (1980), the artist reminded viewers that the
theoretical point in the cosmos where "it [is] no longer viable to turn
around and go back," was present in visual data ranging from technical
diagrams, to the concentric grooves from an "afro-comb."

When asked about the role of a black consciousness in his work,
Whitten replied:

> I can't define what is black in my work. I think it's not necessary that I
> have to define it as much as I should know that it's there....I'm black,
> and my sensibility derives from my being black. But I'm also dealing
> with art...on the highest universal level. And that's what I want to be
> known for. I want to maintain that search for what it means to be
> black, whatever it is....But at the same time, I must deal with this
> within the issues that have grown out of the history of art....

Whitten's acknowledgment of a black presence in his abstractions was
not only corroborated by the products of his fellow black abstractionists
in New York, but supported by the paintings of black abstractionists
living and working abroad. The Nigerian painter Uzo Egonu (a British
resident since 1945) launched an impressive series of colorful, abstract
pattern paintings in London in the mid-1960s. Works like Egonu's

94 UZO EGONU *Deserted Asylum* 1964

94 *Deserted Asylum* (1964)—curiously conversant with as well as alien to London's contemporary arts scene—emphasized the conscious and often effective insertion of a black cultural sensibility into such Western art protocols as painterly abstraction.

Besides Egonu and Aubrey Williams, the other leading proponent in England of this ideological merger was artist and critic Frank Bowling. Bowling, who was active during this period in both London and New York, stood in the forefront of painters working with a type of chro-
92 matic, cultural abstraction, as seen in the impressionistic *Night Journey* (1968–69). This and other paintings by Bowling dealing with geography, belonging, and the fluid, often transitory notions of pigmentation, catapulted this Guyanese-born, British-trained artist into wide recognition, but it was his critical essays that earned him special notice and, in many instances, discredit among advocates of an explicit black consciousness in art. In his Saunders-inspired essay, "Is Black Art About Color?"(1971), Bowling was perhaps at his bluntest, saying that "Were we not afraid...of being considered white, we would be truly black. We would be wholly black (this new entity) and tackle our 'instruments' and language the way the leading jazz musicians and writers do...." Apart from his analogy here between abstraction, free jazz, and experimental writing, Bowling claimed that a new form of racial and cultural authenticity could result from excavations of materials, methods, and the self. This assertion carried deep, though problematic implications, since identical claims were also made by the period's black cultural nationalists.

"CORRECTION: THE REVOLUTION *WILL* BE TELEVISED"

H. Marshall McLuhan's mid-century prediction of an increasingly influential and often intrusive mass media was proved right, and this influence on people's lives in fact extended far beyond expectations. For the first time, wars, disasters, political campaigns, major cultural figures, and social trends were surveyed by the Cyclopean eye of the press, and either affirmed or negated by radio, television, and the media's newest abitrator: the public opinion pollster.

Never before had activists in the civil rights movement received the kind of media scrutiny that they received after 1960. From the Reverend Martin Luther King Jr.'s latest act of civil disobedience, to Malcom X's most eloquent statement against racism, the coverage of America's social revolution was more pervasive and culturally instrumental than ever before. In the 1940s and '50s it would have been unthinkable for the

media to report regularly on the words and deeds of NAACP executive secretary Walter White or black labor leader A. Philip Randolph. However, by the 1960s it was almost taken for granted that, as well as seeing and hearing excerpts from the latest speeches by the Reverend King and Malcom X, James Baldwin's thoughts could be read in *Esquire*, Stokely Carmichael of the Student Non-Violent Coordinating Committee would be appearing on an evening talk show, and the opinions of African American intellectuals and political activists like Kenneth Clark, Bayard Rustin, Whitney Young, and others would be widely reviewed, analyzed, and discussed by the press.

Although African American-owned newspapers, magazines, and radio stations had always covered black issues, the 1960s (and its more entrepreneurial climate) ushered in a market-driven black press, with informational and cultural programming that was zealous in its race-based promotions. The African American media, often in concert with a powerful entertainment industry, supplied the news to "the community" (a popular euphemism for a fictitiously cohesive and monolithic black urban proletariat), as well as fostering a consumer culture of identities, goods, and services. Black pride and Black Power—at one time considered heretical ideas from the lunatic fringe—were now advocated in African American schools, churches, businesses, and media with the often combined goals of social freedom, economic gain, and self-affirmation. From the Afrocentric advertisements that plastered inner-city billboards in the U.S.A., to James Brown's declaration of cultural independence in his 1968 recording "Say It Loud, I'm Black and I'm Proud," black America's self-realization was just as much a marketing strategy as it was "the real thing."

Artistic responses to this media-saturated culture ranged from an empathy with the merging of art and society, to a suspicion of pop culture's infiltration into people's lives. When further compounded by the issue of race, these responses became even more complicated. For example, in Andy Warhol's *Race Riot* (1964) the widely reported police-dog attacks on black demonstrators in Birmingham, Alabama in 1963 were transformed into radar blip-like graphics, drained of all emotional impact and details. In contrast, Jeff Donaldson's handling of a racial confrontation in *Aunt Jemima and the Pillsbury Doughboy* (1963) interjected intense, opinionated sentiments on these racial clashes. Whereas Warhol rendered the scene via a detached photo-silkscreen transfer that obliterated specifics, Donaldson imposed on the image and incident a cast of ironic characterizations. Donaldson's self-defensive "Jemima," club-wielding "Doughboy," and swastika-like American flag contested

95

96

95 ANDY WARHOL
Race Riot 1964

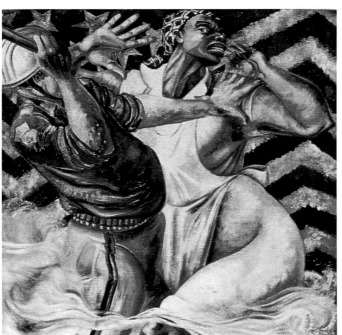

96 JEFF DONALDSON
*Aunt Jemima and the
Pillsbury Doughboy* 1963

Pop Art's love-hate relationship with American culture, while simultaneously making the African American struggle for civil rights a key component of it. Indeed, Donaldson's *The Civil Rights Yearbook* (1964)—a collection of satiric portraits drawn from an already commodified civil rights scene—continued this exploration of the movement's potential for appropriation and exploitation.

As Donaldson's book suggested, the media's power over the public's opinion on race was more than one-sided. Activists with public relations know-how frequently employed the media to promote their causes. In other instances, African American-related social issues conveyed enough universal appeal and human interest to attract many journalists, advertising agencies, and other media professionals to their cause. For example, when the U.S. Boxing Commission stripped Muhammad Ali of the world heavyweight championship title because of his refusal on religious grounds to join the U.S. armed forces and his opposition to the Vietnam war, the art director of *Esquire* magazine, George Lois, created a photomontage of a bound Ali, riddled with arrows and mock anguish, in the manner of Mantegna's *St. Sebastian*. Boxing legend Ali, a master at self-promotion and "spin control," used such media images to publicize his cause and ultimately to succeed in his legal battle, winning back his former championship title.

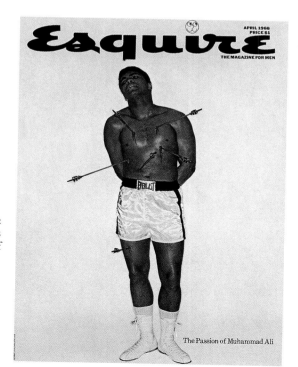

97 CARL FISCHER
AND GEORGE LOIS
"The Passion of
Muhammad Ali,"
cover of *Esquire*,
April 1968

98 With the 1971 release of the feature-length film *Sweet Sweetback's Baadasssss Song*, film producer, director, script writer, and featured actor Melvin Van Peebles provoked Hollywood into taking notice of a financially lucrative, African American market. Van Peebles's cinematic "song" about a gigolo-turned-political outlaw was one of the year's most profitable films, grossing over four million dollars despite a limited number of rentals nationwide. What was surprising was that the picture's eclectic mix of genres—action movie, *cinema verité*, erotica, and "art film"—with its African American and overwhelmingly bleak urban setting, defied Hollywood's traditional formulae for artistic and commercial success. Van Peebles knew that after the 1968 assassination of Martin Luther King, a rash of urban riots, and the all-too-common instances of bloody, often fatal confrontations between black activists and governmental authorities, many African Americans yearned for an escapist art that, as portrayed in his film, placed members of the black underclass in the role of unbridled, avenging anti-heroes.

Even when African American and other black diasporal tastes did not include Van Peebles's brazen images of a rebellious black underclass, the prevailing aesthetic called for other, equally distinctive, black visual markers. British fashion photographer Patrick Lichfield recorded one of the period's signifiers—a large, fluffy, combed-out, "Afro" hairstyle, worn by actor and model Marsha Hunt—for a 1969 issue of *Vogue*. African

98 MELVIN VAN PEEBLES
Sweet Sweetback's Baadasssss Song
1971

99 PATRICK LICHFIELD
Marsha Hunt 1969

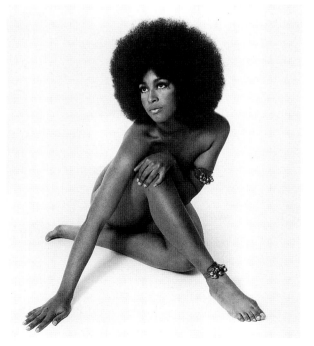

, But Clean 1972

101 ANTHONY BARBOZA, *Fadiouth, Senegal, West Africa*, 1972

American printmaker Lev Mills, also working in London, portrayed himself as a grid- and photoscopic-enveloped dandy in *I'm Funky, But*
100 *Clean* (1972). And New Yorker Anthony Barboza, in the "decisive moment" tradition of Henri Cartier-Bresson, captured the grace and
101 rhythmic possibilities of black bodies in *Fadiouth, Senegal, West Africa* (1972).

These media-influenced artists equated a "black" style with self-confidence, beauty that was the antithesis of white supremist models, and "power." In the use of an ontologically inverted, black colloquialism like "I'm Funky, But Clean," Lev Mills proclaimed a cultural difference and even an aesthetic advantage over those who not only lacked his particular fashion sense, but also those who, unlike him, were unable to communicate on both the vernacular and the standard levels. Although many blacks scoffed at the idea that a hairstyle, an attitude, or an alternative worldview could advance black people in the same way that political revolts had liberated oppressed peoples in the past, others believed that revolutions began with these metamorphoses of the self. The African Commune of Bad Relevant Artists, or AFRI-COBRA, was a Chicago-based

144

group of black artists (founded in 1969 by Jeff Donaldson and Wadsworth Jarrell) who hoped to facilitate this self-transformation. A humanist orientation, design sensibilities that used African prototypes as reference, agendas that fostered liberation and solidarity throughout the African diaspora, and an art of "expressive awesomeness" were the philosophical concepts that AFRI-COBRA promoted. Among the original members of this black nationalist artists' group were three women—Jae Jarrell, Barbara Jones-Hogu, and Carolyn Lawrence—whose art (while sometimes eclipsed in discussions about the works of AFRI-COBRA's mostly male members) frequently revealed a countertype to AFRI-COBRA's often patriarchal view of black culture. For example, textile artist Jae Jarrell's inventive work *Revolutionary Suit* (1970) most certainly 102 alluded to the aggressive position that black women could take in this revolution of the mind, body, and spirit.

102 JAE JARRELL,
Revolutionary Suit 1970

103 *I Like Olympia in Black Face* (1970), created by the white American artist Larry Rivers, was originally commissioned by the Menil Foundation for "Some American History": the artist's 1971 exhibition on "the black experience." Although the exhibition (which also included works by Joe Overstreet, Frank Bowling, and others) received mixed reviews, works like this *tableau vivant* burlesque of *Olympia* (Edouard Manet's scandal-provoking painting shown at the Paris Salon of 1865) marked a historic detour in black cultural representations in American art. Unlike Rivers's other works in the exhibition (which dealt with Africa, slavery, contemporary issues in race relations, and important black cultural figures), *I Like Olympia in Black Face* redressed the peripheral and often negative place of blacks in Western art history. While blacks were certainly not invisible to artists prior to 1970, their sympathetic representations in Western art were rare. Although Rivers's juxtaposition of Manet's *Olympia* with a "black" version (like Picasso's 1901 rendition of a black *Olympia*) smacked of a tongue-in-cheek witticism, it also fearlessly ventured into a forbidden territory of black erotica that very few artists in the U.S.A. had dared to enter.

Indeed very few American artists, black or white, concentrated on depicting black nudes prior to the 1970s. The exceptions included sculptor Richmond Barthé, painter Eldzier Cortor, and photographers F. Holland Day and Carl Van Vechten. Beyond the larger societal restrictions under which American artists had long operated (even when confronting the nude's widely accepted position in classical and Western art), the reactionary values of many African Americans prevented artists from depicting blacks in ways that departed from the conservative or social-realistic. This self-censorship emanated from artists who worked within black communities, as well as from artistic "outsiders," who feared that if they created sexually provocative images of blacks they would be perceived as racists or pornographers. All these factors, along with a history of assumptions by social scientists about pathology and moral depravity in black communities, discouraged artists from creating images that would have supplied visual fodder for these pernicious views. Not until the late 1960s—with the onslaught of a sexual and social revolution—would a few artists and select audiences feel comfortable enough to explore the formal and psychological implications of black nudes in art.

Of course, the artistic process of removing a human subject's clothing and focusing on his or her essentially biological, naked self, interjected a

103 LARRY RIVERS *I Like Olympia in Black Face* 1970

close and discomfiting element of objectification into representation.
When this disrobing, deindividualizing, and sexualizing was imposed on
black subjects (who were already susceptible to erasures of personhood),
the visual results—even in a seemingly innocuous image like Lichfield's
nude photograph of *Vogue* model Marsha Hunt—often meant that the 99
individual was presented as both artifact and sexual object.
 For figurative artists whose aesthetics were shaped by the period's
various black nationalist ideologies, the nude embodied a multiplicity of
themes, ideas, and meanings. And, depending on whether the nude was a
black male or a black female, these same themes, ideas, and meanings
often carried additional and, at times, conflicting messages. In the works
of painter Murry N. DePillars (who, with poet Gwendolyn Brooks,
editor Hoyt Fuller, and jazz musician Muhal Richard Abrams, helped
shape Chicago's vibrant black arts scene in the late 1960s), images of
black women fused traditional "feminine" qualities with the themes
of omnipotence and physical potentiality. DePillars's *Queen Candace* 104

104 MURRY N. DEPILLARS
Queen Candace 1989

105 FAITH RINGGOLD *Fight to Save your Life* 1972, from the *Slave Rape* series

(1989), produced after his initial Chicago period and under the utopian tenets of AFRI-COBRA, bespoke royalty and placed colorful, African-style designs on the silhouetted, pregnant, and virtually nude body of a black woman.

105 From the vantage point of New Yorker Faith Ringgold and her multi-paneled *Slave Rape* series (1972), the black female nude also conveyed multiple messages, concerning her union with and sanctuary in nature, as well as resistance and self-defense. Ringgold's visual black nationalism—prescribed by a feminist stance that constantly negotiated between a personal identity and a political one—was in accord with Dana C.

106 Chandler's similarly conceptualized approach in his *Genocide* series (1971). This Boston-based artist created his nude with the Black Power movement's anxieties about sexual emasculation and political violation uppermost in his mind, as seen in his *agitprop* image of a jailed, chained, yet defiantly erect, black penis. Despite the gendered demarcations here between the black female nude as an object of desire and the black male

nude as an objectified desirer, in both works nakedness and the specter of sexuality become icons of fear, imprisonment, and dislocation.

Ideologically placed between Rivers's art-historical commentary on *Olympia,* and DePillars, Ringgold, and Chandler's politically charged images of black naked bodies were the African American nudes of the Philadelphia-born, Connecticut-based painter Barkley L. Hendricks. His portraits of the 1970s—black, beautiful, and suave—stood apart from the majority of black cultural representations produced during this period. The jarring combination of a droll, self-effacing humor with an unnerving naturalism that bordered on the profane was Hendricks's artistic trademark: a characteristic that even in a work like *Brilliantly Endowed* 111 *(Self-Portrait)* of 1977 dominated the artist's dual discourse on blackness and masculinity. With an attitude that recalled Albrecht Dürer's nude *Self-Portrait* of *c.* 1518, Hendricks's *Brilliantly Endowed (Self Portrait)* examined the myths of artistic greatness and black male sexual prowess, but within the context of his study of an African American *élan*—an investigation which informed his whole career as an artist.

Photographic studies of the black nude during this same period were often dismissed as pornographic, although they were capable of being as innovative and thematically complex as their painted counterparts. For example, in Adger Cowan's surrealistic *P.B.* (1974), his allusions 107 to the folklore surrounding black steatopygia—here isolated and symmetrically viewed—introduced an ethnographic element into this particular work. In Robert Mapplethorpe's *Alistair Butler* (1980), the artist 108

106 DANA C. CHANDLER JR. *American Penal System... Pan-African Concentration Camps and Death Houses* 1971, from the *Genocide* series

107 ADGER COWANS
P.B. 1974

108 ROBERT
MAPPLETHORPE
Alistair Butler 1980

likened a homoerotic gaze on the black male body to the art of antiquity. In both, the black body as a photographed object of desire, while unquestionably nuanced, elicited what author Alice Walker pronounced in her novel *Meridian* (1976) as the ultimate sin: the turning of real, thinking and feeling people into Art. Yet one could also argue that, at this moment of an expanded black consciousness, it was precisely this sense that blacks could be both objects of artistic contemplation and actors in their own aesthetic discernment, that made these works provocative and central to a revised art history of transgressive, radical black images.

CONJURE

If the 1960s was the decade when a new black cultural consciousness came into existence, then the period of the 1970s and early 1980s with its milieu of black art institutionalization was certainly its watershed. Through a number of catalysts—including the loud petitions for artistic equity, the Smithsonian Institution's acquisition of works by black artists from the recently closed Harmon Foundation, a series of "all-black" art exhibitions at mainstream institutions, and the creation and expansion of the National Endowment for the Arts—African American artists, their works, and a loosely defined black aesthetic were focal points in the contemporary arts scene.

In addition to the reprinting of earlier art history "classics" by Locke, Porter, and Cedric Dover (the Anglo-Indian sociologist and author of the 1960 book *American Negro Art*), the 1970s ushered in a plethora of new "black art" publications, such as Samella Lewis and Ruth Waddy's *Black Artists on Art* (1969, 1971), Elton Fax's *Seventeen Black Artists* (1971), Romare Bearden and Harry Henderson's *Six Black Masters of American Art* (1972), Elsa Honig Fine's *The Afro-American Artist* (1973) and Samella Lewis's journal *Black Art: An International Quarterly*. These publications, with the catalogues and reviews that accompanied the flurry of solo and group exhibitions by African American artists, documented the earlier contributions of black artists, as well as the principal figures and icons of a concurrent black arts scene. Artist and curator David C. Driskell's accumulative achievement—the corporate-sponsored exhibition and publication *Two Centuries of Black American Art* (1976)—signaled a dramatic shift in the mainstream art world. This change in perception acknowledged not only individual black talent, but the idea of a collective artistic genius based on race, history, and a creative drive whose source was a spirituality that, in turn, sprang from the phenomenon of cultural connections throughout the African diaspora.

109 BILL GUNN
Ganja and Hess 1973

In 1973, filmmaker Bill Gunn attempted to visualize this spiritual,
black essence in *Ganja and Hess*: his updated, African American version
of the Hollywood vampire movie. But rather than depicting supernatural
metamorphoses and horrific, murderous acts, Gunn, through the rituals
and habits of sex, drug addiction, and religion, explored symbiosis and
possession in Afro-America. At the same time, Betye Saar, a Los Angeles-
based artist, was continuing to create her memory and spirit-conjuring
assemblages made from discarded bric-a-brac, family mementos, and
other ephemera. As representative of a different school of artists who
were plunging into a previously unexamined African American psyche,
Saar regarded works like her own *The Time Inbetween* (1974) in spiritual
and trans-racial terms, rather than in a purely secular or "black" way.
In sharp contrast to the black nationalist references of activist Ron
Karenga or the members of AFRI-COBRA, a group of artists emerged in
the 1970s who, while conversant with the current discourse on black
consciousness, devoted themselves to an art of symbolic accretions and
altar-like settings, whose inspiration was just as likely to come from Latin
American art, California Funk, or so-called folk arts, as from a traditional
African or African American source.

With this emphasis on a blackness that was metaphysical and that
derived its form not from painted or sculpted black humanity but, rather,
from a marshaling of symbolic or conceptual strategies in visual commu-
nication, Betye Saar, with fellow Los Angeles artists Houston Conwill,

109

110

110 BETYE SAAR
The Time Inbetween
1974

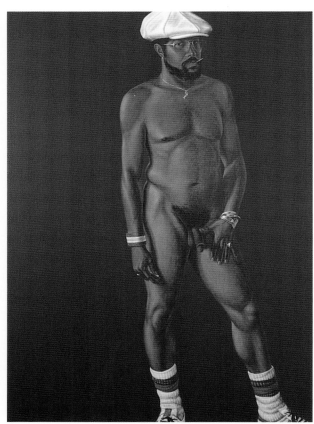

111 BARKLEY L. HENDRICKS
Brilliantly Endowed
(Self-Portrait) 1977

112 DAWOUD BEY, David Hammons constructing *Higher Goals* in Cadman Plaza, Brooklyn, New York, 1986

David Hammons, Senga Nengudi, John Outterbridge, and Noah Purifoy, gradually began to redefine "black consciousness" in art. Of particular importance to this revisionist impulse was the work of David Hammons. Beginning with his "body prints" of the early 1970s, Hammons contested conventional black representations with works and performances that delved deeply into race, culture, class, and commodification in America. With his move to New York City in the mid-1970s, and his affiliation with the Just Above Midtown Gallery, Hammons established himself as a major presence in New York, creating installations with African American hair, food, and detritus, and producing outdoor environmental works that invoked black cultural metaphors that were often ironic, but with lyricism and empathy.

Although considered an imitator of the European avant-garde by critics sympathetic to black nationalist views, Hammons's utilization of materials and things that were once in direct, physical contact with black people (such as hair, foods, bottles) strongly resonated with similar artistic practices and religious beliefs among West and Central African peoples. Thus, as a creator of "African American power objects," Hammons inadvertently joined his more conservative black colleagues in their quest to recreate an African sensibility in American art. What made this artistic identification with Africa different from, say, the visual appropriations by artists aligned with the "New Negro" arts movement was, first, the

113 FRANCIS GRIFFITH *Untitled c. 1963–95*

timing of this aesthetic embrace with the era of colonial dismantlement and African independence, and second, a greater knowledge in Europe and the Americas of African peoples, cultures, and geography.

Beginning in the 1950s with the African American painter John Biggers and his "discovery" of a modernist impulse in West African art, European and American artists throughout the '60s and '70s went to Africa, reimagining the continent and reconceptualizing their work along the way. The idea that Africa was a cultural utopia and mecca (as visualized in a *c.* 1963–95 painting by the Barbadian artist Francis Griffith) was often put forward during this period by Jamaican and other English-speaking Caribbean intellectuals with a historic memory of Marcus Garvey and his "Back to Africa" movement. These millennial ideas, in conjunction with the myths and imagery surrounding the Ethiopian Emperor Haile Selassie and his symbolic stewardship of the black race, led to the rise in Jamaica of the Rastafarian movement, and its attendant black nationalist influence on Caribbean politics and art. 113

Among the many African American artists who experienced similar esoteric revelations as a result of their encounters with Africa were Elton Fax, Tom Feelings and, remarkably, James Lesesne Wells and Lois Mailou Jones: two sexagenarians and original participants in the "New Negro" arts movement of some forty years earlier. Following her tour of Africa in 1970, Jones embarked on a two-dimensional, brilliantly colored painting

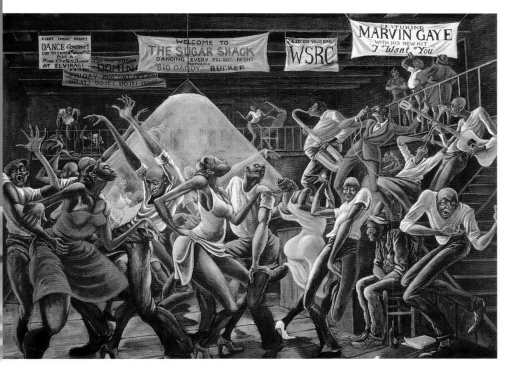

115 ERNIE BARNES *The Sugar Shack* 1972–76

style that (as seen in her 1971 *Magic of Nigeria*) aligned itself with the 114
African pattern paintings of AFRI-COBRA artists like Jeff Donaldson.
Donaldson, chairman of the U.S. delegation for the Second World Black
and African Festival of Arts and Culture in 1977, led his African American
emissaries to FESTAC's Nigerian headquarters with the conviction that,
unlike the largely white-administered U.S. delegation for the First World
Festival of Negro Arts in 1966 (held in Dakar, Senegal), FESTAC was going
to be a Black- and African-directed artistic undertaking.

Although FESTAC presented visual arts, theatrical performances, and
literary readings by black artists from all over the world, music drew the
Festival's disparate black peoples together more than any of the other
featured art forms. For example, what other medium at FESTAC had the
distinction of having assembled, in perfect artistic equality, the diverse
sensibilities of a battery of Yoruba talking drums, Trinidadian steel bands,
Cuban *conjuntos*, Brazilian *afoxé*, and such musical talents as Stevie
Wonder, Miriam Makeba, Osibisa, and Sun Ra's Intergalactic Arkestra?

157

116 ARCHIE RAND *The Groups* 1970

117 SISTER GERTRUDE MORGAN *Come in my Room, Come on in the Prayer Room c.* 1970

That the world's various black musics had an allure that crossed the boundaries of culture, nationality, and racial identity was something that many visual artists knew and attempted to recreate. In addition to the rhythmic abstractions and music-themed works of a whole range of artists in the 1970s, the Brooklyn painter Archie Rand summoned the performing energies of assorted African American–influenced singers in his series entitled *The Groups*. In a 1970 painting from this series (with the same name), Rand's hand-rendered, marquee-like invocation of various rock-and-roll singers was both a homage to African American popular music and a witty rejoinder to the period's reigning Art & Language conceptualists.

Black music and art also found a common space to inhabit in the record industry's innovative packaging of long-playing albums during

this period. Of special note was Columbia Records' eye-catching reproductions of the *Aleph Sanctuary* murals by artist Abdul Mati Klarwein for selected album covers of recordings by Carlos Santana, Jimi Hendrix, and Miles Davis. But even more popular than Klarwein's hallucinatory album covers was the football player-turned-artist Ernie Barnes's "Neo-Mannerist" treatment of ecstatic black dancers on the cover of singer Marvin Gaye's 1976 album, *I Want You*. If ever African American images coincided with African American sounds, then Barnes's *The Sugar Shack* 115
was the visual equivalent to Gaye's percussive, multilayered dance tracks.

This desire to visualize something racial and cultural, yet also conceptual and metaphysical, found the ideal subject in black religion. In New Orleans, the street evangelist and artist Sister Gertrude Morgan transformed her humble living quarters into a space for meditation and spiritual union by painting the walls, floors, and all her furnishings white. In *Come in my Room, Come on in the Prayer Room* (*c.* 1970) Sister Morgan 117
portrayed herself within her literally white yet figuratively black and sanctified Everlasting Gospel Mission, surrounded by white angels, interracial groups of people tending to the sick and the children, and (on the right) her own painting of the all-seeing "Eye of God." The Divine Eye, identified by Sister Morgan as "the unseen host at every meal," also appeared at this time in several works by the Jamaican artist Brother Everald Brown. Like Sister Morgan, Brother Brown's religion— Rastafarianism and the Ethiopian Orthodox Church—shaped his entire cultural sphere, turning his self-built home in the hills of St. Ann Parish and even his hand-made musical instruments like *Dove Harp* (1977) into 118
media for visual and spiritual fulfillment.

118 EVERALD BROWN *Dove Harp* 1977

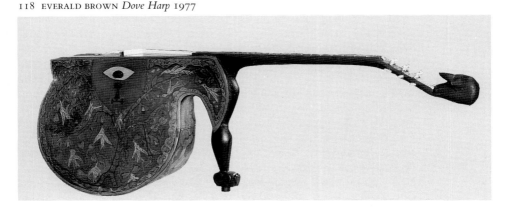

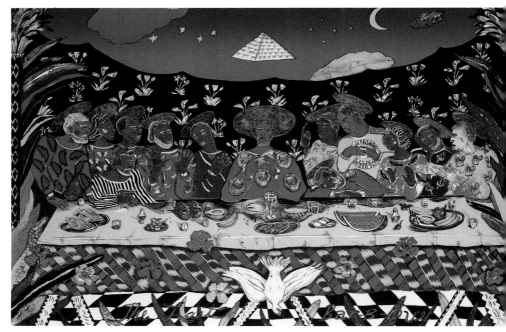

119 MARGO HUMPHREY *The Last Bar-B-Que* 1988–89

With these black visionaries as a source of inspiration, printmaker Margo Humphrey transformed one of Christianity's most venerated scenes—Jesus's last supper with his disciples—into a post-nationalist statement on community and syncretism. Like much of her work since the mid-1970s, *The Last Bar-B-Que* (1988–89) framed blackness within an absurdist, yet penetrating and heartfelt view that ultimately reinvigorated and redeemed an often restrictive black nationalism. Humphrey's consciously naive treatment of this motley crew of disciples and their final feast of barbecued chicken, watermelons, and the standard liturgical fare perfectly represented what cultural critic Greg Tate described as "the impulse towards enmeshing self-criticism and celebration" found in the works of the more provocative black artists of the period. Moving beyond questions of nomenclature and vaulting beyond the choice between making either "abstractions" or "black figures," Humphrey and her cohorts set sail on uncharted waters that were perhaps more choppy and heterogeneous than any that had come before. And like the decorative façades that permeated *The Last Bar-B-Que*, representations of black culture in the future were likely to be placed against the contrasting rigs of the shifting racial paradigms of this period.

119

160

Culture as Currency

BEYOND SCARIFICATION

Lyle Ashton Harris's exhibition in the fall of 1994 of large format Polaroids, "The Good Life," received a remarkably wide coverage for a young artist presenting his first solo show in New York. In response to his self-portraits, one reviewer concluded that his work was "a rich and probing photographic autobiography" that stressed "issues of racial, gender, and sexual marginalization." Commenting on the other works in "The Good Life"—staged and impromptu photographs of family members and friends—another writer observed that Harris's photographic rejoicing and dominion over his subjects made him the "goad," "provocateur," and "locus of emotional catharsis" in these works.

What neither reviewer noted about "The Good Life" was Harris's complete subversion of various notions of identity—gender, sexual, and familial—which, ironically, caused another indicator of identity—blackness—to twist, snake, and splice itself into a complex yet irreducible ingredient. For many viewers, the anonymity of the person with scarifications, dreadlocked hair, and black nationalist tricolors in Harris's *For Cleopatra* (1994) confounded their basic assumptions about gender and beauty: an unease for which, surprisingly, blackness was a consoling presence. But instead of a 1960s or '70s styled blackness with raised fists and neo-African figures, Harris's blackness was soft, ambiguous, mercurial, non-exclusionary, and completely unencumbered by racial doctrine or social conventions.

"Fertile Ground," Alison Saar's 1993–94 traveling exhibition, also presented protean concepts. In this collection of carved wooden figures, organic matter, and other manufactured and environmental elements, Saar attempted to give three-dimensional form and allegorical meaning to a southern U.S. landscape. This ambition of Saar's—to create certain moods, emotions, and states of consciousness in her work—not only resonated with her family's long involvement in the visual arts and spiritual dimensions of objects, but with her own, acquired knowledge of non-Western religions, world art, and social history.

120

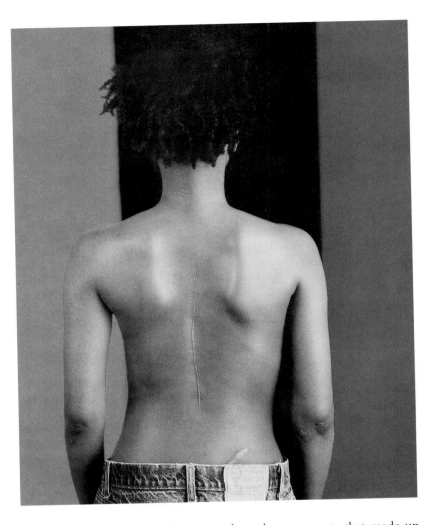

121 *Terra Rosa* (1993), one of seven sculptural components that made up
the "Fertile Ground" installation, reflected Saar's intellectual complexity
as much as it communicated her installation's multifaceted theme. As
described by "Fertile Ground" curator Susan Krane, "The pregnant *Terra
Rosa* consumes and is consumed by the soil—by red earth endowed with
spiritual powers, as is cemetery earth throughout the African American
South." This figure's attitude of charity and supplication moved freely
between German Expressionist *angst*, Roman Catholic *pietas*, and
Kongo/Angolan *kiyaala-mooko* ("she who holds out hands"), defying

single interpretations, just as Saar's focus on the products and impact of an African diasporic culture has resisted glib categorization.

The embracing of an artistic and intellectual plurality took other forms beyond Harris's multivocal portraiture and Saar's installations. The sculptor Martin Puryear engaged both three-dimensional form and suggested meaning while still maintaining a sense of artistic and thematic unity in his work. In *His Eminence* (1993–95), the sculpture's solitary grandeur and anthropomorphic presence are matched by journeyman-like sawing, assembling, joining, bending, shaping, and finishing: lessons learned among the artists and craftsmen of West Africa, Northern Europe, the Far East, and the U.S.A. Recalling the spatial witticisms of Brancusi and the monolithic sculptures of prehistory, *His Eminence* also conjures an icon that is distinctly American: akin to John Henry, Casey Jones, Stagger Lee, and a host of other mythological, strong, and enigmatic male personas.

Gary Simmons also employed vestiges of mythological figures in his work, but with irony and a legacy of racial misapprehension. From his

123

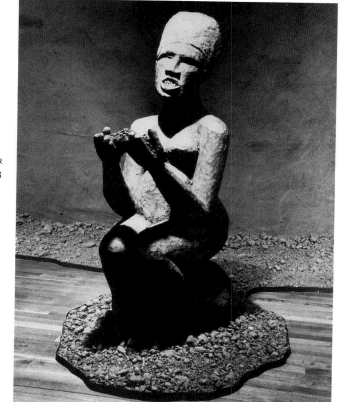

120 LYLE ASHTON HARRIS
For Cleopatra 1994

121 ALISON SAAR
Terra Rosa 1993

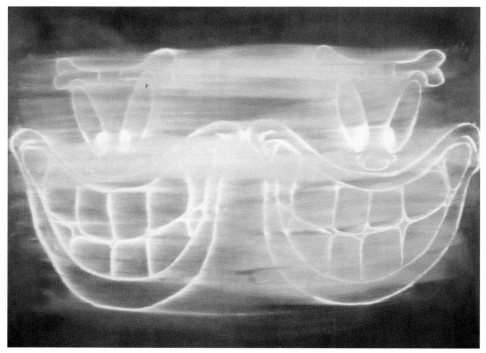

122 GARY SIMMONS *Black Chalkboard* 1993, from the *Erasure* series

large-scale drawings, diagrammatic images of footprints and blurred gestures, to the more intimate works from his *Erasure* series, Simmons drew on a whole archive of stereotypes. His fleeting images of the tap-dancing, shuffling, and grinning actions of clowns, athletes, and other black entertainers turned the watching of black performance into a multifaceted act of admiration, revulsion, and complicity.

These late twentieth-century artists and their responses to culture and identity emerged at an odd moment in history. While the 1980s and '90s were a time of expanding opportunities, greater global awareness, and increasing public access to visual art, this period also saw cultural conservativism, a less enthusiastic support for the arts, *de facto* censorship, and an unstable art market.

Practitioners and supporters of black culture also experienced highs and lows during this period. In the U.S.A., the Civil Rights Act of 1965 and subsequent federal legislation for a more racially diverse workplace and educational system meant that African Americans entered into social, political, and economic arenas with a new-found confidence.

164

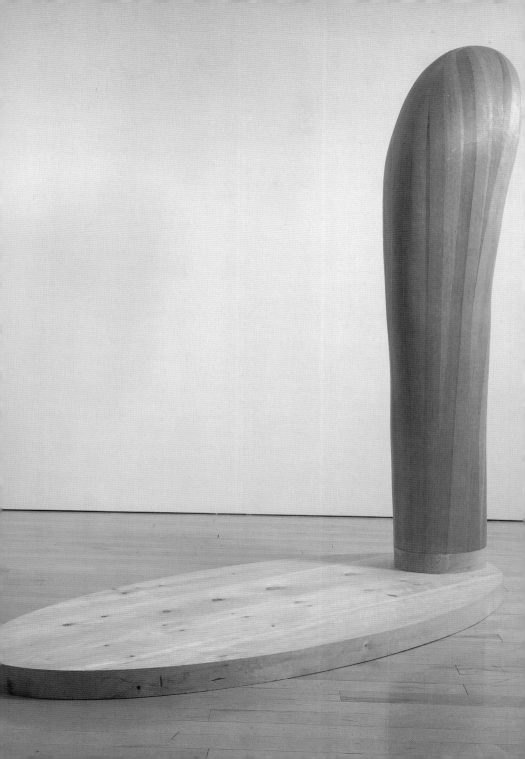

Correspondingly, a black middle class grew and asserted itself in the economy. The black nationalist politics of the previous decades were transformed into a less authoritative philosophy, creating a renewed sense of black solidarity. The U.K. experienced its own black "renaissance" as seen in an outpouring of literary works, art exhibitions, and mass media products on the subject of a black cultural identity. Finally, the dismantling of *apartheid* in South Africa and the ascent of the political activist Nelson Mandela were universal symbols of an acceptance of black self-determination and social justice.

In contrast to these milestones of progress, black culture during this period also suffered disillusionment, dislocation, and a moral vacuum. In spite of the growth of a black middle class, Americans in the '80s and '90s encountered even larger numbers of the black poor, unemployed, and homeless. The unfortunate reality in the success story of black America's new-found purchasing power was the collapse of inner cities and the subsequent demise of small, historically black businesses and social institutions. This black hopelessness—unimaginable in those heady years of the '60s and '70s—manifested itself in incidents ranging from drug-related acts of violence in countless African American communities, to the spiritual "deaths" and territorial violence that plagued the peoples of Haiti, Liberia, Somalia, Rwanda, and other centers of political unrest.

For visual artists, these conflicting signs—both within and beyond black culture—often resulted in analytic (though not always dispassionate) investigations in their work. For example, in Gary Simmons's drawings of racist caricatures and the telltale traces of black humanity, a major part of his cross-examination was the dismantling of black objectivity and (in Simmons's own words) the revealing of its structural "blue-print." In this way, many late twentieth-century artists took their work beyond the racial and cultural "scarification" that identified previous generations and, instead of these "tribal markings," employed a multiplicity of conceptual mechanisms: analyzing socially rooted emblems, questioning traditional concepts of identity, utilizing testimony and scripted narrative, and, in general, dealing with culture and history as artistic currency.

Because of an omnipresent racial dimension in the works of these artists and others working with similar concepts, these postmodernist activities are seen as different. This ideological aligning of artworks with black history and culture—as seen in Harris's intimations of the slave master's lash in *For Cleopatra*, or Saar's allegories on race and nature in *Terra Rosa*, or even Puryear's allusions to the totemic potential of the abstract in *His Eminence*—has converted postmodernism into a far more

lineage-conscious and, therefore, intriguing approach. The role of black culture in this period of ruin and reconfiguration has been to divest art of its current despair and create in its place a new optimism, an alternative worldview, and an unparalleled critical stance.

ICONS AND SIGNS

Like the allusions to a portentous sign in the old African American spiritual "Handwriting on the Wall," the graffiti that began to cover virtually everything in New York City in the late 1970s prophesied a sociological shift in this urban landscape, from an environment of suppressed disorder, to an atmosphere of virtual chaos and decline. But rather than being emblematic merely of society's ills, these ink marker scrawls and spray paint "tags"—produced mostly by Latino and African American youth—transmitted information, such as neighborhood boundaries, social rankings, artistic *noms de plume*, and even creativity itself.

One of the participants in this writing of names and claims, the African American painter Jean-Michel Basquiat, went through a rapid rise and fall in this period. Beginning with his 1980 debut in a widely reviewed group exhibition (held in a vacant building in New York City's Time Square district), Basquiat and his works were soon incorporated into the larger New York art scene, and then internationally celebrated, marketed, and imitated. During his relatively brief career and after his premature death in 1988, Basquiat's paintings were dismissed by some critics as having been promoted undeservedly by art dealers in the U.S.A. and Europe who knew how to play the media, but their collective energy and, in many cases, their explorations of an African American psyche, entitle them to serious study. A frequent motif in Basquiat's work—the "see-through" man—not only responded metaphorically to this period's fascination with exposé and destroying people's façades, but also spoke to the notion that anatomy had a theatrical quality that, when paired with blackness, was a radical attack on society's superficiality and deep-seated racism. The exposed lungs, sinew, and guts in Basquiat's *Flexible* (1984) convey this notion of the black-body-as-public-theater, 124 while the entire piece recalls a white-washed wooden barrier, fit to be covered with urban hieroglyphs and prophetic black imagery.

Basquiat's invocations of blackness appeared both independently and correspondingly in the works of other artists, especially those who, like Basquiat, reacted to the cultural politics of race and racism during this period. For example, in the London-based painter Tam Joseph's *Learning* 126 *to Walk* (1988), action verbs and historically charged pictographs joined

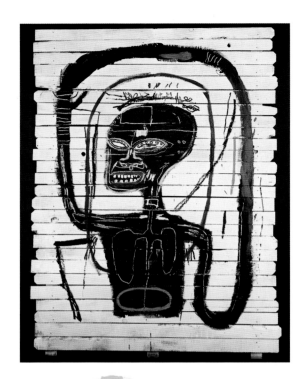

124 JEAN–MICHEL BASQUIAT
Flexible 1984

125 OUATTARA
Hip-Hop Jazz Makoussa 1994

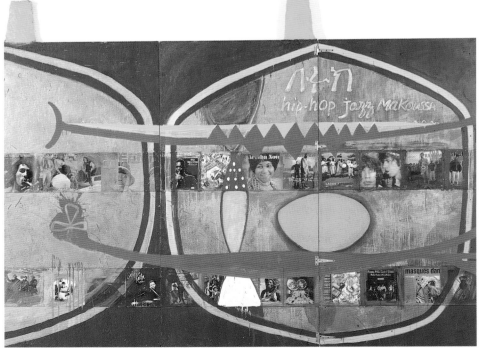

126 TAM JOSEPH *Learning to Walk* 1988

forces in a visual discourse about evolutionary, revolutionary, and personal advancement. In his *Hip Hop Jazz Makoussa* (1994) the Côte d'Ivoire painter Ouattara symbolically hinged together ancient and modern motifs from Africa with collaged friezes of album covers for jazz, reggae, rock, rap, and traditional ethnic music. In this way he communicated his adherence to a multilingual, though commonly valued, spirituality from his native West Africa. The paintings of the Barbadian artist Ras Ishi Butcher joined his personal iconographies of slavery and rebellion in the West Indies with chromatic, heavily-textured surfaces (present, for example, in his 1995 *400 Years New World Order*) which gave his Basquiat brand of cultural analysis an international countenance.

Beyond the generic symbols of blackness, Butcher incorporated into his compositions large anecdotal figures, whose presence made a socio-political statement about human agency and cultural intervention. Butcher, Basquiat, and other iconographers used black subjects (and sometimes actual figures) to revisit the cultural nationalist's goals of recognizing and celebrating distinctiveness, but with a postmodern difference. For example, in the assemblages by the Chicago artist Mr. Imagination (formerly Gregory Warmack), the artist's humble, bricolage-like use of discarded paintbrushes and bottle caps deflated their allusions to royal effigies and finery.

The Guyanese painter Philip Moore also displayed a visual atavism and reformulation of black consciousness in his work. *King Sparrow in Sacred*

125

127

128

169

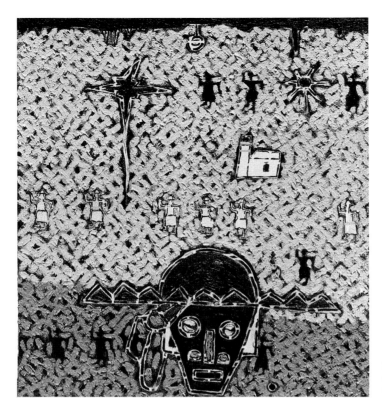

127 RAS ISHI BUTCHER
*400 Years New World
Order* 1995

129 *Wonder Heart* (1992)—Moore's "portrait" of the legendary West Indian
calypso singer "the Mighty Sparrow"—replaced the naturalistic depic-
tions of this cultural icon with a radiant, gestural, and pigment-laden
image. By the 1990s, Moore believed that blacks needed "to reinterpret
the Myths and Legends of life" which were imposed on them by whites;
in addition, they had to be "bold enough to recreate [their] destinies" by
assuming control over the processes of analysis and performance. As
shown in *King Sparrow in Sacred Wonder Heart*, Moore's neo-nationalist
call embraced experimentation, improvisation, and the opening of one's
work as the conduit through which a spiritual rollcall of black culture
could flow.

 The tenacity of an aesthetic that dealt with old and new icons, and
also recognized the inspiration in artistic media and human experience
made both cultural nationalism and postmodernism less demanding and
divisive. This revisionist spirit reigned supreme in Martha Jackson-Jarvis's
130,131 *Last Rites: Sarcophagi II (Earth)* (1992–93) and Melvin Edwards's *Tambo*

128 MR. IMAGINATION *Portrait Head Paintbrush Tree* 1991

129 PHILIP MOORE *King Sparrow in Sacred Wonder Heart* 1992

130 MARTHA JACKSON-JARVIS
Last Rites: Sarcophagi II (Earth) 1992–93

131 MELVIN EDWARDS
Tambo 1993

(1993), resulting in two highly idiosyncratic art objects that responded to several late twentieth-century theoretical concerns. Jarvis's rococo, ceramic reinterpretation of an ancient Greek form introduced a theatrical, festive and, therefore, black diasporal way of thinking about death. And Edwards's platter-like assembly of welded hardware and industrial parts—named after the late South African political activist Oliver Tambo, and closely related to other assemblages from Edwards's *Lynch Fragment* series—imposed a specific historical and political meaning on to this object's material reality.

NO PLACE / LIKE HOME

The concept of home figured prominently among the many cultural icons that artists explored toward the end of the twentieth century. But rather than a definition of home as an inviting and cozy domicile, or even as a figurative place of rest and comfort, home often took on an ironic character, having just as much to do with disconnectedness and annexation as with a sense of belonging in the world. No doubt the more visible presence of the urban homeless during this period, as well as the increased numbers of refugees internationally, forever shattered the image of the universal hearth. Whereas in previous times, black artists often waxed nostalgic about "the old homestead," "the community," or "the motherland," by the 1980s and '90s a more sober and perhaps cynical view of "the hood" had entered into black cultural discourse, with multiple views of place and position emerging in literary works, visual arts, and popular culture. In her novel *The Bluest Eye* (1970), Toni Morrison deftly anticipated this fascination and dread in late twentieth-century black culture in having a home, as well as being homeless, describing the latter (being "put outdoors") as "the end of something, an irrevocable, physical fact, defining and complementing our metaphysical condition."

As an extension of this theme—and as part of a postmodernist rejection of conventional art practices—many artists in the '80s and '90s created installations: object-, image-, and concept-laden environments, manufactured either within the art gallery proper or in the world, with the intention (wrote Museum of Modern Art curator Robert Storr in 1991) of displacing, disorientating, re-placing, and re-orientating. Even when these inquiries into place and position were confined to just the art world and its inner sanctum of objects, galleries, curators, and audiences, there was a similar sense of domestic and familial disjuncture (as described in the passage from Morrison's *The Bluest Eye*).

132 LORNA SIMPSON *Five Rooms* (detail of Room One). View of installation at
Spoleto Festival U.S.A., Charleston, South Carolina, 1991

New York artist Lorna Simpson in collaboration with actor, singer,
and composer Alva Rogers created such an installation in Charleston,
South Carolina, for the "Places With A Past" exhibition for the 1991
Spoleto Festival U.S.A. In a vacant outbuilding of *c.* 1822 next to the
Governor Thomas Bennett House, Simpson used Charleston's impor-
tance in the infamous transatlantic slave trade to explore "those things
that connect you to your identity and those things (violence) that happen
to you because of your identity." In Room One of the *Five Rooms*, she
displayed dozens of large glass jugs, filled with water and labeled with the
names of slave ships, the African and Caribbean countries from which
their human cargoes originated, and the names of the South Carolina

132

133 BEVERLY
BUCHANAN
Richard's Home 1993

134 KERRY JAMES
MARSHALL
*Better Homes Better
Gardens* 1994–95

waterways that ultimately linked these disparate worlds. On one wall, Simpson's four-part photographic image of two, virtually identical black women, linked by a long, chain-like braid, continued this exegesis on perpetuity and dislocation in black culture.

For Beverly Buchanan, Sue Williamson, and Kerry James Marshall, the unadorned realities of a contemporary black existence inspired each of them to incorporate aspects of those received realities into their work: art objects that channeled both the experiential "truths" of their respective subjects, as well as the artifices and imaginings of the artists involved. Georgia-based artist Beverly Buchanan's miniature reconstructions of the homes of an African American, southern, and rural poor (as in *Richard's* 133 *Home* of 1993), possessed a diminutive yet emphatic power, communicating an ingenuity and spiritual presence where society usually sees offensive poverty and underdevelopment. On an altogether different scale and level of intent, the Cape Town artist Sue Williamson envisioned a monument to South Africa's black dispossessed in her *Mementoes of* 145 *District Six* (1993), with its lucite bricks of encased rubble from an annexed (and demolished) "non-White" community and amplified interviews with its former residents. Chicagoan Kerry James Marshall's interplay between perspectival cityscape and graffiti-covered signs in

175

135 FRED WILSON *Insight: In Site: In Sight: Incite: Memory.* View of installation in St Philips's Church, Old Salem, Winston-Salem, North Carolina, 1994

134 *Better Homes Better Gardens* (1994–95) avoided the essentialist trap of turning this visual essay on public housing into either an indictment of or an apology for these failed urban experiments in living. Rather, Marshall's loving, colloquial "homeboy" and "homegirl" (like Buchanan's "Richard" and Williamson's disembodied black voices) converted these humble lodgings into sites of miraculous, restorative possibilities.

 Simpson's use of plastic exhibition labels mocked the museum world's often unsatisfactory efforts to educate audiences, and also exposed the sexist and racist ways in which the English language is used. This critical stance—directed toward museum practices and display strategies—was also the theoretical locus for several other artists engaged in site-specific installations. New Yorker Fred Wilson achieved similar objectives with

135 his 1994 art installation in the eighteenth-century Moravian village of Old Salem (in Winston-Salem, North Carolina). His re-positioning of historical objects and manipulation of exhibition labels, lighting, and other display techniques helped reveal aspects of the site's tragic African American past that (because of the conspiratorial forces of time, ignorance, and racism) had largely become invisible. Similarly, London

136 artist Sonia Boyce papered over the glass of the display cases in Brighton Museum's diminutive "Cultures" gallery (where art objects by the

176

world's black, brown, and yellow peoples were exhibited) transforming them into a series of translucent vitrines: a few strategically placed "peep holes" allowed glimpses of the exhibits, which included Boyce's own *faux* ethnographic creations. In both instances, voyeurism and disclosure of the cultural crimes that were perpetrated against blacks and other colonized peoples framed the artist's and audience's relationship to the "official" history on exhibition.

Installations that addressed the entire conceptual basis of past black lives—from the axiomatic womb to the proverbial tomb—took center stage in site-specific works by the collaborative artists' team of Houston Conwill, Joseph De Pace, and Estella Conwill Majozo. Their floor-level cosmogram *The New Ring Shout* (1995) was situated in a lower Manhattan office building on the site of a long-forgotten, eighteenth-century African burial ground. Related to Houston Conwill's marked and ritualized art spaces of the 1970s and '80s, *The New Ring Shout* used assorted texts, lexicons, and ideograms to reveal history and a spiritual "mapping" of the universe. Although removed from Conwill, De Pace,

136 SONIA BOYCE *Peep*. View of installation of museum intervention in Cultures Gallery, Brighton Museum and Art Gallery, Sussex, 1995

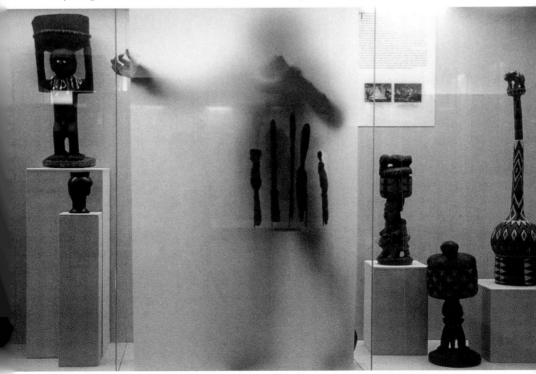

137 HOUSTON CONWILL,
JOSEPH DE PACE,
ESTELLA CONWILL MAJOZO
The New Ring Shout 1995.
Central rotunda of
Federal Office Building
built over an excavated
African burial ground,
New York

138 ALFREDO JAAR
Benjamin. View of
installation at Galerie
Lelong, New York, 1995

and Majozo's aesthetics of black space and spirituality, the Chilean-born
artist Alfredo Jaar achieved similar ends in his gallery installation of 1995, 138
addressing the genocide in the central African nation of Rwanda follow-
ing the assassination of its president in 1994. Jaar's "cemetery of images'—
boxed (that is, unseen) and stacked photographs of Rwanda's dead and
dying—changed the often intrusive act of documentary photography
into a procedure that supported a bigger and more consequential enter-
prise: a conceptual art of social contrition and humanitarianism.

VIRTUAL REALITIES

The Ghanaian philosopher Kwame Anthony Appiah wrote:

> If an African identity is to empower us, what is required is not so
> much that we throw out falsehood but that we acknowledge first of
> all that race and history and metaphysics do not enforce an identity:
> that we can choose, within broad limits set by ecological, political, and
> economic realities what it will mean to be African in the coming years.

Almost simultaneously with this statement, the Ethiopian artist
Achamyeleh Debela created *Artist Under A Mask* (1990–91): a computer- 139
assisted "portrait" of his Euro-American teacher, the pioneering
computer artist Charles Csuri. Debela's christening of Csuri with a
"spirit" mask from the Punu peoples of Gabon, was a telling act,
especially in the light of Appiah's statement, which rejected racial,
historical, and spiritual determinants in an African consciousness, and,

139 ACHAMYELEH DEBELA
Artist Under a Mask
1990–91

179

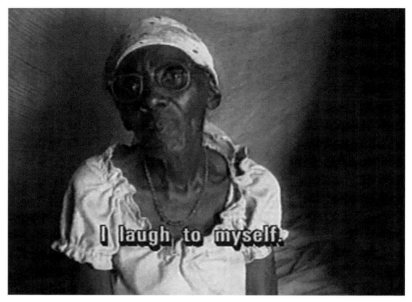

140 PHILLIP MALLORY JONES *First World Order* 1994

instead, embraced a deliberate, politically-centered act of cultural identi-fication. Appiah's stress on the political will toward self-definition and Debela's digital/spiritual license to Africanize the "uninitiated" were, in fact, components of one comprehensive mindset in the 1990s: namely cultural empowerment through image processing, transmutation, and choice.

One example of how issues of racism and visual perception became linked in the '90s was the controversy that arose in 1991 after the national screening of George Holliday's videotape of the beating of Rodney King, an African American, by several Los Angeles County police officers. Another example was the public outcry in 1994 over the darkened and duly demonized *Time* magazine cover of the African American Hollywood actor, ex-athlete, and murder suspect O. J. Simpson. These debates underscored how photographed, videographed, and filmed images of blacks became case studies in the U.S. on cultural slander, as well as public disputes over contested black realities and authenticities. Even in the world of advertising, the racially integrated—and frequently controversial—print and billboard advertisements set up by the Italian clothing manufacturer Benetton exploited perceived racial difference as a blatant, visual stop sign for its products.

In the 1980s and '90s, the African American videographer Phillip Mallory Jones created a series of short works that, using original music, animation and, occasionally, multichannel and synchronized monitors, visualized his notion of an interconnected black diaspora. Jones, attuned to the battles in the media over the representations of black people, eventually expanded upon these earlier works with his longer and more layered *First World Order* (1994): a part documentary/part impressionistic 140 vision of creativity and spirituality in the so-called Third World, which ambitiously cut across the presumed borders of these territories. With the use of computer-assisted image morphing in *First World Order* (where, for example, African and Pre-Columbian sculptures were digitally "transformed" into human beings) Jones succeeded in articulating the connections—transracial as well as intercultural—between group creativity and individual emotions and desires.

The Jamaican photographer Albert Chong, based in the U.S.A., vied for similar effects in such works as his *Winged Desire* (1994), but the 141 arresting and spiritually charged elements in his art curiously turned these photographs into timeless, iconographic documents. In Chong's solarized surfaces and darkroom manipulated layers of ritual artifacts (animal skulls, cowrie shells, feathers, and the artist's own body), a

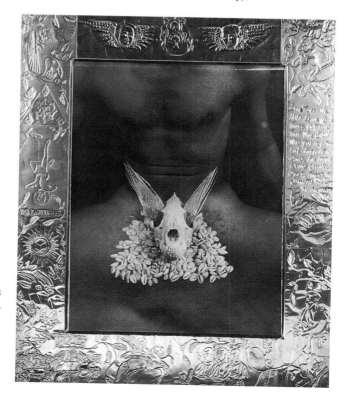

141 ALBERT CHONG
Winged Desire 1994

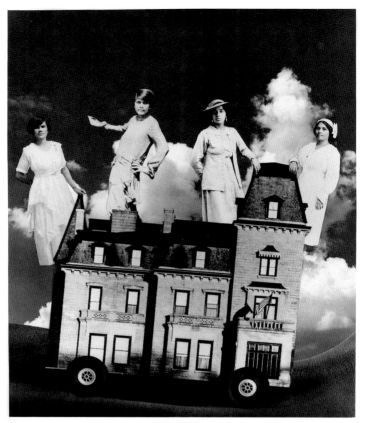

142 LORRAINE O'GRADY *The Strange Taxi: From Africa to Jamaica to Boston in 200 Years* 1991

metamorphosis was more likely to issue from the mind's eye than from a filmic perspective, coalescing into a reality largely shaped by Caribbean, anthropological and syncretic factors.

For New York artists Lorraine O'Grady and Emma Amos, the fact that the photographic image can be altered redirected their shared theme of transformation into two distinct yet related realms of intent. In Lorraine O'Grady's *The Strange Taxi: From Africa to Jamaica to Boston in 200 Years* (1991), the neo-Dadaist combining of old family photos with environmental and anatomical details presented viewers with an architectonic montage, whose black and female armature literally propelled viewers through pictorial space. On a somewhat different

142

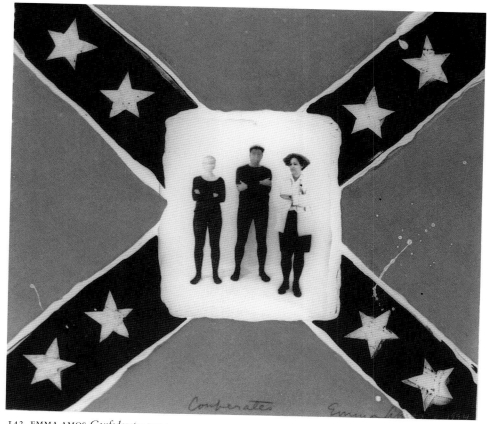

143 EMMA AMOS *Confederates* 1994

path, Emma Amos in *Confederates* (1994) not only challenged the racist premise presented by the Confederate flag, but also photography's so-called objectivity. 143

Even when many artists relied on "direct" photographic techniques, it was important that they were able to reinvent and reinvigorate a black reality that "wouldn't fade in the light of day" (to paraphrase the African American pop songwriters Nickolas Ashford and Valerie Simpson). This was vital to counteract the visual assaults on black culture from both the wider society and scattered, spiritually impoverished pockets within black communities. One of those photographic "purists," New Yorker Coreen Simpson, responded in the 1980s to the one-dimensional and

144 COREEN SIMPSON
Jamien 1984, from the
B-Boy series

often negative representations of blacks with a series of larger-than-life, black-and-white studio photographs of the most maligned members of the culture. Especially provocative were Simpson's photographs of the institutionally "written-off," yet self-consciously visual, urban black youth, as seen in her 1984 *Jamien,* from the *B-Boy* series. In the spirit of past portrait/social documentary photographers like Diane Arbus and Weegee, Simpson made no apologies for her fascination with and empathy for these young, black, social outcasts, describing them—and, in effect, captioning their portraits—with the honorific "the soul of our people."

Similarly, Dawoud Bey, another New Yorker, embarked on a series of photographic portraits in the early 1990s that (using the large format Polaroid camera) revisited the theme of the formation of identity. His triptych of sociologist Sara Lawrence-Lightfoot and her children, Martin David and Tolani (1992), was imbued with color and the passage of time, and an example of what art historian Kellie Jones described in Bey's portraits as "testimonies to people always 'becoming,' to their being forever in the midst of transformation."

The time factor in Bey's work (like the long, exhaustive sittings that people endured in photography's early years) changed these portrait sessions into extended, interpersonal exchanges between Bey and his sitters. In her *Zabat* series (1989), the black Scottish artist Maud Sulter created a similar photographer-sitter relationship, but framed by a

144

146

145 SUE WILLIAMSON *Mementoes of District Six* 1993

146 DAWOUD BEY
Sara, Martin David and Tolani 1992

feminist, postmodern, and postcolonial vision of portraiture as "an occasion of power." Among the series' nine Cibachromes of black women (including novelist Alice Walker and Sweet Honey in the Rock group member and vocalist Ysaye Maria Barnwell) was a portrait of Sulter as *Calliope*, the classical muse of heroic poetry. Like Debela's masking of Charles Csuri in *Artist Under A Mask*, Sulter's re-creation of Jeanne Duval, Charles Baudelaire's black mistress and muse—enshrouded in plush velvet, holding a daguerreotype, and reminiscent of a Nadar photograph from the 1860s—moved effortlessly between autobiography, fiction, *tableau vivant*, and spirit possession in this period of dismantled and refurbished realities.

149
139

TESTIMONY

Many artists in the 1980s and '90s—in addition to making the theoretical leap from a fixed and racially circumscribed blackness to one that was conceptually rooted, culturally grounded, and complex in its subjectivity —turned to personal or political events for source material. What singled out these text- and narrative-driven creations from similar works in other traditions (Romare Bearden's folk medleys for instance, or Ernie Barnes's interpretations of a fabled black athleticism) was an acknowl-

80
115

186

edgment of the pliancy and unreliability of texts, as well as an appreciation of the narrative's capacity for a visual elucidation.

Edouard Duval-Carrié's *Un Touriste chez lui* (1981)—inspired by the artist's return to his native Haiti—exemplified this unfettered and ingenious approach to the pictorial narrative. Haiti in the 1980s—fraught with *coup d'états*, public strikes, civil disobedience, and violence—was re-imagined by Duval-Carrié as an idyllic and luminous seascape in which a naked, brown angel watches over the artist. In this strange, almost sacred setting, an artist-in-exile can return home, but only as a tourist and only by imagining a deformed street-beggar from Port-au-Prince as his guardian spirit.

Unlike Duval-Carrié's pastoral re-landscaping of a turbulent Haiti, Sue Coe's visual transcription of an incident which precipitated one of London's worst urban uprisings vaulted all conceptions of the ideal. The incident was the 1985 shooting of Mrs. Cherry Groce, a black woman, by a white policeman. In the manner of George Grosz's caustic drawings of Weimar Berlin, Coe—ever alert to the inequities and atrocities in Britain in the time of Margaret Thatcher's government—drew *Woman Shot in Back* (1985) with a journalistic immediacy comparable only to photography, but with her measured, dramatic application of chiaroscuro and line.

147

148

187

147 ÉDOUARD DUVAL–CARRIÉ
Un Touriste chez lui 1981

SAT 24th Sep 1985 - BRIXTON, LONDON
7am Ten Police Officers - with guns and dogs break down a womans door. She thought they
were armed robbers - she ran, and was shot in the back, her children watched.
Scotland Yard admitted it was a mistake.

148 SUE COE
Woman Shot in the Back 1985

149 MAUD SULTER *Calliope* 1989, from the *Zabat* series

In 1986 conceptual artist Adrian Piper also created a linear, text-based art in the form of multiple, machine typeset business cards, for instance, *My Calling (Card) No.2*, which she described as a "reactive guerilla performance (for dinners and cocktail parties)." As an African American who was often taken for "white" in unfamiliar social settings, Piper's euphemistic "calling" in art (apart from her postmodern interrogations of artistic practices and definitions) was frequently a judgment of American racism, as well as of racial categories as a whole. Recalling literary critic Robert Stepto's theory of "narrative control" in the nineteenth-century autobiographies of African Americans, Piper's "narrative" interjected into the New York art scene her identity and capacity (as an object-turned-subject) to engage, interact and, if necessary, challenge racism on all fronts.

Howardena Pindell, another artist who was a critic of society's shortcomings concerning racial justice, reconstituted the stars and stripes of the American flag into two parallel black-and-white fields in her mixed media work *Separate But Equal: Genocide: AIDS* (1990–92). Pindell's juxtaposition of the two sets of names—all of people who have died from the disease known as AIDS—underscored (like Piper) the absurdity of racism, especially in the face of this late twentieth-century plague and its power to mete out sickness and death indiscriminately.

Pindell—whose abstractions from the '60s and '70s employed relief and collage techniques comparable to works like her *Separate But Equal: Genocide: AIDS*—served as a role model for other formalists in the 1990s preoccupied with text and narrative. Korean American Byron Kim and African American Glenn Ligon collaborated on *Rumble, Young Man, Rumble (Version No. 2)* (1993): a suspended punchbag with statements by boxing legend Muhammad Ali stenciled on its canvas. Despite the awkwardness that audiences felt walking round this piece and trying to decipher Ali's words in their entirety, his repeated references to "white"people clearly stood out and, in effect, emphasized how concepts like "white" and "black"obstruct people's thinking, eventually forming inpenetrable barriers to understanding cultural differences beyond these abstractions.

In contrast to these text-based strategies for investigating blackness, whiteness, and all the racial categories and controversies packed between them, the African American figurative expressionist Robert Colescott painted *Lightning Lipstick* (1994): a humorous and telling commentary on race, history, and society's prevailing illusions about them. Colescott's implied narrative was that a "Latina blanca," while applying her cosmetics, confronted a history of slavery, racial miscegenation, and the genealogical

Dear Friend,
I am black.
I am sure you did not realize this when you made/laughed at/agreed with that racist remark. In the past, I have attempted to alert white people to my racial identity in advance. Unfortunately, this invariably causes them to react to me as pushy, manipulative, or socially inappropriate. Therefore, my policy is to assume that white people do not make these remarks, even when they believe there are no black people present, and to distribute this card when they do.
I regret any discomfort my presence is causing you, just as I am sure you regret the discomfort your racism is causing me.

150 ADRIAN PIPER *My Calling (Card) No. 2* 1986

151 BYRON KIM AND GLENN LIGON
Rumble Young Man, Rumble (Version No. 2) 1993

152 HOWARDENA PINDELL
Separate But Equal: Genocide: AIDS 1990–92

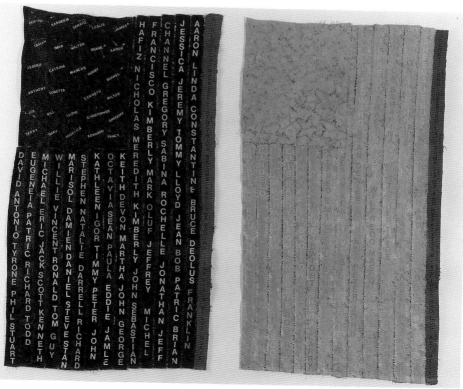

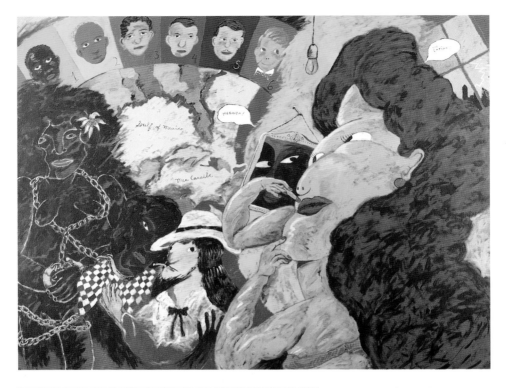

153 ROBERT COLESCOTT
Lightning Lipstick 1994

154 STANLEY GREAVES
The Presentation No. 2 1992,
from *There is a Meeting Here
Tonight* series

155 KEITH MORRISON
Chariot 1988

prospects of being "negrita". Color was therefore *Lightning Lipstick*'s primary subject and (like the Byron Kim/Glenn Ligon collaboration) placed viewers in the position of "sparring" with these unfounded but embedded racial assumptions.

The idea of "color," an illusory concept yet with such a power to transform, was redeemed in *Lightning Lipstick* by placing it within the literal borders of culture and geography. In the 1988 painting *Chariot*, 155 the Jamaica-born, Bay area artist Keith Morrison also saw culture (as opposed to race) as his conceptual point of departure. However, Morrison's irreverent consignment of civilization (including Piero della Francesca's *The Flagellation* and an African statue) to a fantastic, funerary cortege drawn by demons and horses, assigned culture to a less elevated station and made it into something ephemeral and mortal.

This view of culture—as fleeting, narrative-generated, politically contentious, and impervious to single definitions or reductive categories—appeared in the works of numerous artists for whom language and image were partners in visual communication. The realization that labor and leisure in the culturally distinct yet marginalized communities throughout the black diaspora could yield an abundance of information led many artists into these margins, in search of artistic models. These revelations from the periphery played an important role in the work of Stanley Greaves, who was born in Guyana and settled in Barbados.

Although educated in three, rather distinct, art institutions—Guyana's Working People's Art Class, the University of Newcastle upon Tyne in the U.K., and Howard University in the U.S.A.—Greaves combined their divergent curricula with his own Caribbean sense of a visual polemic. *The Presentation No. 2* (1992), one of three paintings from his series *There is a Meeting Here Tonight,* showed the porch, the alley, and their actors-in-residence in a view reminiscent of de Chirico, and therefore emphasized the jostling for prestige and position that often characterizes social and political behaviour in the Caribbean. The ubiquitous "black dogs" in this series symbolized the constant struggle in the postcolonial world for territory and power: an issue for which Greaves and other late twentieth-century commentators offered two fundamental questions: "How can I get what I want?" and "What methods am I prepared to use?" As mercenary as these questions—and these "mongrels"—might be, concealed within the shadows of *The Presentation* were a few life-affirming signs, as well as a colloquial pair of used but natty double-width shoes, waiting to be stepped into (by someone from this black diasporal "frontier") with all the answers.

BLACK BODIES

A language and imagery that objectified black bodies filtered through much of the cultural nationalist poetry, prose, and visual arts during the '60s and '70s. In the light of a long, tortured history of racist lampooning and devaluation of black people, one might argue that this emphasis on hair, skin, and black physicality was an understandable and even necessary strategy. Yet these tributes to the "black and beautiful" ones, especially when uncritically voiced or visualized, also contained their own special venom: the compulsion toward superficiality, reverse racism, and racial fetishism.

Around 1975–78 (coinciding with a major exodus of West Coast and Midwestern artists—musical, literary, and visual—to New York City), this fascination with black bodies in poetry and painting shifted to the conviction that this artistic idea could exist in time and space, proclaiming itself in both words and images, and realized by people of color. For example, in the Bay area (and a little later in New York) various poets and actors (including Ntozake Shange, Jayne Cortez, Jessica Hagedorn, Miguel Algarín) staged performances of their poetry and prose in jazz clubs and cafés (like those of the Beat poets of the 1950s and '60s), while in other major cultural centers in the U.S.A., Europe, and Africa, musical performers like Sun Ra's Intergalactic Arkestra, the

Art Ensemble of Chicago, and Fela Anikulapo Kuti and his "Africa '70" turned their concerts into multimedia spectacles, with costumes, make-up, and innovative staging. Among several New York- and Miami-based artists—many of whom were of Cuban and Puerto Rican descent—the rituals and regalia of *Santeria, Vodun, Candomble*, and other African-derived New World religions also inspired a body-centered art.

These harbingers of a late twentieth-century black performance art movement, raised the stakes in their artistic identification with black peoples through explorations of black myths and religion, African masking traditions, and also through consciously playing off a long, often tangled, history of objectification and culturally encoded theatrics (or what art historian Lowery Stokes Sims has described in black women's performance art as "acting out"). These culture-specific theatrics with the artistic cues inherited from a mostly European and Euro-American tradition of "happenings," situationist and action art, and creative acts of a political and social dimension—influenced a whole new generation of performance artists, many of whom (like Adrian Piper, David Hammons, Houston Conwill, Faith Ringgold, and Lorraine O'Grady) would also make definitive statements about black culture through art objects.

In 1983, photographer Tseng Kwong Chi, painter Keith Haring, and the avant-garde dancer/choreographer Bill T. Jones collaborated in an art "happening" which illustrated the pivotal role that performance played in the blurring (and even the breakdown) of traditional art categories. Their collaboration merged their special talents under the thematic canopy of an articulated, culturally positioned, black male body. Critic Kobena Mercer perhaps captured the essence of this collaboration—the homoerotic implications of the black male body both as altar and as *tabula rasa*—in his discussion of similar collaborations between photographer Robert Mapplethorpe and his black male models when he described these projects as ambivalent products of the "political unconscious."

Mercer's reflections on Mapplethorpe's racial fetishism and on the challenges that filmmaker Isaac Julien, photographer Rotimi Fani-Kayode, and other artists imposed on these systems of seeing and repre-senting black male bodies would have been further complicated had Mercer also analyzed the works of Ben Jones and Sherman Fleming. These are two African American artists for whom the black male body has long been the starting point, as well as the ultimate destination for theoretical and performing possibilities. Jones—whose painted plaster body casts of black faces and arms in the early 1970s signaled a dramatic

157

166

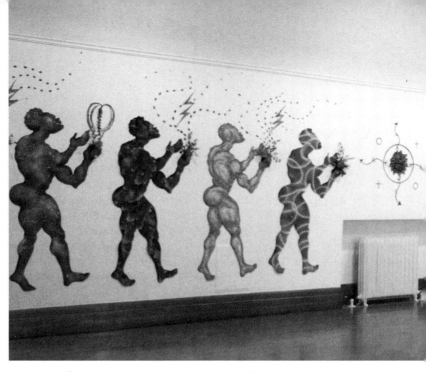

step away from more conventional modes of black representation—used
these past works as yet another stepping stone for his 1994 *Shango Wall*
156 *Installation*. The life-size paper cut-outs of stylized men and women, each
painted differently and mounted on walls that enclosed an art gallery-
cum-ritual space, functioned (like many black diasporal shrine settings) as
both tracings of black corporeality and diagrams for spiritual action.

 Sherman Fleming's 1995 performance in Amsterdam, *UN/SUB: De*
158 *Jacht op Zwarte Piet* (*The Hunt for Black Peter*), was inspired by the Dutch
myth of Zwarte Piet, who was St. Nicholas's black helper, and the
African American story of Harriet Tubman, the nineteenth-century
escaped slave and liberator of slaves. Fleming played on the theme of
slaves "stealing away," as well as on Zwarte Piet's dual nature (benevolent
in dispensing sweets to well-behaved children, and malevolent in threat-
ening to abduct the ill-mannered ones to a faraway, Moorish Spain). He
first submerged his body, clad only in a G-string, for an hour in a vat of
sugar and cinnamon, and then, after this "tub man's" dramatic emergence
from the vat, stepped on to the gallery floor, removed his breathing tubes
(and protection for eyes and nose), and shook off the excess confection.
Finally, Fleming's two Dutch assistants licked the clinging "sugar and
157 spice" off his body in patterns that (like the paintings on Bill T. Jones's

196

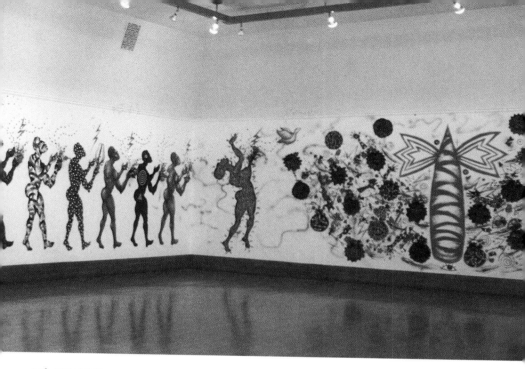

156　BEN JONES
Shango Wall Installation (detail)
1994

157　TSENG KWONG CHI
AND KEITH HARING
Bill T. Jones 1983

158 SHERMAN FLEMING *UN/SUB: De Jacht op Zwarte Piet* 1995

body) resembled the body decorations in Leni Riefenstahl's photographs of the nomadic Nuba people of East Africa. As with all Fleming's performances, this merged the spectacle of a perceived racial difference with notions of desire, contagion, concealment, and emancipation, all within his theoretical construct of physical (as well as psychological) endurance.

Each of these "body-centric" works toyed with representations of black masculinity shaped to a great extent by a particular view, or rather impression, of the African body. Whether specifically informed by Riefenstahl's photographs, or inspired by the legions of other exotic (and often sexually-charged) photographic images of African men, women, and children, they nonetheless fed into a common image of African peoples that, ironically, was not perceptually different from the primitivist attitudes about Africans that had long been held by many Europeans and Americans.

The works of two African women have provided an interesting counterpoint to these racial and sexual images. In Sokari Douglas Camp's *Gelede From Top to Toe* (1995), the sculptor has shifted the emphasis of a traditional masquerade (when males impersonate females) among the

159

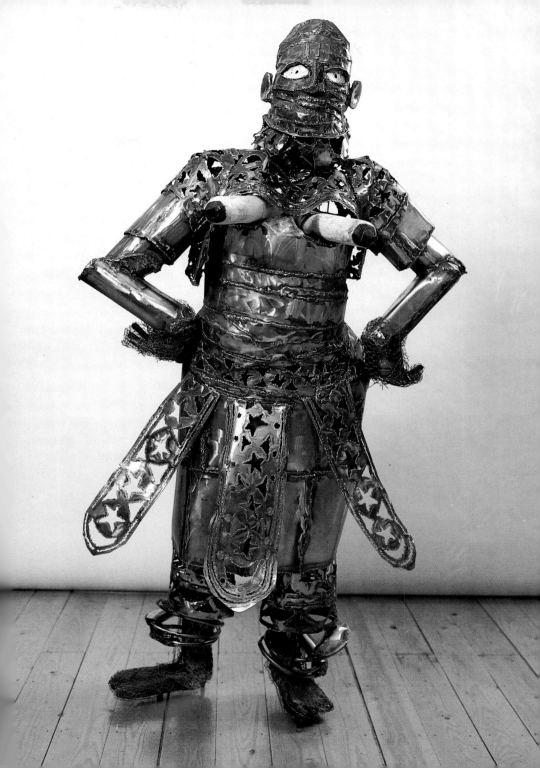

160 WEREWERE LIKING *Un Touareg s'est marié avec une Pygmée* 1992

Yoruba peoples of southwestern Nigeria. Constantly balancing her Kalabari roots with her interest in Nigeria's diverse cultures, her American and British art training, and her London home, Douglas Camp created something here that was no longer Yoruba, nor even Nigerian but, rather, transnational, industrial, and postmodern. Similarly, Werewere Liking, the Cameroon-born, Côte d'Ivoire-based perfor-

160 mance artist, used multimedia, ritual-based works such as her 1992 *Un Touareg s'est marié avec une Pygmée (The Marriage of a Touareg and a Pygmy)* as a catharsis for an ailing, morally dissolute, African body politic. Ki-Yi Mbock Théâtre (Liking's theatrical troupe and artists collective) performed her fantasy of a marriage between a North African nomadic man and a Central African hunting/gathering woman using an inter-textual, black African aesthetic that, according to Liking, communicated "different kinds of emotions" and reached "different levels of language" from which "everything can be expressed." In both instances, Douglas Camp and Liking avoided stereotypical conceptions of Africans, while still engaged in an identity-conscious discourse on visual embodiments of culture.

In the U.S.A., artists Joyce J. Scott and Carrie Mae Weems were also creators of an alternative art of gendered and racialized bodies. But rather than a black-body-centered art whose image and thematic impetus resided in the realm of the erotic or exotic, Scott and Weems shifted their performances and figurative works in the direction of ethical and political questions. In her performance piece *Generic Interference/Genetic Engineering* (1988–93), Scott leveled high-spirited critiques of racism and sexism, framed by the thorny and problematic presence in a post-industrial world of a striving for physical perfection, a revolution in reproductive technology, and a climate of moral absolutism. Scott's satirical yet emotionally gripping characterizations—such as Gene 3000: the last, genetically untampered-with human being—emphasized that our fixations on idealized identities and social engineering have irrevocably complicated and even imperiled life as it was once known. 161

These *fin-de-siècle* misgivings about identity—especially related to culture and consciousness within various black diasporal experiences—encircled Carrie Mae Weems's *Ode to Affirmative Action* (1989). Like Scott's parodic character Gene 3000, Weems's black female singer, Dee Dee (performed and staged by Weems herself), challenged audiences 162

161 JOYCE J. SCOTT *Generic Interference, Genetic Engineering* 1992

162 CARRIE MAE WEEMS *Ode to Affirmative Action* 1989

with the hypothesis, "If You Should Lose Me": an assumption that, given Weems's allusions to the largely African American Mississippi Delta in her song "Clarksdale" and U.S. policies of racial restitution in her song "Affirmative Action," revolved around questions of black inclusion, participation, and advantage in a world that, alas, resembled a mob-controlled nightclub. The performative dimensions of not only art, but black lives, encouraged these and other artists in the 1980s and '90s not only to analyze and dissect a culture-in-process, but to lay claim to those spirits and truths that, in this atmosphere of post-structuralist doubt, called for recognition.

Through A Glass, Diasporally

AFTERBIRTH

Most art historians have ignored the pivotal position of black cultural themes in the construction of a cinematic vision in the twentieth century. They have also slighted the important role that black actors, directors, cinematographers, and screenwriters have played in creating what could be described as a performative, vocal, and interactive "black art." Of course, those who could not fully appreciate the art of photography or the most expressionistic paintings by African American artists, would not have been able to see the intrinsic visuality in Oscar Micheaux's early films, or the self-conscious artistry in films featuring the inimitable Paul Robeson. Not only were they incapable of seeing film (and later video) as art, but they maintained that the mass media was primarily a vehicle for commercial entertainment and propaganda. Considering the uphill struggle that black culture in general has faced, there was little possibility that black film and video would be considered of artistic value and historical worth.

Even with a proliferation of black images in the media arts, several fundamental questions arise: do blatantly racist, stereotype-wielding films like D.W. Griffith's *The Birth of a Nation* (1915) qualify for inclusion in a diasporally rooted art history? Do primitivist works like Jean Renoir's *Sur Un Air de Charleston* (1926) deserve consideration in the context of studies of black subjectivity and identity in art? Are the "all-black" films by white directors like Vincente Minnelli or Marcel Camus more reflective of a white mindset, rather than of a black consciousness or cultural ethos?

In spite of the distorted characterizations of black culture in the works of filmmakers like D.W. Griffith and others, a study of these images educates people in racial and cultural stereotyping: visual assaults that have a historical precedent in eighteenth- and nineteenth-century representations of the proverbial Other. This visual data strengthens rather than disables scholars, allowing them to see critically what other see cursorily and naively. A study of specific racist mechanisms (for example, Griffith's sinister uses in *The Birth of a Nation* of black and white actors) ultimately politicizes the scholar, not through dismissing or censoring Griffith's

15

30

work, but in revealing the film's underlying structure, evaluating its artistic strategies, and countering its white supremacist motives. The black comedian and television actor/producer Bill Cosby wrote in his introduction to *The Black Book* (1974)—a collection of sometimes beautiful, sometimes racist, black memorabilia—"the pickin's ain't always easy, but they're always good."

The value of examining white-directed films or videos with predominately black casts is a more difficult one to gauge—it is conceivable that they could be a product of a European or Euro-American cultural framework. Supporters of this view could point to Vincente Minnelli's *Cabin in the Sky* (1943), Otto Preminger's *Carmen Jones* (1954), or even Robert Downey's *Putney Swope* (1969) as examples of white accounts of black people. But one could also argue that a film or video with a black cast and a well-crafted screenplay, based on the experiences, narratives, and emotional states of black peoples (as seen, for example, in the 1976 U.S. television series *Roots*), cannot be anything but a black cultural statement, regardless of the ethnicity of the directors involved. When white directors sacrifice, for example, the typical Hollywood approach to musicals for something more interactive, musically sophisticated, and structurally integrative (as in Perry Henzel's 1973 *The Harder They Come*, or George T. Nierenberg's 1983 *Say Amen, Somebody*), the result is often regarded as unquestionably black.

What then does make a film black, or, rather, what components of cinema make a film that has black characters and a black *mise-en-scène* an appropriate subject for exploring diasporal arts and aesthetics? A glance at Minnelli's 1943 *Cabin in the Sky,* and a close look at *The Blood of Jesus* (1941)—an independent film by the African American actor and director Spencer Williams—may provide some answers.

The plots for both films were derived from earlier works: the 1930 Broadway musical, and 1936 motion picture, *The Green Pastures* (Marc Connelly's folk-inspired fable about African American conceptions of the Old Testament), and the original 1940 Broadway version of *Cabin in the Sky* (also indebted to *The Green Pastures*). In *Cabin,* Minnelli's fascination with the contest between reality and illusion (rather than the script's surface battle between good and evil) was matched—and perhaps opposed—by Williams's unabashed sermon on redemption and resurrection in *The Blood of Jesus*. These distinctions—between a cinema of "smoke and mirrors" and a cinema about spiritual restoration—did not necessarily indicate an aesthetic schism between Minnelli's Hollywood and Williams's Harlem, so much as they represented two distinct views about African Americans life around World War II. The scene in *Cabin*

56

163

204

when *femme fatale* Georgia Brown (played by Lena Horne) plucks a magnolia blossom from a tree and fastens it to her hair (like Billie Holiday's trademark white gardenia) functioned as a subtle reminder to audiences of improvisation and the illusory nature of appearances. These were twin themes that haunted this film, from its beginnings in a rural, black Baptist church, to its conclusion in Little Joe and Petunia's bedroom. *Cabin*'s dream-within-a-fantasy premise—a narrative ploy straight out of Arthur Freed's *Wizard of Oz* (1939)—had a special resonance with black audiences, given the film's required mock belief in the integrity of waiting for one's hard-earned recompense in Heaven: an unlikely proposition that Minnelli, his cast of black urban sophisticates, and their cinematic deconstruction of Negro rectitude, could not accept.

The *Blood of Jesus* (1941)—also about an out-of-the-body brush with divinity—differed from *Cabin in the Sky* in that its director, producer, writer, and featured actor, Spencer Williams, specifically created his film for African American audiences. His main message—that following a Christian path provided black people with not only their just rewards in the afterlife, but blessed assurances here on earth—diverged dramatically from *Cabin in the Sky*'s counterfeit "pie-in-the-sky" prescription. Where *Cabin* avoided the potentially estranging details of an authentic African American experience, *The Blood of Jesus* stepped head-on into a semi-documentary world of open-air baptisms, tawdry speakeasies, and "saints" falling into fits of religious ecstasy. Indeed, one could imagine the reactions of black filmgoers of 1941 when, toward the end of the film, they "witnessed" the blood of a crucified Jesus dripping on to the face

of the female protagonist (played by Cathryn Caviness). This showed Williams's familiarity with an exaggerated theatricality in the African American church pageant tradition, as well as his willingness to experiment with the most provocative and visceral special effects in filmmaking.

For Spencer Williams, the moral compass of Afro-America resisted co-option by the market forces that dictated the struttings of Vincente Minnelli's star-studded cast of pseudo-religious types. Of course, Williams limited his ambitions to appealing to an already attuned, church-going black audience. Thirteen years before *The Blood of Jesus*, in a period of materialism and commodification, the filmmaker and actor Richard D. Maurice also appealed to an African American sense of morality. Maurice's *Eleven p.m.* (1928)—another cinematic story within a story— explored the common literary themes of moral incorrigibility, spiritual retribution, and the city as a den of deception, but now situated among "New Negro" types in Detroit. What singled out *Eleven p.m.* from the stock silent productions of this period were Maurice's abilities as both actor and *auteur*. His portrayal of the morally upright, racially mixed protagonist, the street violinist Sundaisy, elicited compassion, and his flirtation with the idea of reincarnation—when a dog with the face of the deceased Sundaisy attacked the film's villain—interjected a fantastic, almost mystical element into what was otherwise an urban melodrama. Although succeeded by dozens of other "all black" films of various minds and motives, *Eleven p.m.* introduced a decidedly visionary way of looking at black culture: a vision that, with its allusions to hybridity and spirituality, and implanted tensions between the real and make-believe, suggested something on the order of a black cinematic imagination in the making.

In *The Cinema as Art* (1965), Ralph Stephenson and J. R. Debrix discussed how cinema—from its beginnings as the twentieth century opened, to its New Wave ruminations in the early 1960s on the meaning of life after the atomic bomb—had a language and structure comparable to painting, sculpture, and other visual art forms. Among the many observations that Stephenson and Debrix made about cinema's intrinsic artistry was that an "objectively false" film universe asked viewers to suspend their disbelief, and that films as art first emerged within the context of this "false seeming." Stephenson and Debrix continued their examination with the view that, in spite of its artifice, films as works of art not only affected the senses and seized the imagination, but were "deliberately made to attack us, to force [their] way into our feelings and our beliefs." This anthropomorphic, confrontational view of film—an artistic entity capable of grasping, attacking, and forcing its way into one's mind and soul—summoned an alternative meaning for this art form in light of the cultural moment in which Stephenson and Debrix were writing and the artistic weight that three films from that period carried in redefining this vision, namely Jean-Luc Godard's *A Bout de Souffle (Breathless,* 1959), Alain Resnais's *Hiroshima, Mon Amour (Hiroshima, My Love,* 1959), and François Truffaut's *Les Quatre-cent Coups (The 400 Blows,* 1959).

Absent from most studies of New Wave cinema was Marcel Camus's *Black Orpheus* (1958). Despite its inherently "false" film universe, it seduced the imagination and ingratiated itself rather than forcing itself on its audience. Despite winning the prestigious Palme d'Or at the 1959 Cannes Film Festival, the 1959 Academy Award (for best non-English language motion picture), as well as a commercial success in international film markets, *Black Orpheus* received mixed reviews. The most criticized features of the film were its travelogue-like footage of Rio de Janeiro, its dazzling (to the point of intoxicating) Afro-Brazilian soundtrack and color photography, and finally its highly stylized atmosphere. Although these criticisms of *Black Orpheus* were valid from the perspective of the majority of films being produced at that time, curiously missing from these discussions was the obvious: that Camus had placed not just a racial blackness, but also a cultural and discursive blackness, at the core of his retelling of an ancient Greek myth, and that this imposition fundamentally altered his *New Wave* aesthetics into something that dealt a sharp blow to the artistic consciousness.

Camus introduced this aesthetic rupture in the film's opening shot, where a colorless detail of a seemingly immovable Greek sculptural relief

72

207

was visually shattered, giving way to four, colorfully dressed black people, dancing and promenading to the rhythms of African-sounding drums. In the establishing shots of Rio de Janeiro, black women negotiating steep slopes with burdens on their heads, wattle-and-daub houses, and barefoot children underlined that this rarely filmed world—black, humble, and teeming with life—had its own, visual allure.

Brazilian soccer player Breno Mello and African American dancer Marpessa Dawn played the ill-fated lovers with an athletic grace and a deep intelligence that converged into something far more abstract than usually communicated by black film characters up to that point. Cinematographer Jean Bourgoin's *plein air* medium shot near Orpheus's hillside shack—with Orpheus curled up beside Eurydice and resting his head on her hand, and she sitting upright with her back to the camera and facing a horizon across which a jet plane soars—perfectly captured this abstract essence and the bittersweet refrain of one of *Black Orpheus*'s bossa nova anthems: "Sadness has no end, but happiness does."

This acknowledgment of fleeting pleasures—in spite of life's hardships and, ultimately, death—emerged not only in the film's music and screenplay, but in the documentary-like footage of black revelers (photographed by Bourgoin over several Carnival seasons). In a neo-realist gesture that unknowingly recalled Williams's crude but effective use of non-professional, black churchgoers in *The Blood of Jesus*, Camus's lingering, close pan shots of Rio de Janeiro's black peasants—as they clapped hands, moved to the rhythms of the drums, and threw back their heads and laughed with abandon—turned *Black Orpheus* into a diasporal document. Whether depicted as eighteenth-century European courtiers in their Carnival finery, or as possessed souls in a clandestine, Afro-Brazilian religious rite, these images of blacks embodied joy in the recognition of their own existence, survival, and capacity to love. In an amazing allusion to (as well as a stark departure from) a black minstrel tradition, Camus's final scene of three dancing children, photographed against Rio's harbor at sunrise—redefined the use of black music and dance in film. Beyond this scene's outdoor, impromptu setting, Camus's pairing of an exhilarating musical soundtrack with a trio of seemingly carefree children again stressed *Black Orpheus*'s paean to black pleasure: a joy, free of licentiousness and buffoonery that, despite cinema's artificiality, appeared to reflect reality.

Since *Black Orpheus*, the combined aesthetic forces of first a scenic verisimilitude and secondly a compelling audio and musical soundtrack, have provided other filmmakers working within a black cultural sphere with strategies for creating films that present an alternative worldview. Fred Padula and Edward Spriggs employed these devices effectively in

Ephesus (1966). Filmed at the Ephesian Church of God in Christ in 165
Berkeley, California, *Ephesus* compressed this African American church's
revival services (and the farewell to their soon-to-be demolished build-
ing) into half-an-hour's worth of interior shots of the church,
congregation, choir, and the church's spiritual leader, Elder James E.
Cleveland. Although photographed in black and white, with a separately
recorded soundtrack, *Ephesus* succeeded in capturing a colorful, black
Pentecostal style of worship via a broad range of camera-to-subject dis-
tances, hand-held shots, and sophisticated editing techniques. By the end
of *Ephesus*, the spirited singing, shouting, and exhorting had, in effect,
transformed the camera—and therefore the film audience—into a simi-
larly convulsive, prostrate, and "happy" convert.

Two very dissimilar cinematic works of art—Melvin Van Peebles's
Sweet Sweetback's Baadasssss Song (1971) and Isaac Julien's *Looking for* 98
Langston (1989)—shared this impulse to invoke an almost indescribable, 166
transitory joy, largely through the devices of an audio/music soundtrack
and what film critic Manthia Diawara described as a "cinema of the real."
In Van Peebles's film, his unrelenting funky soundtrack dominated by key-
board and saxophone (by the progressive soul group, Earth, Wind, and

165 EDWARD SPRIGGS AND FRED PADULA *Ephesus* 1966

166 ISAAC JULIEN *Looking for Langston* 1989

Fire) perfectly matched his hyper-edited exterior shots of Los Angeles, so much so that the results reinforced his twin themes of transgression and revolution. Almost twenty years later, the black British filmmaker Isaac Julien also employed hypnotic soundtracks and documentary footage to show a black gay presence in the world, and, once it was identified, to celebrate a beauty denied and a sexuality demonized. One sequence juxtaposed the electronically derived dance rhythms of "house music," the incantatory recitations of the African American poet Essex Hemphill, and a mélange of special effects, cross-cuts, and moving camera shots; here Julien attained an emotional pitch in *Looking for Langston* that, like Van Peebles's ode to the renegade in *Sweet Sweetback's Baadasssss Song*, fused style with rebellion, and the quest for cultural blueprints with a revolution-turned-carnival.

DREAMING IN COLOR

In *Looking for Langston*, the mix of old documentary footage from the 1920s and '30s with contemporary black and white photography by Nina Kellgren, Robert Mapplethorpe, and Sunil Gupta framed Julien's meditation on race, sexuality, and cultural regeneration within a historicized yet postmodern notion of beauty: images more akin to George Hurrell's

210

(or, rather, Herb Ritts's) black and white celebrity portraits than to Kodachrome or Eastmancolor realities. The tensions that arose out of this interplay between documented, black gay lives, and fantasies (in black and white) about black gay lives, inevitably shifted the prevailing attitudes on black cinema. It was first suggested by literary critic Henry Louis Gates Jr., in his discussion of Julien and Kobena Mercer's film theories, that this shift marked an ideological tug-of-war between "representation as a practice of depicting" and "representation as a practice of delegation." In the context of late twentieth-century film and video, a brief discussion on how color, optical effects, and *mis-en-scène* served the "black representation" debate will, it is hoped, add to an understanding of how these strategies influenced other black images.

As discussed earlier, Bill Gunn's *Ganja and Hess* (1973) reveled in a race-109 conscious yet abstract world of interpersonal rituals and doubts. Gunn's desired cinematic atmosphere—gothic tinged with contemporary race and class conflicts—was achieved when he cast Duane Jones, an actor featured in George Romero's horror classic of 1968, *Night of the Living Dead,* as the diseased Dr. Hess Green. Photographed mostly in shadows, with raking light, and against a fairly intense color scale, Gunn's study of contamination, addiction, and possession looked neither to ideal nor real depictions of black culture but, rather, to a collection of symbols (blood, Africa, and Christianity) that, through a postmodern lens, offered a flexible and metaphysical definition of blackness.

Perhaps even more than *Ganja and Hess*, Martina Attille's *Dreaming Rivers* (1988) used the symbolic possibilities of scenery, an actor's physical 167 type, and the manner in which these elements were lit and framed, in order to visualize what Diawara called the "terrain of contestation" that

168 CAMILLE BILLOPS AND JAMES HATCH *The KKK Boutique Ain't Just Rednecks* 1994

occurred both between the characters and within their black selves. In this non-linear treatment of the story of Miss T, an older Caribbean woman in England, and her three young adult children who were assimilated into British culture, questions of identity and lineage were raised in close, painstakingly arranged shots of this family, as well as in extreme close-ups and tracking shots of the deceased Miss T's bedroom, where a dressing-table, photographs, religious artifacts, books, flowers, and candles introduced other cultural markers.

Attille, aided by her set designer, fellow black British artist Sonia Boyce, transformed the insular bedroom world of a culturally dislocated Caribbean mother into a theory-free zone of self-representation. In a related vein, New York artists and filmmakers Camille Billops and James Hatch turned the racialized trappings of life in the U.S. into a comedic excursion through an imagined underworld in *The KKK Boutique Ain't Just Rednecks* (1994). Sculptor and graphic artist Billops, in addition to co-directing, co-writing, and co-producing, designed its costumes and sets; she constructed this part *cinéma vérité*, part scripted story line around her conviction that "hatred does not deliver." In a scene that recalled the ecclesiastical "fashions" in Federico Fellini's *Roma* (1972), Billops staged

168

(among other spectacles) a "racist fashion show," in which shots of models wearing a Klansman's white hooded robe and neo-Nazis "goose-stepping" down a stage-lit runway were intercut with "real people" recounting past encounters with hate groups. In instances such as these, Billops's juxtaposition of a scripted theatricality with personal testimony was accentuated by her scenic (and, by association, chromatic) reimagining of a filmed space.

Two other films that relied upon color to address issues of difference, dissension, and cultural expressivity were Spike Lee's *School Daze* (1988) and Felix de Rooy's *Ava and Gabriel* (1990). Riding on the critical and commercial success of his 1986 sex comedy *She's Gotta Have It*, Lee turned in *School Daze* to the class and color antagonisms found among African Americans at historically black colleges and universities. To underline these tensions, as well as to highlight their absurdist, almost surreal dimensions, cinematographer Ernest Dickerson photographed Lee's script in vivid colors, and also processed certain scenes in jarring, expressionistic hues. These techniques—especially in tandem with the

169
170

169 SPIKE LEE *School Daze* 1988

Broadway-styled set and music of Lee's fantasy "challenge dance" scene between two "camps" of black women (the stylistically "Euro-centric" versus the stylistically "Afro-centric")—pushed what was otherwise a heavy-handed race/class polemic into something operatic and visual.

Shortly after *School Daze*, Ernest Dickerson again explored the possibilities of color and light in *Ava and Gabriel* (1990): a film by the Dutch Antillean director and visual artist Felix de Rooy from a screenplay by Norman de Palm. De Rooy's film revolved around the controversies that arose when in Curaçao in the late 1940s the Roman Catholic Church commissioned a Surinamese artist to paint a mural of the Virgin Mary. Unlike *School Daze*, *Ava and Gabriel*'s compelling and inflammatory narrative about race and representation, along with Dickerson's luxurious color cinematography, anchored the film's multiple messages on colonialism, censorship, and illicit love, and, simultaneously, moved de Rooy's social consciousness into the realm of the visually seductive.

In response to curator Roger Malbert's observation that "the mix is what defines de Rooy," the artist/filmmaker offered this:

> . . . a vision born—a colonial orgasm torn from historical hypocrisy—cultural schizophrenia—religious insanity with the delicate balance of sexual duality—a universal identity set free

171 OUSMANE SEMBENE *Ceddo* 1976

Although referring to his own art, de Rooy's evocation described the cinematic works of several other black diasporal filmmakers before him, especially in regard to the impact of the colonial experience on their films. The "Father of African Cinema," Senegalese filmmaker Ousmane Sembene, brought colonialism, history, and religion to the forefront of his critically acclaimed 1976 film epic, *Ceddo* (which, figuratively translated 171 from the Wolof language, means "the common people who resist religious and/or cultural expropriation"). Mixing Western dramatization, modern film techniques, and traditional West African story-telling and oratory, *Ceddo* confronted the often suppressed history of Islamic and Christian expansionism in West Africa, and its damaging effects on indigenous African societies. If Sembene's fusion of stylistic approaches and cultural subjects were not sufficient evidence for viewing *Ceddo* (in de Rooy's words) as "an identity set free," then the jazz-influenced soundtrack by the Cameroonian musician Manu Dibango and the film's assertive black heroine, played by Senegalese actress Tabara N'Diaye, made *Ceddo* a truly diasporal work about cultural "conversion" and "resistance."

Euzhan Palcy's film *Rue Cases-Nègres (Sugar Cane Alley,* 1983), set in 172 French-dominated Martinique around 1930, also negotiated the treacherous divide between a soul-sustaining African identity and an equally

170 FELIX DE ROOY *Ava and Gabriel* 1990

172 EUZHAN PALCY
*Rue Cases-Nègres
(Sugar Cane Alley)* 1983

173 JULIE DASH
Daughters of the Dust 1991

essential mastery of Western discourse. Palcy's photographic close-ups—on the inquisitive faces of children, as well as on the gnarled hands and feet of the aged and infirm—communicated a cultural philosophy that prevented either "black" traditions or a "white" education from being the only options: the film's child protagonist, José (played by Garry Cadenet), seemed to have an intuitive understanding of this philosophical premise. One of the most powerful scenes is a fireside exchange at night between José and an elder, Mdouze (played by Senegalese actor Douta Seck). It was used by Palcy as an opportunity to examine black narratives and histories not just as occasions for verbal artistry and free interpretations of the past, but, more importantly, also as vehicles for grassroots education, a personal code of ethics, and political action.

Sembene and Palcy's art—defined by differences with former French colonialists and, paradoxically, collaborations with the French film industry—brought to filmmaking the recounting of black diasporal experiences and historical narratives. They constructed small, intimate worlds in which history unfolded through the simple actions, language, and images of black peoples. *Ceddo* and *Sugar Cane Alley* featured a specifically African mode of storytelling that avoided a fact-bound, structural linearity for a collaged, rhythmic, and prophetic testimony.

173 Julie Dash's *Daughters of the Dust* (1991) and Haile Gerima's *Sankofa*
174 (1993) had intellectual investments in black history comparable to *Ceddo* and *Sugar Cane Alley*, although Dash and Gerima's works—both

216

informed by a Los Angeles-based "school" of black filmmakers in the 1970s, and a general boom in films by and about African Americans in the early 1990s—expressed more expansive views of a black universe. The core narrative in *Daughters of the Dust* concerned a large, turn-of-the-century black family, living on one of the isolated Sea Islands off the coast of South Carolina, and struggling with the decision by several of its members to migrate to the mainland and eventually north. But interestingly, there was a visual subtext running through *Daughters of the Dust* that came through more strongly. This dealt with black modes of self-presentation and metaphysical perspectives on the natural environment, articulated from a black feminist perspective that had not before been

217

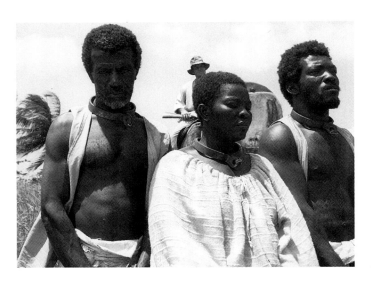

174 HAILE GERIMA
Sankofa 1993

encountered on such a scale in film. The contributions of artist and production designer Kerry James Marshall, cinematographer Arthur Jafa, and hair stylist Pamela Ferrell especially helped shape Dash's vision.

In *Sankofa,* the veteran Ethiopian filmmaker Haile Gerima continued the sweeping, cinematic explorations of black landscapes, identities, and anxieties that *Daughters of the Dust* had inaugurated; it was independently released about a year after Dash's film. The screenplay revolved around an African American fashion model who, while on assignment in an old Ghanaian fort and slave dungeon, experienced a flashback that for the majority of the film turned her into human chattel and transported her back to colonial Jamaica during the period of the transatlantic slave trade. Although as surrealistically conceived and beautifully photographed (by Augustin Cubano) as *Daughters of the Dust,* *Sankofa* (which, in the Akan language, means "to go back and retrieve") was more emphatic with its principal narrative, its prevailing theme of black remembrance, and the pain that remembering often brings. Both films used impressionistic, outdoor color photography that, with poignant close-ups and long shots from the sea and sky, turned bodies of water, expanses of land, and black faces into translucent pools of memory, mirroring the beauty and anguish in a past recollected and reimagined.

Moving from cinema to video, the merging of a meaningful and artistic representation of blackness suffered not so much from the medium itself as from the fact that the portable video camera was not used for artistic projects until around 1968: until then it was confined to commercial

218

ventures. From the early (and rare) appearances by black entertainers during television's infancy, to the post-1971 flood of black-casted sitcoms, dramas, and musicals, a broadcast and videographed image of black culture has usually been for entertainment and advertising.

In the U.S.A., the first signs of a black artistic life in this vast television wasteland occurred in the late 1960s and early 1970s when (following Martin Luther King's assassination and a rise in black urban unrest) several television producers broached the idea of black cultural programming to their local educational channels: these were eventually syndicated nationally on public television stations. Pioneering television programs like Maya Angelou's *Blacks, Blues, Black!* (1967-68), William Greaves's *Black Journal* (1968-70), and Ellis Haizlip's *Soul!* (1968-1975) introduced the possibilities of broadcasting serious (and often challenging) African American poetry, theater, dance, visual arts, cultural criticism, and a range of black musical styles that were absent from the commercial stations. Ironically, by the 1980s and '90s in a period of cable, direct broadcast satellite, and public access television—most black cultural programming in the U.S.A. (with the exception of the occasional specials, documentaries, or independent video art productions like Philip Mallory Jones's *First World Order* of 1994) recalled a conservative agenda that, even with the advent of Music Television, Black Entertainment Television, and a profusion of black music videos, was often without an artistic, experimental, and political perspective.

140

Since the arrival of music videos in the early 1980s artists have been limited mostly to making marketing tools for record companies. All the same, many have excelled in their respective genres with interesting story lines, innovative art direction, unusual camera work, and sophisticated imaging technology. The collaborations, for example, between performing legend Michael Jackson and director John Landis for the 1983 video *Thriller,* or between rap group Black Sheep and director Charles S. Stone III for the 1992 video *The Choice is Yours,* were recognized as artistic and commercial successes in black music video production. But one of the earliest examples of a visually stunning black music video was the 1982 feature-length work, *A One Man Show,* created by the Jamaican American fashion model, singer, and actor Grace Jones and the French photographer, graphic designer, and video director Jean-Paul Goude. In contrast to the hyper-edited concert-stage approaches of many music videos of the time, *A One Man Show,* according to film historian Raymond Durgnat, relied on what Russian filmmaker Sergei Eisenstein called "dynamic montage." Goude's postmodernist yet enamored video manipulations of Grace Jones's face and figure—recalling the Josephine Baker and Paul

175

32

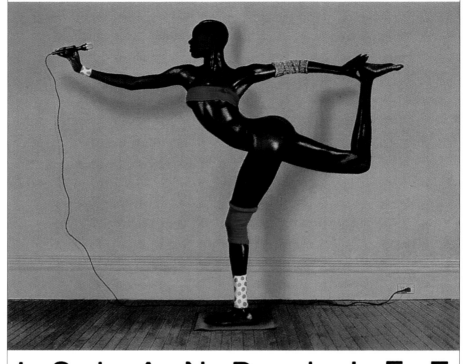

175 JEAN-PAUL GOUDE album cover for *Island Life,* Grace Jones, 1985

Colin collaborations of almost sixty years earlier—selected from a whole range of historical black images. Minstrels, *l'art nègre*, Carmen Miranda, and Harlem zoot suits were interpolated with 1980s exhibitionism and examination of identity. In their follow-up music video, *A State of Grace* (1986), Jones and Goude continued their assault on black representational conventions with, again, a series of video "sound paintings" that projected a persona whose very voice and posture confounded mainstream expectations of black popular culture.

As in the U.S.A. after the 1968 riots, a black cultural presence in the British media followed civil disturbances in Brixton in south London during the spring of 1981. This emerging black British consciousness, which happened to coincide with the advent of Channel 4 (the country's alternative, cultural television channel), encouraged British television to diversify staffs, to expand cultural programming, and (following the leads of such organizations as the British Film Institute and the Greater London Council) to give financial and technical assistance to various black media initiatives. It was out of this mix that several black independent media organizations emerged—Black Audio Film Collective, Ceddo Film/Video Workshop, Retake Film and Video Collective, and Sankofa Film and Video Collective, among others. This resulted in the creation of an important, London-based, black media arts scene in the '80s and '90s: a scene whose roots in the race politics and in the ideologies of postmodernism and cultural studies have produced films (such as *Dreaming Rivers* and *Looking for Langston)* and videos that reinvigorated an artistic cross-examination of identity, culture, and history.

The difference, however, between this group of black filmmakers and videographers and a mostly white, European and North American-based group of media (and, increasingly, computer) artists, was the realization that, in spite of the so-called "worldwide webs" and "networks," the majority of peoples of color in the world were neither connected nor

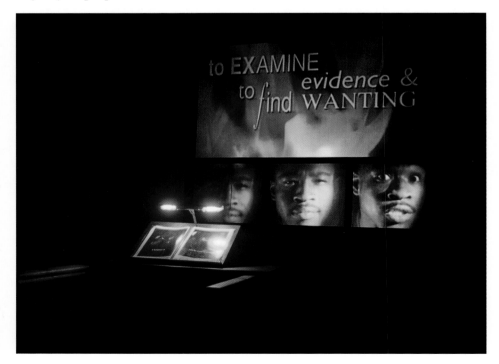

allowed any power over how they were represented in these new tech-
nologies. This recognition that they had little imput on "the information
highway" gave black media artists a sense of trailblazing, as well as of polit-
ical insurgency and anti-utopianism in their work.

176 Keith Piper's *Reckless Eyeballing* (1995) was a video and laser disk install-
ation activated by spectators as they stepped up to one of three lecterns
in an art gallery. This explored the very question of black participation
in the acts of seeing, of being seen and, more pointedly, of being seen
seeing. The title of this installation was taken from the 1950s American
euphemism about the then fatal, black male act of merely looking at
78 white women (as in the notorious Emmett Till murder case of 1955).
Its relationship to Piper's succession of projected black images and ampli-
fied sounds nevertheless leapt beyond any historically documented
incident of white-on-black violence, or of individual spectatorship.
Rather, in the context of a late twentieth-century black British renais-
sance in the arts, this installation advanced Keith Piper's notion of
"true interactivity"—an experience that via computers, videography,
and black cultural interventions such as "call and response," aural "cutting
and mixing," and "polyphony," allowed for "an unpredictable and intuitive
interaction between presenter and spectator." Emphasizing histories
(both remote and recent) of exclusion and subjugation, Piper's *Reckless
Eyeballing* suggested an alternative way of moving through cyberspace
and through the more conventional art world that, in spite of the promi-
nence of the forbidden look, balanced this with messages of empower-
ment for both the artist and the viewer.

SITES AND SOUNDS

Keith Piper's indictment in *Reckless Eyeballing* and Haile Gerima's oppres-
sive yet beautiful black world in *Sankofa,* were pushed to their extreme in
177 Jonathan Demme's *Beloved* (1998). Adapted for the screen from the
acclaimed novel of the same name by Toni Morrison, it was based on an
actual 1856 incident when a runaway slave, rather than see her children
taken from her and returned to slavery, killed one of them. Ironically, it
suffered in the view of most film critics and audiences from having
brought these horrific truths to the cinema screen. *Beloved,* however,
arguably succeeded in doing what no other film had done before: it
turned a very psychologically complex work of literature based on a true
event in African American history into a film of major artistic importance.
 The film's cinematography, innovative uses of color-saturation in film
stock, historic sets, and period costume designs transformed this ersatz

177 JONATHAN DEMME
Beloved 1998

commercial product into art. The story of the spirits of the past who re-emerge and cause havoc among ex-slaves required the creation of an historically accurate, atmospheric place that both amazed and terrified. Cinematographer Tak Fujimoto's close-ups of water, woodland, and black skin—the latter often disfigured and bloodied—made it a far from typical cinematic experience.

A large part of Demme's conjuration in *Beloved*—apart from Toni Morrison's word magic and Oprah Winfrey's bewitching performance—was his use of Haitian imagery in this tale of horror and redemption. "On an unconscious level," Demme acknowledged while filming *Beloved*, "[Haitian art] has affected my work enormously." Although set in Kentucky and Ohio in the 1870s, the film contained vestiges of a Haitian world view, where Creole is miraculously spoken and unsuspecting individuals are "mounted" by the spirits (or *loas*). From Demme's opening shot of graveyard tombstones to the film's hallucinatory house-party (reminiscent of streamer-festooned, *Vodun* temples), *Beloved* drew much of its visual and aesthetic strength from Haiti and its symbolic image of the *zombi*. Morrison's incarnated slave/child/ghost shared many of the

223

attributes of the *zombi*—an oppressed being denied a decent death and trapped in a world it should have left—and it was Demme who made this diasporic connection.

Not all film and video artists in the 1990s, and later, followed Demme's use of black diasporic imagery. As with their counterparts in the art world, many film, video, and computer artists made no explicit reference to either racial or cultural blackness in their work. Instead, media artists like Oladélé Ajiboyé Bamgboyé, Rico Gaston, and others disguised this blackness inside abstract passages, experimental film and video techniques, distorted soundtracks, and other manipulations—methods of expression that, while synonymous with "hip-hop" music and other forms of black urban art, were sufficiently postmodernist and self-critical to be perceived as "universal."

This "sometimes I am, sometimes I'm not, sometimes I forget" sense of the racial self at the end of the twentieth century was exemplified in British filmmaker Steve McQueen. He became a pivotal figure in the black British art scene of the 1990s—an artist who made "beautifully composed ciphers out of human existence and its wants," wrote one reviewer. From his earliest experimental film *Bear* (1993), which featured two nude male wrestlers (one of them himself), to his acclaimed *Deadpan* (1997), in which the façade of a wooden building falls around McQueen, this time clothed (reminiscent of Buster Keaton's famous scene from Hollywood's silent era), McQueen's "heartfelt immersion in his chosen medium . . . to speak to the mechanics and history of cinema itself" distinguished him. The fact that in his work the humanity was black, while of secondary importance to the greater artistic vision, was undoubtedly a part of this work's allure, and inseparable from McQueen's visual imagination.

Another black filmmaker at the end of the twentieth century, Charles Stone III, stood on the opposite end of the spectrum from McQueen. Stone has been noticed himself as an *auteur* and maker of distinctive music videos in the short history of this genre. By the end of the 1990s Stone had expanded his repertoire to include short experimental films, one of which, entitled *True* (1998), was a series of deftly edited cross-cuts between five African American men who chat with one another by phone in a hilarious coded language; this was sold to a national advertising agency and repackaged as the "Whassup True" television campaign for Budweiser Beer. This T.V. commercial—which Stone had conceived, directed, co-written, and acted in—received many awards worldwide, and soon brought his work to the attention of Hollywood.

But prior to this mainstream acceptance, Stone (with several innovative urban musicians) had already pushed the music video genre to

comparable heights. Stone's *You Got Me* (1998), performed by The Roots, Eve (of Destruction), and Erykah Badu, introduced a more tender and conceptually poignant perspective on black identity than most music videos of the time. The words of *You Got Me*—about love, emotional neglect, jealousy, and reassurance—were translated by Stone into a surreal urban reverie: the city's sidewalks, playgrounds, and buses are filled with reclining, comatose people, who are roused only towards the end of the video, and replaced with the death-like recumbency of Black Thought, The Roots' lead voice on this piece.

The push-and-pull between, on one hand, the conventions of communication in film and video production and, on the other, the high-art means of expression was constantly being put into play by *fin-de-siècle* black artists. This creative dialogue was evident in many projects, ranging from Thomas Allen Harris's films, which bridged fictional script-writing with documentary, to Jean-Pierre Bekolo's films, which seemed to luxuriate in an often fractured succession of *mis-en-scènes*. Even music videos were subjected to artistic analysis and occasional derision, as seen in the work of Susan Smith-Pinelo and several of Charles Stone III's satires of the genre. Similarly, meticulously splicing footage from obscure films into a rhythmic montage of sensory unease and social commentary was taken to a heightened level of intensity by Rafael Montañez-Ortiz, Fatimah Tuggar, Sanford Biggers, and other media artists of color.

Describing this aesthetic, which combines postmodernism and an African American "cut-and-mix" sensibility, conceptual artist Paul D. Miller, a.k.a. DJ Spooky, wrote:

... the sense here is one of prolonging the formal implications of the expressive act – move into the frame, get the picture, re-invent your name. Movement, flow, flux: the nomad takes on the sedentary qualities of the urban dweller. Movement on the screen becomes an omnipresent quality. Absolute time becomes dream machine flicker. The eyes move. The body stays still. Travel. Big picture, small frame .

He recalled a hundred years of technological innovations in film, video, and digital imaging: a century that, unacknowledged by most critics, owed a part of its language to black diasporal concepts of time and space. From filmed and theorized "ritual time" in Haitian *Vodun* to a multimedia language of hip-hop, Miller included these contributions in a set of acknowledged creative acts, thoughts, and players. He constantly re-visited the metaphor of a record-spinning, sound-and-light controlling, sensibility-fragmenting disk jockey. In this way he was not only

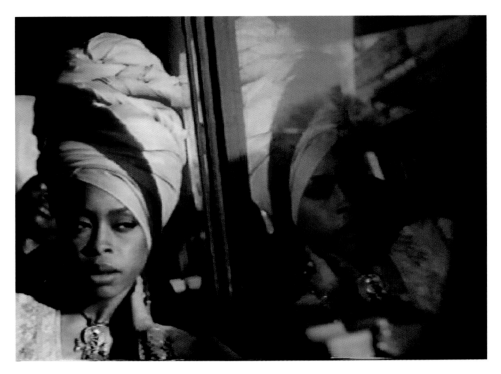

178 CHARLES S. STONE III *You Got Me* 1998

reminding readers of his own artistic persona and alter ego, but also of the conceptual reach of this deconstructing aesthetic, and of how largely this cultural contingent figures in a virtual world.

Paul Miller's own artistic forays into what he called a "prosthetic realism"—under the name DJ Spooky—drew from a whole universe of sensory data. He constructed soundtracks for experimental films and videos from snippets of pre-recorded music, monologues, and static, repeated and "scratched" (re-played in quick flutters of the reverse mode). But such aural and visual samplings did not seem chaotic, and audiences found wholeness and continuity in this work. *Rebirth of a Nation* (2002), for example, DJ Spooky's retort to D. W. Griffith, paired an elegiac synthesizer soundtrack with a sequence of grayscale-altered, split-screened frames from the 1915 original. Mindful of how *The Birth of a Nation* employed sophisticated editing to develop an alter-

179

226

native U.S. history that promoted white supremacy and advocated black subjugation, DJ Spooky also used advanced technologies to transform Griffith's transformative film: a politically inspired interference where, according to the artist, "echo meets alias in the coded exchange of glances."

Almost a hundred years after D. W. Griffith and his followers branded "with lightning" their version of history, DJ Spooky and other new media artists challenged those accounts with their own, digitally enriched works. By invoking the storytelling and prophesying of the West African *griot*, embellishing the narratives with cultural representations informed by the media and cyberspace, and adding reinterpretations of the past and present, they not only raised the perception of black diasporal arts but, more importantly, they changed their function. No longer just diversions or art for art's sake, these modes of image-making—demarcated by what Paul Miller called a "geographic and temporal simultaneity"—revealed contemporary conditions and, like the futuristic rays in an Aaron Douglas painting or a Keith Piper installation, they illuminated today's sites and sounds, as seen through a glass, diasporally.

179 DJ SPOOKY (a.k.a. Paul D. Miller) *Rebirth of a Nation* 2002

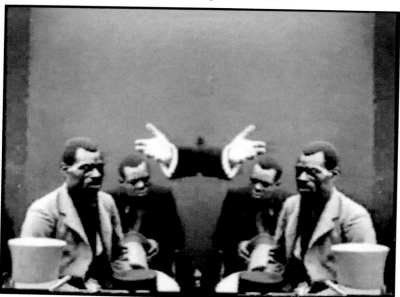

Fin-de-Siècle Blues

SUBVERTING THE "B" WORD

Unlike the European artistic dominance of the early twentieth century, the late 1990s and early years of the twenty-first century were full of a black cultural consciousness that was especially strong in the visual arts. Previously it had been a disadvantage for one's art to be too closely associated with black cultural concerns, but in the late 1990s it was acceptable, even fashionable, to be a black artist, or to interrogate black identity in one's work. This was an era that saw several major exhibitions and international biennials featuring exciting new work by artists from Africa, the Caribbean, and throughout the black diaspora. Johannesburg, Dakar, and Havana joined New York, London, and Paris as meeting grounds for serious art collectors and other observers of contemporary art. From "Seven Stories about Modern Art in Africa" (1995) at London's Whitechapel Gallery to "Freestyle" (2001) at New York's Studio Museum in Harlem, exhibitions put black artists under the spotlight, and they and their works became the subjects of widespread critical interest.

As with the black literary flowerings of the 1920s and 1960s, the 1990s saw art historians, theoreticians, and critics embracing the once-marginalized black artist, and examining racially encoded signs and images. A general interest in the artistic manifestations of racial identities, postcolonialism, the politics of difference, and the impact of globalization on the world's communities was clearly communicated by the flood of artists' monographs, critical studies, exhibition catalogues, articles, and websites.

Yet this was also a period when some artists built their reputations on works that clearly turned away from the current constructs of racial identity and, instead, undermined historical representations of racial and cultural difference. Beneficiaries of a more inclusive attitude as well as saboteurs of anything redolent of postcolonial complacency, "political correctness", or a celebration of the era of civil rights, these artists subverted the "b" word—black—and, like no generation before them, experienced critical and financial success through their artistic advocacy of a questionable racial and cultural identity.

228

Certain critics and curators at the start of the twenty-first century also foretold the end of the "black" label in contemporary culture, arguing that it could no longer effectively describe a racially hybrid people of cultural diversity, social complexity, and broad-based political alliances. While acknowledging the socially constructed realities of race and the lingering effects of racial discrimination for large segments of the world's population, they called for a critical discourse to cut through, like the works of art themselves, a cultural and racial clarity too often assumed by commentators. The descriptive term black did not make sense anymore.

These *fin-de-siècle* anxieties were echoed by sociologist Paul Gilroy in *Against Race: Imagining Political Culture Beyond the Color Line* (2000). Although written as an historical critique of racism and fascism, much of Gilroy's complaint was against those perpetrators of racist and fascist acts, past and present, who have more or less operated under the programs and designs of an "Afrocentric" or "black" cause. For Gilroy no amount of racial and cultural redress for past injustices justified black supremacism, especially when this implied segregation and resounded with overwhelmingly misogynist and racial myth-making tendencies.

The representative artist for the critical successes and conceptual limitations of a "black art" at this time was Kara Walker. While studying for a Master of Fine Arts degree at the Rhode Island School of Design in the early 1990s, Walker had discovered the old-fashioned and genteel technique of mounting black paper silhouettes of sentimental scenes on white backgrounds. With postmodern irony and an unapologetic ambivalence towards what Gilroy has described as a burdensome "black particularity," Walker skillfully gave her black silhouettes the trappings of an antebellum Southern melodrama, but they are large, the size of murals, and depict horrific acts of sexual assault and violence. Even in works not tied to a nightmarish master–slave narrative (like Walker's large-scale print *African / American*, 1998), her meticulous delineation of physical characteristics and costumes are fearlessly propelled into the viewer's inner maelstrom of racial, cultural, and sexual clichés. Walker stated: 180

> …the power [of these images], for me, comes from … [my] all-encompassing sense of blackness, an all-encompassing kind of awareness that I didn't know I had. So like it's an acknowledgment of a naiveté on the one hand, and a really heavy acknowledgment that I think I'm getting to a point where I understand not just what it means to be black, but what blackness means in our culture, and how, as a thing disembodied from myself or ourselves, it goes about making itself known in the world, in the culture.

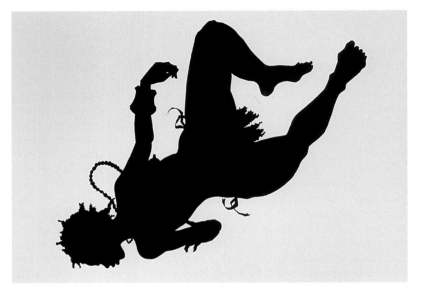

180 KARA WALKER *African/American* 1998

Walker's description of an illusory yet phenomenological blackness may explain why such images are particularly incendiary for many African Americans, who also sense the false nature of this version of blackness, but cannot tolerate its physical portrayal.

David Levinthal produced a series of photographs in the mid-1990s that, like Kara Walker's cut-outs, embraced the racial underside. Acknowledging that "race is probably one of the rawest nerves in our society," Levinthal used this truth in a close scrutiny of the black stereotype, resulting in *Blackface* (1995). His close-up, dramatically lit color photographs of racist, mass-produced ephemera against black velvet transformed rather ordinary mechanical toys, cookie jars, tins, dolls, and figurines into rarified treasures. Levinthal's *Blackface,* Michael Ray Charles's paintings, which revamped black stereotypes with a controversial edge, and *Without Sanctuary,* a collection of postcards documenting lynchings, which was exhibited and published, all intentionally blurred the historical boundaries between the evidence of racism and the desirable art object.

181

WHAT'S SO FUNNY ABOUT BEING BLACK?

Thelma Golden, who curated "Freestyle," the Studio Museum in Harlem's exhibition, wrote in her catalogue essay that the artists "live in a world

where their particular cultural specificity is marketed to the planet and sold back to them." Her undisguised sarcasm for a kind of black "free-trade agreement." is only equalled by the absurdity of the phenomenon itself: that of mass marketers, in a media-saturated, fantasy-inducing society, selling people's identities back to them in the form of popular culture, although in a repackaged and often degraded version. Paul Gilroy also noted in *Against Race* how the already problematic condition of blackness is further mired and cheapened "amid the gloss of cultural industries and their insatiable machinery of commodification." As perceived by Golden and Gilroy, this global marketing of black cultures is an undeniable fact of the early twenty-first century, fueling social schizophrenia, ethical debates and, remarkably, contemporary art.

The work of Renée Cox is especially preoccupied with a perceived progression towards a market-driven blackness. Throughout the 1990s this artist exhumed (and frequently laid bare) society's racial, sexual and gender-informed stereotypes in her large photographs, sometimes studio-based, sometimes digitally manipulated. Often using her own nude body as the vehicle for these social critiques (as in *Yo Mama*, 1993), Cox's sardonic and rather unconventional approach to self-portraiture made her photographs ironic rather than exploitative. This was most evident in her *Rajé Superhero* series: a collection of computer-altered photo-narratives featuring the artist as an Afrocentric Wonder Woman avenger. In a work from this series, subtitled *The Liberation of Lady J.* 182 *and U.B.* (1998), Cox has her Rajé Superhero character escort two fashion models out of two food packages that feature the most familiar and commercially successful black characters in modern advertising history: Aunt Jemima and Uncle Ben. By staging such a fantastic escape, Cox comments on the "thin line" between stereotypic characterizations and idealized depictions.

181 DAVID LEVINTHAL *Blackface* 1995

142 RENÉE COX *The Liberation of Lady J. and U. B.* 1998

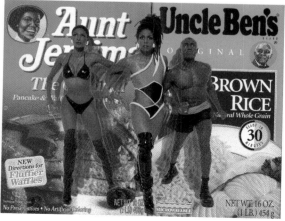

Huey Freeman, the wise-cracking main character in Aaron McGruder's comic strip *The Boondocks,* shared Cox's bemusement with the absurdities of racial representations and role models, as seen in his Afrocentric critique of the *X-Men* comics. McGruder fuses the popular Japanese *anime* style with a personal graphic shorthand, but his biting commentaries on mass media and African American affairs are entirely American.

Chris Ofili's *Afrodizzia (2nd Version),* 1996, raises similar questions. Like so many of this British artist's paintings, it operates on multiple levels of seeing and believing. At a distance one marvels at the swirling, paisley-like patterns made from colorful map pins and textured pigments, and a strident underpainting of multicolored scallops and circular shapes. Close-up, one discerns balls of elephant dung, strategically placed over and under the stretched canvas, many with map pins spelling out the names of famous black performing artists (like rapper LL Cool J) and sports heroes (like boxing impresario Don King). Closer still one can see hundreds of little black faces, cut from assorted magazines, adorned with crudely painted "Afro" hairstyles, and dispersed over the entire painting surface.

One school of thought views works like *Afrodizzia (2nd Version)* as an artistic variation on 1990s hip-hop music—the aural layering and musical quotations akin to Chris Ofili's layers of paint, collage, and cultural references. Other interpretations focus on Ofili's ironic yet decidedly critical stance towards contemporary black culture, disparaging the necessity or efficacy of identity markers, sartorial and individual. Like Renée Cox's *Rajé Superhero,* Ofili here uses satire to pose a serious question: at what social cost in historical ignorance and cultural disintegration are people "free" from the psychological shackles of racism in an era of media saturation and cultural commodification? Although the answer (as sensed from Ofili's preoccupation with excrement and ephemera) is at a *tremendous* social cost, both he and Cox have chosen to respond with humor and ambiguity, rather than a solemn denunciation. In both instances the wit in imagining a completely transformed or exaggerated sign of blackness (Cox's Lady J. and U. B. and Ofili's "Afros," respectively) only underscores how ineffectual and even counterproductive are many racial conventions in today's world.

That humor and visual irony are adopted to communicate this identity-conundrum in turn-of-the-century art is no surprise given the prominence in mass culture since the early 1990s of such black humorists as the U.S.'s Eddie Murphy and the U.K.'s Lenny Henry. Although seemingly light-years removed from the raucous joking of a "Def Comedy Jam," the works of Cox, Ofili and others all rely on a comic premise: that being black, an active participant in contemporary culture,

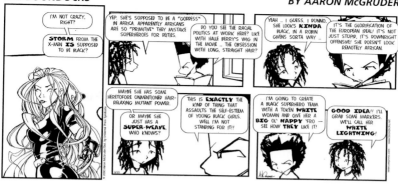

183 AARON MCGRUDER Strip from *The Boondocks* 2000

and ideologically wedged between a "Negro past" and a "post-black" present—regardless of how far society has progressed in terms of racial and economic parity—often invites an astonished recognition of laughable human folly. In 2000 the *New York Times Magazine* rhetorically posed the question, "What's so funny about being black?" The answer is: inherently nothing—and, in terms of a paradoxical position regarding race and self in the twenty-first century—plenty.

ANOTHER FORM OF IDENTIFICATION

There was a similar resistance to one-dimensional art categorizations based on race and ethnicity among African artists and curators at the end of the twentieth century. In 1999 Okwui Enwezor, the Nigerian-born US-based artistic director of the 2nd Johannesburg Biennale (1997) and of Documenta XI (2002), wrote: "This practice of ratification, which postmodernism processes, reproduces, and fashions into 'difference' denies African artists a claim to subjectivity and self-narration." According to Enwezor, many forces—both from the traditional cultural factions and current art regimes—were implicated in limiting the ways in which many contemporary African artists' works were understood. The fact that African artists were practising in the metropolises of the West made it problematical to use difference as a "determining criterion for their inclusion within the pantheon of contemporary cultural producers." Even within the context of so-called inclusive categories of contemporary art concerned with difference, globalization, or identity, African artists rarely received informed assessments of their works that

184 CHRIS OFILI *Afrodizzia (2nd version)* 1996

185 YINKA SHONIBARE *Cloud 9* 1999–2000

did not succumb to a stock anthropological response to peoples and things *African*. Many critics were unable to accept that African artists could be culturally conversant across national and linguistic boundaries, and that their reply to contemporary conditions was a sophisticated deployment of conceptual, performance, and other postmodern art-making strategies.

The works of Yinka Shonibare were emblematic of a *fin-de-siècle* art that disrupted conventional as well as non-conventional notions of what it meant to be *African, British, black, postmodern,* or any combination of these. Shonibare's visual dialogue between, on one hand, his installations of mannequins wearing tailored clothes made from so-called "African" printed fabrics—taken to unearthly heights in his *Cloud 9* (1999/2000)— and, on the other, his photo-serializations of historical costume dramas featuring himself, challenged those critics who might have categorized him as just a sculptor, a photographer, or a performance artist. In his installations his masterful assortment of historical allusion, postcolonial critique, and craftsmanship thrust his examinations of the authenticity of art, himself, and the artistic vocation straight into the heart of visual meaning. Similarly, his highly theatrical photographs, fusing a visualization

185

235

of the English literary tradition (as in a Merchant/Ivory film) with a meditation on the history of blacks in Great Britain, have generated much

187 discussion on the black persona. Works from Shonibare's *Dorian Gray* series (2001), with their moody cinematic atmosphere and Shonibare's portrayal of Oscar Wilde's narcissistic protagonist, revealed a conceptual link to his mannequin-and-printed-fabric installations through their shared investigation of fashion as a marker of distinction and disjuncture.

It was in this scrutiny of European/African cultural relations that many African artists at the end of the twentieth century found an abundance of visual information. In urban centers both on the continent of Africa and in the West they grappled with the contradictions of "first-world" surplus and "third-world" poverty, a sustained white entitlement and interminable black derogation, as well as U.S. cultural dominance and disregard for all things non-Western. These contradictions, with the end of racial *apartheid* in South Africa still recent, encouraged several to employ a mix of theory, practice, and morality in their investigations of this new social reality. The South African artist Johannes Phokela, quoted sixteenth- and seventeenth-century Dutch art in a series of ironic paintings. *Pantomime*

186 *Act Trilogy* (1999) was partly inspired by the 1599 Jacob de Gheyn II drawing *Allegory of Death,* and continued its moralizing tenor. Phokela's iconography—diagrammatic grids and an armed and clownish African cherub/child soldier—reflects the desire for a systemic understanding of an often fatal and tenuous postmodern existence.

Minnette Vári, another South African artist, also made works that frequently probed a traumatized and marginalized psyche. Her contro-

188 versial *Self Portrait 2* (1995), a digitally altered and conscious affectation of

236

186 JOHANNES PHOKELA
Pantomime Act Trilogy 1999

187 YINKA SHONIBARE
Dorian Gray Scene 6, 2001

188 MINNETTE VÁRI
Self Portrait 2 1995

the artist as a primordial black woman, fueled the indignation of even the most indulgent critics of contemporary African art. "Here we may not find hate necessarily," wrote the Nigerian artist and art historian Olu Oguibe, "but we do find racial disregard and license alright." Vári's *Self Portrait 2* intentionally elicited a critique of the limitations of a postmodern and post-*apartheid* "self portrait" in South Africa: a place weighted down with racial and political baggage too pervasive to ignore.

Another conceptual work by a South African artist that roused a barrage of criticism was Tracey Rose's *Span II* (1997): a performance for the 2nd Johannesburg Biennale that featured the artist—nude and sheared of all scalp and body hair—within a large glass case. Knotting the strands of her shorn hair and seated on a video monitor that simultaneously zoomed in on her handiwork, Rose offered a whole litany of cultural references—Europe's former practice of exhibiting peoples of color, women's fundamental role in cottage industries worldwide—and themes—feminism and racial difference. In this work she was also proffering her allegiance to what curator Gerardo Mosquera described in 2001 as the unstable "international language" of contemporary art.

189

Mosquera's thoughts on a growing lack of interest in identity were largely directed towards contemporary art and artists from Latin America, yet these same observations strongly resonated with other art works and artists. In other words, African artists like Yinka Shonibare, Johannes Phokela, and others show an *Africanity* in their art not through folk, religious, or historical references but, rather, through artistic practices and critical discourses that, in different ways, establish open channels of communication between continents, cultural zones, and communities.

237

Further evidence of this subtle but distinct shift at the turn of the century—from an ethnically or racially emblematic art, to an internalized or profound African/black/postmodern art—can be seen in the work of the Senegalese fashion designer and performance artist Oumou Sy. In her *Cyberdress* (1997), for instance, the juxtaposition of costly hand-dyed fabrics and recyclable CD-ROMs made it more concept than artifact, a work worthy to considered in a contemporary, cosmopolitan context.

These sites of new African art—London, Johannesburg, Dakar, Paris, New York, cyberspace, and all—have exploded the assumption that ethnic and geographic demarcations define and authenticate the genre. Similarly, artists like Tracey Rose and Oumou Sy (and Sokari Douglas Camp and Werewere Liking before them) have further questioned the images of the African craftswoman and the cosmopolitan African male artist, bringing radical ideas, including those of gender, to an African artistic identity.

Finally, South Africa's multiracial makeup, its history of struggle, and its post-*apartheid* entry into the world community in 1991 have given African artists a new racial significance. Some have seen this as an unfortunate imposition on more inclusive views of modern culture in Africa, but others have acknowledged how impossible it is for African artists, curators, and intellectuals to deny racial oppression and discrimination.

Shonibare, Phokela, Vári, Rose, Sy, and others have abandoned the expectation that they will "show their passports" (Gerardo Mosquera), replacing this with something more conceptual in their quest for individ-

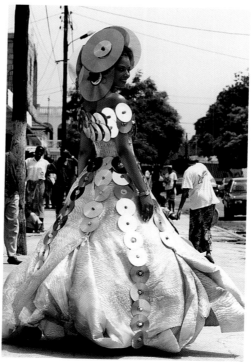

ual recognition. The message for other artists of African nationalities and descent is that by coming to terms with the act of declaring one's genealogy and repudiating historic injustices they, too, can transcend the distorted versions of *race* and *place,* participate in an international conversation in the visual arts and, paradoxically, also take part in an African diasporal and black postmodern dialogue.

RECUPERATIONS

Writing in 1990, Adrian Piper argued that the linguistic latitude of poststructuralism and the historical relativism of postmodernism were ideal "if you want to co-opt women and people of color and deny them access to the potent tools of rationality and objectivity." Well known for her denunciations of institutional and individual racism through conceptual art, Adrian Piper surprised many when she admonished the reigning cultural theorists (like Piper, among the art world élite) for undermining the very real struggle by African Americans for recognition.

239

In 1997 philosopher Patricia Huntington substantially added to Piper's arguments, but within a larger study of an "Africana philosophy of existence." In her essay entitled "Fragmentation, Race, and Gender: Building Solidarity in the Postmodern Era," Huntington negotiated the theoretical expanse between W. E. B. Du Bois's premise that racial problems lie at the center of modern social issues, and the opposite position upheld by the French feminist Luce Irigaray that sexual difference is "the burning issue." Huntington, critical of both absolutes, prescribed "unlearning racial myopia" and cultivating "the ability to grasp any social event or phenomenon in terms of its multiple dimensions and its disjunctive and conflicting impact on various groups and individuals."

There were also several artists who attempted to bring a degree of moral purpose and conceptual wholeness to black art. Chakaia Booker's *Wrench Wench II,* 2001, an undulating column of twisted rubber tires on a solid armature, brought a refreshing immediacy to the art scene. Its reference to earlier modernist sculptures was respectful, and its invocation of former instruments of labor—both inanimate and human, the latter demarcated by race and gender—introduced a significant theoretical layer and, by association, a modicum of the postmodern. Several artists at this time opposed postmodernism's emotional distance with a spiritual, racially charged vision, in which black histories and mythologies were paramount. The Cuban artist Belkis Ayón, from the late 1980s until her untimely death in 1999, introduced bold yet enigmatic black-and-white depictions of the ceremonies of the Afro-Cuban Secret Society known as *Abakuá*. Although she used the demanding technique of collagraphy (a melding of relief and intaglio printmaking from a combination of

191

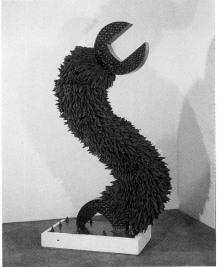

191 CHAKAIA BOOKER
Wrench Wench II 2001

192 BELKIS AYÓN *La Cena
(The Dinner)* 1991

collaged and hand-engraved plates), Ayón created elaborate, graphically dense, and often multi-paneled scenes like *La Cena (The Dinner)*, 1991, featuring faceless human figures with staring eyes and a serpent's skin, engaged in mysterious, anguished rituals.

In *The Dinner*, the "brotherhood" at a ritual meal served as a visual metaphor not just for a symbolic Afro-Cuban covenant, but also for the possibility of a universal banquet where all humanity would be present, regardless of cultural distinctions. There was some evidence towards the end of Ayón's life and later that African diasporal arts and black artists were, indeed, becoming a recognized part of this new art world. During these years, awards and important art commissions were given to such black artists as Robert Colescott, Jacob Lawrence, Kerry James Marshall, Steve McQueen, Chris Ofili, Kara Walker, and artist and critic Deborah Willis. Belkis Ayón herself was honored with a purchase by MOMA, New York, and an art retrospective at the 7th Havana Bienal in Cuba. The Studio Museum in Harlem, the world's leading institution for African diasporal arts, also flourished during this period with new facilities, and the dynamic leadership of Lowery Stokes Sims and Thelma Golden.

Finally, plans to build two major museums dedicated to black art and culture were announced in 2001: a new Museum of African and Oceanic art in Paris (to supersede its 1931 predecessor), and a new Museum of African American History and Culture in Washington, D.C. (to be housed in the renovated 1881 Arts & Industries Building). These museum projects, even at this contentious moment, promised that African diasporal arts, rather than disappearing or "fading to black," will persist in the collective and cultural imagination well into the twenty-first century.

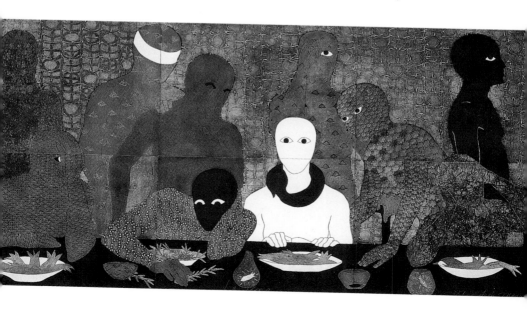

Biographical Notes

Compiled by Alexander X. Byrd and Richard J. Powell

These notes include those artists whose work is illustrated and discussed.

★ = cross-reference.

AFRI-COBRA = African Commune of Bad Relevant Artists, Chicago-based, founded 1969.

WPA/FAP = Works Projects Assocation/Federal Arts Projects, U.S.A. 1935–43, state-funded artistic projects in the job creation scheme under the Roosevelt administration.

Adams, John Henry Jr.
(*c.* 1880, *fl.* 1910s)
African American graphic artist and arts educator. Based in Atlanta, and a contributor to *Voice of the Negro*.

Adede, Sosa
(*fl.* late 19th C)
Dahomey sculptor also known as Sosa Adede Likohe. Called "Da Atinkpato" or Lord Woodcarver for the imposing royal figures he carved for Dahomey kings Guezo and Glele.

Amos, Emma
(1938–)
African American painter. Most acclaimed work explores individual freedom and fear through the imaginative arrangement of human figures—often as falling or floating—on flat planes.

Attille, Martina
(1959–)
St. Lucia-born filmmaker. Co-founder of the London-based film and video collective Sankofa, and director or producer for several of its influential features. As evinced in her work on *Passion of Remembrance* (1986), and *Dreaming Rivers* (1988), especially concerned with the cultural politics of contemporary Britain—their historical roots and contemporary manifestations.

Ayón, Belkis
(1967–99)
Cuban artist whose enigmatic, spiritually infused, multi-paneled prints raised the profile not only of Afro-Caribbean religious traditions internationally, but of late 20th-century Cuban art and culture in general.

Barboza, Anthony
(1944–)
African American photographer. In the 1960s, active in New York's pace-setting Kamoinge Workshop of black photographers. Since the mid-1970s has worked in fashion, documentary, and editorial photography. Produced a highly acclaimed portrait series on black musicians, literati, and visual artists.

Barnes, Ernie
(1939–)
African American painter and former professional football player. In the 1970s, and with some commercial success, depicted black social life and recreation.

Barthé, Richmond
(1901–89)
African American artist. Began his career as a painter, but mature work and present reputation stem from his remarkable talent as a sculptor—especially his long, lithe figures of black workers, dancers, and Broadway notables.

Basquiat, Jean-Michel
(1960–88)
American painter of Haitian and Puerto Rican parentage. In the 1980s achieved meteoric fame in the U.S. and Europe for his crayon-and-paint drawings, graffiti art, and assemblages. In 1984–85 he collaborated with ★Andy Warhol on a series of paintings.

Bearden, Romare
(1911–88)
African American painter and collagist. His work, rich in historical references, employs dazzling technique. He is an outspoken advocate for African American arts and artists.

Bey, Dawoud
(1958–)
African American photographer. His patient, immensely contemplative portraits survey the attitudes and aspirations of black urbanites.

Biggers, John
(1924–2001)
African American painter, sculptor, and muralist. Celebrated for the potent realism and painterly rhythm evident in his depiction of West African and African American life. Founded and chaired the art department at Texas Southern University.

Billops, Camille
(1933–)
African American sculptor, painter, and filmmaker. Thought-provoking satires of contemporary racial imagery prevail in all three of her chosen media. Frequently collaborates with her husband James Hatch.

Boghossian, Alexander "Skunder"
(1937–)
Recognized together with Gebre Kristos Desta as one of the main progenitors of contemporary Ethiopian art. His paintings and assemblages reflect a deep and strong basis in the ancient culture and symbolism of his homeland.

Booker, Chakaia
(1953–)
African American sculptor. Proponent of a latter-day school of abstraction, this artist invests found materials, such as discarded automobile tires and machine parts with a dynamic, culturally suggestive character in her sculptural assemblages.

Bowling, Frank
(1936–)
Guyanese painter working in London and New York since the late 1950s. Experimented with Pop Art subjects and techniques in 1960s, but moved on to thickly encrusted abstracts executed through various paint-pouring techniques.

Boyce, Sonia
(1962–)
Black British painter and installation artist of Barbadian and Guyanese parentage. Issues relating to domesticity, sexual abuse and the myriad cultural complexities of contemporary Britain permeate her work.

Broodhagen, Karl
(1909–)
Guyana-born sculptor, raised and working in Barbados. Recognized for finely executed busts of Barbadian notables and plain folk, as well as for trailblazing work as a Caribbean-wide arts educator.

Brown, Everald
(1917–)
Jamaican carpenter, sculptor, and self-taught painter. Considered one of the Caribbean's outstanding folk artists. Work inspired by religious visions and often incorporates the iconography of Rastafarianism and the Ethiopian Orthodox Church.

Buchanan, Beverly
(1940–)
African American painter and sculptor. Her representations of Southern living space—paintings, drawings, assemblages, and full-sized installations—explore black rural life, past and present.

Burra, Edward
(1905–76)
White British painter, stage designer and draughtsman. Significant here for watercolors of Marseilles and Harlem street life, executed in the late 1920s and early '30s respectively.

Butcher, Ras Ishi
(1960–)
Barbadian painter. Informed by a Pan-Caribbean iconography and cultural impetus, his canvases are brightly colored

contributions to the region's long-thriving and traditionally frank discourse on island history, culture, and politics.

Camus, Marcel
(1912–82)
French filmmaker. From the late 1950s to the late '70s directed a series of haunting, exotic, location-films of which *Orfeu Negro* (*Black Orpheus*) of 1958 was the most celebrated, and remains the best known.

Catlett, Elizabeth
(1915–)
African American sculptor. Work deals masterfully with the struggles and triumphs of people of color throughout the hemisphere. She has lived in Mexico since the late 1940s but has remained, nonetheless, a celebrated interpreter of black life on both sides of the border.

Chandler, Dana C. Jr.
(1941–)
African American painter and muralist, with a prominent place and vocal presence in the black arts movement of the late 1960s and early '70s. Work explores themes of racial exploitation, uplift, and comparative race relations in the United States and South Africa. As an instructor at Northeastern University, was also a principal in the artist-in-residence movement during the 1970s.

Chase-Riboud, Barbara
(1936–)
African American writer and sculptor. In the 1960s and '70s, her enigmatic abstract sculpture—primarily in bronze—ensconced her among the leading lights of contemporary art. In 1979, her fictionalized account of Thomas Jefferson's affair with his slave, *Sally Hemmings*, was a cause célèbre.

Chong, Albert
(1958–)
Jamaican photographer. Acclaimed for prints capturing the complexes of identity in multi-ethnic Jamaica, and honoring the contours and consequences of African American spirituality and ritual—especially Rastafarianism, *Obeah*, *Santeria*, and *Candomble*.

Clark, Edward
(1926–)
African American painter. Expatriate in Paris from 1951–56, and during late 1960s. An eclectic abstractionist, he has experimented with and mastered a range of non-representational techniques during his career—gestural and hard-edge abstraction, and color-field painting among them.

Coe, Sue
(1951–)
White British political activist, illustrator, and painter working in New York. Since the mid-1970s, her protest art has caricatured and critiqued social antagonists from racial terrorists to the meat industry.

Colescott, Robert
(1925–)
African American painter and arts educator. Distinguished since the late 1970s for dense, brightly colored montages reconnoitering the social maze of race and sexuality in American life—especially the contemporary and historical exigencies of interracial sex.

Colin, Paul
(1892–1985)
French graphic artist, set designer and lithographer, famous in the 1920s and '30s for his poster designs. Image maker to Josephine Baker and to the equivalent of the "New Negro" ideal of 1920s Paris.

Conwill, Houston
(1947–)
African American conceptual and installation artist, whose work focuses on transformations, marrying symbolism with a subtle irony. In some 1990s projects collaborated with architect Joseph de Pace and writer Estella Conwill Majozo.

Cortor, Eldzier
(1916–)
African American painter and print-maker. Gained national attention in the mid-1940s for his statuesque black nudes, some published in *Life* magazine. His work deals prominently with representations of black femininity and beauty.

243

Covarrubias, Miguel
(1904–57)
Mexican draughtsman, painter, and stage designer. Working in New York in the 1920s and '30s, he committed himself, for a time, to illustrating various "Negro types." Later deeply involved in anthropology and archaeology, and co-founder of Mexico's Ballet Bellas Artes.

Cowans, Adger
(1936–)
African American photographer. Pioneer in the movement of American photography from craft to fine art. In the 1960s, he documented the civil rights movement—capturing critical moments in the history of the Student Non-Violent Coordinating Committee (SNCC) and the Congress of Racial Equality (CORE). A member of AFRI-COBRA.

Cox, Renée
(1960–)
Jamaican-born, New York based photographer. Best known—and, in some critical circles, considered notorious—for her at times sexually charged, often humorous tableau-vivant satires of racism and sexism.

Crichlow, Ernest
(1914–)
African American painter and arts educator. In the late 1930s was among the cadre of black artists nurtured under Harlem's first WPA/FAP arts projects. Achieved commercial success as an illustrator of children's books and has exhibited extensively. Co-founder—with ★Romare Bearden and Norman Lewis—of New York's Cinque Gallery.

Cruz, Emilio
(1938–)
African American artist. Recognized for his use of vibrant colors, symbolism, and highly stylized human figures. He shared a studio with ★Bob Thompson in the late 1950s, and exhibited in New York, Dakar, and Chicago in the 1960s.

Dash, Julie
(1952–)
African American, independent filmmaker. Acclaimed for her literate, non-linear, historical dramas such as *Illusions* (1984) and *Daughters of the Dust* (1991).

Davis, Stuart
(1892–1964)
White American painter and art theorist. Until the 1950s, his studied, bold Cubism distinguished him as America's preeminent modernist. In the 1910s, he composed a series of saloon and dance hall portraits of blacks—some featured in the radical periodical *The Masses*.

Dawson, Charles C.
(1889–1982)
African American painter and illustrator. In the 1920s and '30s he worked in product advertising, and illustrated race publications—among them his 1933 *ABC of Great Negroes*. Also served as curator of the Tuskegee Institute Museum.

Debela, Achamyeleh
(1947–)
Ethiopian media artist, noted for his cutting-edge recourse to arts technology, and as a curator for his efforts to maintain an Ethiopian presence in American and black diasporal arts.

Delaney, Beauford
(1901–78)
African American painter. His search for a satisfying, individual aesthetic led him to experiment in the early 1940s with non-representational abstract forms. He studied and worked in Harlem during the Depression, and from the 1950s as an expatriate in Paris. Closely associated in New York and Paris with the eminent African American writer James Baldwin.

Demme, Jonathan
(1944–)
White American film director. In addition to *Beloved* (1998), this Academy Award-winning director's most notable film credits include *Melvin and Howard* (1980), *Stop Making Sense* (1984), *The Silence of the Lambs* (1991), and *Philadelphia* (1993).

DePillars, Murry N.
(1938–)
African American painter, educator, and arts administrator. Renowned for using the canvas to explode stereotypical images of black culture; heralded as an educator for his efforts to integrate black artists into the modern canon. Member of AFRI-COBRA, and, with

★Jeff Donaldson, shepherded the black arts movement in Chicago in the 1960s and '70s.

de Rooy, Felix
(1952–)
Curaçao-born artist and filmmaker. From the mid-1980s, his Comic Illusion Productions delivered a number of astute historical dramas— among them, *Almacita di Desolato* (1986), and *Ava and Gabriel* (1990).

DJ Spooky, a.k.a. Paul D. Miller
(1972–)
African American musician, conceptual artist, and writer who uses a variety of digitally created sounds as key elements in his work. Based in New York City, he is widely acknowledged for his insightful cultural criticism as well as for his innovative art.

Donaldson, Jeff
(1932–)
African-American printmaker, painter and educator. Intent on the recovery and exhibition of a distinctly black aesthetic linking and encompassing visual traditions from Ancient Egypt to the contemporary art of Africa and its diaspora. Co-founder, with Wadsworth Jarrell, of AFRI-COBRA.

Douglas, Aaron
(1899–1979)
African American painter, muralist, and illustrator. Prominent in the 1920s and '30s, his drawing style featured highly stylized silhouettes; earthy, soft colors; and sharp angles. His subject matter ranged from moments in African American history to contemporary motifs of jazz culture. Reached large audiences because his illustrations were featured in *The Crisis*—the organ of the NAACP—and in several quintessential "New Negro" publications, including James Weldon Johnson's *God's Trombones: Seven Negro Sermons in Verse*.

Douglas Camp, Sokari
(1958–)
Nigerian-born sculptor trained in California and London. Her kinetic assemblages of wood, steel and cloth engage and re-present the cultural practices of the Niger Delta.

244

Drummond, Arthur
(1871–1951)
White British genre and figure painter. Exhibited at the Royal Academy and other London galleries from the 1890s.

Dunkley, John
(c. 1891–47)
Jamaican barber and self-taught painter. Work depicted the Jamaican landscape and natural environment. Exhibited in Jamaica, England, and Canada in the 1930s and '40s.

Duval-Carrié, Edouard
(1954–)
Haitian painter, based in south Florida. Takes as his subject the culture and history of his birth place—often concentrating on *Vodun*, and the absurdity and tragedy of Haitian politics.

Edmondson, William
(c. 1870–1951)
African American sculptor. The first black artist to have a one-man exhibition at the Museum of Modern Art in New York. He had no formal art training, worked only in limestone using a few basic tools, and sculpted mainly religious and Biblical figures—the crucifixion, angels, and preachers among them.

Edwards, Melvin
(1937–)
African American sculptor. His studio pieces and large-scale public works in steel and stainless steel are often executed and deployed to evoke significant themes and episodes in African American cultural politics, such as his celebrated series *Lynch Fragments*.

Egonu, Uzo
(1931–96)
Nigerian-born printmaker and painter residing in London from the late 1940s. His work—always showing a strong sense of design and often flirting with abstraction—drew on African religious themes, Igbo oral traditions, and motifs from contemporary Nigerian life.

Evans, Minnie
(1892–1987)
Self-trained African American painter. Began sketching her religious visions in the mid-1930s, but did not show her work publicly until 1961. Acclaimed as a folk artist.

Evans, Walker
(1903–1975)
White American documentary photographer. His Depression-era depiction of the American South—its people, its architecture, and its social convulsions—have earned him a place among the great photographers of the 20th century. Collaborated with James Agee on *Let Us Now Praise Famous Men* (1939).

Fleming, Sherman
(1953–)
African American visual and performance artist. From 1976 to 1988 his performances provocatively concentrated on issues relating to black masculinity, eroticism, and representations of them in society at large. Subsequently—often in collaboration with art historian Kristine Stiles—has focused his attention on issues of race and gender.

Fuller, Meta Warrick
(1877–1968)
African American sculptor. Best known for work during the first and second decades of the century prefiguring themes arid styles of "New Negro" arts movement. Working predominantly in bronze and plaster, she explored the African heritage of black art, and condemned—through faithful depiction—the political and social tragedies of contemporary African American life.

Gerima, Haile
(1946–)
Award winning Ethiopian filmmaker. Renowned for his cinematic critiques of "modernization" and the resulting class relations in contemporary Africa in films such as *Harvest, 3000 Years* (1974), *Bush Mama* (1975), and *Ashes and Embers* (1982).

Gilliam, Sam
(1933–)
African American painter who came to prominence in late 1960s with stained, unsupported canvases draped or suspended from walls and ceiling. Since the late '70s celebrated for his jazz-influenced collage and thickly painted canvases reminiscent of patchwork quilts.

Goude, Jean-Paul
(1938–)
Commercial artist of French and Irish-American parentage. Celebrated for his advertising campaigns, for Chanel fragrances Egoïste and Coco. Decried for his fascination with racial typing (apparent in his image-making for pop singer Grace Jones and model Toukie Smith).

Greaves, Stanley
(1934–)
Guyana-born painter working and living in Barbados. Work interrogates political and social machinations in the post-colonial Caribbean. Founder of the Department of Creative Arts at the University of Guyana.

Griffith, D. W. (David Wark)
(1875–1948)
White American screenwriter and director. A pioneer in the technical and dramatic development of U.S. film. Revered and reviled for his epic, *The Birth of a Nation* (1915).

Griffith, Francis
(1916–2001)
Barbadian painter. In the 1960s his portrayals of the African landscape informed and reflected a revived black nationalist impulse in Caribbean and American arts.

Gunn, Bill
(1934–89)
African American director and screenwriter born William Harrison Gunn. Best known for his direction of the award-winning *Ganja and Hess* (1973). Wrote the screenplay for *The Landlord* (1970) and *The Greatest: The Muhammad Ali Story* (1977).

Gwathmey, Robert
(1903–88)
White American painter and arts educator. From the late 1930s through the early 1970s—against the grain of Abstract Expressionism—the racial politics of the American South remained his prime subject matter.

Hammons, David
(1943–)
Avant-garde African American artist. His body prints, installations and assemblages explore the problematic relationship between the stark material reality of contemporary black life, and the consumerism and political mythology of American society at large.

Hampton, James
(1909–1964)
African American millenarian. Gained posthumous recognition as a folk artist for the sprawling testament to his religious faith that he constructed and installed in a rented Washington, D.C. garage: *Throne of the Third Heaven of the Nations Millennium General Assembly*.

Harleston, Edwin A.
(1882–1931)
African American painter characterized as a romantic realist for his portraits, executed during the first third of the 20th century, of African American rural folk and élite.

Haring, Keith
(1958–90)
White American artist whose graffiti-like drawings and commercial inroads into the market-driven art world made him one of the art celebrities of the 1980s.

Harrington, Ollie
(1912–95)
African American journalist and political cartoonist. From the 1930s best known for his satirical anti-racist panels—*Dark Laughter* and *Jive Gray* among them. Branded a subversive, in 1951 he left the U.S.A. for Europe, where he continued his searing critiques of American race-relations.

Harris, Lyle Ashton
(1965–)
African American photographer. His self-portraits interrogate the social processes of gender construction, and confront stereotyped, heterosexual notions of black masculinity.

Hathaway, Isaac Scott
(b. *c.* 1874, *fl.* 1910–50)
African American sculptor, ceramist and arts educator. At mid-century, referred to among race men and women as "the

dean of Negro ceramists." This for having executed busts and death masks of numerous African American notables, and for introducing ceramics education to several black colleges.

Hayden, Palmer C.
(1893–1973)
African American painter renowned for work incorporating black folk hero John Henry, as well as for bright, action-packed scenes of African American life in the 1920s and '30s (though also notorious for those that verged on stereotypes). In 1926, Hayden won the first Harmon Foundation prize for black achievement in fine arts.

Hendricks, Barkley L.
(1945–)
African American painter. The self-assured, naturally rendered black men and women of his portraits reflected and informed the black consciousness movement of the 1970s.

Humphrey, Margo
(1942–)
African American printmaker. She brings a refreshing irreverence to issues of race and class in American life—subjects often considered from an over-somber distance. Her arrangement of incongruous combinations of symbols and signs gives her work a disarming surrealism.

Hunt, Richard
(1935–)
African American sculptor. His abstract and surrealist manipulations of welded metal, steel, aluminium, copper, and bronze have made him a leading U.S. artist. Since the 1960s regularly awarded commissions for large public outdoor sculptures in the U.S.A.

Hyppolite, Hector
(1894–1948)
House painter, *Vodun* priest, and internationally acclaimed, self-taught Haitian painter. In the late 1940s his interpretations of the *Vodun* pantheon intrigued Surrealist artists and theorists.

Jaar, Alfredo
(1956–)
Chilean-born photographer. His installations—often photographs

accompanied with light-boxes, mirrors, and transparencies—document and explore the exploitative links between the developed and developing worlds.

Jackson, Harlan
(1918–93)
African American painter. Following a trip to Haiti in the late 1940s (with *Eldzier Cortor), he developed a semi-abstract approach to art that continued into the late 1960s.

Jackson-Jarvis, Martha
(1952–)
African American ceramic sculptor and installation artist. Her abstract, ceramic accretions emote a concern with familial traditions—especially processes and rituals of cultural regeneration.

Janniot, Alfred
(1889–1969)
French sculptor. Commissions that he completed in the 1930s reflected the primitivist fascination with things African then coursing through European and American arts.

Jarrell, Jae
(1935–)
African American textile artist and fashion designer. Works primarily in leather and suede, with hand-painted appliqué and silk screens. From the 1970s—first in Atlanta and now in New York—has designed for men, women, and children. Member of AFRI-COBRA.

Johnson, Sargent
(1887–1967)
African American sculptor, ceramist, and printmaker especially active in the 1920s and '30s. Working in wood and clay, he sculpted stylized African American figures of great dignity.

Johnson, William H.
(1901–70)
African American artist now considered one of the most important of his generation. He lived and worked in the U.S., Europe, and North Africa, and the subject matter and style of his paintings were as wide-ranging as his wanderings. He is best known for a series of brightly colored, narrative panels and portraits executed from the late 1930s to the mid-1940s depicting historical images as well

as scenes from everyday African American life.

Jones, Ben
(1942–)
African American mixed-media artist and printmaker. Combines African and Afro-American cultural symbolism—from Cuba and Brazil especially—with American political iconography—from the civil rights and gay rights movements in particular—to present black men as positive subject matter.

Jones, Lois Mailou
(1905–98)
African American painter who has worked extensively in the French-speaking world, especially in France, Haiti and Senegal. Known for her Cubist incorporation of African imagery. Recognized as a teacher for her prodigious influence on a generation of African American artists.

Jones, Phillip Mallory
(1947–)
African American video artist. Work attempts to capture the physicality and aesthetic of African, and diasporal performance. Among his projects are *Soldiers of a Recent and Forgotten War* (1981), *Ghosts and Demons* (1987), *Footprints* (1988), and *First World Order* (1994).

Joseph, Tam
(1947–)
Dominican-born painter of Nigerian descent, based first in London, later in France. Appreciated for his eclectic subject matter, and understated treatment of race and nation, and known for his use of acrylic paints on sand.

Julien, Isaac
(1960–)
Black British critic and filmmaker. His productions—*Looking for Langston* (1989), and *Young Soul Rebels* (1991) among them—address issues concerning race, nation, and sexuality. A co-founder of the London-based film and video collective Sankofa.

Kim, Byron
(1961–)
Asian American painter. Explores contemporary representations of race and

the body through thought-provoking use of color and text. His paintings, though often non-figurative, inveigh against monolithic, homogenizing notions of race and ethnicity.

Kirchner, Ernst Ludwig
(1880–1938)
German painter. A co-founder of the Dresden Expressionist artists' group Die Brücke (The Bridge) in 1905. His art was suppressed as "degenerate" by the Nazis in 1937.

Lam, Wifredo
(1902–82)
Cuban painter. Work was influenced by Picasso and Surrealism, and often based on African sculpture. Following his return to Cuba and his travels throughout the Caribbean, also strongly influenced by such Africa-derived religions as *Santeria* and *Vodun*.

Lawrence, Jacob
(1917–2000)
Prolific African American painter with a singular talent for depicting the high drama of black life and history. He began exhibiting in the 1930s, and is arguably the most popular black artist of the century.

Lee, Spike
(1957–)
African American filmmaker and producer born Shelton Jackson Lee. Notable since the mid-1980s for films depicting the dilemma of American race-relations, and the intra-group tensions of black culture—especially issues turning on class, color, and gender. Best known for *She's Gotta Have It* (1986), *School Daze* (1988), *Do the Right Thing* (1989), and *Malcolm X* (1992).

Levinthal, David
(1949–)
White American photographer, especially recognized for his theatrical, psychologically complex still lifes of miniature toy soldiers, vintage American bric-à-brac, and racist memorabilia.

Lewis, Norman
(1909–79)
African American painter of Caribbean parentage who began in the 1930s as a Social Realist painter of black urban life.

Following World War II he embraced Abstract Expressionism. Yet, his non-representational paintings remained based in natural and urban milieux and were never wholly given over to emotion and technique.

Lichfield, Patrick
(1939–)
White British fashion and portrait photographer. Best known for his portraits of the British royal family.

Ligon, Glenn
(1960–)
African American painter. Seeks through his work to transform specific cultural experiences and current events into wider explorations of race and identity. He is especially concerned with the power of language to define, dictate, and marginalize.

Liking, Werewere
(1950–)
Cameroon-born playwright, theater director, performance artist, and novelist. Prominent in France and French-speaking Africa for dramatic, highly symbolic plays often based in Bassa initiation and healing rituals—among them *La Queue du diable* (*The Devil's Tail*) 1979, and *La Rougeole arc-en-ciel* (*The Rainbow Measles*) 1987. In 1984, she founded the Ki-Yi Mbock Théâtre, a theatrical troupe and artists' collective.

Lois, George
(1931–)
White American graphic designer. In the early 1960s he was one of the first designers to move successfully from art direction into the business side of advertising. Trailblazing in his use of celebrities and star athletes in commercial advertising.

Loving, Al
(1935–)
African American, self described "material abstractionist." His collages—constructed from oils, fabrics, dyes, and paper—explore the ranges and possibilities of color.

McGruder, Aaron
(1974–)
African American cartoonist. His controversial comic strip

The Boondocks, which features a mostly African American cast of offbeat, discontented youth, has enjoyed phenomenal popularity since first nationally syndicated in 1999.

Manley, Edna
(1900–87)
English-born sculptor of wood and stone, living and working in Jamaica from the early 1920s. Her busts of Jamaican notables, and cubist renderings of the island's populace were exhibited in London from the late 1930s. Her efforts in arts education led to the founding of the Jamaica School of Art.

Mapplethorpe, Robert
(1946–89)
White American photographer. His work dealt predominantly with issues of sexuality and race. His subjects were human figures, flowers, and portraits of personalities from the gay social scene of the 1980s.

Marshall, Kerry James
(1955–)
African American figure painter, prominent since the early '80s for representational paintings rich in metaphor and symbol, yet feigning simplicity. His work complicates the received wisdom concerning the ideas of beauty, and deconstructs unyielding American categories of racial and cultural identity.

Maurice, Richard D.
(*fl.* 1920–30)
Trailblazing African American filmmaker. Between 1920 and 1928, his Detroit-based Maurice Film Company produced a number of serious-minded, didactic black dramas—among them *Our Christianity and Nobody's Children* (1920) and *Eleven p.m.* (1928).

Mills, Lev
(1940–)
African American graphic artist and printmaker, whose work contemplates contemporary notions of racial identity and manhood, while exploiting and reflecting the ever-growing technology available to present-day artists.

Miner, Leigh Richmond
(1864—1935)
White American educator and photographer. Taken in the 1910s and '20s, his sympathetic but unsentimental portraits of blacks at St. Helena Island, South Carolina, and Hampton, Virginia, offer a corrective to the prevailing photographic record of rural blacks from the period.

Minnelli, Vincente
(1903–86)
White American stage and film director. Highly regarded for film and Broadway musicals, and winner of several Academy awards in the 1950s. Directed black casts in *Cabin in the Sky* and *I Dood It* (1943).

Mr. Imagination, né Gregory Warmack
(1948–)
Self-taught African American sculptor. Since the early 1970s, known locally in Chicago as a street artist, sign maker, and neighborhood art teacher. In the 1980s his work with found materials—industrial sandstone, nails, bottle caps, old paint brushes, etc.—earned him national acclaim as an intuitive artist.

Moore, Philip
(1921–)
Guyanese painter and sculptor. Especially concerned with the artistic maintenance of a larger Afro-Caribbean memory.

Morgan, Sister Gertrude
(1900–80)
African American singer, preacher, and self-taught painter. In the 1970s, her brilliantly colored, religiously oriented work gained her recognition in New Orleans and later nationwide as an highly talented folk artist.

Morrison, Keith
(1942–)
Jamaica-born painter working in San Francisco. His expansive, and deeply colored canvases deploy and rework symbols from the folklore and mythology of Africa and Afro-America.

Motley, Archibald J. Jr.
(1891–1981)
African American painter. Highly acclaimed during the 1920s and '30s for sympathetic black portraiture, and for his vibrant, frenetic portrayals of black social life in the U.S. and abroad.

Ofili, Chris
(1968–)
Black British painter of Nigerian descent. In the late 1990s garnered both top critical honors—the Turner Prize—and condemnation from many cultural conservatives for his provocative art, which combined lively, brilliantly painted surfaces with unconventional, arguably scatological, collaged elements.

O'Grady, Lorraine
(1940–)
African American of Jamaican descent. Conceptual and performance artist, and cultural critic. Renowned in the early 1980s for staging art criticism as guerrilla performance in several New York galleries—*Mlle Bourgeoisie Noire*. Since the 1990s has concentrated on portraiture and photomontage—taking as her subject the exigencies of race, class, and gender in contemporary Afro America.

Ouattara
(1957–)
Côte d'Ivoire painter working in Paris from 1977, and in New York since 1989. His work—shot through with symbols and iconography of West African initiation—interrogates intersections of spirituality and technology. Physically his paintings often consist of mixed media incorporated in acrylic.

Overstreet, Joe
(1934–)
African American painter using huge canvases, bright and bold colors, and three-dimensional geometric shapes. In the 1970s his canvases were usually stretched by wood and rope, suggesting sculpture as well as painting.

Palcy, Euzhan
(1957–)
Martiniquan filmmaker. Her first feature film, *Rue Cases-Nègres* (*Sugar Cane Alley*) in 1983—a moving, beautifully shot period drama of 1930s Martinique—opened to great acclaim in France. Her American début was *A Dry White Season* (1986).

Pierce, Elijah
(1892–1984)
African American sculptor, carver, and painter of Biblical and slave scenes. At age 79 gained widespread recognition as a folk artist.

Pindell, Howardena
(1943–)
African American abstract artist. Her collaged paintings and mixed-media works offer engrossing explorations of her personal development and life travels—especially her visits to Asia and Africa.

Piper, Adrian
(1948–)
African American performance and conceptual artist. Recognized since the 1960s for confronting audiences with the stark personal consequences of race and gender discrimination, and for exploring the complexities of modern notions of identity.

Piper, Keith
(1960–)
Black British media artist. Since the early 1980s has used video, photocollage, and other technologies to analyze the social and political issues around contemporary images of black masculinity.

Piper, Rose
(1917–)
African American painter. In the late 1940s began a series of folk paintings fusing the growing impulse towards abstraction with a studied, painterly improvisation reminiscent of African American rhythms.

Phokela, Johannes
(1966–)
Black South African painter, based in London. By consciously referencing and transforming the moralizing compositions of 16th and 17th Netherlandish art, this postmodernist rejuvenates the old-fashioned pictorial allegory for 21st-century viewers.

Powers, Harriet
(1837–1911)
African American homemaker and quilter. Her vibrant, narrative quilts—some exhibited in local southern fairs in the late 19th century—are indicative of

larger, though long unrecognized, domestic artistic tradition.

Puryear, Martin
(1941–)
African American sculptor of large studio pieces, museum installations, and environmental pieces. Works primarily in wood and often from African-inspired designs. Always exhibits remarkable imagination and superior craftsmanship.

Rand, Archie
(1949–)
White American painter. Often frames his work explicitly in relation to the outpourings and inspirations of other artists and intellectuals. His series *The Letter Paintings*—completed by 1970—incorporated and referred to the work of various jazz, blues, and doowop groups.

Reiss, Winold
(1887–1953)
German painter and muralist, and graphic and interior designer. Lived and worked in New York during the 1920s and '30s. Noted for his sensitive pastel renderings of American ethnics, especially blacks and Native Americans.

Renoir, Jean
(1894–1979)
French-born filmmaker. Left France after the German invasion in 1941 and became a U.S. citizen. Among his early films was the controversial fantasy *Sur un Air de Charleston* (1926). From the late 1930s, developed a reputation for Social Realist filmmaking—especially for *Toni* (1935) and *The Southerner* (1945).

Riggs, Robert
(1896–1970)
White American artist and illustrator. In the early 1930s, began a series of pugilism prints that earned him the reputation as the first artist of boxing. Also remembered for subsequent series of circus and hospital prints.

Ringgold, Faith
(1930–)
African American painter, soft sculptor, and performance artist. Recognized from the 1960s for work exploring American feminism and race relations. Subsequently has gained significant

popular appeal for her watercolors and quilting, which were used as subjects for illustrated children's books.

Rivers, Larry
(1923–)
White American painter. Started as a jazz musician, and turned seriously to painting only in his mid-twenties. Recognized since the early 1950s for his ironic riffs on classic paintings and grand themes from art history, as well as for his artistic translations of everyday items.

Robinson, John
(1912–94)
African American painter. From the mid-1930s—while working full-time as a cook—his portraiture, landscapes, and church murals were well known and sought after in the Anacostia and Garfield regions of Washington, D.C. Concentrated on his art after his retirement from catering, and from the mid-1970s was acclaimed by a national audience for the warmth and intimacy of his work.

Rockwell, Norman
(1894–1979)
White American painter and illustrator. From the late 1910s through the 1960s his covers for the *Saturday Evening Post* and other periodicals portrayed middle-class Americans in an uncritical light.

Rose, Tracey
(1974–)
South African conceptual artist of Khosian and German ancestry. Fusing performance with photographic self portraiture, this artist spans contemporary visual media in her probing interrogations of identity and history.

Saar, Alison
(1956–)
African American sculptor and artist. Her installations tend toward a didactic mysticism, and draw simultaneously on contemporary urban motifs as well as African and African American mythologies. Daughter of the renowned artist ★Betye Saar.

Saar, Betye
(1929–)
African American artist whose assemblages and collages—often

composed of found and natural materials—reflect her interest in folk culture and mythology. She frequently employs stereotyped black imagery in order to subvert its traditional meaning.

Saunders, Raymond
(1934–)
African American abstract artist. His brightly colored, textured paintings attempt to express through symbols and letters the fragmentary nature of memory and experience, and the grain of American urban life.

Savage, Augusta
(1892–1962)
African American sculptor. Her wide-ranging work with Depression-era WPA arts projects, and her signal contributions to the organization of the Harlem Artists Guild place her among the most important African American art educators of the century.

Savain, Petion
(c. 1906–73)
Haitian painter and writer. Grounded his fiction and visual art in the folklore, physical environment, and peasant life of Haiti—best exemplified in the text and illustrations of his 1939 novel La Case de Damballah (Damballah's Hut). One of the generation of Haitian painters encouraged by William Scott's artistic mission to the island in the early 1930s.

Scott, John T.
(1940–)
African American sculptor and printmaker. Prominent in the 1980s for work addressing historical themes. Lately celebrated for kinetic sculptures of painted metal.

Scott, Joyce J.
(1948–)
African American jewelry maker, quilter, sculptor, and performance artist. An accomplished artist in several scales— from brooches to environmental site installations—her work pays close attention to black cultural agency in contexts of pronounced racism.

Sekoto, Gerard
(1913–93)
Pioneering, black South African painter, expatriate in Paris from 1947. Oils and

watercolors executed both before and following his emigration capture the soul and travail of South African townships—especially Sophiatown, District Six, and Eastwood.

Sembene, Ousmane
(1923–)
Award-winning Senegalese novelist and filmmaker. From the mid-1960s gained international fame for his trenchant yet often satirical cinematic critiques of African neocolonialism—among them, La Noire de . . . (Black Girl) 1966, Mandabi (The Money Order) 1968, and Xala (Impotence) 1974.

Shonibare, Yinka
(1962–)
Black British artist of Nigerian descent. Critically acclaimed for his sculptural installations of upholstered furniture and fiberglass mannequins dressed in period costumes, made from Western-manufactured, so-called "African" printed cloth, and several large-scale photographic series that feature the artist in historical and literary parodies.

Simmons, Gary
(1964–)
African American painter and installation artist, who is especially concerned with recording and subverting modern representations of black masculinity.

Simpson, Coreen
(1942–)
African American photographer and jewelry designer. In the mid-1980s embarked on a documentary project dedicated to capturing contemporary urban street culture—most notably hip hop, and transvestism.

Simpson, Lorna
(1960–)
African American photographer and installation artist. Conceptually her portraits and phototexts address contemporary constructions of race and gender; technically, they challenge traditional methods of framing a subject.

Smith, Albert Alexander
(1896–1940)
African American painter, printmaker, and musician. An expatriate in Paris from

the early 1920s, he often made fellow black performers the subject of his work.

Snowden, Sylvia
(1942–)
African American painter. A figurative expressionist whose works are bold, intensely colored, contorted, and, at times, violent.

Spriggs, Edward
(1934–)
African American graphic artist and filmmaker. An early director of the Studio Museum in Harlem, and now Head of Atlanta's Hammonds House.

Stone III, Charles S.
(1966–)
African American video and film director, whose mix of satire, narrative subtleties, and visual panache has garnered much commercial and critical praise, opening the way to assorted feature-length film projects.

Sulter, Maud
(1960–)
Black British photographic and installation artist. Especially concerned with confronting the challenges and catastrophes of race in the modern history of the Western world.

Sy, Oumou
(1952–)
Senegalese designer. Founder of an experimental fashion and jewelry design workshop in Dakar, Senegal, and the creator and frequent director of that city's Carnival: a dazzling spectacle of inventive fashions, impromptu performances, and street happenings.

Tanner, Henry Ossawa
(1859–1937)
The most acclaimed African American painter of the late 19th century. He began as a painter of land and seascapes, but toward the turn of the century began executing religious subjects and detailed genre scenes of African American life, of which the The Banjo Lesson (1893) is perhaps the best known.

Télémaque, Hervé
(1937–)
Haitian-born painter and collagist working in Paris since 1961. Painterly

agility, a bright palette, and a thoughtful though often muted recourse to symbolism characterize the otherwise diverse developments in his subject matter and style.

Thomas, Alma
(1891–1978)
African American painter and educator. Became a full-time artist only on retirement from secondary school teaching in 1960. In 1924, was the first student to graduate from the Howard University art department. An abstract artist, she uses systemics and color theory in the creation of her paintings.

Thompson, Bob
(1936–1966)
Shortlived, but prolific African American painter, a figurative expressionist. In the 1960s his brilliantly colored reinterpretations of European masters—Goya and Titian among them—brought him contemporary recognition, and later, significant posthumous fame.

Tseng Kwong Chi,
(1950–90)
Hong Kong born photographer working in New York from 1978. Best known for his series of globe-trotting, sometimes surreal self-portraits, East Meets West.

Ulmann, Doris
(1882–1934)
White American photographer who worked in the pictorialist tradition of photography as did her teacher and mentor Clarence White. Her photographs of black Southerners from the Lang Syne Plantation in South Carolina accompanied Julia Peterkin's text in the sentimental, but now valuable period piece Roll, Jordan, Roll (1933).

VanDerZee, James
(1886–1983)
African American commercial photographer, recognized many years later for his artistry. His portraits of Jazz-Age Harlem speak eloquently to the substance of black identity and aspiration in the 1920s and '30s.

Van Peebles, Melvin
(1932–)
Iconoclastic African American film director, and screenwriter. Critically acclaimed for The Story of a Three Day Pass (1968), but propelled into the public imagination for the independent making, marketing, and distribution of Sweet Sweetback's Baadasssss Song (1971).

Van Vechten, Carl
(1880–1964)
White American critic, photographer, and novelist. Significant in the 1920s and '30s—especially in New York—for his patronage and portraits of black artists.

Vári, Minnette
(1968–)
White South African conceptual artist. Employing photography, computer technology and occasionally mass-marketing techniques, this artist excavates the art of portraiture and, using her own image and personal history, dismantles postmodernism's most inviolable subjects: race and gender.

Walker, Kara
(1969–)
African American graphic artist, painter, and installation artist who, from the 1990s was applauded, publicly vilified, and internationally recognized for her mural-size, meticulously conceived, black paper silhouette cut-outs of previously unimagined master/slave narratives.

Warhol, Andy
(1928–87)
White American artist and filmmaker, and a main exponent of American Pop Art. In 1984–85 collaborated with *Jean-Michel Basquiat.

Waring, Laura Wheeler
(1887–1948)
African American painter. Noted for her still lifes, and for warmly colored, affectionate portraits of black notables—*Alma Thomas and W. E. B. Du Bois among them. She taught at and later headed the art department at Cheyney State Teachers College in Pennsylvania.

Weems, Carrie Mae
(1953–)
African American photographer working in the documentary tradition. A self-described "image maker," she has been especially concerned with how images inform and reflect contemporary notions of race, class, and gender.

Wells, James Lesesne
(1902–93)
African American painter, and printmaker of mainly religious, mythical, and natural subjects. Aspects of his work borrow from German Expressionism and Cubism. Founder of Howard University's graphic arts department.

White, Charles
(1918–79)
African American painter and draftsman. Heroically resisted the artistic movements that swept up many of his contemporaries—Minimalism, Abstract Expressionism, and Conceptualism. From the 1940s through the '70s he produced masterfully drafted pieces dedicated almost exclusively to social and economic themes in black America.

Whitten, Jack
(1939–)
African American painter. His philosophically loaded, optically complex work qualify him as one of the leading abstract artists in the U.S.A.

Williams, Aubrey
(1926–90)
Guyanese painter living in Britain from the mid-1950s. Prominent in the London-based Caribbean Artists' Movement in 1960s and '70s. His work mines the Pre-Columbian impulse in Caribbean art and culture.

Williams, Spencer
(1893–1969)
African American actor and director. Active as a Hollywood writer and performer from the late 1920s, he later made a series of films centered on black religious experience—The Blood of Jesus (1941) and Go Down Death (1944) among them. With Oscar Micheaux one of the pioneering black filmmakers, though perhaps best known as Andy in the '50s sitcom Amos 'n' Andy.

Williamson, Sue
(1941–)
White, English-born artist and writer living in South Africa since the age of eight. In the Apartheid era, her prints

and installations—celebrated as subtle yet powerful examples of political or protest art—surveyed gender and racial injustice in South Africa. Lately an important critic and curator of contemporary South African art.

Wilson, Fred
(1954–)

African American installation artist. His provocative yet deeply contemplative exhibitions probe and attempt to counter the tendency of American art, letters,

and history to obscure the contributions and voices of American blacks.

Withers, Ernest C.
(1922–)

African American photojournalist. Noted for work during the American civil rights movement—especially his photographs of the open-casket funeral for the brutalized Emmett Till, and his pictures of Martin Luther King Jr. during the the civil rights leader's last days.

Woodruff, Hale
(1900–80)

African American painter and educator. From the late 1920s his style and subject matter ranged from Cubism to Abstract Expressionism, and from picturesque French cityscapes to abstract riffs on African sculpture. Best known for his historical murals at Talledega College in Alabama (1939), Clark Atlanta University in Georgia (1950–51), and the Golden State Mutual Insurance Company in California (1949).

Select Bibliography and Sources

There are several key works that provide basic art-historical information on black diasporal cultures in twentieth-century art, and these are listed in the General section below. Many other books, monographs, exhibition catalogs, directories, articles, and essays that have been published on this topic and that have provided source material are included in the bibliographical notes that follow for each chapter; these are grouped under subject headings and are listed in the order in which the points and quotations appear in the text. Where n.p. appears in the place of a page reference, the publication has no pagination.

GENERAL

Araeen, Rasheed, *The Other Story: Afro-Asian artists in post-war Britain*, South Bank Centre, London, 1989.
Archer Straw, Petrine and Kim Robinson, *Jamaican Art*, Kingston Publishers, Kingston, 1990.
"Critical Decade: Black British Photography in the 80s," *Ten.8* 2 (Spring 1992).
Dover, Cedric, *American Negro Art*, The New York Graphic Society, Greenwich, 1960.
Driskell, David C., *Hidden Heritage: Afro-American Art, 1800–1950*, Bellevue Art Museum, Bellevue, 1985.

Fine, Elsa Honig, *The Afro-American Artist: A Search for Identity*, Harcourt Brace Jovanovich, New York, 1973.
Igoe, Lynn Moody and James Igoe, *Two Hundred Fifty Years of Afro-American Art: An Annotated Bibliography*, R. R. Bowker, New York, 1981.
Kennedy, Jean, *New Currents, Ancient Rivers: Contemporary African Artists in a Generation of Change*, Smithsonian Institution Press, Washington, D.C., 1992.
Lewis, Samella, *African American Art and Artists*, University of California Press, Berkeley, 1990.
Lippard, Lucy R., *Mixed Blessings: New Art in a Multicultural America*, Pantheon Books, New York, 1990.
Owusu, Kwesi, ed., *Storms of the Heart: An Anthology of Black Arts & Culture*, Camden Press, London, 1988.
Perry Reginia, *Free Within Ourselves: African American Artists in the Collection of the National Museum of American Art*, Pomegranate Artbooks, San Francisco, 1992.
Porter, James A., *Modern Negro Art* (first published 1943), Howard University Press, Washington, D.C., 1992 edn.
Rodman, Selden, *Where Art is Joy, Haitian Art: The First Forty Years*, Ruggles de Latour, New York, 1988.
Thompson, Robert Farris, *Flash of the Spirit: African and Afro-American Art

and Philosophy*, Random House, New York, 1983.
Walmsley, Anne, *The Caribbean Artists Movement, 1966–1972: A Literary and Cultural History*, New Beacon, London, 1992.

The following journals, magazines, and periodicals have also been especially informative:
African American Review, African Arts, American Art, Artist and Influence, BWIA Caribbean Beat, Callaloo, International Review of African American Art, Jamaica Journal, Nka: Journal of Contemporary African Art, Revue Noire, Screen, Ten.8, Third Text, Transition.

Also useful, but not specifically concerned with black culture:
Clifford, James, *The Predicament of Culture: Twentieth-Century Ethnography, Literature, and Art*, Harvard University Press, Cambridge, MA, 1988.
Deleuze, Gilles, *Cinema 1: The Movement-Image*, University of Minnesota Press, Minneapolis, 1986.
—*Cinema 2: The Time-Image*, University of Minnesota Press, Minneapolis, 1989.
Foster, Hal, ed., *Recodings: Art, Spectacle, Cultural Politics*, Bay Press, Seattle, 1985.
Foucault, Michel, trans. and ed. Colin Gordon, *Power/Knowledge: Selected

Interviews and Other Writings, 1972–1977, Pantheon Books, New York; Harvester Press, Brighton, 1980.

Freedberg, David, The Power of Images: Studies in the History and Theory of Response, University of Chicago Press, Chicago, 1989.

Geertz, Clifford, The Interpretation of Culture, Basic Books, New York, 1973.

Kristeva, Julia, The Kristeva Reader, Columbia University Press, New York, 1987.

Petro, Patrice, ed., Fugitive Images: From Photography to Video, Indiana University Press, Bloomington, 1995.

Spivak, Gayatri Chakravorty, In Other Worlds: Essays in Cultural Politics, Methuen, London and New York, 1987.

Stafford, Barbara Maria, Body Criticism: Imagining the Unseen in Enlightenment Art and Medicine, MIT Press, Cambridge, MA, 1991.

Tagg, John, The Burden of Representation: Essays on Photographies and Histories, University of Minnesota Press, Minneapolis, 1988.

Wallis, Brian, ed., Art after Modernism: Rethinking Representation, New Museum of Contemporary Art, New York, 1984.

Wood, Paul and Francis Frascina, Jonathan Harris, and Charles Harrison, Modernism in Dispute: Art Since the Forties, Yale University Press, New Haven, 1993.

INTRODUCTION: THE DARK CENTER

Defining "Blackness": Fanon, Frantz, trans. Charles Lam Markmann, Black Skin, White Masks (Peau noire, masques blancs, 1952), Grove, New York, 1967, p. 135. Vlach, John Michael, The Afro-American Tradition in Decorative Arts, Cleveland Museum of Art, Cleveland, 1978, pp. 20–22. Tibbles, Anthony, ed., Transatlantic Slavery: Against Human Dignity, HMSO, London, 1994, pp. 110, 152. Thompson, Robert Farris, "The Flash of the Spirit: Haiti's Africanizing Vodun Art," in Ute Stebich, ed., Haitian Art, The Brooklyn Museum, Brooklyn, 1978, pp. 26–37. Curtin, Philip D., The Atlantic Slave Trade: A Census, University of Wisconsin Press, Madison, 1969. Patterson, Orlando, Slavery and Social Death: A Comparative Study, Harvard

University Press, Cambridge, MA, 1982. Jahn, Janheinz, Muntu: The New African Culture, Grove, New York, 1961. Jordan, Winthrop D., "The Bodies of Men: The Negro's Physical Nature," in White Over Black: American Attitudes Toward the Negro, 1550–1812, Pelican Books, Baltimore, 1969, pp. 216–65. Gates, Henry Louis Jr., "The Blackness of Blackness: A Critique of the Sign and the Signifying Monkey," in Figures in Black: Words, Signs, and the "Racial" Self, Oxford University Press, New York and Oxford, 1987, pp. 235–76. Sáiz, María Concepción García, The Castes: A Genre of Mexican Painting, Olivetti, Milan, 1989, pp. 180–81. "La Pintura de Castas," Artes de México 8, 1990.

Locating and describing black cultures: Hall, Stuart, "What is this 'Black' in Black Popular Culture," in Gina Dent, ed., Black Popular Culture, Bay Press, Seattle, 1992, pp. 21–33. Bastide, Roger, African Civilizations in the New World, Harper Torchbooks, New York, 1971. Jaynes, Gerald David and Robin M. Williams Jr., eds, A Common Destiny: Blacks and American Society, National Academy Press, Washington, D.C., 1989. Powell, Richard J., African and Afro-American Art: Call and Response, Field Museum of Natural History, Chicago, 1984. Blier, Suzanne, African Vodun: Art, Psychology, and Power, University of Chicago, Chicago, 1995. Blackwell, James E., The Black Community: Diversity and Unity, 2nd edn, Harper & Row, London and New York, 1985.

Theories of black subjectivity: Murray, Freeman H.M., Emancipation and the Freed in American Sculpture, privately published, Washington, D.C., 1916; particularly pp. 135–36. Powell, Richard J., "Face to Face: Elizabeth Catlett's Graphic Work," in Elizabeth Catlett: Works on Paper, 1944–1992, Hampton University Museum, Hampton, 1993, pp. 49–53. Hassan, Salah, "The Modernist Experience in African Art: Visual Expressions of the Self and Cross-Cultural Aesthetics," Nka: Journal of Contemporary African Art 2, Spring/Summer 1995, pp. 30–33, 72. West, Cornel, Race Matters, Beacon Press, Boston, 1993. Locke, Alain, The Negro in Art: A Pictorial Record of the Negro Artist

and of the Negro Theme in Art, Associates in Negro Folk Education, Washington, D.C., 1940. Parry, Ellwood C., The Image of the Indian and Black Man in American Art, 1590–1900, George Braziller, New York, 1974. Honour, Hugh, The Image of the Black in Western Art, Volume IV, From the American Revolution to World War I, Harvard University Press, Cambridge, MA, 1989. Wardlaw, Alvia, Black Art, Ancestral Legacy: The African Impulse in African-American Art, Dallas Museum of Art, Dallas, 1989. McElroy, Guy C., Facing History: The Black Image in American Art, 1710–1940, Bedford Arts, San Francisco, 1990. Pieterse, Jan Nederveen, White on Black: Images of Africa and Blacks in Western Popular Culture, Yale University Press, New Haven, 1992.

Key writings by Jeff Donaldson, Paul Gilroy, Robert Farris Thompson: Donaldson, Jeff, "10 in Search of a Nation," Black World 19, October 1970, pp. 80–89; and "TransAfrican Art," The Black Collegian 11, October/November 1980, pp. 90–101. Gilroy, Paul, The Black Atlantic: Modernity and Double Consciousness, Harvard University Press, Cambridge, MA, 1993. Thompson, Robert Farris, "African Influence on the Art of the United States" (1969), in William Ferris, ed., Afro-American Folk Art and Crafts, G.K. Hall, Boston, 1983, pp. 27–63; Flash of the Spirit: African and Afro-American Art and Philosophy, Random House, New York, 1983; Face of the Gods: Art and Altars of Africa and the African Americas, Museum for African Art, New York, 1993; and with Joseph Cornet, The Four Moments of the Sun: Kongo Art in Two Worlds, National Gallery of Art, Washington, D.C., 1981.

Feminist theory: De Lauretis, Teresa, Alice Doesn't, Indiana University Press, Bloomington, 1984. Trinh T. Minh-ha, Woman, Native, Other: Writing Postcoloniality and Feminism, Indiana University Press, Bloomington, 1989. Alcoff, Linda, "Cultural Feminism Versus Post-Structuralism: The Identity Crisis in Feminist Theory," Signs: Journal of Women in Culture and Society 13, 1988, pp. 405–36. King, Deborah K., "Multiple Jeopardy, Multiple Consciousness: The

Context of Black Feminist Ideology" (1988), in Beverly Guy-Sheftall, ed., *Words of Fire: An Anthology of African-American Feminist Thought*, The New Press, New York, 1995, pp. 293–317. Crenshaw, Kimberle, "Demarginalizing the Intersection of Race and Sex: A Black Feminist Critique of Antidiscrimination Doctrine, Feminist Theory and Antiracist Politics," *The University of Chicago Legal Forum 1989*, 1989, pp. 139–67. hooks, bell, *Black Looks: Race and Representation*, South End Press, Boston, MA, 1992.

Art histories and postmodernism: Smalls, James, "A Ghost of a Chance: Invisibility and Elision in African American Art Historical Practice," *Art Documentation*, Spring 1994, pp. 3–8. Nicodemus, Evelyn, "The Center of Otherness," in Jean Fisher, ed., *Global Visions: Towards a New Internationalism in the Visual Arts*, Kala Press, London, 1994, pp. 91–104. Bailey, David A., "Mirage: Enigmas of Race, Difference, and Desire," in *Mirage: Enigmas of Race, Difference, and Desire*, Institute of International Visual Arts, London, 1995, pp. 57–96.

1 ART, CULTURE, AND "THE SOULS OF BLACK FOLK"

Black images at the turn of the century: Geiss, Imanuel, *The Pan-African Movement*, Methuen, London, 1974. Honour, Hugh, *The Image of the Black in Western Art, 4: From the Revolution to World War I, Part 1*, Harvard University Press, Cambridge, MA, 1989, pp. 259–304. Kemble, Edward Windsor, *Kemble's Coons: A Collection of Southern Sketches*, R. H. Russell, New York, 1896. Fletcher, Tom, *100 Years of the Negro in Show Business!*, Burdge, New York, 1954. Mosby, Dewey F., *Henry Ossawa Tanner*, Rizzoli, New York, 1991, pp. 10–53, 116–20. Long, Richard A., *Black Americana*, Crescent Books, New York, 1993, pp. 11–21. Perry, Regenia A., *Harriet Powers's Bible Quilts*, Rizzoli, New York, 1994. Johnson, James Weldon, *The Autobiography of an Ex-Colored Man* (first published 1912), Avon Books, New York, 1965 edn, pp. 393–511. Johnson, James Weldon, *Along This Way*, Viking Press, New York, 1933, pp. 151–59.

Stuart Davis and Ernst Ludwig Kirchner: Zurier, Rebecca, *Art for The Masses*, Temple University Press, Philadelphia, 1988, pp. 148–51. Museen der Stadt Koln, *Expressionisten, Sammlung Buchheim*, Feldafing, Cologne, 1981.

In response to cultural assaults on "the race": Gates, Henry Louis Jr., "The Trope of a New Negro and the Reconstruction of the Image of the Black," *Representations* 24, Fall 1988, pp. 129–155. Du Bois, W. E. B., *The Souls of Black Folk* (first published 1903), Avon Books, New York, 1965, pp. 209–389. Washington, Booker T., *Up From Slavery* (first published 1901) Avon Books, New York, 1965, pp. 145–50. Dunbar, Paul Laurence, *Candle-Lightin' Time*, Dodd Mead, New York, 1901, pp. 117–27. Adams, John Henry Jr., "The Modern Cyrenian's Cross, or the Black Man's Burden," *Voice of the Negro* 4, July 1907, p. 285. Du Bois, W. E. B., "Roosevelt," *The Horizon: A Journal of the Color Line* 1, January 1907, pp. 2–10. Dixon, Thomas, *The Leopard's Spots: A Romance of the White Man's Burden, 1865–1900*, Doubleday, Page, New York, 1902.

Isaac Scott Hathaway, Meta Vaux Warrick Fuller and Edwin A. Harleston: "The Isaac Hathaway Art Company," *The Crisis* 15, November 1917, p. 46. Jackson, Giles B. and W. Webster Davis, *The Industrial History of the Negro Race of the United States*, The Virginia Press, Richmond, Virginia, 1908. Brawley, Benjamin G., *The Negro in Literature and Art in the United States*, Duffield, New York, 1918, pp. 113–24. Murray, Freeman Henry Morris, *Emancipation and the Freed in American sculpture: A Study in Interpretation*, Murray Brothers, Washington, D.C., 1916, pp. 55–66, 183. Casely Hayford, J.E., *Ethiopia Unbound: Studies in Race Emancipation* (first published 1911), Frank Cass, London, 1969. McDaniel, M. Akua, "The Life of Edwin Augustus Harleston, Portrait Painter" (unpublished Ph. D. dissertation, Emory University), 1994. Franklin, John Hope and Alfred A. Moss Jr., *From Slavery to Freedom: A History of African Americans*, McGraw-Hill, New York, 1994, pp. 323–60.

Preludes to the "New Negro": Du Bois, W. E. B., "Letters from Dr. Du Bois," *The Crisis* 17, February 1919, pp. 169. Johnson, James Weldon, "Preface to Original Edition," *The Book of American Negro Poetry* (first published 1922), Harcourt, Brace & World, New York, 1958.

2 ENTER AND EXIT THE "NEW NEGRO"

Race and Modernity: Smith, Terry, *Making the Modern: Industry, Art, and Design in America*, University of Chicago Press, Chicago, 1993. Gates, Henry Louis Jr., "The Trope of a New Negro and the Reconstruction of the Image of the Black," *Representations* 24, Fall 1988, pp. 129–55. Lewis, David Levering, *When Harlem Was In Vogue*, Alfred A. Knopf, New York, 1981. Douglas, Ann, *Mongrel Manhattan in the 1920s*, Farrar Straus & Giroux, New York, 1995. "Harlem: Mecca of the New Negro," *Survey Graphic* 6, March 1925. Locke, Alain, ed., *The New Negro: An Interpretation* (first published 1925), Atheneum, New York, 1980.

Winold Reiss and Aaron Douglas: Stewart, Jeffrey C., *To Color America: Portraits by Winold Reiss*, Smithsonian Institution Press, Washington, D.C., 1989. Douglas, Aaron, "The Harlem Renaissance," unpublished manuscript, 18 March 1973, Special Collections, Fisk University Library, Nashville. Douglas, Aaron, interview by L. M. Collins, 16 July 1971, Special Collections, Fisk University Library, Nashville. Douglas, Aaron, letter to Langston Hughes, 21 December 1925, as quoted in Richard J. Powell, "Art History and Black Memory: Toward a Blues Aesthetic," in Genevieve Fabre and Robert O'Meally, eds, *History and Memory in African American Culture*, Oxford University Press, New York, 1994, pp. 228–43.

Representing the "New Negro": Hughes, Langston, "The Negro Artist and the Racial Mountain," *Nation* 122, 23 June 1926, pp. 692–94. Rampersad, Arnold, *The Life of Langston Hughes, Vol. 1: 1902–1941 I, Too, Sing America*, Oxford University Press, New York, 1986. Gaines, Jane, "Fire and Desire:

Race, Melodrama, and Oscar Micheaux," in Manthia Diawara, *Black American Cinema*, Routledge, London and New York, 1993, pp. 49–70. Toomer, Jean, *Cane* (first published 1923), Harper & Row, 1969. *The Darkness And The Light: Photographs by Doris Ulmann*, Aperture, Millerton, New York, 1974. Foucault, Michel, "Powers and Strategies," trans. and ed. Colin Gordon, *Power/Knowledge: Selected Interviews and Other Writings, 1972–1977*, Pantheon, New York, 1980, pp. 134–45. Reynolds, Gary A. and Beryl J. Wright, *Against the Odds: African-American Artists and the Harmon Foundation*, Newark Museum, Newark, 1989. Powell, Richard J. *Homecoming: The Art and Life of William H. Johnson*, Rizzoli, New York, 1991.

The evolution of the "Harlem Renaissance" concept: Brawley, Benjamin G., "The Negro Literary Renaissance," *The Southern Workman* 56, April 1927, pp. 177–84. Hughes, Langston, *The Big Sea* (first published 1940) in David Levering Lewis, ed., *The Portable Harlem Renaissance Reader*, Penguin, New York, 1994, pp. 77–91. Franklin, John Hope, "A Harlem Renaissance," in *From Slavery to Freedom: A History of American Negroes*, Alfred A. Knopf, New York, 1947, pp. 489–511. Huggins, Nathan, *Harlem Renaissance*, Oxford University Press, New York, 1971. Campbell, Mary Schmidt, *Harlem Renaissance: Art of Black America*, Abrams, New York, 1987. Anderson, Jervis. *This Was Harlem: A Cultural Portrait, 1900–1950*, Farrar Straus & Giroux, New York, 1982. Johnson, James Weldon, *Black Manhattan*, Alfred A. Knopf, New York, 1930, pp. 264–80. Porter, James A., *Modern Negro Art* (first published 1943), Howard University Press, Washington, D.C., 1993, pp. 86–101. Williams, Adriana, *Covarrubias*, University of Texas, Austin, 1994, pp. 17–58. Robinson, Jontyle Teresa and Wendy Greenhouse, *The Art of Archibald J. Motley Jr.*, Chicago Historical Society, Chicago, 1991. De Jongh, James L., "The Image of Black Harlem in Literature," in Christopher Mulvey and John Simons, eds, *New York: City as Text*, Macmillan, London, 1990, pp. 131–46. Wright, John S., "A Scintillating Send-Off For Falling Stars: The Black Renaissance Reconsidered," in *A Stronger Soul Within A Finer Frame:*

Portraying African-Americans in the Black Renaissance, University of Minnesota, Minneapolis, 1990, pp. 12–45.

Jazz, blues and the performance paradigm: Van Vechten, Carl, "Memories of Bessie Smith," *Jazz Record* 58, September 1947, pp. 6–7. Morand, Paul, *Black Magic*, Viking Press, New York, 1929, pp. v–vi. Powell, Richard J., *The Blues Aesthetic: Black Culture and Modernism*, Washington Project for the Arts, Washington, D.C., 1989.

Black culture in Jazz-Age Paris: Leininger, Teresa, "The Transatlantic Tradition: African American Artists in Paris, 1830–1940," in Asake Bomani and Belvie Rooks, eds, *Paris Connections: African American Artists in Paris*, Q. E. D. Press, San Francisco, 1992, pp. 9–23. Fabre, Michel, *From Harlem to Paris: Black American Writers in France, 1840–1980*, University of Illinois Press, Urbana, 1991. Viry-Babel, Roger, *Jean Renoir: Le jeu et la règle* (first published 1986), Editions Ramsay, Paris, 1994, pp. 38–39. Baker, Jean-Claude and Chris Chase, *Josephine: The Hungry Heart*, Random House, New York, 1993.

Primitivism, Africa, and the "race renewal": Torgovnick, Marianna, *Gone Primitive: Savage Intellects, Modern Lives*. University of Chicago Press, Chicago, 1990. Mudimbe, V.Y., *The Invention of Africa: Gnosis, Philosophy, and the Order of Knowledge*, Indiana University Press, Bloomington, 1988, pp. 1–23. McKay, Claude, *A Long Way From Home*, Lee Furman, New York, 1937, pp. 348–54. Locke, Alain, "The Negro: 'New' or Newer: A Retrospective Review of the Literature of the Negro for 1938," in Jeffrey C. Stewart, ed., *The Critical Temper of Alain Locke*, Garland Publishing, New York, 1983, pp. 271–83.

3 THE CULT OF THE PEOPLE

Art and culture in the 1930s: Montgomery, Evangeline J., "Sargent Claude Johnson," in *San Francisco Art Commission Honors Award Show*, San Francisco Art Commission Gallery, San Francisco, 1977. Baigell, Matthew, *The American Scene: American Painting of the 1930s*, Praeger Publishers, New York, 1974. Hills, Patricia, *Social Concern and*

Urban Realism: American Painting of the 1930s, Boston University Art Gallery, Boston, 1983. Park, Marlene and Gerald E. Markowitz, *New Deal for Art*, Gallery Association of New York State, Hamilton, New York, 1977. Doss, Erika, *Benton, Pollock, and the Politics of Modernism: From Regionalism to Abstract Expressionism*, University of Chicago Press, Chicago, 1991. Gordon, Allan, *Echoes of Our Past: The Narrative Artistry of Palmer C. Hayden*, The Museum of African American Art, Los Angeles, 1988. Wright, Richard, *Lawd Today* (first published 1963), Northeastern University Press, Boston, MA, 1986. Duberman, Martin, *Paul Robeson*, Alfred A. Knopf, New York, 1988, pp. 207–208. Spencer, Jon Michael, *Blues and Evil*, The University of Tennessee Press, Knoxville, 1993, pp. 1–34. Oliver, Paul, *Songsters and Saints*, Cambridge University Press, Cambridge, 1984, pp. 109–39. Anderson, Jervis, "Harlem Explodes," in *This Was Harlem: A Cultural Portrait, 1900–1950*, Farrar Straus & Giroux, New York, 1982, pp. 295–98. Greene, Lorenzo J. and Carter G. Woodson, *The Negro Wage Earner*, The Association for the Study of Negro Life and History, Washington, D.C., 1930. Pells, Richard, *Radical Visions and American Dreams: Culture and Social Thought in the Depression Years*, Harper & Row, New York, 1973, pp. 43–95. Hurlburt, Laurance P., "New Workers School, 1933," in *The Mexican Muralists in the United States*, University of New Mexico Press, Albuquerque, 1989, pp. 175–93. Stange, Maren, *Symbols of Ideal Life: Social Documentary Photography in America, 1890–1950*, Cambridge University Press, Cambridge, 1989. King-Hammond, Leslie, "Black Printmakers and the W. P. A.," in *Faces Alone in the Crowd: Prints of the 1930s–40s by African American Artists*, American Federation of Arts, New York, 1993, pp. 10–20. M.M.S., "Comments on Art Exhibitions," *Parnassus* 7, March 1935, p. 24. Bibby, Deirdre L., *Augusta Savage and the Art Schools of Harlem*, Schomburg Center for Research in Black Culture, The New York Public Library, New York, 1988.

Edward Burra and Walker Evans: Rothstein, John, *Edward Burra*, The Tate Gallery, London, 1973. Mora, Gilles, *Walker Evans: Havana 1933*, Pantheon Books, New York, 1989.

The *Negritude* and *Indigenist* movements: Harris, Wilson, *The Womb of Space: The Cross-Cultural Imagination*, Greenwood Press, Westport, CT, 1983. Kutzinski, Vera, "The Carnivalization of Poetry: Nicolas Guillen's Chronicles," in *Against the American Grain: Myth and History in William Carlos Williams, Jay Wright, and Nicolas Guillen*, The John Hopkins University Press, Baltimore, 1987, pp. 131–235. Vaillant, Janet G., *Black, French, and African: A Life of Léopold Sédar Senghor*, Harvard University Press, Cambridge, MA, 1990, pp. 87–116. Douglas, Aaron, "Forge Foundry," *La Revue du Monde Noir* I, 1931, p. 4. Benjamin, Tritobia H., *The Life and Art of Lois Mailou Jones*, Pomegranate Artbooks, San Francisco, 1994, pp. 26–44. Lerebours, Michel-Philippe, *Haïti et ses Peintres, de 1804 à 1980: Souffrances & Espoirs d'un Peuple*, L'Imprimeur II, Port-au-Prince, 1989. Césaire, Aimé, *Cahiers d'un Retour au Pays Natal* (first published 1939), Brentano's, New York, 1947, n.p. Shelton, Marie-Denise, *Image de la Societé dans le roman haïtien*, L'Harmattan, Paris, 1993, pp. 7–31, 55–76. Savain, Petion, *La Case de Damballah* (first published 1939), Kraus Reprint, Nendeln, 1970.

Black diasporal religions and art: Mead, Chris, *Champion: Joe Louis, Black Hero in White America*, Scribner, New York, 1985. Herskovits, Melville J., "Les Noirs du Nouveau Monde: sujet de recherches africanistes," *Journal de la Societé du Africanistes* 8, 1938, pp. 65–82. Archer Straw, Petrine and Kim Robinson, *Jamaican Art*, Kingston Publishers, Kingston, 1990, pp. 5–10. Beckwith, Martha Warren, "The Pukkemerians," in *Black Roadways: A Study of Jamaican Folk Life: The Black Folk Hero*, The University of North Carolina Press, Chapel Hill, 1929, pp. 176–82. Hemenway, Robert E., *Zora Neale Hurston: A Literary Biography*, University of Illinois Press, Urbana, 1977. Metcalf, Eugene, "Black Art, Folk Art, and Social Control," *Winterthur Porfolio* 18, Winter 1983, pp. 271–89. Preece, Harold, "The Negro Folk Cult," *The Crisis* 43, 1936, pp. 364, 374. Fuller, Edmund L., *Visions in Stone: The Sculpture of William Edmondson*, University of Pittsburgh Press, Pittsburgh, 1973. Radin, Paul, "Status, Fantasy, and the Christian Dogma," in *God Struck Me Dead: Religious Conversion Experiences and Autobiographies of Ex-Slaves*, ed. Clifton H. Johnson, Pilgrim Press, Philadelphia, 1969, pp. vii–xiii. *Elijah Pierce: Woodcarver*, Columbus Museum of Art, Columbus, 1992. Bearden, Romare, "The Negro Artist and Modern Art," *Opportunity* 12, December 1934, pp. 371–72.

4 PRIDE, ASSIMILATION, AND DREAMS

"Negro Cavalcade" of the 1940s: Ottley, Roi, *New World A-Coming*, Houghton Mifflin, Boston, 1943. Robinson, John N., "John N. Robinson: An Autobiographical Sketch," in *John N. Robinson: A Retrospective*, Smithsonian Institution Press, Washington, D.C., 1976, pp. 13–18. "Karl Broodhagen," in *Pioneer Artists of the Pre-Independence Era*, Art Collection Foundation, Bridgetown, 1993. Lamming, George, *In the Castle of My Skin*, McGraw-Hill, New York, 1953. Thomas, Jesse O., *Negro Participation in the Texas Centennial Exposition*, The Christopher Publishing House, Boston, MA, 1938. Locke, Alain, *Contemporary Negro Art*, Baltimore Museum of Art, Baltimore, 1939. Locke, Alain, "Up Till Now," in *The Negro Artist Comes of Age*, Albany Institute of History and Art, Albany, 1945, pp. iii–vii. Locke, Alain, *The Negro in Art*, Associates in Negro Folk Education, Washington, D.C., 1940. Porter, James A., *Modern Negro Art* (first published 1943), Howard University Press, Washington, D.C., 1992.

Jacob Lawrence and William H. Johnson: Wheat, Ellen Harkins, *Jacob Lawrence: American Painter*, University of Washington Press, Seattle, 1986. Powell, Richard J., *Homecoming: The Art and Life of William H. Johnson*, Rizzoli, New York, 1991.

Eldzier Cortor and the "folk cult" revisited: Naremore, James, "Uptown Folk: Cabin in the Sky (1943)," in *The Films of Vincente Minnelli*, Cambridge University Press, Cambridge, 1993, pp. 51–70. Cortor, Eldzier, letter to Homer St. Gaudens, 15 September 1947, Archives of American Art, Smithsonian Institution, Washington, D.C. Jennings; Corrine L., "Eldzier Cortor: The Long Consistent Road," in *Three Masters: Eldzier Cortor, Hughie Lee-Smith, Archibald John Motley Jr.*, Kenkeleba Gallery, New York, 1988, pp. 12–22. Vlach, John Michael, "Contemporary Plain Painters: New Forms, New Criteria," in *Plain Painters: Making Sense of American Folk Art*, Smithsonian Institution, Washington, D.C., 1988, pp. 161–75.

John Dunkley and Hector Hyppolite: Archer Straw, Petrine and Kim Robinson, "Self-Taught Artists—Africa Incarnated," in *Jamaican Art*, Kingston Publishers, Kingston, 1990, pp. 124–49. Rodman, Selden, *Where Art Is Joy*, Ruggles de Latour, New York, 1988. Breton, André, "Hector Hyppolite," in *Surrealism and Painting* (1965), reprint, Icon Editions, New York, 1972, pp. 308–12. Glissant, Edouard, "On Haitian Painting," in *Caribbean Discourse*, University of Virginia Press, Charlottesville, 1992, pp. 155–57.

James Hampton and Minnie Evans: Powell, Richard J., "Art, History, and Vision," *Art Bulletin* 77, September 1995, pp. 379–82. Kahan, Mitchell Douglas, *Heavenly Visions: The Art of Minnie Evans*, University of North Carolina Press, Chapel Hill, 1986.

Black culture and abstract art: Gibson, Ann, "Two Worlds: African-American Abstraction in New York at Mid-Century," in *The Search for Freedom: African American Abstract Painting, 1945–1975*, Kenkeleba Gallery, New York, 1991, pp. 11–53. Frascina, Francis, "Attitudes: Origins and Cultural Difference," in *Modernism in Dispute: Art Since the Forties*, Yale University Press, New Haven, 1993, pp. 124–57. "Leading Young Artists," *Ebony* 13, April 1958, pp. 33–38. Gibson, Ann, "Norman Lewis in the Forties," in *Norman Lewis*, Kenkeleba Gallery, New York, 1989, pp. 9–23. Wilson, Judith, "Go Back and Retrieve It: Hale Woodruff, Afro-American Modernist," in *Selected Essays: Art & Artists From the Harlem Renaissance to the 1980s*, National Black Arts Festival, Atlanta, 1988, pp. 41–49. Woodruff, Hale, letter to Charles Alston, 18 February 1947, Archives of American Art, Smithsonian Institution, Washington, D.C. Rosenberg, Harold, as quoted in Charles Childs, "The Artist Caught between Two Worlds," *Tuesday Magazine*,

April 1967, pp. 8–10, 23. *The Sculpture of Richard Hunt*, Museum of Modern Art, New York, 1971. Walmsley, Anne, ed., *Guyana Dreaming: the Art of Aubrey Williams*, Dangaroo Press, Coventry and Sydney, 1990. Inge, M. Thomas, ed., *Dark Laughter: The Satiric Art of Oliver W. Harrington, From the Walter O. Evans Collection of African-American Art*, University Press of Mississippi, Jackson, 1993.

Sartre, universality, and the "Orphic" myth: Fabre, Michel, *From Harlem to Paris: Black American Writers in France, 1840–1980*, University of Illinois Press, Urbana, 1991. Wilson, Sarah, "Paris Post War: In Search of the Absolute," in Frances Morris, *Paris Post War: Art and Existentialism, 1945–55*. Tate Gallery, London, 1993, pp. 25–52. Diop, Alioune, "Niam n'goura ou les raisons d'être de *Présence Africaine*," *Présence Africaine* 1, October–November 1947, p. 7. Sartre, Jean-Paul, "Black Orpheus" (1948), English translation, *The Massachusetts Review* 6, Autumn/Winter 1964–65, pp. 13–52. Fanon, Frantz, trans. Charles Lam Markmann, *Black Skin, White Masks*, Grove, New York, 1967, pp. 109–40. Herzberg, Julia P., "Wifredo Lam: The Development of a Style and a World View, The Havana Years, 1941–52," in *Wifredo Lam and his Contemporaries, 1938–1952*, Studio Museum in Harlem, New York, 1992, pp. 30–51. Ellison, Ralph, *Invisible Man*, Random House, New York, 1952. Moraes, Vinicius de, *Orfeu da Conceição*, Editôra Dois Amigos, Rio de Janeiro, 1967. Trémois, Claude-Marie, "Comment Camus a tourné *Orfeu Negro*," *Nouveaux Films Français* 474 (1960). Miller-Keller, Andrea, *Bob Thompson: Matrix 90*, Wadsworth Atheneum, Hartford, 1986. Miller, Henry, "The Amazing and Invariable Beauford DeLaney," in *Remember to Remember* (first published 1941), reprint, Studio Museum in Harlem, New York, 1980. Porter, Thomas J., "Skunder Boghossian: Spaces," in *Skunder*, Trisolini Gallery of Ohio University, Athens, 1980, n.p.

Black figuration and protest: Spiro, Lesley, *Gerard Sekoto: Unsevered Ties*, Johannesburg Art Gallery, Johannesburg, 1989. *Elizabeth Catlett: The Negro Woman*,

Barnett-Aden Gallery, Washington, D.C., 1947. Hansberry, Lorraine, "Foreword," in *Charles White*, ACA Gallery, New York, 1961, n.p. Bush, Martin H., *The Photographs of Gordon Parks*, Edwin A. Ulrich Museum of Art, Wichita, 1983. Hughes, Langston, and Roy DeCarava, *The Sweet Flypaper of Life*, Simon and Schuster, New York, 1955. Frank, Robert, *The Americans*, Grove, New York, 1959. *Let Us March On! Selected Civil Rights Photographs of Ernest C. Withers, 1955–1968*, Massachusetts College of Art, Boston, 1992. *102 Favorite Paintings by Norman Rockwell*, Crown, New York, 1978.

5 "BLACK IS A COLOR"

Romare Bearden and the metamorphosis of identity: Jones, LeRoi, "blackhope," in *Home*, William Morrow, New York, 1966, pp. 234–37. Childs, Charles, "Bearden: Identification and Identity," *Art News* 63, October 1964, pp 24–25, 54, 61–62. Powell, Richard J., "What Becomes a Legend Most? Reflections on Romare Bearden," *Transition* 55, 1992, pp. 63–72.

Barbara Chase-Riboud and Raymond Saunders: *Chase-Riboud*, University Art Museum, Berkeley, 1973. Fanon, Frantz, trans. Charles Lam Markmann, *Black Skin, White Masks*, Grove, New York, 1967, pp. 109–40. Saunders, Raymond, *Black Is A Color*, privately printed, San Francisco, c. 1968, n.p. Powell, Richard J. "The Art of Raymond Saunders: Colored," *New Observations* 97, September/October 1993, pp. 10–15.

Alma Thomas and Sam Gilliam: Kingsley, April, *Afro-American Abstraction*, The Art Museum Association, San Francisco, 1982. *Alma W. Thomas: Retrospective Exhibition*, Corcoran Gallery of Art, Washington, D.C., 1972. Foresta, Merry A., *A Life in Art: Alma Thomas, 1891–1978*, Smithsonian Institution Press, Washington, D.C., 1981. Beardsley, John, *Modern Painters at the Corcoran: Sam Gilliam*, Corcoran Gallery of Art, Washington, D.C., 1988, n.p. Morrison, Keith, *Art in Washington and its Afro-American Presence: 1940–1970*, Washington Project for the Arts, Washington, D.C., 1985.

Hervé Télémaque and Emilio Cruz: *Hervé Télémaque*, Musée d'Art Moderne de la Ville de Paris, Paris, 1976. Fleminger, Susan, *Emilio Cruz: Spilled Nightmares, Revelations & Reflections*, Studio Museum in Harlem, New York, 1987.

Joe Overstreet and Al Loving: Fine, Elsa Honig, *The Afro-American Artist: A Search for Identity*, Holt, Rinehart and Winston, New York, 1973, pp. 234–35, 261–62. Reed, Ishmael, *Mumbo Jumbo*, Doubleday, New York, 1972. Colby, Joy Hakanson, "For Al Loving, there's no place like home," *The Detroit News*, 3 February 1988, 2D.

Edward Clark and Jack Whitten: Feldman, Anita, "A Complex Identity: Edward Clark, 'Noir de Grand Talent,'" in *Edward Clark*, Studio Museum in Harlem, New York, 1980. Wright, Beryl J., *Jack Whitten*, The Newark Museum, Newark, 1990, pp. 7–13. Jacobs, Joseph, "Jack Whitten," in *Since the Harlem Renaissance: 50 Years of Afro-American Art*, Bucknell University, Lewisburg, PA, 1985, p. 45.

Uzo Egonu and Frank Bowling: Oguibe, Olu, *Seen/Unseen*, Bluecoat Gallery, Liverpool, 1994. Araeen, Rasheed, *The Other Story: Afro-Asian artists in post-war Britain*, South Bank Centre, London, 1989, pp. 37–41, 119–21. Bowling, Frank, "Is Black Art About Color?" in Rhoda L. Goldstein, ed., *Black Life and Culture in the United States*, Thomas Crowell, New York, 1971, pp. 302–21.

African Americans and the media: McLuhan, H. Marshall, *Understanding Media: The Extensions of Man*, Routledge and Kegan Paul, London; McGraw-Hill, New York, 1964. Campbell, Mary Schmidt, *Tradition and Conflict: Images of a Turbulent Decade, 1963–1973*, Studio Museum in Harlem, New York, 1985. Donaldson, Jeff, *The Civil Rights Yearbook*, Henry Regnery, Chicago, 1964. Shecter, Leonard, "The Passion of Muhammad Ali," *Esquire* 69, April 1968, pp. 128–31, 140, 148–60. Bogle, Donald, *Toms, Coons, Mulattoes, Mammies, and Bucks: An Interpretive History of Blacks in American Film*, Viking Press, New York, 1973, pp. 232–35.

Black cultural signifiers: "Beauty Bulletin: The Natural," *Vogue* 153, January 1969, pp. 134–37. Lewis, Samella, *African American Art and Artists*, University of California Press, Berkeley, 1994. Willis-Thomas, Deborah, *Introspect: the photography of Anthony Barboza*, Studio Museum in Harlem, New York, 1982. *AFRI-COBRA III*, University Art Gallery, University of Massachusetts at Amherst, Amherst, 1973. Donaldson, Jeff, "10 in Search of a Nation," *Black World* 19, October 1970, pp. 80–89.

The black nude: Childs, Charles, "Larry Ocean Swims the Nile, Mississippi and other Rivers," in *Some American History*, Institute for the Arts, Rice University, Houston, 1971, pp. 9–20. Wilson, Judith, "Getting Down to Get Over: Romare Bearden's Use of Pornography and the Problem of the Black Female Body in Afro-U.S. Art," in Gina Dent, ed., *Black Popular Culture*, Bay Press, Seattle, 1992, pp. 112–22. *Murry DePillars: Paintings*, Studio Museum in Harlem, New York, 1976. Ringgold, Faith, *We Flew Over the Bridge: The Memoirs of Faith Ringgold*, Bulfinch Press, Boston, 1995. Chandler, Dana, *If The Shoe Fits, Hear It! Paintings and Drawings, 1967–1976*, Northeastern University, Boston, 1976. Campbell, Mary Schmidt, *Barkley L. Hendricks*, Studio Museum in Harlem, New York, 1980. Willis, Deborah, ed., *Picturing Us: African American Identity in Photography*, The New Press, New York, 1994. Mercer, Kobena, "Reading Racial Fetishism: The Photography of Robert Mapplethorpe," in *Welcome to the Jungle: New Positions in Black Cultural Studies*, Routledge, London and New York, 1994, pp. 171–219. Walker, Alice, *Meridian*, Deutsch, London; Harcourt Brace Jovanovich, New York, 1976, p. 130.

Alternatives to the "Black Arts" movement agenda: Driskell, David C., *Two Centuries of Black American Art*, Alfred A. Knopf, New York, 1976. Diawara, Manthia, ed., *Black American Cinema*, Routledge, London, 1993. Shepherd, Elizabeth, ed., *The Art of Betye and Alison Saar: Secrets, Dialogues, Revelations*, Wight Art Gallery, University of California, Los Angeles, 1990. Gordon, Allan, "Nommo Muse: Black Improvisation in California," *New Art Examiner* 7, June 1980, pp. 6–7. Bryant, Linda Goode and Marcy S. Philips, *Contextures*, Just Above Midtown Gallery, New York, 1978, pp. 38–45. Cannon, Steve, Kellie Jones, and Tom Finkelpearl, *David Hammons: Rousing the Rubble*, The MIT Press, Cambridge, MA, 1991.

Reimaging "Africa" after colonialism: Beier, Ulli, *Art in Nigeria*, Cambridge University Press, Cambridge, 1960. Thompson, Alison, *Son et Lumière: The Paintings of Francis Griffith*, Barbados Museum and Historical Society, Bridgetown, 1995. Bender, Wolfgang, *Rastafari Kunst aus Jamaica*, Übersee-Museum, Bremen, 1984. Benjamin, Tritobia Hayes, *The Life and Art of Lois Mailou Jones*, Pomegranate Press, San Francisco, 1994. Poinsett, Alex, "Festac '77," *Ebony* 32, May 1977, pp. 33–49.

Music, art, and the black ethos: Powell, Richard J., *The Blues Aesthetic: Black Culture and Modernism*, Washington Project for the Arts, Washington, D.C., 1989. Archie Rand, *The Groups: Paintings by Archie Rand*, Museum of Art, Carnegie Institute, Pittsburgh, 1983. *Ernie Barnes / Artist*, The Company of Art, Los Angeles, 1979.

"Folk," "fine," and reconciliations of black culture: Livingston, Jane and John Beardsley, *Black Folk Art in America: 1930–1980*, University of Mississippi Press, Jackson, 1982. Poupeye-Rammelaere, Veerle, "The Rainbow Valley: The Life and Work of Brother Everald Brown," *Jamaica Journal* 21, May–July 1988, pp. 2–14. Powell, Richard J., "Margo Humphrey: An Interview," in *Hatch-Billops Collection, Inc / Artist and Influence* 5, 1987, pp. 56–65. Tate, Greg, "Cult-Nats Meet Freaky-Deke," *Flyboy in the Buttermilk: Essays on Contemporary America*, Fireside Book, New York, 1992, pp. 198–210.

6 CULTURE AS CURRENCY

Lyle Ashton Harris, Alison Saar, and Martin Puryear: Hapgood, Susan, "Lyle Ashton Harris at Jack Tilton," *Art in America* 82, November 1994, p. 122. Aletti, Vince, "It's a Family Affair: Photographer Lyle Ashton Harris Scores a Strategic Hit," *Village Voice*, 27 September 1994, pp. 39–40. Krane, Susan, *Art at the Edge: Alison Saar / Fertile Ground*, High Museum of Art, Atlanta, 1993. Benezra, Neal, *Martin Puryear*, Art Institute of Chicago, Chicago, 1991.

Culture as an artistic currency: Tate, Greg, "Startblack-Owned, Conceptual Bomber," *Vibe* 3, February 1995, p. 32. *The Decade Show: Frameworks of Identity in the 1980s*, Museum of Contemporary Hispanic Art / The New Museum of Contemporary Art / The Studio Museum in Harlem, New York, 1990. "Critical Decade: Black British Photography in the 80s," *Ten.8* 2, Spring 1992. West, Cornel, "Nihilism in Black America," in Gina Dent, ed., *Black Popular Culture*, Bay Press, Seattle, 1992, pp. 36–47. Hall, Stuart, "What is this 'Black' in Black Popular Culture?" in Gina Dent, ed., *op. cit.*, pp. 20–33. *Interrogating Identity*, Grey Art Gallery and Study Center, New York University, New York, 1991.

Black signs and symbols: Reed, Dock, Henry Reed, and Vera Hall, "Handwriting on the Wall" (1937), on Alan Lomax, ed., *Afro-American Spirituals, Work Songs, and Ballads*, Library of Congress AFS L3. Marshall, Richard, *Jean-Michel Basquiat*, Whitney Museum of American Art, New York, 1993. Hughes, Robert, "Jean-Michel Basquiat: Requiem for a Featherweight," in *Nothing If Not Critical: Selected Essays on Art and Artists*, Alfred A. Knopf, New York, 1990, pp. 308–12. *Tam Joseph: Learning to Walk*, Bedford Hill Gallery, London, 1989. Enwezor, Okwui, "Ouattara: Beyond Shamanism," *Nka: Journal of Contemporary African Art* 2, Spring/Summer 1995, pp. 24–29. Powell, Richard J., unpublished notes on meeting with Ras Ishi Butcher, St. John, Barbados, 13 March 1995.

Mr. Imagination and Philip Moore: Patterson, Tom, "Manifesting the World of Mr. Imagination," in *Reclamation and Transformation: Three Self-Taught Chicago Artists*, Terra Foundation for the Arts, Chicago, 1994, pp. 34–63. Moore, Philip, unpublished notes on his work, 8 April 1992, Mervyn Awon Archives, St. Michael, Barbados.

Martha Jackson-Jarvis and Melvin Edwards: Swift, Mary, "The Power of One: Martha Jackson-Jarvis," *Washington Review* 20, February/March 1995, pp. 3–5. *Melvin Edwards: Sculptures (1964–1984)*, Maison de l'Unesco, Paris, 1984.

Placement/displacement: Grynsztejn, Madeleine, *About Place: Recent Art of the Americas*, Art Institute of Chicago, Chicago, 1995. Morrison, Toni, *The Bluest Eye* (first published 1970), Pocket Books, New York, 1972, pp. 17–18. Storr, Robert, *Dislocations*, Museum of Modern Art, New York, 1991. Wilson, Fred, "The Silent Message of the Museum," in Jean Fisher, ed., *Global Visions: Towards a New Internationalism in the Visual Arts*, Kala Press, London, 1994, pp. 152–60. Jacob, Mary Jane, *Places with a Past: New Site-Specific Art at Charleston's Spoleto Festival*, Rizzoli, New York, 1991, pp. 138–45. Sims, Lowery Stokes, "Home is Where the Heart is: Beverly Buchanan's Shack Sculpture in Context," in *Beverly Buchanan: Shack Works, a 16–Year Survey*, Montclair Art Museum, Montclair, 1994, pp. 33–39. Solomon, Andrew, "The Artists of South Africa: Separate, and Equal," *New York Times Magazine*, 27 March 1994, p. 78. Williamson, Sue, letter to Richard J. Powell, 28 November 1995. Grynsztejn, Madeleine, *op. cit.*, pp. 31–33.

Fred Wilson, Sonia Boyce, Conwill/De Pace/Majozo and Alfredo Jaar: Fleming, Jeff, "Ground-Truthing," in *Insight/In Site/In Sight/Incite: Memory/Artist and the Community: Fred Wilson*, Southeastern Center for Contemporary Art, Winston-Salem, 1994, pp. 15–19. Tawadros, Gilane, "Peeping Toms," in *Peep: Sonia Boyce*, Institute of International Visual Arts, London, 1995, n.p. Majozo, Estella Conwill, "To Search for the Good and make it Matter," in Suzanne Lacy, ed., *Mapping the Terrain: New Genre Public Art*, Bay Press, Seattle, 1995, pp. 88–93. Gilroy, Paul, *The Black Atlantic: Modernity and Double Consciousness*, Harvard University Press, Cambridge, MA, 1993. Grynsztejn, Madeleine, *Afredo Jaar*, La Jolla Museum of Contemporary Art, La Jolla, 1990.

Identities in flux: Appiah, Kwame Anthony, "African Identities," in *In My Father's House: Africa in the Philosophy of Culture*, Methuen, London; Oxford University Press, New York, 1992, pp. 173–80. Demerson, Bamidele Agbasegbe, "Canvas and Computer, Painting and Programming: Tradition and Technology in the Art of Acha Debela," *The International Review of African American Art* 10, 1992, pp. 28–39. Trachtman, Paul, "Charles Csuri is an 'Old Master' in a new medium," *Smithsonian* 25, February 1995, pp. 56–65. Golden, Thelma, "My Brother," in *Black Male: Representations of Masculinity in Contemporary American Art*, Whitney Museum of American Art, New York, 1994, pp. 19–43. *Toscani al Muro, débat de rue: Les Images Benetton, 1990–1994*, Old England, Brussels, 1994.

Phillip Mallory Jones and Albert Chong: Levin, Julie, "Visions of Diaspora: Five Video Works by Phillip Mallory Jones," in *1992 Dallas Video Festival*, Dallas Museum of Fine Arts, Dallas, 1992, p. 63. *Ancestral Dialogues: The Photographs of Albert Chong*, The Friends of Photography, San Francisco, 1994.

Lorraine O'Grady and Emma Amos: Reid, Calvin, "A West Indian Yankee in Queen Nefertiti's Court," *New Observations* 97, September/October 1993, pp. 5–9. hooks, bell, "Aesthetic Intervention," in *Emma Amos: Changing the Subject, Paintings and Prints, 1992–1994*, Art in General, New York, 1994, pp. 5–12.

Coreen Simpson, Dawoud Bey, and Maud Sulter: Ashford, Nickolas and Valerie Simpson, *Ashford & Simpson: Gimme Something Real* (1973), Warner Bros. Records BS 2739. Birt, Rodger, "Coreen Simpson: An Interpretation," *Black American Literature Forum* 21, Fall 1987, pp. 289–304. Jones, Kellie, "Dawoud Bey: Portraits in the Theater of Desire," in *Dawoud Bey: Portraits, 1975–1995*, Walker Art Center, Minneapolis, 1995, pp. 9–55. Sulter, Maud, *Zabat*, Urban Fox Press, West Yorkshire, 1989. Hambourg, Maria Morris, François Heilbrun, Philippe Néagu, *Nadar*, Abrams, New York, 1995, pp. 238–40.

Social narratives and "color" concepts: Merewether, Charles, "Banality and Tragedy. A History of the Present in Haiti," in *Edouard Duval-Carrié*, Museo de Arte Contemporáneo de Monterrey, Monterrey, 1993, pp. 19–23. Gill, Susan, "Sue Coe's Inferno," *Art News* 86, October 1987, pp. 110–15. Thomas, Jo, "Black Youths Riot in London District," *New York Times*, 29 September 1985, pp. 1, 20.

Adrian Piper and Howardena Pindell: *Adrian Piper: Reflections, 1967–1987*, Alternative Museum, New York, 1987. Stepto, Robert B., *From behind the Veil: A Study of Afro-American Narrative*, Urbana, University of Illinois Press, 1979. *Howardena Pindell: Paintings and Drawings*, Roland Gibson Gallery, Potsdam, New York, 1992.

Glenn Ligon/Byron Kim and Robert Colescott: Harrison, Helen, "Skin Pigmentation as a Determinant of Attitudes," *New York Times*, 1 December 1991, section 12, p. 22. Bailey, David A., "Mirage: Enigmas of Race, Difference, and Desire," in *Mirage: Enigmas of Race, Difference, and Desire*, Institute of Contemporary Arts, London, 1995, p. 78. Johnson, Robert, "Colescott on Black and White," *Art in America* 77, June 1989, pp. 148–53, 197.

Keith Morrison and Stanley Greaves: Powell, Richard J., "Anansi Revisited: Keith Morrison's New Work," in *Keith Morrison: Recent Paintings*, Alternative Museum, New York, 1990, pp. 4–5. Roopnaraine, Rupert, "Caribbean Metaphysics, Another Reality," in *Caribbean Metaphysics, Another Reality: An Exhibition of Mini Paintings of Stanley Greaves*, Queen's Park Gallery, Bridgetown, 1993, pp. 5–10. Greaves, Stanley, letter to Richard J. Powell, 13 June 1995.

Bodily acts of black art: Henderson, Stephen, *Understanding the New Black Poetry: Black Speech & Black Music as Poetic References*, William Morrow, New York, 1972. Other Sources: An American Essay, San Francisco Art Institute, San Francisco, 1976. King-Hammond, Leslie and Lowery Stokes Sims, *Art As A Verb: The Evolving Continuum/Installations, Performances, and Videos by 13*

African-American Artists, Maryland Institute, College of Art, Baltimore, 1988. *The Decade Show: Frameworks of Identity in the 1980s*, Museum of Contemporary Hispanic Art/The New Museum of Contemporary Art/The Studio Museum in Harlem, New York, 1990. Sims, Lowery Stokes, "Aspects of Performance in the Work of Black American Women Artists," in Arlene Raven, ed., *Feminist Art Criticism: An Anthology*, UMI Research Press, Ann Arbor, 1988, pp. 207–25. Thompson, Robert Farris, *Face of the Gods: Art and Altars of Africa and the African Americas*, Museum for African Art, New York, 1993. Fusco, Coco, "Performance and the Power of the Popular," in Catherine Ugwu, ed., *Let's Get it On: The Politics of Black Performance*, Bay Press, Seattle, 1995, pp. 158–75.

Keith Haring/Tseng Kwong Chi/Bill T. Jones: Gruen, John, *Keith Haring: The Authorized Biography*, Prentice-Hall Press, New York, 1991, pp. 95–98, 111. Mercer, Kobena, "Reading Racial Fetishism: The Photographs of Robert Mapplethorpe," in *Welcome to the Jungle: New Positions in Black Cultural Studies*, Routledge, London and New York, 1994, pp. 171–219.

Ben Jones and Sherman Fleming: Patrick, John, "The Big Picture: Multiculturalism evoked in Jersey City exhibit," *The Jersey Journal*, 6 January 1995, p. E7. *Ben Jones: In the Spirit*, 198 Gallery, London, 1994. Stiles, Kristine, "Rodforce: Thoughts on the Art of Sherman Fleming," *High Performance* 10, 1987, pp. 34–39. "Other Bloods/ Dagboek Aldert Mantje," *De Maat Schappy Arti et Amicitiæ* 3, March 1995, pp. 5–7. Riefenstahl, Leni, *The Last of the Nuba*, Harper & Row, New York, 1974; Collins, London, 1976.

Black women artists performing "the body": Sokari Douglas Camp: *Play and Display*, Museum of Mankind, London, 1995. Magnier, Bernard, "A la rencontre de. . .Werewere Liking," *Notre Librairie* 79, 1985, pp. 17–21. James, Curtia, "Joyce J. Scott: Generic Interference/Genetic Engineering," *Art Papers*, September/October 1993, pp. 66. Sterling, Susan Fisher, "Signifying:

Photographs and Texts in the Works of Carrie Mae Weems," *Carrie Mae Weems*, The National Museum of Women in the Arts, Washington, D.C., 1993, pp. 19–36.

7 THROUGH A GLASS, DIASPORALLY

Towards a definition of "black film": Cripps, Thomas, "Oscar Micheaux: The Story Continues," in Manthia Diawara, ed., *Black American Cinema*, Routledge, London and New York, 1993, pp. 71–79. Bill Cosby, "Introduction," in Middleton A. Harris, Morris Levitt, Roger Furman, and Ernest Smith, eds., *The Black Book*, Random House, New York, 1974, p. i. Snead, James, *White Screens/Black Images: Hollywood from the Dark Side*, Routledge, London and New York, 1994.

Vincente Minelli and Spencer Williams: Naremore, James, "Uptown Folk: Cabin in the Sky (1943)," in *The Films of Vincente Minnelli*, Cambridge University Press, Cambridge, 1993, pp. 51–70. Coleman, Gregory D., *We're Heaven Bound! Portrait of A Black Sacred Drama*, University of Georgia Press, Athens, 1994.

Realities and pleasures via the cinematic artifice: Stephenson, Ralph and J. R. Debrix, *The Cinema as Art*, Penguin, London, 1965, pp. 13–36. Callenbach, Ernest, "Film Reviews: Orfeu Negro," *Film Quarterly* 13 (Spring 1960), pp. 57–58. Sainville, Leonard, "Le Cinéma: Orfeu Negro," *Présence Africaine* 26 (June–July 1959), pp. 130–31. Dent, Gina, "Black Pleasure, Black Joy: An Introduction," in Gina Dent, ed., *Black Popular Culture*, Bay Press, Seattle, 1992, pp. 1–19. Diawara, Manthia, "Black American Cinema: The New Realism," in Manthia Diawara, ed., *Black American Cinema*, Routledge, London and New York, 1993, pp. 3–25. Hemphill, Essex, "Brother to Brother: Interview with Isaac Julien," *Black Film Review* 5 (Summer 1989), pp. 14–17. Mercer, Kobena, "Dark and Lovely: Black Gay Image-Making," *Welcome to the Jungle: New Positions in Black Cultural Studies*, Routledge, London and New York, 1994, pp. 220–32. Gates, Henry Louis Jr.,

"Looking for Modernism," in Manthia Diawara, ed., *Black American Cinema*, pp. 200–207. Diawara, Manthia and Phyllis R. Klotman, "Ganja and Hess: Vampires, Sex, and Addictions," and Diawara, Manthia, "The Nature of Mother in Dreaming Rivers," in *Black American Literature Forum* 25 (Summer 1991), pp. 283–98 and 299–314. Smith, Valerie, "Facing the Spectre of Racism," *Emerge* 6 (October 1994), pp. 60–61.

Spike Lee and Felix de Rooy: Lee, Spike, and Lisa Jones, *Uplift the Race: The Construction of School Daze*, Fireside Book, New York, 1988. Fusco, Coco, "Stateless Hybrids: An Introduction," *Hybrid State Films*, Exit Art, New York, 1991, n.p. Malbert, Roger, "Felix de Rooy," *In Fusion: New European Art*, The South Bank Centre/Ikon Gallery, Birmingham, 1993, p 42.

Ousmane Sembene and Euzhan Palcy: Ukadike, Nwachukwu Frank, *Black African Cinema*, University of California Press, 1994, pp. 182–84. Pfaff, François, *The Cinema of Ousmane Sembene, A Pioneer of African Film*, Greenwood Press, Westport, CT, 1984. De Stefano, George, "Sugar Cane Alley," *Cineaste* 13 (1984), pp. 42–45.

Julie Dash and Haile Gerima: Dash, Julie, *Daughters of the Dust: The Making of an African American Woman's Film*, The New Press, New York, 1992. Brown, Georgia, "The haunting," *Village Voice* 39 (12 April 1994), p. 56.

Broadcast television and music videos: MacDonald, J. Fred, *Black and White TV: African Americans in Television since 1948*, Nelson-Hall Publishers, Chicago, 1992. Rose, Tricia, "Voices from the Margins: Rap Music and Contemporary Black Cultural Production," *Black Noise: Rap Music and Black Culture in Contemporary America*, University Press of New England, 1994, pp. 1–20. Laing, Dave, "Music Video—Industrial Product, Cultural Form," *Screen* 26 (March–April 1985), pp. 78–83. Durgnat, Raymond, "Amazing Grace," *American Film* 11 (January–February 1986), pp. 31–35.

Keith Piper and black British video initiatives: Mercer, Kobena, "Recoding Narratives of Race and Nation," *Black Film/British Cinema: ICA Documents 7* (1988), pp. 4–14. Piper, Keith, "Introduction," *The Exploded City*, Center 181 Gallery, London, 1994, n.p.

Jonathan Demme, Steve McQueen, and Charles Stone III: Morrison, Toni, *Beloved,* Alfred A. Knopf, New York, and Chatto & Windus, London, 1987. Winfrey, Oprah, *Journey to Beloved,* Hyperion, New York, 1998. Dobrzynski, Judith H., "A Convert Spreads the Word for Haitian Art," *New York Times,* June 10, 1997. Bickers, Patricia, "Let's Get Physical: Steve McQueen Interviewed," *Art Monthly* 202, December 1996/ January 1997, pp. 1–5. O'Kane, Paul, "Reviews: Steve McQueen: ICA, London, England," *Zing Magazine* 10, Summer 1999, see www.zingmagazine.com. Powell, Richard J., unpublished notes on meeting with Charles Stone III, Durham, North Carolina, 5 April 1995. Elliot, Stuart, "Responsible Party: Charles Stone III; A Buzzword Rises from an Inside Joke," *New York Times,* April 16, 2000.

The "Cut and Mix" Aesthetic: Oguibe, Olu, " African Cinema Today: Interview with Mark Reid," *Nka* 9, Fall/Winter 1998, pp. 58–61. Miller, Paul D., "Time and The Cinematic Image: Notes for the Oberhausen Film Festival 2001," see www.djspooky.com.

CONCLUSION: *FIN-DE-SIÈCLE* BLUES

The Allure and Loathing of Blackness: *Seven Stories about Modern Art in Africa,* Flammarion, Paris, 1995. *Freestyle,* Studio Museum in Harlem, New York, 2001. Doy, Gen, *Black Visual Culture: Modernity and Postmodernity,* I. B. Tauris Publishers, London, 2000. *Septima Bienal de la Habana,* Centro de Arte Contemporaneo Wifredo Lam, Havana, 2000. Bedford, Emma, "Dak'Art 2000: In Search of the Magic Moment," *Nka* 13/14, Spring/Summer 2001, pp. 14–17. Enwezor, Okwui, *Trade Routes:*

History and Geography, 2nd Johannesburg Biennale, Johannesburg, 1997. Gilroy, Paul, *Against Race: Imagining Political Culture beyond the Color Line,* Belknap/Harvard, Cambridge, 2000.

Kara Walker, David Levinthal, and other visual provocateurs: *Kara Walker,* The Renaissance Society, Chicago, 1997. Lott, Tommy, "Kara Walker Speaks: A Public Conversation on Racism, Art, and Politics," *Black Renaissance/Renaissance Noire* 3, Fall 2000: pp. 66–91. *David Levinthal: Works from 1975-1996,* D.A.P., New York, 1997. *David Levinthal: Blackface,* Arena Editions, Santa Fe, New Mexico, 1999. *Re/Righting History: Counternarratives by Contemporary African-American Artists,* Katonah Museum of Art, Katonah, New York, 1999. *Without Sanctuary: Lynching Photography in America,* Twin Palms Publishers, Santa Fe, New Mexico, 2000.

Renée Cox, Aaron McGruder, and Chris Ofili: Isaak, Jo Anna, *Looking Forward, Looking Black,* Hobart and William Smith Colleges Press, Geneva, New York, 1999. McGruder, Aaron, *Fresh for '01 You Suckas!,* Andrew McMeel Publishing, Kansas City, 2001. *Chris Ofili,* Southampton City Art Gallery and Serpentine Gallery, London, 1998. Hirschberg, Lynn, "How Black Comedy Got the Last Laugh," *The New York Times Magazine,* September 3, 2000.

African Artists in the Global Imagination: Enwezor, Okwui, *The Short Century: Independence and Liberation Movements in Africa, 1945–1994,* Prestel, Munich, 2001. Enwezor, Okwui, "Between Worlds: Postmodernism and African Artists in the Western Metropolis," in Olu Oguibe and Okwui Enwezor, eds, *Reading the Contemporary: African Art from Theory to the Marketplace,* in IVA, London, 1999. M.I.T. Press, Cambridge, MA, 1999, pp. 244–75. *In/sight: African Photographers, 1940 to the Present,* Guggenheim Museum, New York, 1996. Oguibe, Olu, "Beyond Visual Pleasures: A Brief Reflection on the work of Contemporary African Women Artists," in Salah M. Hassan, ed., *Gendered Visions: The Art of Contemporary*

Africana Women Artists, Trenton, Africa World Press, Inc., 1997, pp. 63–72. Williamson, Sue and Ashraf Jamal, *Art in South Africa: The Future Present,* David Philip, Cape Town, 1996. Hassan, Salah M., and Olu Oguibe, *Authentic/Ex-Centric: Conceptualism in Contemporary African Art,* Forum for African Arts, Ithaca, 2001. Haines, Bruce, "Johannes Phokela: Changing the Title," in Salah M. Hassan and Iftihar Dadi, eds., *Unpacking Europe: Towards a Critical Reading,* Museum Boijmans Van Beuningen and NAI Publishers, Rotterdam, 2001, pp. 380–83. Williamson, Sue, "Artbio: Tracey Rose," *Artthrob* 43, March 2001, see www.artthrob.co.za. Mosquera, Gerardo, "Good-Bye Identity, Welcome Difference: From Latin American Art to Art From Latin America," *Third Text* 56, Autumn 2001, pp. 25–32. Kasfir, Sidney Littlefield, *Contemporary African Art,* Thames and Hudson, London, 1999. Enwezor, Okwui, "Reframing the Black Subject: Ideology and Fantasy in Contemporary South African Representation," in Oguibe and Enwezor, eds., *Reading the Contemporary,* 1999, pp. 377–99. *Mode/Fashion* (Special Issue), *Revue Noire* 27, December 1997/January & February 1998. Mustafa, Hudita Nura, "Sartorial Ecumenes: African Styles in a Social and Economic Context," in *The Art of African Fashion,* Prince Claus Fund, The Hague, 1998, pp. 13–45.

In response to the "post-black" phenomenon: Berger, Maurice, *Adrian Piper: A Retrospective,* D.A.P., New York, 1999. Berger, Maurice, "The Critique of Pure Racism: An Interview with Adrian Piper," *Afterimage* 18, October 1990, pp. 5–9. Huntington, Patricia, "Fragmentation, Race, and Gender: Building Solidarity in the Postmodern Era," in Lewis Gordon, ed., *Existence in Black: An Anthology of Black Existential Philosophy,* Routledge, New York, 1997, pp. 185–202. *Chakaia Booker: New Sculptures,* Marlborough Galleries, New York, 2001. *Siempre Vuelvo: Colografis de Belkis Ayón,* VII Bienal de la Habana/Galería Habana, Havana, 2000.

List of illustrations

Measurements are given in inches, then centimeters, unless otherwise stated, height before width, a third numeral indicating depth

1 Slave drum, late seventeenth century. Wood, height 18 (45.7). Copyright British Museum, London

2 ANONYMOUS *Las Castas* (*The Castes*) late eighteenth century. Oil on canvas 105 × 106 (266.7 × 269.2). Museo Nacional del Virreinato, Tepotzotlan, Mexico

3 ARTHUR DRUMMOND *The Empress* (detail) 1901. Oil on canvas 135 × 79⅞ (343 × 203). Private collection

4 SOSA ADEDE *King Glele in the guise of a lion* late nineteenth century. Wood, pigment, height 66⅞ (170). Collection Musée de l'Homme, Paris

5 ELIZABETH CATLETT *Negro es Bello II* 1969. Lithograph 30 × 23⅓ (76.2 × 59.5) Hampton University Museum, Hampton, Virginia

6 JEFF DONALDSON *Victory in Zimbabwe* 1977–80. Mixed media on acid-free corrugated board 42 × 45 (106.7 × 114.3). Courtesy the artist

7 Cover of sheet music for "All Coons Look Alike to Me" by Ernest Hogan, 1896. 13⅜ × 10⅜ (34 × 26.4). Special Collections, Perkins Library, Duke University, Durham, North Carolina

8 HENRY OSSAWA TANNER *The Banjo Lesson* 1893. Oil on canvas 49 × 35½ (124.5 × 90.2). Hampton University Museum, Hampton, Virginia

9 HARRIET POWERS *Bible Quilt* c. 1895–98. Pieced, appliquéd and printed cotton embroidered with plain and metallic yarns 69 × 105 (175 × 267). Courtesy, Museum of Fine Arts, Boston. Bequest of Maxim Karolik.

© 1995 Museum of Fine Arts, Boston. All Rights Reserved

10 H. M. PETTIT *Close Competition at the Cake Walk.* From *Leslie's Weekly*, 1899. Photo courtesy of the author

11 STUART DAVIS *Negroe Dance Hall* 1913. Crayon and ink on paper 21¼ × 16⅝. (53.7 × 42.2). Salander O'Reilly Galleries, New York. © Estate of Stuart Davis/DACS, London/VAGA, New York 1996

12 ERNST LUDWIG KIRCHNER *Tapdancing Negro* 1914. Lithograph. Lothar-Gunther Buchheim Collection. Copyright by Ingeborg & Dr. Wolfgang Henze-Ketterer, Wichtrach/Bern

13 LEIGH RICHMOND MINER frontispiece for Paul Laurence Dunbar's *Candle Lightin' Time* 1901. Photo Courtesy of Hampton University Archives, Hampton, Virginia

14 JOHN HENRY ADAMS JR. *The Modern Cyrenian's Cross, or the Black Man's Burden* 1907. Drawing from *Voice of the Negro.* Perkins Library, Duke University, Durham, North Carolina

15 D. W. GRIFFITH *The Birth of a Nation* 1915. Photo BFI Stills, Posters & Designs

16 META WARRICK FULLER *The Awakening of Ethiopia* c. 1914. Plaster full figure (bronze cast) 67 × 16 × 20 (170.2 × 40.6 × 50.8). Art and Artifacts Division, Schomburg Center for Research in Black Culture. The New York Public Library, Astor, Lenox and Tilden Foundations. Photo Manu Sassoonian

17 ISAAC SCOTT HATHAWAY *Frederick Douglass* 1919. Plaster, height approx. 32 (81). Roscoe Conklin Simmons Papers, Harvard University Archives, Cambridge. Photo Harvard College Library Photographic Services

18 Advertisement for Banania, 1917. Color lithograph 65 × 48⅜ (165 × 123). Bibliothèque Forney, Paris

19 EDWIN A. HARLESTON *The Soldier* 1919. Oil on canvas. Whereabouts unknown. Photo courtesy the National Archives, Washington D.C.

20 WINOLD REISS *Portrait of Langston Hughes* c. 1925. Pastel on artist board 30¹/₁₆ × 21⅝ (76.3 × 54.9). National Portrait Gallery, Smithsonian Institution, Washington D.C. Gift of W. Tjark Reiss in memory of his father, Winold Reiss. Reproduced with permission of W. Tjark Reiss

21 AARON DOUGLAS *Dance Magic* 1929–30. Mural in the College Room Inn, Sherman Hotel, Chicago. Destroyed. Photo courtesy of the author

22 CARL VAN VECHTEN *Aaron Douglas* 1933. Photograph. Yale Collection of American Literature, Beinecke Rare Book and Manuscript Library, Yale University. The Estate of Carl Van Vechten, Joseph Solomon, Executor

23 DORIS ULMANN *Baptism in River, South Carolina* 1929–30. Photograph 8½ × 6½ (21.6 × 16.5). Doris Ulmann Collection, CN 3423, Special Collections, University of Oregon Library

24 WILLIAM H. JOHNSON *Self-Portrait* 1929. Oil on canvas. Whereabouts unknown. Photo National Archives, Washington D.C.

25 LAURA WHEELER WARING *Anna Washington Derry* c. 1927. Oil on canvas 20 × 16 (50.8 × 40.6). National Museum of American Art, Smithsonian Institution, Washington D.C. Gift of the Harmon Foundation/Art Resource, New York

26 JAMES VANDERZEE *Couple wearing racoon coats with a Cadillac, taken on West*

127th Street, Harlem, New York 1932. Consolidated Freightways, Inc. Collection, Palo Alto, California

27 Advertisement for Memphis Julia Davis's "Black Hand Blues," from *The Chicago Defender* 1925. Perkins Library, Duke University, Durham, North Carolina

28 ARCHIBALD J. MOTLEY JR. *Jockey Club* 1929. Oil on canvas 25¾ × 32 (65.4 × 81.3). Art and Artifacts Division, Schomburg Center for Research in Black Culture. The New York Public Library, Astor, Lenox and Tilden Foundations. Photo E. Lee White

29 ALBERT ALEXANDER SMITH *A Tap Dancer c.* 1928. Etching 9⅞ × 6⅝ (25 × 17). Reproduced from the collection of the Library of Congress, Washington D.C.

30 JEAN RENOIR, Johnny Hudgins in *Sur un Air de Charleston* 1926. Photo BFI Stills, Posters & Designs

31 RICHMOND BARTHÉ *African Dancer* 1933. Plaster 43½ × 17¹/₁₆ × 14¹¹/₁₆ (110.5 × 43.3 × 37.3). Collection of the Whitney Museum of American Art, New York. Purchase 33.53. Copyright © 1995 Whitney Museum of American Art

32 PAUL COLIN, from *Le Tumulte Noir c.* 1927. Height 18½ (47). Yale Collection of American Literature, Beinecke Rare Book and Manuscript Library, Yale University. © ADAGP, Paris and DACS, London 1996

33 ALFRED JANNIOT, sculptural relief (detail) 1931, for the façade of the Museum of African and Oceanic Arts, Paris. Limestone, height 43' (13 m). Musée des Arts d'Afrique et d'Océanie, Paris. Photo © R.M.N., Paris

34 CHARLES C. DAWSON, advertisement for Madagasco Hair Straightener, from *The Chicago Defender* 1925. Perkins Library, Duke University, Durham, North Carolina

35 MIGUEL COVARRUBIAS "To Hold as t'Were the Mirror Up to Nature," from *Vanity Fair* 1929. Perkins Library, Duke University, Durham, North Carolina

36 AARON DOUGLAS *Harriet Tubman* 1931. Mural at Bennett College, Greensboro, North Carolina. 54 × 72 (137 × 183). © 1996 Bennett College, Greensboro, NC. All Rights Reserved

37 SARGENT JOHNSON *Negro Woman* 1933. Terracotta 9¼ × 5 × 6 (23.5 × 12.7 × 15.2). San Francisco Museum of Modern Art. Albert M. Bender Collection. Bequest of Albert M. Bender

38 ARCHIBALD J. MOTLEY JR. *The Picnic* 1936. Oil on canvas 30⅛ × 36⅛ (76.5 × 91.7). The Howard University Gallery of Art, Washington D.C.

39 PALMER C. HAYDEN *Midsummer Night in Harlem* 1936. Oil on canvas 25 × 30 (63.5 × 76.2). Museum of African American Art, Los Angeles. Palmer C. Hayden Collection. Gift of Miriam A. Hayden. Photo courtesy of The National Archives, Washington D.C.

40 JAMES LESESNE WELLS, book jacket for *The Negro Wage Earner* 1930. Offset print of linoleum cut 9 × 14¼ (22.9 × 36.2). © Addison Gallery of American Art, Phillips Academy, Andover, Massachusetts. All Rights Reserved. Gift of the artist. 1990.46. Photo Greg Heins

41 EDNA MANLEY *Pocomania* 1936. Hoptonwood stone, height 23½ (59.7). The Wallace Campbell Collection, Kingston, Jamaica. Courtesy the Edna Manley Foundation. Photo Mana La Yacona

42 ERNEST CRICHLOW *Lovers* 1938. Lithograph 14 × 12 (35.6 × 30.5). From the collection of Reba and Dave Williams

43 AUGUSTA SAVAGE *Lift Every Voice and Sing (The Harp)* 1939. Destroyed. Yale Collection of American Literature, Beinecke Rare Book and Manuscript Library, Yale University. Photo Carl Van Vechten. The Estate of Carl van Vechten, Joseph Solomon, Executor

44 EDWARD BURRA *Harlem* 1934. Brush, ink and gouache on paper 31¼ × 22½ (79.4 × 57.1). Tate Gallery, London

45 WALKER EVANS *Havana Citizen* 1933. Photograph. © The Walker Evans

Archive, The Metropolitan Museum of Art, New York. All Rights Reserved

46 LOIS MAILOU JONES *Les Fétiches* 1938. Oil on canvas 25½ × 21¼ (64.7 × 54). National Museum of American Art, Washington D.C. Museum Purchase made possible by Mrs. N. H. Green, Dr. R. Harlan and Francis Musgrave/Art Resource, New York

47 PETION SAVAIN, untitled block print from *La Case de Damballah* 1939. Perkins Library, Duke University, Durham, North Carolina

48 ROBERT RIGGS *The Brown Bomber* 1939. Oil on canvas 31 × 41 (78.7 × 104.1). From the collection of the Capricorn Galleries, Bethesda, Maryland

49 WILLIAM EDMONDSON *Angel* 1932–37. Limestone 24⅝ × 14⅛ × 6½ (62.6 × 35.9 × 16.5). Collection of The Newark Museum. Edmund L. Fuller Jr. Bequest. Photo Armen, April 1985

50 ANONYMOUS *Elijah and Cornelia Pierce c.* 1935. Photograph. Columbus Museum of Art, Ohio. Museum Purchase

51 JOHN ROBINSON *Self-Portrait c.* 1945. Oil on canvas 27½ × 25⅓ (69.9 × 64.8). Museum of African American Art, Tampa

52 KARL BROODHAGEN *The Poet (George Lamming) c.* 1945. Terracotta, height 16 (40.6). Collection of the artist. Photo courtesy of Karl Broodhagen

53 HARLAN JACKSON *Mask No. II* 1949. Oil on canvas 46 × 31 (116.8 × 78.7). Collection Mrs. Jaki Jackson. Photo Kenkeleba Gallery, New York

54 JACOB LAWRENCE *Going Home* 1946. Gouache on paper 21½ × 29½ (54.6 × 74.9). Collection of Connie Kay. Photo Sotheby's, New York

55 WILLIAM H. JOHNSON *Jitterbugs* (V) *c.* 1941–42. Oil on wood 36½ × 28¾ (92.7 × 73). Hampton University Art Museum, Hampton, Virginia

56 VINCENTE MINNELLI, Lena Horne, Eddie Anderson, Ethel Waters, and John Bubbles in *Cabin in the Sky* 1943.

© 1943 Turner Entertainment Co. All Rights Reserved. Photo BFI Stills, Posters & Designs

57 ELDZIER CORTOR *Americana* 1947. Oil on canvas 60 × 41 (152.4 × 104.1). Destroyed. Photo courtesy of Eldzier Cortor

58 JOHN BIGGERS *Manda c.* 1945. Pencil on board 37 × 30½ (94 × 77.5). Museum of African American Art, Tampa

59 ROBERT GWATHMEY *Work Song* 1946. Oil on canvas 29¾ × 36 (75.6 × 91.4). Collection of Auburn University, Auburn, Alabama

60 HECTOR HYPPOLITE *Pan de Fleur (Basket of Flowers—Voodoo)* 1947. Oil on cardboard 30 × 24 (76.2 × 61). Courtesy of Michael Rosenfeld Gallery, New York

61 JOHN DUNKLEY *Back to Nature* 1939. Mixed media on hardboard 16 × 28 (40.6 × 71.1). National Gallery of Jamaica, Kingston. Photo © Denis Valentine

62 MINNIE EVANS *A Dream* 1959. Oil and ink on canvas board 11⅞ × 16 (30.3 × 40.6). North Carolina Museum of History, Division of Archives and History, Department of Cultural Resources, Raleigh N.C.; courtesy of the North Carolina Division of Archives and History, Raleigh, N.C.

63 JAMES HAMPTON *The Throne of the Third Heaven of the Nations Millennium General Assembly c.* 1950–64. Gold and silver aluminium foil, colored Kraft paper and plastic sheets over wood, paperboard and glass. 180 pieces in overall configuration 10'6" × 27' × 14'6" (3.2 m × 8.23 m × 4.42 m). National Museum of American Art, Washington D.C. Gift of anonymous donors/Art Resource, New York

64 ROSE PIPER *Slow Down Freight Train* 1946. Oil on canvas 29½ × 23⅛ (74 × 58.7). The Ackland Art Museum, The University of North Carolina at Chapel Hill, Ackland Fund

65 NORMAN LEWIS *Every Atom Glows: Electrons in Luminous Vibration* 1951. Oil on canvas 54 × 34 (137.2 × 86.4).

Collection John P. Axelrod. Photo Kenkeleba Gallery, New York

66 HALE WOODRUFF *Art of the Negro* Murals, Panel 5: *Influences* 1950–51. Oil on canvas 12' × 12' (3.66 m × 3.66 m). Courtesy of Clark Atlanta University. Collection of African-American Art, Atlanta, Georgia

67 BOB THOMPSON *Garden of Music* 1960. Oil on canvas 79½ × 143 × 1½ (201.9 × 363.2 × 3.8). Wadsworth Atheneum, Hartford. The Ella Gallup Sumner and Mary Catlin Sumner Collection Fund. © Wadsworth Atheneum

68 RICHARD HUNT *Arachne* 1956. Welded steel 30 × 24½ × 28¼ (76 × 62.2 × 71.7), including base. The Museum of Modern Art, New York. Purchase. Photograph © 1995 The Museum of Modern Art, New York

69 AUBREY WILLIAMS *Guyana* 1965. Courtesy Eve Williams

70 OLLIE HARRINGTON "No, it dont make no sense to me niether [*sic*] Bootsie…." *c.* 1957. Pencil and ink on paper 18½ × 14½ (21.6 × 36.8). Collection of Dr. Walter Evans, Detroit

71 WIFREDO LAM *The Eternal Presence* 1945. Oil on canvas 85 × 77½ (215.9 × 196.9). Museum of Art, Rhode Island School of Design, Providence © DACS 1996

72 MARCEL CAMUS, Marpessa Dawn and Breno Mello in *Orfeu Negro (Black Orpheus)* 1958. Photo BFI Stills, Posters & Designs

73 BEAUFORD DELANEY *Self-Portrait* 1962. Oil on canvas 26.5 × 48 (48.3). Photograph © 1995 The Detroit Institute of Arts, Founders Society Purchase, City of Detroit by exchange

74 SKUNDER BOGHOSSIAN *The Moon and the Valiant c.* 1964. Oil on canvas 16 × 10 (40.6 × 25.4). Hampton University Museum, Hampton, Virginia

75 GERARD SEKOTO *Woman Ironing c.* 1940–41. Oil on hardboard 28 × 24 (71.1 × 61). Hampton University Museum, Hampton, Virginia

76 ELIZABETH CATLETT *I Have A Special Fear for My Loved Ones* 1946. Linocut 8¼ × 5¾ (21 × 14.6). Courtesy Sragow Gallery, New York. Photo © Sarah Wells

77 CHARLES WHITE *O, Mary, Don't You Weep* 1956. Ink on board. Collection of Harry Belafonte

78 ERNEST C. WITHERS, cover of *Complete Photo Story of Till Murder Case* 1955. Courtesy the artist

79 NORMAN ROCKWELL *The Problem We All Live With* 1964. Oil on canvas 36 × 58 (91.5 × 147.5) By permission of the Norman Rockwell Family Trust. Copyright © 1964 the Norman Rockwell Family Trust. Photo courtesy of The Norman Rockwell Museum at Stockbridge, Massachusetts

80 ROMARE BEARDEN *Summertime* 1967. Collage 56 × 44 (142.2 × 111.8). Private Collection. Courtesy Estate of Romare Bearden/ACA Galleries New York, Munich

81 RAYMOND SAUNDERS *Jack Johnson* 1972. Gouache, chalk, tickets, masking tape on paper 19 × 23 (48.3 × 58.4). Stephen Wirtz Gallery, San Francisco. Photo Ben Blackwell

82 BARBARA CHASE-RIBOUD *Confessions or Myself* 1972. Bronze, painted black, and black wool 120 × 40 × 12 (304.8 × 101.6 × 30.5). University Art Museum, University of California at Berkeley. Purchased with funds from the H. W. Anderson Charitable Foundation (Selected by The Committee for the Acquisition of Afro-American Art)

83 SAM GILLIAM *Lion's Rock Arc* 1981. Acrylic on canvas 82 × 191 (208.3 × 485.1). Collection The Studio Museum in Harlem, New York

84 ALMA THOMAS *Red Azaleas Singing and Dancing Rock and Roll Music* 1976. Acrylic on canvas 72¼ × 156¾ (183.5 × 398.2). National Museum of American Art, Washington D.C. Bequest of Alma W. Thomas/Art Resource, New York

85 JOHN T. SCOTT. View of the Ruggles Street Station Installation, Boston, 1986. Painted aluminium 35' × 32'

(10.7 m × 9.75 m), height variable. Photo courtesy Galerie Simmone Stern, New Orleans

86 AL LOVING *Self-Portrait No. 23* 1986. Dyed cotton-duck canvas 13' × 16' (3.96 m × 4.88 m). Artist's Collection. Photo Contemporary Art, New York

87 HERVÉ TÉLÉMAQUE *Othello No. 1* 1960. Oil on canvas 66 × 68 (167.6 × 172.7). University Art Museum, University of California at Berkeley. Anonymous gift. © ADAGP, Paris and DACS, London 1996

88 EMILIO CRUZ *The Dance* 1962. Oil on paper 21⅞ × 30⅝ (55.5 × 77.8) National Museum of American Art, Smithsonian Institution, Washington D.C. Gift of Virginia Zabriskie / Art Resource, New York

89 SYLVIA SNOWDEN *Mamie Harrington* 1985. Acrylic on masonite 48½ × 67 (123.2 × 170.2). Collection Corcoran Gallery of Art, Washington D.C. Gift of Thurlow E. Tibbs Jr., The Evans-Tibbs Collection

90 JOE OVERSTREET *Saint Expedite* 1971, from the *Flight* series. Acrylic, shaped canvas with guy rope 119½ × 136½ (303.5 × 346.7). Collection the artist. Photo Kenkeleba Gallery, New York

91 EDWARD CLARK *Ife Rose* 1974. Acrylic on canvas 117 × 181 (297.2 × 459.7). Collection of the artist. Courtesy G. R. N'Namdi Gallery, Birmingham

92 FRANK BOWLING *Night Journey* 1968–69. Acrylic on canvas 34 × 60 (86.4 × 152.4). Private collection, New York.

93 JACK WHITTEN *Dead Reckoning I* 1980. Acrylic on canvas 72¾ × 72¾ (184.8 × 184.8). The Studio Museum in Harlem, New York. Gift of Bill Whitten. 84.16. Photo Dawoud Bey

94 UZO EGONU *Deserted Asylum* 1964. Oil on canvas 25⅝ × 29⅞ (65 × 76). Collection Mrs Ruth F. Hudson, Oklahoma, USA

95 ANDY WARHOL *Race Riot* 1964. Oil with silkscreen on canvas 30 × 32⅞ (76.2 × 83.4). Rhode Island School of Design

Museum of Art, Providence. © ARS, New York and DACS, London 1996

96 JEFF DONALDSON *Aunt Jemima and the Pillsbury Doughboy* 1963. Oil on canvas 48 × 48 (121.9 × 121.9). Collection of the artist

97 CARL FISCHER and GEORGE LOIS "The Passion of Muhammad Ali," cover of *Esquire* April 1968. Courtesy Lois/USA, New York

98 MELVIN VAN PEEBLES *Sweet Sweetback's Baadasssss Song* 1971. Photo BFI Stills, Posters & Designs

99 PATRICK LICHFIELD *Marsha Hunt* 1969. Photograph. Copyright Camera Press Ltd, London

100 LEV MILLS *I'm Funky, But Clean* 1972. Serigraph 30 × 22 (76.2 × 55.9). Private collection. Photo courtesy the artist

101 ANTHONY BARBOZA *Fadiouth, Senegal, West Africa* 1972. Photograph. Collection of the artist

102 JAE JARRELL *Revolutionary Suit* 1970. Photo Doug Harris

103 LARRY RIVERS *I like Olympia in Black Face* 1970. Painted construction 41 × 78 × 33⅞ (104 × 198 × 86). Musée National d'Art Moderne, Centre Georges Pompidou, Paris

104 MURRY N. DEPILLARS *Queen Candace* 1989. Acrylic on canvas 47¼ × 36¼ (120 × 92.1) Photo courtesy of the artist

105 FAITH RINGGOLD *Fight to Save your Life* 1972, from the *Slave Rape* series. Oil on canvas 86 × 48 (218.4 × 121.9). Collection of the artist

106 DANA C. CHANDLER JR. *American Penal System. . .Pan-African Concentration Camps and Death Houses* from the *Genocide* series, 1971. Offset lithograph 11 × 17 (28 × 43). Courtesy the artist

107 ADGER GOWANS *P.B.* 1974. Photograph. Collection of the artist

108 ROBERT MAPPLETHORPE *Alistair Butler* 1980. Photograph.

Copyright © 1980 The Estate of Robert Mapplethorpe

109 BILL GUNN *Ganja and Hess* 1973. Photo The Museum of Modern Art/Film Stills Archive, New York

110 BETYE SAAR *The Time Inbetween* 1974. Wooden box containing photos, illustration, paint, envelope, metal findings, beads, fan, glove, tape measure, lace, buttons, coin purse, velvet ribbon, cloth, feathers, bones; closed 3⅜ × 8½ × 11⅝ (8.6 × 21.6 × 29.6). San Francisco Museum of Modern Art. Purchase. Photo Ben Blackwell

111 BARKLEY L. HENDRICKS *Brilliantly Endowed (Self-Portrait)* 1977. Oil on canvas 66 × 48 (167.6 × 122). Collection of the artist

112 DAWOUD BEY, David Hammons constructing *Higher Goals* in Cadman Plaza, Brooklyn, New York, 1986. Photograph. Collection of the artist

113 FRANCIS GRIFFITH *Untitled* c. 1963–95. Enamel on board 24 × 24 (61 × 61). Photo courtesy of the artist

114 LOIS MAILOU JONES *Magic of Nigeria* 1971. Watercolor 34 × 22 (86.4 × 56). Collection of Dr. Tritobia Hayes Benjamin, Washington D.C.

115 ERNIE BARNES *The Sugar Shack* 1972–76. Acrylic on canvas 36 × 48 (91.4 × 121.9). Collection of Mr. and Mrs. Eddie Murphy. Courtesy of The Company of Art, Los Angeles, California

116 ARCHIE RAND *The Groups* 1970. Acrylic and wax crayon on canvas 27 × 157 (68.6 × 398.8). Collection of the artist

117 SISTER GERTRUDE MORGAN *Come in my Room, Come on in the Prayer Room* c. 1970. Tempera, acrylic, ballpoint pen and pencil on paperboard 12⅛ × 23 (30.7 × 58.4). National Museum of American Art, Washington D.C. Gift of Herbert Waide Hemphill, Jr. Museum purchase made possible by Ralph Cross Johnson/Art Resource, New York

118 EVERALD BROWN *Dove Harp* 1977. Mixed media, length 38 (96.5).

Private collection, Kingston.
Photo © Denis Valentine

119 MARGO HUMPHREY *The Last Bar-B-Que* 1988–89. Lithograph with goldleaf 22 × 48 (55.9 × 121.9). Collection of the artist

120 LYLE ASHTON HARRIS *For Cleopatra* 1994. Unique polaroid 20 × 24 (50.8 × 61). Courtesy Jack Tilton Gallery, New York/Lyle Ashton Harris

121 ALISON SAAR *Terra Rosa* 1993. Latex, wax, dirt and polymer on wood 54½ × 15½ × 25 (138.4 × 39.4 × 63.5). Collection of the artist

122 GARY SIMMONS *Black Chalkboard* 1993, from the *Erasure* series. Oak, masonite, slate paint and chalk with fixative 48 × 60 (121.9 × 152.4). Courtesy of the artist and Metro Pictures, New York

123 MARTIN PURYEAR *His Eminence* 1993–95. Red cedar and pine 98 × 44¾ × 97 (248.9 × 113.7 × 246.4). Private collection. Courtesy of McKee Gallery, New York. Photo Sarah Wells

124 JEAN-MICHEL BASQUIAT *Flexible* 1984. Acrylic and oilstick on wood 102 × 75 (259 × 190.5). © ADAGP, Paris and DACS, London 1996. Courtesy Robert Miller Gallery, New York

125 OUATTARA *Hip-Hop Jazz Makoussa* 1994. Mixed media on wood 111 × 144 (281.9 × 365.8). Courtesy of Gagosian Gallery, New York

126 TAM JOSEPH *Learning to Walk* 1988. Sand, acrylic medium and pigment 79⅛ × 152 (201 × 386). Arts Council Collection, London. Photo George Meyrick

127 RAS ISHI BUTCHER *400 Years New World Order* 1995. Oil and sand on canvas 12⅝ × 11 (32 × 28). Collection of Mervyn Awon

128 MR. IMAGINATION *Portrait Head Paintbrush Tree* 1991. Mixed media 65⅛ × 22¾ × 18¾ (165.4 × 57.8 × 47.6). National Museum of American Art, Washington D.C./Art Resource, New York

129 PHILIP MOORE *King Sparrow in Sacred Wonder Heart* 1992. Oil on canvas 18⅞ × 14⅛ (48 × 36). Collection of Mervyn Awon

130 MARTHA JACKSON-JARVIS *Last Rites: Sarcophagi II (Earth)* 1992–93. Clay, glass, pigmented cement, wood, iron 4 × 5½ × 2½ (10.2 × 14 × 6.4). Courtesy the artist. Photo Harlee Little

131 MELVIN EDWARDS *Tambo* 1993. Welded steel 28⅛ × 25¼ × 22 (71.5 × 64.2 × 55.9). National Museum of American Art, Washington D.C. Museum purchase through the Luisita L. and Franz H. Denhausen Endowment and the Smithsonian Collections Acquisition Program/Art Resource, New York

132 LORNA SIMPSON *Five Rooms* (detail of Room One). Installation at Spoleto Festival U.S.A., Charleston, S. Carolina, 1991. Glass water bottles, wooden stools, engraved plastic plaques, 4-color polaroid prints; dimensions variable. Courtesy Sean Kelly Gallery, New York

133 BEVERLY BUCHANAN *Richard's Home* 1993. Wood, oil crayon, mixed media 78 × 16 × 20⅞ (198.1 × 40.6 × 53). © Beverly Buchanan. Collection Eric and Barbara Dobkin. Photo Adam Reich. Courtesy Steinbaum Krauss Gallery, New York

134 KERRY JAMES MARSHALL *Better Homes, Better Gardens* 1994–95. Acrylic on canvas 100 × 144 (254 × 365.8). Courtesy the artist

135 FRED WILSON *Insight: In Site: In Sight: Incite: Memory*. Installation in St Philips's Church, Old Salem, Winston-Salem, N. Carolina, 1994. One room filled with gourds; dimensions variable. Photo courtesy of the Southeastern Center for Contemporary Art and Fred Wilson, New York. Photo Jackson Smith

136 SONIA BOYCE *Peep*. Installation of museum intervention in Cultures Gallery, Brighton Museum and Art Gallery, Sussex, 1995. 50 glass cases covered with tracing paper. Commissioned by the Institute of International Visual Arts, London. Photo David Catchpole

137 HOUSTON CONWILL, JOSEPH DE PACE, ESTELLA CONWILE MAJOZO *The New Ring Shout* 1995. Central rotunda of Federal Office Building built over an excavated African burial ground, New York. Photo courtesy of the artists

138 ALFREDO JAAR *Benjamin* 1995. 99 linen photographic boxes with text and 99 Cibachrome prints 2 × 103½ × 99 (5.1 × 262.9 × 251.5). Courtesy of the artist and Galerie Lelong, New York. Photo Wit McKay, New York

139 ACHAMYELEH DEBELA *Artist Under a Mask* 1990–91. Cibachrome print 20 × 30 (50.8 × 76.2). Collection of the artist

140 PHILLIP MALLORY JONES *First World Order* 1994. Video. Courtesy of Electronic Arts Intermix, New York

141 ALBERT CHONG *Winged Desire* 1994. Gelatin silver print with incised copper mat 24 × 20 (61 × 50.8). Courtesy Porter Troupe Gallery, San Diego, California

142 LORRAINE O GRADY *The Strange Taxi: From Africa to Jamaica to Boston in 200 Years* 1991. Black and white photomontage, dimensions variable. Courtesy the artist

143 EMMA AMOS *Confederates* 1994. Photo laser transfer and silk collagraph 18 × 20 (45.7 × 50.8). Courtesy the artist. Photo Becket Logan

144 COREEN SIMPSON *Jamien* 1984, from the *B-Boy* series. Gelatin silver print 40 × 60 (101.6 × 152.4). Collection of the artist

145 SUE WILLIAMSON *Mementoes of District Six* 1993. Various objects preserved in lucite, steel, rubble, dirt, lights, sound 32¾ × 43 (83.2 × 109.2). Collection of the Birmingham Museum of Art, Birmingham, Alabama. Museum purchase with funds provided by the Collectors' Circle for Contemporary Art

146 DAWOUD BEY *Sara, Martin David and Tolani* 1992. Color polaroid (triptych) 30 × 66 (76.2 × 167.6). © Addison Gallery of American Art, Phillips Academy, Andover, Massachusetts. All Rights Reserved. 1993.36. Photo Greg Heins

147 ÉDOUARD DUVAL-CARRIÉ *Un Touriste chez lui* 1981. Oil on canvas 58 × 77 (147.3 × 195.6). Collection Ann Duval. Courtesy Guiterrez Fine Arts, Miami Beach

148 SUE COE *Woman Shot in the Back* 1985. Graphite and gouache on off-white Bristol board. 22 × 30 (55.8 × 76.2). Copyright © 1985 Sue Coe. Courtesy Galerie St Etienne, New York

149 MAUD SULTER *Calliope* 1989, from the *Zabat* series. Cibachrome print 60 × 48 (152.4 × 121.9). © Maud Sulter. Courtesy of the Trustees of the Victoria & Albert Museum, London

150 ADRIAN PIPER *My Calling (Card) No. 2* 1986. Guerrilla performance with printed calling card 2 × 3½ (5 × 8.9). Courtesy John Weber Gallery, New York

151 BYRON KIM and GLENN LIGON *Rumble Young Man, Rumble (Version No. 2)* 1993. Paintstick canvas punch bag 42 × 14 × 14 (106.7 × 35.6 × 35.6). Courtesy Max Protech Gallery, New York. Photo Dennis Cowley

152 HOWARDENA PINDELL *Separate But Equal: Genocide: AIDS* 1990–92. Acrylic, vinyl type on cut and sewn canvas in two parts. Each part 48 × 72 (121.9 × 182.9), together 102 × 72 (259.1 × 182.9). Collection of the artist

153 ROBERT COLESCOTT *Lightning Lipstick* 1994. Liquitex, acrylic, gel, canvas 90 × 114 (228.6 × 289.6). Collection of the artist. Photo courtesy Phyllis Kind Gallery, New York and Chicago

154 STANLEY GREAVES *The Presentation No. 2* 1992, from *There is a Meeting Here Tonight* series. Acrylic 47¼ × 41⅛ (120 × 104.5). Collection of the artist

155 KEITH MORRISON *Chariot* 1988. Oil on canvas 64 × 87 (162.6 × 221). Collection of the artist

156 BEN JONES *Shango Wall Installation* (detail) 1994. Multi-media, length 30' (9.14 m). Collection of the artist

157 TSENG KWONG CHI and KEITH HARING *Bill T. Jones* 1983. Photograph. © 1983 Tseng Kwong Chi. © ARS,

New York and DACS, London 1996. Courtesy of the Estate of Keith Haring

158 SHERMAN FLEMING *UN/SUB: De Jacht op Zwarte Piet* 1995. Performance held at Arti et Amichitiae, Amsterdam. Courtesy of the artist

159 SOKARI DOUGLAS CAMP *Gelede From Top to Toe* 1995. Steel and wood 72 × 16⅛ × 37 (183 × 41 × 94). Collection of the artist. Photo Peter White

160 WEREWERE LIKING *Un Touareg s'est marié avec une Pygmée* 1992. Performance held at Création au Festival des Francophonies, Limoges, France. Photo © Catherine Millet

161 JOYCE J. SCOTT *Generic Interference, Genetic Engineering* 1992. Performance held at the Baltimore Museum of Art, Baltimore, Maryland. Courtesy of the artist

162 CARRIE MAE WEEMS *Ode to Affirmative Action* 1989. Silver print, record and label 24 × 30 (61 × 76.2). Courtesy P.P.O.W. Gallery, New York

163 SPENCER WILLIAMS, Juanita Riley, Cathryn Caviness, and Spencer Wiliams in *The Blood of Jesus* 1941. Photo Southwest Film/Video Archives, Dallas

164 RICHARD D. MAURICE *Eleven p.m.* 1928. Photo Library of Congress, Washington D.C.

165 EDWARD SPRIGGS and FRED PADULA *Ephesus* 1966. Courtesy of the artist

166 ISAAC JULIEN *Looking for Langston* 1989. Copyright Sankofa Film & Video 1989. Photo Sunil Gupta. Photo courtesy BFI Stills, Posters and Designs

167 MARTINA ATTILLE *Dreaming Rivers* 1988. Copyright Sankofa Film and Video 1988. Photo Christine Parry

168 CAMILLE BILLOPS and JAMES HATCH *The KKK Boutique Ain't Just Rednecks* 1994. Photo Mary Ellen Andrews. © 1994 Mom and Pop Productions

169 SPIKE LEE *School Daze* 1988. Courtesy of Columbia Pictures. Photo David Lee

170 FELIX DE ROOY *Ava and Gabriel* 1990. Photo BFI Stills, Posters and Designs

171 OUSMANE SEMBENE, Tabara N'Diaye in *Ceddo* 1976. Photo BFI Stills, Posters and Designs

172 EUZHAN PALCY, Garry Cadenet in *Rue Cases-Nègres (Sugar Cane Alley)* 1983. Photo BFI Stills, Posters and Designs

173 JULIE DASH *Daughters of the Dust* 1992. Kino International, New York. Photo BFI Stills, Posters and Designs

174 HAILE GERIMA *Sankofa* 1993. Photo Mypheduh Production/WDR

175 JEAN-PAUL GOUDE album cover for *Island Life*, Grace Jones, 1985. Courtesy of Island Records Ltd

176 KEITH PIPER *Reckless Eyeballing*. Installation at Ferens Art Gallery, Hull, Humberside, June-July 1995. Interactive installation with a video projection from laser disk triggered by spectators stepping on to three lecterns. Installation controlled by Apple Macintosh computer running SampleCell and Max

177 JONATHAN DEMME *Beloved* 1998, Oprah Winfrey. Black and white film still. © Touchstone Pictures Company All Rights Reserved. Courtesy Harpo Productions. Photo Ken Regan/Camera 5

178 CHARLES S. STONE III *You Got Me* 1998, Erykah Badu. Video still. Courtesy of Erykah Badu, Charles S. Stone III, MCA Records, and Universal/Motown Records Group

179 DJ SPOOKY (a.k.a. Paul D. Miller) *Rebirth of a Nation* 2002. © 2002 Paul D. Miller/Subliminal Kid Publishing

180 KARA WALKER *African/American* 1998. Linocut 46 × 60 (116.8 × 152.5). Edition of 40. Brent Sikkema Gallery, New York

181 DAVID LEVINTHAL *Blackface* 1995. Color polaroid 24 × 20 (61 × 50.8). Courtesy of the Lisa Sette Gallery, Scottsdale, Arizona

182 RENÉE COX *The Liberation of Lady J. and U. B.* 1998. Cibachrome print 48 × 60 (121.9 × 152.4). © Renée Cox.

267

Courtesy Robert Miller Gallery,
New York

183 AARON MCGRUDER Strip from
The Boondocks 2000. BOONDOCKS
© 2000 Aaron McGruder. Distributed
by UNIVERSAL PRESS SYNDICATE.
Reprinted with permission.
All rights reserved.

184 CHRIS OFILI *Afrodizzia (2nd version)*,
1996. Acrylic, oil, resin, paper collage,
glitter, map pins, and elephant dung
on canvas 96 × 72 (243.8 × 182.8).
Courtesy Chris Ofili/Victoria Miro
Gallery. © Chris Ofili.

185 YINKA SHONIBARE *Cloud 9*,
1999–2000. Dutch wax printed cotton
textile, fiberglass figure, helmet, flagpole
and flag. Astronaut 83½ × 24¾ × 22

(212 × 63 × 56) Flag height
72 (183). Exhibition presented at
Camden Arts Centre, London 2000.
Neuberger Berman Collection,
New York. Courtesy Stephen
Friedman Gallery, London.
Photo Andy Keate

186 JOHANNES PHOKELA *Pantomime Act
Trilogy* 1999. Oil on canvas 72 × 66⅛
(183 × 168). Courtesy of the artist

187 YINKA SHONIBARE *Dorian Gray*,
Scene 6, 2001. 11 black and white
resin prints, 1 digital lambda print
each 48 × 60 (122 × 152.5). Edition
of Five. Courtesy Stephen Friedman
Gallery, London

188 MINNETTE VÁRI *Self Portrait 2*
1995. Photographic print 29½ × 40⅛

(75 × 102). Courtesy of the artist and
Serge Ziegler Galerie, Zurich

189 TRACEY ROSE *Span II* 1997.
Performance/video installation.
Photo Michael Hall.

190 OUMOU SY *Cyberdress* 1997.
Photo Mamadou Touré Béhan, Dakar
Senegal © Prince Claus Fund 1998

191 CHAKAIA BOOKER *Wrench Wench II*,
2001. Steel, rubber, wood 90 × 46 × 21
(228.6 × 116.8 × 53.34). © Chakaia
Booker, courtesy Marlborough Gallery,
New York

192 BELKIS AYÓN *La Cena (The Dinner)*,
1991. Collagraph, 6 panels, each 52⅝ ×
59¼ (133.6 × 150.5). Collection of
Eileen and Peter Norton, Santa Monica

Index

268